THE INDEX OF CHRISTIAN ART

Occasional Papers · XVI

Manuscripta Illuminata

APPROACHES TO UNDERSTANDING MEDIEVAL & RENAISSANCE MANUSCRIPTS

★

Edited by

COLUM HOURIHANE

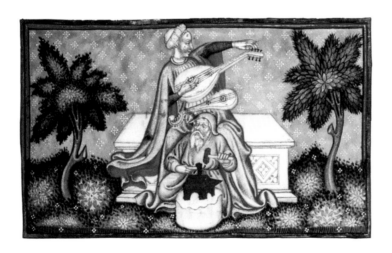

INDEX OF CHRISTIAN ART
DEPARTMENT OF ART & ARCHÆOLOGY
PRINCETON UNIVERSITY
in association with
PENN STATE UNIVERSITY PRESS
M M · X I V

DISTRIBUTED BY
PENNSYLVANIA STATE UNIVERSITY PRESS
820 NORTH UNIVERSITY DRIVE, USB 1, SUITE C
UNIVERSITY PARK, PENNSYLVANIA 16802

ISBN 978–0–9837537–3–5

BOOKS PUBLISHED BY THE INDEX OF CHRISTIAN ART
PRINCETON UNIVERSITY
ARE PRINTED ON ACID-FREE PAPER AND MEET THE
REQUIREMENTS FOR PERMANENCE AND
DURABILITY OF ⊗ ANSI/NISO Z39.48–1992
(PERMANENCE OF PAPER)

CONTENTS

{ vii }

PREFACE

THE RECENT PUBLICATION of *Medieval & Renaissance Manuscripts in the Princeton University Library*, a two-volume catalogue on the Western medieval and Renaissance manuscripts in Princeton's Firestone Library, was the reason behind the conference whose proceedings are to be found in this book.[1]

The 550 medieval and Renaissance manuscripts found in the Princeton University Library and the Scheide Library range in date from the mid-ninth century to the end of the sixteenth century and are representative of most of Western Europe and of both the religious and secular traditions. The collection extends from Books of Hours to unique treatises on man's mortality. Princeton's medieval manuscript collection is primarily made up of individual collections from Robert Garrett, Grenville Kane, Robert Taylor, and the Princeton Medieval and Renaissance Manuscripts; the last is still being added to. There are also a number of other medieval manuscript collections on campus, including those of the Cotsen Children's Library, the Scheide Library, and the Princeton University Art Museum; some of the manuscripts discussed in this book are from these collections.

Princeton University started collecting Western manuscripts in 1876 when two fifteenth-century manuscripts were received as gifts. From this humble beginning, the collection was added to and extended by the gifts of past alumni, including Moses Taylor (Class of 1877) and Robert Garrett (Class of 1897). The library continues to purchase works of interest, the most recent, a Prayerbook (Princeton Ms. 223), is previewed for us by Elizabeth Moodey in this volume. Today the library is a major resource for the study of manuscripts and is heavily used by students and researchers. Although *Medieval & Renaissance Manuscripts in the Princeton University Library* is the first complete catalogue to be published, valiant efforts to externalize the collection beyond Princeton have previously been made, for instance by Adelaide Bennett, Jean Preston, and William Stoneman in *A Summary Guide to Western Medieval Manuscripts at Princeton University*.[2]

Manuscripts have always been the largest medium in the Index of Christian Art and it was our founder Charles Rufus Morey's belief that they preserved the Latinity of the Middle Ages better than any other medium. The Index of Christian Art received a grant from The Andrew W. Mellon Foundation in 2002 that enabled us to digitize and catalogue all of the Western manuscripts in Princeton University's Firestone Library, thus making them available to a wider community. The Firestone Library collection was also amongst the first such manuscript collections to appear in the Andrew Mellon Foundation funded ARTstor Digital Library. We at the Index always felt that these manuscripts in Princeton would perfectly complement the rich manuscript holdings of the Morgan Library and Museum in New York, which we were also digitizing and cataloguing. Together, they make up an unrivalled online resource for the study of the medieval illuminated manuscript. At the Index, however, our interests focus on the image rather than the text, and that is where Don Skemer's catalogue adds significantly. He includes manuscripts that were not illuminated and as such it is the first comprehensive catalogue of all the works in the Library. His publication deals as well with the palaeography, codicology, binding, provenance, etc., details that are beyond the scope of the Index.

Our hope in this conference was not only to highlight the many manuscript treasures found in the Library, but also to look at them in relation to works elsewhere. Our speakers were asked to focus on specific works or types of manuscripts in the Princeton

1. Don C. Skemer, *Medieval & Renaissance Manuscripts in the Princeton University Library*, Incorporating contributions by Adelaide Bennett, Jean F. Preston, William P. Stoneman, and the Index of Christian Art (Princeton, N.J.: Department of Art and Archaeology and the Princeton University Library in association with Princeton University Press, 2013), 2 vols. The conference was held in Princeton University on the 25th and 26th of October 2013 with the same title as this volume.

2. *A Summary Guide to Western Medieval and Renaissance Manuscripts at Princeton University*, by Adelaide Bennett, Jean F. Preston, and William P. Stoneman (Princeton, N.J.: Princeton University Library, 1991).

collection and then if possible to look beyond the university confines. In some cases this was not possible and our speakers simply addressed the whole issue of their chosen manuscript topic. In any case, the ultimate aim was to try to advance our understanding of the medieval manuscript, and I am delighted to say that all of our speakers answered that call admirably. For various reasons, one or two of our speakers could not publish their papers in this collection, but what we do have here presents some of the most eminent scholars in the field addressing the issue of manuscript studies.

Manuscripts have been studied at various conferences organized by the Index over the last few years, but this is the first such event to be singularly devoted to the subject, and it was an event that enlightened us enormously. Our studies ranged from Ottonian manuscripts to the Renaissance library, and in between we looked at individual illuminators and specific manuscripts, covering topics from particular types of books to specific motifs, and all the while presenting many new perspectives. Many of our studies were under-

standably underpinned by iconography—the central focus of the Index of Christian Art.

My thanks must go to my colleagues in the Index of Christian Art for all their help in organizing this event and for their assistance with this publication. The moderators for the conference were Charles Barber, Rowan Watson, and Elizabeth Sears, and again my thanks go to them. The Council of the Humanities in Princeton University generously supported this event and I wish to acknowledge the help of Carol Rigolot and Gideon Rosen in particular. Emily Rose and James Marrow also contributed to making the event a pleasurable and enjoyable gathering and my thanks go to them.

This book was guided through its various stages from manuscript to finished book by the expert eyes of Mark Argetsinger, who has worked with us for many years and whose help is always appreciated. He is never loath to take those final few steps towards getting the best available and his input is always appreciated. I am particularly grateful to him for all his assistance to me over the years.

COLUM HOURIHANE
Director
Index of Christian Art

NOTES ON THE CONTRIBUTORS

ADELAIDE BENNETT is a research scholar in the Index of Christian Art, where she has been based since 1968. She studied under Robert Branner at Columbia University, where she received her Ph.D. She has published widely in the area of manuscript illumination and is presently compiling a catalogue of French Books of Hours from 1200 to 1320. She has contributed to many past Index publications. Amongst her studies are 'Making Literate Lay Women Visible: Text and Image in French and Flemish Books of Hours, 1220–1320,' in *Thresholds of Medieval Visual Culture: Liminal Spaces*, edited by Elina Gertsman and Jill Stevenson (2012); 'Devotional Literacy of a Noblewoman in a Book of Hours of ca. 1300 in Cambrai,' in *Manuscripts in Transition: Recycling Manuscripts, Texts and Images*, Proceedings of the International Congress held in Brussels, 5–9 November 2002, edited by Brigitte Dekeyzer and Jan van der Stock (2005).

WALTER CAHN is the Carnegie Professor (Emeritus) of the History of Art at Yale University. He received his Ph.D. from the Institute of Fine Arts, New York University, in 1967. He has been the recipient of Fulbright and Guggenheim Fellowships, and is a Fellow of the Medieval Academy of America. Editor of the journal *Gesta* (1967–70) and Editor-in-Chief of the *Art Bulletin* (1988–91), he has also served for three separate terms as Chair of the History of Art Department at Yale. Among his many publications are *The Romanesque Wooden Doors of Auvergne* (1974); *Masterpieces: Chapters on the History of an Idea* (1979); *Romanesque Bible Illumination* (1982); *Romanesque Manuscripts: The Twelfth Century* (1996); *Studies in Medieval Art and Interpretation* (2000), as well as numerous articles.

MARC MICHAEL EPSTEIN has been teaching at Vassar since 1992, and was the first Director of Jewish Studies. He is a graduate of Oberlin College, received his Ph.D. at Yale University, and did much of his graduate research at the Hebrew University in Jerusalem. He has written on various topics in visual and material culture produced by, for, and about Jews. His most recent book, *The Medieval Haggadah: Art, Narrative, and Religious Imagination* (2011), was selected by the London *Times Literary Supplement* as one of the best books of the year. During the 1980s, Epstein was Director of the Hebrew Books and Manuscripts division of Sotheby's Judaica Department, and continues to serve as consultant to various libraries, auction houses, museums, and private collectors throughout the world. Among them are the Herbert C. and Eileen Bernard Museum at Temple Emanu-El in New York City, for which he curated the inaugural exhibition, and the Jewish Museum, London, where he is currently serving as consultant for a major exhibition on aspects of magic, Kabbalah, and their relationship to visual culture.

MARILYN ARONBERG LAVIN has taught Art History at Washington University, the University of Maryland, Yale, Princeton, and Sapienza University of Rome. She has worked for more than fifty years on fourteenth- and fifteenth-century Italian art, with emphasis on the painter-mathematician Piero della Francesca. She has received international recognition for books on Piero's *Flagellation* (in Urbino), his *Baptism of Christ* (in London), and for her *Monarca della Pittura: Piero and his Legacy*, the colloquium she directed in honor of Piero's quincentenary at the National Gallery of Art, Washington, D.C. For her monumental *Seventeenth-Century Barberini Documents and Inventories of Art* (1975), she received the Charles Rufus Morey award for distinguished scholarship from the College Art Association, and her book *The Place of Narrative: Mural Decoration in Italian Churches, 431–1600 A.D.* (1990), was First Place Winner in the Chicago Women in Publishing Award. Other publications include two written with Irving Lavin, *The Liturgy of Love: Images of the 'Song of Songs' in the Art of Cimabue, Michelangelo, and Rembrandt* (2001) and *Artists' Art in the Renaissance* (2009), in which she analyzed a previously unrecognized category, that is, personal works made by artists without commission. She was one of the first art historians to introduce computers for research and teaching, and her 3-D walkthrough computer model

of Piero della Francesca's frescoed chapel in Arezzo is online and open to the public.

HENRY MAYR-HARTING was born in Prague in 1936, and took his B.A. and doctorate at Merton College, Oxford. He was Lecturer in Medieval History at Liverpool University from 1960 to 1968; Fellow and Tutor in Medieval History, St. Peter's College, Oxford, 1968–97, and Regius Professor of History at Oxford University from 1997 to 2003. He was Slade Professor of Fine Art at Oxford in 1987, and an expanded version of his Slade lectures was published as *Ottonian Book Illumination: An Historical Study* (1991, 2nd ed. 1999). He has also written *Church and Cosmos in Early Ottonian Germany: The View from Cologne* (2007), has participated in the past four biennial Libelli Rhenani conferences in Cologne Cathedral Library, and has published several articles on the Ottonian Empire. One of his most recent publications is *Religion, Politics and Society in Britain 1066–1272* (2011). He was elected a Fellow of the British Academy in 1992.

ELIZABETH J. MOODEY is Assistant Professor in the Department of The History of Art at Vanderbilt University. She received her Masters as well as her Ph.D. from Princeton University, the latter in 2002 for a study entitled 'Illuminated Crusader Histories for Philip the Good of Burgundy (1419–1467),' which was undertaken under the supervision of James H. Marrow. She was visiting lecturer at Yale University in 2005, as well as an instructor at Fordham University in 2004. She contributed to the exhibition catalogue *Splendor of the Word: Medieval and Renaissance Manuscripts at The New York Public Library* (2005). Amongst her other publications is 'Historical Identity in the Burgundian Netherlands: The Role of Manuscripts,' in *Tributes in Honor of James H. Marrow: Studies in Late Medieval and Renaissance Painting and Manuscript Illumination* (2006). Her most recent book is *Illuminated Crusader Histories for Philip the Good of Burgundy* (*Ars Nova* series, 2012).

STELLA PANAYOTOVA is Keeper of Manuscripts and Printed Books at The Fitzwilliam Museum in Cambridge, where she has been since 2000. She received a Masters in Cultural Studies from Jesus College, Oxford in 1998 and a Ph.D. in Medieval History from St. Peter's College, Oxford, in 1993. She was Visiting Professor at the Pontifical Institute and the Centre for Medieval Studies, University of Toronto, in 2013, as well as being a Guest Scholar at the Getty Research Institute, Los Angeles, in 2009. She is an Associate Member of the International Center of Medieval Art (2010), an Honorary Member of The Calligraphy and Lettering Arts Society (since June 2008), as well as being a Member to the Visiting Manuscripts Committee of the Morgan Library and Museum, New York (since 2007). Amongst her most recent publications is 'Cristoforo Cortese in Cambridge,' in *Miniatura. Lo sguardo e la parola: Studi in onore di Giordana Mariani Canova* (2012). She has also contributed to *Florence at the Dawn of the Renaissance: Painting and Illumination 1300–1350*, ed. by C. Sciacca (2012), and *A Catalogue of Western Book Illumination in the Fitzwilliam Museum and the Cambridge Colleges*, co-editor with Nigel Morgan (vols. i–v, 2009–2013).

VIRGINIA REINBURG is a historian of religious life in late medieval and early modern France and she is an Associate Professor of History at Boston College. She received her Masters (1981) and Ph.D. (1985) from Princeton University. Amongst her many articles, which focus on prayer, pilgrimage, and devotional books, are 'Oral Rites: Prayer and Talk in Early Modern France,' in *Spoken Word and Social Practice: Orality, 1400–1700* (forthcoming); '"For the Use of Women": Women and Books of Hours,' in *Early Modern Women: An Interdisciplinary Journal* (2009); 'The Nuns of the Ronceray d'Angers and Their Tapestries of the Eucharist,' and 'Illustrated Religious Books,' in *Secular / Sacred: 11th–16th Century Works from the Boston Public Library and the Museum of Fine Arts, Boston* (2006). Her monograph *French Books of Hours: Making an Archive of Prayer, c. 1400–1600* was published in 2012 by Cambridge University Press. She is now working on pilgrimage, sacred landscapes, and the bonds linking religion, place, and nature in France, c. 1450–1750.

RICHARD and MARY ROUSE are two of the foremost experts on medieval manuscripts. Richard received his Masters from the University of Chicago in 1957 for a thesis on 'Medieval Book-Production' and his Ph.D. from Cornell University in 1963 for a dissertation entitled 'The *Catalogus scriptorum ecclesiae*:

Introduction, Text, Notes.' He was based at UCLA from 1963 to 2011, being full Professor from 1975 to 2004 and Emeritus from 2005; he is now honorary Curator of Medieval Manuscripts (2011–). He sits on the editorial boards of many publications and has received countless awards and honors in his distinguished career. Mary Rouse received her Masters in History from Cornell University in 1961. She was managing editor of *Viator* from 1975 to 1999 and Beinecke Distinguished Visiting Professor at Yale University in 2009. Amongst their many publications are the recent 'Eloi's Books and their Bookcase' in *Manuscripta* (2011); 'Why Teach with Medieval Manuscripts?' *UCLA Library Occasional Papers* (2012), *Law, Rulership, and Rhetoric: Select Essays of Robert L. Benson,* ed. by Loren J. Weber in collaboration with Giles Constable and Richard H. Rouse (2013); 'Crime and Punishment in Paris, 1412,' *UCLA Library Occasional Papers,* no. 1 (2013); and *Bound Fast with Letters: Medieval Writers, Readers, and Texts* (2013).

LUCY FREEMAN SANDLER received her Ph.D. from the Institute of Fine Arts, New York University, in 1964. She joined the faculty of New York University the same year as Assistant Professor before becoming full Professor in 1975. She became the Helen Gould Sheppard Professor of Art History Emerita in 2003. She has served on the boards and as an advisor to a number of learned organizations, amongst which are the Medieval Academy of North America, the International Center of Medieval Art, the Medieval Manuscripts Society, and the American Council of Learned Societies. She is a Fellow of the Society of Antiquaries of London and a Fellow of the Medieval Academy of America. Her many publications include *Gothic Manuscripts, 1285–1385,* A Survey of Manuscripts Illuminated in the British Isles, vol. v (1986); *The Lichtenthal Psalter and the Patronage of the Bohun Family* (2004); and *The Splendor of the Word: Medieval and Renaissance Illuminated Manuscripts at The New York Public Library,* co-edited with J.J.G. Alexander and James H. Marrow (2005). She is a regular contributor to Index publications.

DON C. SKEMER is Curator of Manuscripts, Department of Rare Books and Special Collections, Princeton University Library. He has a Ph.D. in Medieval History from Brown University, and his research interests are the history of the medieval book, manuscript studies, and magic. He is the author of *Binding Words: Textual Amulets in the Middle Ages* (2006); principal author of *Medieval & Renaissance Manuscripts in the Princeton University Library* (2013); and a contributor to *Greek Manuscripts at Princeton, Sixth to Nineteenth Century: A Descriptive Catalogue* (2010). He also has many articles in scholarly journals, including *Bibliofilía; English Manuscript Studies; Gazette du livre médiéval; Gutenberg Jahrbuch; Historical Research; Miscellanea Marciana; Revue belge de philologie et d'histoire; Scriptorium; Scrittura e civiltà; Traditio;* and *Viator.*

ANNE RUDLOFF STANTON is Associate Professor in the Department of Art History and Archaeology at the University of Missouri in Columbia. She received her Masters (1987), and Ph.D. (1992) from the University of Texas at Austin. Amongst her many articles are 'Isabelle of France and her Manuscripts, 1308–1358,' in *Capetian Women,* ed. by Kathleen Nolan (2003), 'The Other Miss Rickert: Margaret Rickert (1888–1973) and the Study of Illuminated English Manuscripts,' in *Women Medievalists in the Academy,* ed. by Jane Chance (forthcoming). Her book *The Queen Mary Psalter: A Study of Affect and Audience* was published in 2001. At the moment she is working on 'Turning the Pages: Stories in the Margins of Gothic Prayerbooks,' a book-length project that explores the phenomenon of sequential paintings in the margins of seven English manuscripts, examining the relationships of visual storytelling, decoration, and function.

PATRICIA STIRNEMANN is a researcher at the Institut de recherche et d'histoire des textes (within CNRS) in Paris. She received her Ph.D. from Columbia University under John Plummer for a thesis entitled 'The Copenhagen Psalter.' Eventually her research led to the discovery that the manuscript had been made in England in 1169–1170 for the coronation in June 1170 of the Danish king's young son, Canute. She is best known for her studies on manuscripts of French origin, especially her reconstruction of the library of Henry the Liberal, count of Champagne, but she has also published catalogues on the Insular manuscripts in the Bibliothèque nationale de France and on manuscripts of the Academy of Science in Saint

Petersburg, *Catalogue des manuscrits médiévaux en écriture latine de la Bibliothèque de l'Académie des sciences de Russie de Saint-Pétersbourg*, co-edited with Ludmila Kisseleva (2005). Amongst her recent publications are *The très riches heures of the Duke of Berry* (2010), *Der Psalter Ludwigs des Heiligen: Ms. lat. 10525 der Bibliothèque nationale de France*, commentary by Patricia Stirnemann and Marcel Thomas (2011) and 'L'ancien rituel irlandais de consécration des églises : sources médiévales et particularités,' in *Bulletin monumental* (2012).

MANUSCRIPTA ILLUMINATA

HENRY MAYR-HARTING

Public Liturgy and Private Prayer in Ottonian Liturgical Manuscripts c. 1000*

IN THIS PAPER I see myself more as a bee than a botanist, seeking to extract a little nectar of cultural/religious history from a few manuscripts rather than studying them as specimens in themselves—although I love botany, i.e., codicology, and depend heavily on botanists. Indeed my nectar-extracting process involves careful consideration of the nature of my manuscripts and their actual use in church. My manuscripts come from the German world of the late tenth and early eleventh centuries, that is, from the Ottonian, or Saxon, Empire.

Much has been written recently, and excellently, about ritual, gesture, and the importance of public communication through external symbolism in the political and ecclesiastical life of the Ottonian Empire. Foremost in this have been two great medieval historians, Gerd Althoff and Hagen Keller, both of Münster. But many others have also played their part, not least my Oxford colleague, Karl Leyser, and two American scholars, John Bernhardt and David Warner.[1]

These scholars have studied such matters as the crown-wearings of kings, their itineraries as kinds of sacral processions, the ceremonial nature of much conflict resolution or of drawing up and granting a diploma, and the public ritual expressions of lordships and subordination. Recently, for example, Hagen Keller has published a magisterial article on how the issue of a charter in the Early to High Middle Ages has to be seen within the context of what he arrestingly characterizes as a public ritual 'performance' of its granting, and on how that granting often reflects the prior attainment through hard work of a political consensus.[2] Keller's article offers a rare opportunity to read in English translation the work of a great German historian. It reminds me of an early and powerful article by Peter Brown on how the outcome of a ritual or an ordeal had to be interpreted, and on how that interpretation was often achieved by a lot of hard socializing previous to the ritual.[3] All in all ritual was part of real life. By articulating in

* This is a somewhat altered English version of a paper which I originally gave in German at the fifth Libelli Rhenani conference of November 2012 in the Dombibliothek of Cologne, and which is due to be published in German by the Dombibliothek in the Libelli Rhenani publications of 2014. I owe a large debt of gratitude to Heinz Finger, Director of the Library, and to Harald Horst, Keeper of Manuscripts, and to their colleagues for the imaginative and friendly organization of these conferences and for making it a great pleasure to work in the Dombibliothek; to Harald Horst for much specific help in the preparation of this paper; and to Jennifer Hülsberg, who not only produced a felicitous and scholarly translation of my paper, but also in the process made me aware of some cloudinesses in my thinking.

1. E.g., G. Althoff, *Spielregeln der Politik im Mittelalter: Kommunikation in Frieden und Fehde* (Darmstadt, 1997); G. Althoff, *Inszenierte Herrschaft: Geschichtsschreibung und politisches Handeln im Mittelalter* (Darmstadt, 2003); G. Althoff, *Die Macht der Rituale: Symbolik und Herrschaft im Mittelalter* (Darmstadt, 2003). H. Keller, 'Ottonische Herrschersiegel,' and 'Herrscherbild und Herrschaftslegitimation,' in H. Keller *Ottonische Königsherrschaft: Organisation und Legitimation königlicher Macht* (Darmstadt, 2002);

'Herrschaftsrepräsentation im ottonischen Sachsen: Ergebnisse und Fragen,' in *Herrschaftsrepräsentation im ottonischen Sachsen*, ed. G. Altoff and E. Schubert (Singmaringen, 1998), 431–52. K. Leyser, esp. 'Ritual Ceremony and Gesture: Ottonian Germany' in his *Communications and Power in Medieval Europe: The Carolingian and Ottonian Centuries*, ed. Timothy Reuter (London, 1994), 189–213. J. W. Bernhardt, *Itinerant Kingship and Royal Monasteries in Early Medieval Germany c. 936–1075* (Cambridge, 1993), esp. 45–50. D. Warner, e.g., 'Thietmar of Merseburg on Rituals of Kingship,' *Viator* 26 (1995), 53–76, and his masterly Introduction to his *Ottonian Germany: The Chronicon of Thietmar of Merseburg* (Manchester, 2001), 1–64.

2. H. Keller, 'The Privilege in the Public Interaction of the Exercise of Power: Forms of Symbolic Communication beyond the Text,' in *Medieval Legal Process: Physical, Spoken and Written Performance in the Middle Ages*, ed. M. Mostert and P. S. Barnwell, Utrecht Studies in Medieval Literacy 22 (Turnhout, 2011), 75–108.

3. Peter Brown, 'Society and the Supernatural: A Medieval Change,' *Daedalus* 104 (1975), 133–51, reprinted in his *Society and the Holy in Late Antiquity* (London, 1982), 302–32.

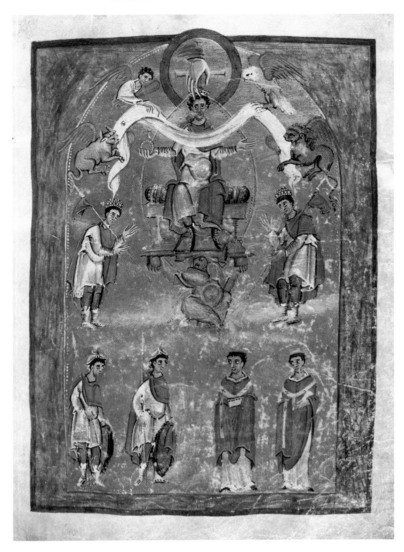

FIGURE 1. Apotheosis of Otto III. Aachen Evangeliary, Reichenau, *c.* 996. Aachen,
Cathedral Treasury, Inv.-Nr. 25, fol. 16ʳ (© Domkapitel Aachen; photo: Pit Siebigs).

manifold ways the exercise of power, it actually helped to shape it.

The tenth and early eleventh centuries were relatively short on political theory or theological writing, and very long on art and ceremony as primary modes of expressing ideas. Why this was so is an open question, but that it was so can hardly be doubted. People only started to write *treatises* on what Ernst Kantorowicz called Christ-centered kingship, that is, a public image of the ruler projected as if he were a *Christus*

Pantocrator, or world ruler, when, in the very different climate of the late eleventh-century papal reform, this idea came to be seriously *questioned*.[4] But in the tenth century, Christ-centered kingship was an idea primarily expressed through ceremony and art. Why, for example, is the apotheosis of the youthful Emperor Otto III, son of a Byzantine princess, represented in the famous Aachen Gospels (*c.* 996) like a Christ in Majesty ascending to heaven, seated, according to the then Byzantine iconography of the Ascension (Fig. 1)?

4. E. H. Kantorowicz, *The King's Two Bodies: A Study in Medieval Political Theology* (Princeton, N.J., 1957), 42–61. K. Leyser, 'The Polemics of the Papal Revolution' (1965), reprinted in his *Medieval Germany and Its Neighbours, 900–1250* (London, 1982), 138–60. H. Mayr-Harting, *Ottonian Book Illumination: An Historical Study* (London, 1991), 1: 64.

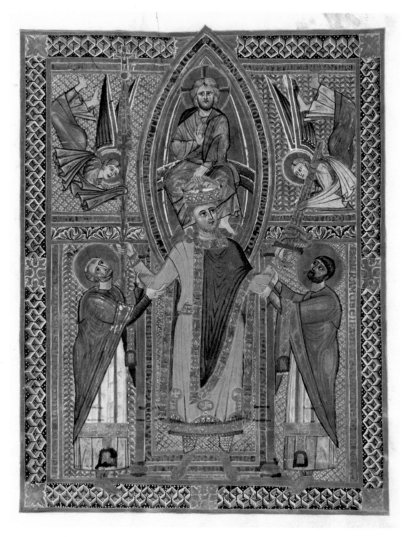

FIGURE 2. The Crowning of Henry II. Sacramentary of Henry II, Regensburg,
1002–1014. Munich, Staatsbibl., Clm 4456, fol. 11ʳ.

Surely this relates to the fact that for the date of his imperial coronation ceremony in Rome, when he was sixteen, the feast of Christ's Ascension was chosen.[5]

In Ottonian times the greatest ceremony of the church, as always, was the celebration of the Mass. In the ninth and tenth centuries there was a huge elaboration of liturgical books used at Mass, and of treatises about how the ritual of the Mass should be celebrated, especially the various *ordines*.[6] The Mass could be a potent milieu for the projection of the ruler's image.

For example, in the Sacramentary of Henry II, made at Regensburg (1007–1012) for Henry's foundation of Bamberg Cathedral, the ruler is shown on the left-hand side of a double page being crowned by Christ and invested by angels with sword and Holy Lance, as if he were continuing by art and ceremony the ritual of his kingly coronation and his being invested by Duke Bernhard of Saxony with the Holy Lance, amidst the succession conflicts of 1002[7] (Fig. 2). On the right-hand side the king is seated in majesty. And this

5. Mayr-Harting (as in note 4), I: 65; and his 'Artists and Patrons' in *New Cambridge Medieval History, c. 900 – c. 1024*, ed. Timothy Reuter (Cambridge, 1999), III: 228.

6. Esp. M. Andrieu, *Les 'Ordines Romani' du haut moyen-âge*,

5 vols., in the series Spicilegium Sacrum Lovanense, nos. 11, 23, 24, 28, 29 (Louvain, 1938, 1948, 1951, 1956, 1961).

7. Mayr-Harting, *Ottonian Book Illumination* (as in note 4), I: 194–95.

magnificent double page is placed in the book imme-diately before the Canon of the Mass.[8] This is clearly the place at which the Sacramentary stood open on the altar, before the Canon. It was as if the king, his power visibly derived from heaven, would always be presiding at the Mass in the church of which he was a lay canon,[9] whether he himself was present in the flesh, or was absent.

For bishops, too, when they celebrated solemn Mass in public, there could be an element of projecting epis-copal sacrality, so closely bound to royal sacrality. The chronicler, Thietmar Bishop of Merseburg, expressed a high ideology of the bishop's office, though he had a low opinion of several contemporary bishops, when he called bishops 'princes of the earth,' as constituted by God under the king or emperor.[10] When bishops celebrated Mass, their real lives could at any time erupt into the ceremony with electric effect. Thietmar of Merseburg tells the story of Abraham of Freising, a tenth-century bishop whom he admired, that Judith, widow of Duke Henry of Bavaria, had lived with Abraham in her widowhood, continently but not with-out malicious gossip. The bishop himself celebrated her funeral Mass, and before communion he turned to the congregation with host in hand, and exclaimed, 'if she ever committed the sin of which she has been diffamed, may the Almighty Father cause the saving remedy of his Son's body and blood to be to me a just and due damnation, and to her soul everlasting salvation.' He then took the consecrated host and was believed.[11]

Important as it was, however, it is possible to exag-gerate the element of ritualism in the religious culture of the Ottonians, to exaggerate the distinction be-tween liturgical and private prayer, or between external and interior religion. Contrary to some views, interi-ority of religion is not something that developed only with the Twelfth-Century Renaissance, let alone with the Late Middle Ages or the Reformation. Thietmar of Merseburg loved stories of bishops and abbots who celebrated Mass with true inner devotion, like Tagino, Archbishop of Magdeburg, who, unusually, chanted the *Kyrie Eleison* with his clergy, and who before cel-ebrating Mass was all severity and afterwards was all smiles and cheerfulness.[12] Hardly beneath the surface of many liturgical books in the Ottonian period is a discernible element of private prayer or meditation involving the celebrant.

My first example of this is the Epistolary of Arch-bishop Everger of Cologne (985–999), which is gener-ally considered by art historians to have initiated the Ottonian Cologne school of book painting[13] (Fig. 3). This is a book of epistle readings—including under that generic name also Old Testament readings—at Mass for the liturgical year. It contains some fine or-namental initials and text frames. But its most strik-ing art feature is its double-page frontispiece showing Archbishop Everger, who certainly himself commis-sioned the book, prostrated before the majestically seated figures of Saints Peter and Paul, whom Everger calls his patrons, or protectors. And Everger is pros-trated in penitence. For the hexametric legend above him reads, in English translation:

Release me effectively, beloved father (Peter), from
 the chain of my sins.

You, Paul, equally the chosen of God, release me
 from my guilt,

That I may attain, by the gift of Christ, pardon from
 above.

8. F. Mütherich, in F. Mütherich and K. Dachs, *Regensburger Buchmalerei: Von frühkarolingischer Zeit bis zum Ausgang des Mittel-alters* (Munich, 1987), 25.

9. See J. Fleckenstein, 'Rex Canonicus: über Entstehung und Bedeutung des mittelalterlichen Königs-kanonikats,' *Festschrift Percy Ernst Schramm zu seinem siebzigsten Geburtstag von Schülern und Freunden zugeeignet*, ed. P. Classen and P. Scheibert (Wiesba-den, 1964), 57–71.

10. Thietmar of Merseburg, *Die Chronik des Bischofs Thiet-mar von Merseburg und ihre Korveier Überarbeitung*, ed. Robert Holtzmann, Monumenta Germaniae Historica, Scriptores

Rerum Germanicorum, N.S. 9 (Berlin, 1955), bk. I, sec. 26, 34–35.

11. *Ibid.*, bk. II, sec. 41, 90–91.

12. *Ibid.*, bk. VI, sec. 65, 354–55.

13. P. Bloch and H. Schnitzler, *Die Ottonischer Kölner Maler-schule* (Düsseldorf, 1967, 1970), I: 13–25; A. von Euw, in *Vor dem Jahr 1000: Abendländische Buchkunst zur Zeit der Kaiserin Theo-phanu* (Köln, 1991), 28–29. For the Cologne school of painting, see now Harald Horst, 'Illuminierte Kölner Handschriften und ihre Verbindungen nach Trier,' in *Libri Pretiosi. Mitteilungen der Bibliophilen Gesellschaft Trier* 15 (2012), 65–77.

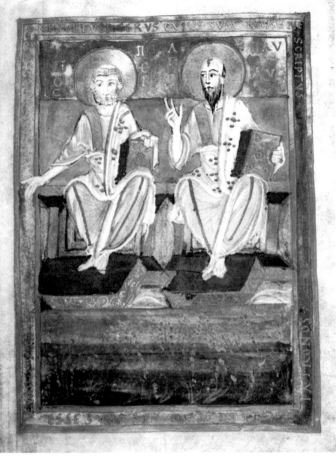

FIGURE 3. Dedication page in the Everger-Epistolary. Cologne, 985–999. Cologne, Cathedral Library, 143, fols. 3ᵛ–4ʳ.

On the right-hand page, Peter seems to be introducing the archbishop into the presence of Paul, while Paul appears to raise his hand in a gesture of absolution. Beside the heads of the two apostles are their names in Greek letters, indicating the often-commented-upon interest in things Greek at tenth-century Cologne,[14] as well as the close connection between Everger and the Greek mother of Otto III, Empress Theophanu.[15]

The contributor to the great catalogue of the Cologne Manuscripts Exhibition of 1998, entitled *Glaube und Wissen*, has written that what this unusual *Devotionsbild* is all about is still unresearched (*sind noch unerforscht*).[16] But it requires little *Forschung* to see what must lie behind these pages, namely, the story in Thietmar of Merseburg about the death of Archbishop Gero, Everger's predecessor but one. At the time of

14. W. Berschin, *Griechisch-Lateinisches Mittelalter von Hieronymus zu Nikolaus von Kues* (Bern, 1980), 230–236; his 'Salomons III. Psalterium quadrupartitum in Köln und Heidelberg,' in *Kaiserin Theophanu: Begegnung des Ostens und Westens um die Wende des ersten Jahrtausends*, ed. A. von Euw and P. Schreiner (Cologne, 1991), I: 327–34. N. Staubach, 'Graecae Gloriae: Die Rezeption des Griechischen als Element spätkarolingisch-frühottonischer Hofkultur,' in *Kaiserin Theophanu* I: 353–64; W. Berschin, 'Drei griechische Majestas-Tituli in der Trier-Echternacher Buchmalerei,' in W. Nyssen, *Begegnung zwischen Rom und Byzanz um des*

Jahr 1000 (Cologne, 1991), 37–52; H. Mayr-Harting, *Church and Cosmos in Early Ottonian Germany: The View from Cologne* (Oxford, 2007), esp. 56–59.

15. H. Müller, 'Die Kölner Erzbischöfe von Bruno I bis Hermann II, 953–1056,' in *Kaiserin Theophanu* (as in note 14), I: 24.

16. U. Surmann, 'Everger-Lektionar,' cat. 80 in *Glaube und Wissen im Mittelalter: Die Kölner Dombibliothek*, ed. J. Plotzek *et al.* (Cologne, 1998), 390.

Gero's death (976), Everger appears to have been *Dom-probst*, but in any case a high official in the cathedral. This is the kernel of Thietmar's story, in David Warner's excellent translation:[17]

> When Gero was struck by his infirmity, he commended himself to the protection of Everger. At Everger's orders, the archbishop, so exhausted by the excruciating pain that he appeared dead, was washed, brought to the church on a catafalque and buried a day later. People say that in the night he awoke as if from a deep sleep, heard the sound of a bell ringing, and demanded three times with a loud call that they quickly release him. Horrified, one who heard this accosted Everger, the custodian of the church, and demanded that he help the desperate archbishop. But Everger, judging this to be a pack of lies,[18] hit him with a big stick. Thus the archbishop, of blessed memory, found rest on the 29 June.... By election and by the Emperor's grant, Warin was quickly anointed in his place.

If complicity in Gero's death was one sin of Everger—and Thietmar implies that it was, and that he was disappointed of his expectation of immediately succeeding Gero as archbishop because of it—it was not the only sin of which Cologne contemporaries thought him guilty (note the phrase *nexus vitiorum* in the Epistolary). Others had to do with his dealings with monasteries.[19] In a powerful article of 1978, Heribert Müller sought to lighten the dark colors of the received picture of Everger. As archbishop he played a constructive role in the Reichspolitik, especially under Theophanu; he was a friend of monastic

reform, as well as a champion of art; and his dealings with monasteries showed good sense, not blind passion. Müller recognized that Thietmar's story could not be dismissed as a fiction, but maintained that all in all Everger's behavior was not unreasonable, that it was absurd to accuse him of complicity in the death of Gero, and that at worst it could be said that diplomatic skill and adroitness were not among his foremost characteristics![20]

It is obvious that Everger saw himself in his Epistolary as a repentant sinner. Tenth-century bishops, as also rulers, were constantly and publicly confessing and repenting of their sins.[21] There was not this allergy to doing U-turns that exists in our own day, at least amongst British politicians. Thietmar of Merseburg was a connoisseur of what particular sins his fellow bishops, and to be fair he himself, suffered particular punishments for.[22] One point of importance, apparently overlooked by Müller, which shows that Everger himself must have regarded his role in the death of Gero as his principal sin, is the fact that Gero actually died on 29 June, the feast of the Apostles Peter and Paul. Or rather he died on the feast of St. Peter, the patronal feast of Cologne Cathedral. For in the early Middle Ages, some churches celebrated both apostles on 29 June; others like Cologne celebrated Peter on 29th, Paul on the next day, 30 June.[23] Either way, however, they were liturgically conjoined. And here we must surely have the explanation of why this frontispiece is in an Epistolary rather than in a book of gospel readings, where it would be less unusual,

17. Thietmar of Merseburg (as in note 10), bk. III, sec. 4, 100; Warner, *Ottonian Germany* (as in note 1), 129.

18. This phrase is my one deviation from Warner, to try and get the full effect of *per omnia fuisse mentitum*.

19. L. Vones, 'Klöster und Stifte: Geistige und geistliche Erneuerung. Reform-Gedanke,' in *Kaiserin Theophanu* (as in note 14), esp. I: 147–48, where he makes a case for these dealings.

20. H. Müller, 'Studien zu Erzbischof Everger von Köln (985–999),' *Jahrbuch des Kölnischen Geschichtsverein* 49 (1978), 1–18. Also his contribution to *Kaiserin Theophanu* (as in note 15).

21. E.g., Thietmar of Merseburg (as in note 10), bk. VI, secs. 61–62, 350–353; bk. VI, sec. 75, 364–65. And for Cologne in particular (and not only bishops), see the important book of S. Hamilton, *The Practice of Penance, 900–1050* (Woodbridge, 2001), 204–05.

22. E.g., Thietmar of Merseburg (as in note 10), bk. VI, sec.

78, 367–68. And for himself, bk. I, sec. 20, 26–27; bk. VI, sec. 43, 326–331; bk. VI, sec. 71, 360–61. Thietmar's general idea is expressed at bk. VII, sec. 41, 448: *Nobis autem scriptura prohibet credere fatum vel casum aliquid esse*, i.e., Scripture forbids us to believe that anything is fate or coincidence.

23. Cologne, Dombibliothek, Ms.143, fols. 104ᵛ–107ᵛ. Here St. Peter is on 29 June, St. Paul on 30 June, as in the Gregorian Sacramentary, see J. Deshusses and B. Darragon, *Concordances et tableaux pour l'études des grands sacramentaires* (Tableaux Synoptiques) (Fribourg, 1982), II: 162. The Gelasian Sacramentary has, 'in natale apostolorum petri et pauli' for 29 June, and for 30 June, 'in nat. S. Pauli proprie,' ibid., 93–94. Likewise the Fulda Sacramentary of c. 965–970 (Göttingen University, Cod. Theol. 231, fols. 93ʳ–94ʳ), see, *Sacramentarium Fuldense saeculi X*, ed. G. Richter and A. Schönfelder (Fulda, 1912), 128–30.

namely, this connection between Gero's death and the feast/feasts of the Apostles, both of them authors of epistles, but neither of gospels. And if only the hand of Paul is raised in absolution of the sinner, there was plenty in his epistles to remind one of sin, repentance, and salvation.

What might have been the relevance of this image of Everger to the liturgical use of the book itself? The Mass *ordines* of the time tell us quite a lot about the handling of gospel books during the ceremony but nothing about epistolaries.[24] There is clear evidence that Everger's Epistolary was actually intended for use in church and was not just a master copy of the texts. That is principally in the way that the initial words of greeting (*Fratres, Karissimi*, etc.) have been studiously inserted for the individual readings.[25] But it is likely that during Mass, the book, as used by the subdeacon, was never seen or touched by the archbishop as celebrant. In one sense that makes the image of the repentant Everger all the more public property. This is precisely a public ritual of repentance in art, despite my saying that ritual was not everything. And nor is it everything here, unless we go along with the characteristic modern dilemma between the extremes of hypocrisy and sincerity, or of ritual and true feeling.

For Everger must have been acutely aware of the presence of this image in his book, especially when the epistle was read. Immediately before that the celebrant read the collect, and immediately before that came the chanting of the *Gloria in Excelsis Deo*. What was supposed to be going on in a celebrant bishop's mind during the *Gloria*? We have a clue from a remarkable book belonging to Bishop Warmund of Ivrea (969–1011), and so an exact contemporary of Everger. Warmund has left behind a clutch of rather crudely illustrated but very interesting liturgical books, now in the Biblioteca Capitolare of Ivrea. One of these is

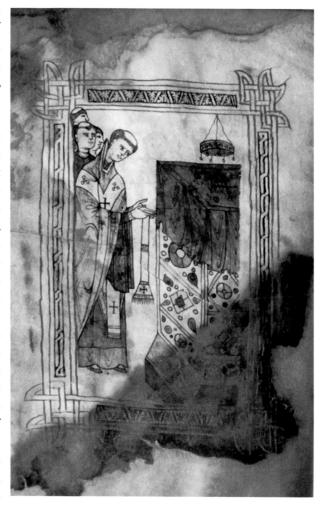

FIGURE 4. Bishop preparing for the celebration of Mass. Prayerbook, Ivrea, *c.* 1000. Ivrea, Biblioteca Capitolare, Cod. IV, fol. 4ᵛ.

a rather rare collection of private prayers that a bishop should say during Mass when he is not actually speaking himself, prayers now not always easy to read, for the manuscript has suffered considerable damage from water (Fig. 4). The rubric for the *Gloria* reads, 'When

24. E.g., how, if carried closed in the gospel procession, the deacon should keep a finger in the correct place in the gospel book; and how the book should be proffered to the celebrant, and sometimes to the other clergy present to kiss after the reading, Andrieu, *Ordines* (as in note 6), II: 89, 332, 357 (Ordo I, c.62, Ordo IX, c.20, Ordo X, c.34).

25. *Fratres* for St. Paul, or *Karissime* when addressing a single recipient like Timothy, e.g., fol. 132ʳ, or *Karissimi* for SS. Peter, James, and John. Mostly these words, abbreviated, are in the ru-

bric as FRS, KMI, etc. But sometimes they are squeezed into the rubric, clearly added as an afterthought, e.g., fols. 94ʳ, 98ᵛ, and several other examples; sometimes they are written in black ink by a contemporary scribe, after the rubric, e.g., fols. 78ᵛ, 101ʳ, 117ʳ, or even in the margin, in red or black as F, e.g., fols. 12ʳ, 15ʳ. One way or another, whatever the carelessness of the original scribe, one or more correctors have always made sure that the subdeacon or reader, surely for church use, was always reminded to open with the correct word of address.

the *Gloria in Excelsis Deo* is chanted, he [the bishop] shall say these prayers,' the first of which begins, 'O God who desires not the death but the life of sinners,' and there follows a prayer for his own sins to be taken away.[26] Thus, almost immediately before the reading of the epistle, the Bishop of Ivrea's mind is supposed to be focussed on the forgiveness of sins, the subject, by the way, of one third of the *Gloria* itself, despite its triumphant first section. Everger's Cologne and War-mund's Ivrea might seem almost at opposite ends of Otto III's empire, but both bishops had the *familiaritas* of the ruler;[27] and Otto III's own book of private prayers, now in Munich, shows that he himself was keenly interested in such prayers as Warmund had.[28] And for all the rarity of Warmund's book as a survival, that does not mean that the *idea* of such prayers, with their commonplace character, was a rarity.

Now to a more obvious example of personal meditation just below the surface of public ritual, again in an Ottonian Cologne liturgical book, the *Sacramentary of St. Gereon*, dated between 996 and 1002, and now in Paris.[29] Unlike an Epistolary, a Sacramentary was used directly by the celebrant of Mass, whether a bishop or an ordinary priest. This book is one of the master works of Cologne Ottonian book art, second only to the Hitda Codex. Immediately before the text of the collect for Easter Sunday is a double page of illustrations, with *tituli*, or legends, as the book lies, or stands, open. On the left is the rare scene of Pilate, ordering a guard to be set on Christ's tomb. On the right are the two women (two according to Matthew, three according to Mark) at the tomb, on which is seated a resplendent angel (Ottonian society was very angel-conscious) (Fig. 5). And the *titulus* above the angel lets the cat out of the bag about the function of such Sacramentary illustrations: *Hic erit contemplandum,* 'here it is to be contemplated how the heavenly angel testified that Christ had risen from the dead.' Then the page is turned, and there is the opening of the collect for Easter Sunday, with a glorious initial D, in its magnificent frame, sparkling with gold, the rest of the collect following on the right-hand page (Fig. 6). Whether the contemplation would occur during the *Gloria*—again, which comes immediately before the collect, or in private before Mass and the image be remembered during the *Gloria*, one cannot say. But the Ottonians must have been familiar with the Augustinian idea of the importance of memory in private prayer.[30]

I could give many other similar examples from elsewhere, but it is not surprising that I have been drawn to two Cologne examples. For if one may speak of a religious ethos at tenth-century Cologne, it very much included private prayer amidst public action and ceremony. That is how Gero of Cologne's devotion to the Eucharist is presented by Thietmar of Merseburg;[31] while in his *Vita* of Bruno, Archbishop of Cologne (953–965), brother of Otto I, Ruotger, writing in the late 960s, represents Bruno's whole life as one of prayer and meditation amidst his external activities, a bishop in the Gregorian pastoral mold.[32] Once, says Ruotger, it was while actually celebrating Mass that Bruno received the spirit of prophetic discernment about a serious family enmity (*et hoc maxime missarum tempore cerneret*).[33]

My final example must be the Sacramentary made at the monastery of St. Gall for Bishop Sigebert of

26. Ivrea, Biblioteca Capitolare, Cod. IV, fols. 1ᵛ and esp. 6ʳ⁻ᵛ. See Mayr-Harting, *Ottonian Book Illumination* (as in note 4), II: 89–90.

27. Müller, 'Studien zu Everger' (as in note 20), 5–10, 17. Mayr-Harting, *Ottonian Book Illumination* (as in note 4), II: 53, 88.

28. Bayerische Staatsbibliothek, Gebetbuch Ottos III, Clm. 30111 (Munich, 1995), esp. E. Klemm, 'Das Gebetbuch Ottos III,' 39–45; S. Hamilton, 'Most illustrious king of kings: Evidence for Ottonian Kingship in the Otto III Prayer Book,' *Journal of Medieval History* 27 (2001), 257–88. Also Mayr-Harting, *Ottonian Book Illumination* (as in note 4), I: 173.

29. Bloch and Schnitzler (as in note 13), I: 37–42; and for the history of this manuscript and how it came to be in Paris, *ibid.*, 43. Now also Horst (as in note 13).

30. For memory in Augustine, e.g., H. Chadwick, *Augustine: A Very Short Introduction* (Oxford, 1986), 69, 74. For the subject in the Carolingian period, C. Chazelle, 'Matter, Spirit and Image in the Libri Carolini,' *Recherches Augustiniennes* 21 (1986), esp. 176; and H. Mayr-Harting, 'Charlemagne as a Patron of Art,' *The Church and the Arts*, Studies in Church History 28, ed. Diana Wood (Blackwell, Oxford, 1992), 64–65.

31. Thietmar of Merseburg (as in note 10), bk. III, sec. 2, 98–101.

32. H. Mayr-Harting, *Church and Cosmos* (as in note 14), esp. 98–99.

33. *Ruotgers Lebensbeschreibung des Erzbischofs Bruno von Köln*, ed. I. Ott, Monumenta Germaniae Historica Scriptores Rerum Germanicarum, N.S. 10 (Cologne, 1958), ch. 9, p. 10, ll. 2–3.

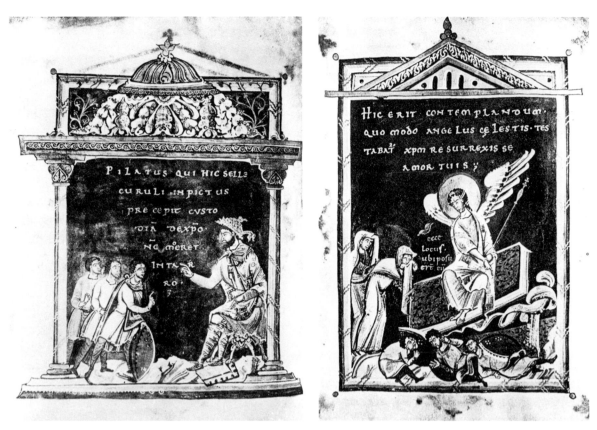

FIGURE 5. Pilate and the guards—Two women at Christ's tomb. Sacramentary of St. Gereon, Cologne, 996–1002. Paris, Bibliothèque nationale de France, Ms. lat. 817, fols. 59ᵛ–60ʳ.

FIGURE 6. The initial D[EU]s for Easter Mass and facing text. Sacramentary of St. Gereon, Cologne, 996–1002. Paris, Bibliothèque nationale de France, Ms. lat. 817, fols. 60ᵛ–61ʳ.

Minden (1022–1036), and now in Berlin.[34] Minden
was not a front-line Ottonian bishopric, but Sigebert
had no mean idea of his public sublimity as a bishop,
being represented on an ivory book cover celebrat-
ing Mass, in an hieratic posture, as if he were Christ
transfigured[35] (Fig. 7). Most unusually this book, im-
mediately after the *Agnus Dei*, has two powerful min-
iatures opposite each other as the book lies, or stands,
open[36] (Fig. 8). One is the apocalyptic Lamb, with a
highly meditational *titulus*. Then comes a remarkable
image of Bishop Sigebert himself, standing at the altar
of his cathedral, on which is the communion bread,
celebrating Mass, taking the chalice with the blood of
the Lamb from a warrior-like *Ecclesia*. In the margin
are the words (in Engish):

> Drink, Sigebert, the gifts of eternal life, by which the
> mother of graces mercifully refreshes you.

Sigebert could contemplate all this during the sing-
ing of the *Agnus Dei*, when he would certainly be
standing at the altar with this book open in front of
him. This picture and meditation bring us close to a
psalm prayer becoming prevalent in the early eleventh
century, which would be recited by the celebrant in
the public liturgy only a few moments later as he took
the chalice in his hand, the *Quid retribuam domino*…[37]

> What return shall I make to the Lord for all he has
> done for me?
> I will take the chalice of salvation and call on the
> name of the Lord.
> (Ps. 115/116: 12–13).

This prayer is not in our manuscript, but it is already
strongly implied by its illustration and meditation.

One postscript before I end. It is not an afterthought
but arises from a very recent, important and original
paper delivered in Cologne by Susanne Wittekind.
When I heard it, I could not but think that I was striv-
ing to head in the same direction as she, in an only

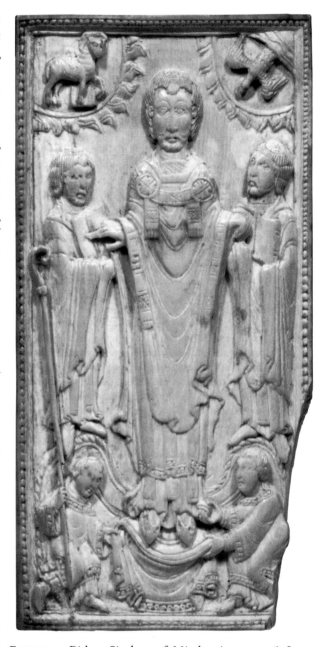

FIGURE 7. Bishop Sigebert of Minden (1022–1036). Ivory
Book Cover from a Sacramentary, originally from Helmstedt,
now in Berlin, Staatsbibl. Preussischer Kulturbesitz, Ms. germ.
qu. 42.

34. H. Hoffmann, *Buchkunst und Königtum im ottonischen und
frühsalischen Reich* (Stuttgart, 1986), i, 374.

35. K. Ortmanns, *Das Bistum Minden in seinen Beziehungen zu
König, Papst und Herzog bis zum Ende des 12 Jahrhunderts* (Bens-
berg, 1972), esp. 39–43.

36. For the miniatures of this book in general, R. Meyer, 'Die
Miniaturen in dem Sakramentar des Bischofs Sigebert von Min-
den,' *Studien zur Buchmalerei und Goldschmiedekunst des Mittelal-
ters. Festschrift für K. H. Usener* (Marburg, 1967), 181–200; and
for these two pages in particular, Mayr-Harting, *Ottonian Book
Illumination* (as in note 4), II: 92–95.

37. J. Jungmann, *Missarum Sollemnia: Eine genetische Erklärung
der römischen Messe*, 2nd ed. (Vienna, 1949), II: 429.

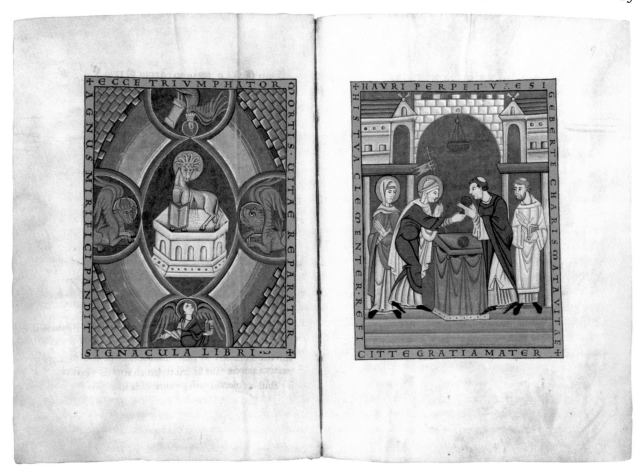

FIGURE 8. Lamb of God, and Sigebert at Mass. Sacramentary of Bishop Sigebert of Minden, St. Gall, 1022–1036. Berlin, Staatsbibl. Preussischer Kulturbesitz, Ms. theol. lat., fol. 2, fols. 8ᵛ–9ʳ.

slightly later period, was heading. She spoke of a new kind of bishop's *Pontificale*, developing in the eleventh century, whose texts as always continued to point up the bishop's hierarchical authority, but whose illustrations had a different purpose. These focussed on the religious content of the feasts as subjects of meditation, and even on the seeking of forgiveness for sins.[38]

I hesitate to end with a word about methodology, about which my kindest critics would think me ill-qualified to pronounce! But in studying medieval liturgical books and their art, it is always important to ask how and when they were or might have been used, and to try to answer in the light of what we can know more generally of the religious culture of their time.

38. Publication in the Libelli Rhenani series forthcoming.

STELLA PANAYOTOVA

The Rohan Masters: Collaboration and Experimentation in the Hours of Isabella Stuart *

FOR A CENTURY now scholars have been marvelling at the work of the Rohan Master, the leading illuminator of the eponymous Book of Hours[1] and one of the most powerful artistic personalities in fifteenth-century France. He has been seen as a 'magnificent barbarian,' a master of pictorial drama, human emotion, and expressive power, an individualistic proponent of the International Gothic style, and a member of the artistic generation that paved the way for Jan Van Eyck.[2] He is thought to have worked as a panel painter as well as an illuminator. Apart from a fragmentary altarpiece[3] and several drawings[4] associ-

* My observations on the manuscript's production benefited enormously from the imaging and technical analyses undertaken by Paola Ricciardi as part of the MINIARE project (www.miniare.org). I thank her and Deirdre Jackson for our fruitful discussions. I am very grateful to François Avril, Richard Emmerson, Ebarhard König, James Marrow, and Inès Villela-Petit for their insightful comments on an earlier draft of this paper.

1. Paris, BnF, Ms. lat. 9471. A. D. Rodríguez, E. L. García, G. S. Casero, and J. D. Capilla, *Grandes Horas de Rohan (Ms. Lat. 9471, Biblioteca Nacional de Francia)*, facsimile and commentary volume (Madrid, 2006).

2. L. Delisle, 'Livres d'images destinés à l'instruction religieuse et aux exercices de piété des laïques,' in *Histoire littéraire de la France*, XXXI (Paris, 1893), 252–53; P. Durrieu, 'Le maître des "Grandes Heures de Rohan" et les Lescuier d'Angers,' *Revue de l'art ancien et moderne* 32 (1912), 81–98, 161–83; V. Leroquais, *Les livres d'heures manuscrits de la Bibliothèque nationale*, 3 vols. and Supplement (1927–43), I: 281–90; A. Heimann, *Der Meister der Grandes Heures de Rohan und seine Werkstatt*, Städel-Jahrbuch 7–8 (1932), 1–61; E. Panofsky, 'Reintegration of a Book of Hours Executed in the Workshop of the "Maître des Heures de Rohan,"' in *Mediaeval Studies in Memory of Arthur Kingsley Porter*, ed. W. R. W. Koehler, 2 vols. (Cambridge, Mass., 1939), II: 479–99; J. Porcher, 'Two Models for the "Heures de Rohan,"' *JWCI* 8 (1945), 1–6; É. Mâle, *Les Grandes Heures de Rohan* (Paris, 1947); E. Panofsky, *Early Netherlandish Painting: Its Origins and Character* (Cambridge, Mass., 1953), 74; J. Porcher, *The Rohan Book of Hours* (London, 1959); M. Meiss and M. Thomas, *The Rohan Master: A Book of Hours* (London; New York, 1973); M. Meiss, *French Painting in the Time of Jean de Berry*, III: *The Limbourgs and Their Contemporaries* (London; New York, 1974), 256–77, 401–04; F. Avril, 'La peinture française au temps de Jean de Berry,' *Revue de l'art* 28 (1975), 40–52, esp. 46–48; *Les manuscrits à peinture en France 1440–1520*, ed. F. Avril and N. Reynaud, Exhib. cat. (Paris, 1993), 25–27; R. Simons, *The Rohan 'Société Anonyme': A Study in Collective Creativity*, Ph.D. diss. (University of Maryland, 1994); A. Châtelet, *L'Age d'or du manuscrit à peintures en France au temps de Charles VI et les Heures du Maréchal de Boucicaut* (Dijon, 2000), 181–83; R. Simons, 'Rohan Workshop Books of Hours: Reassessing the Models,' *Gazette des Beaux-Arts* 140 (2002), 65–92; F. Avril and E. Taburet-Delahaye, 'L'éclatement des ateliers parisiens,' in *Paris 1400: Les arts sous Charles VI*, ed. E. Taburet-Delahaye and F. Avril, Exhib. Cat. (Paris, 2004), 366–67; I. Villela-Petit, entry in *Paris 1400*, no. 232, pp. 371–73; J. D. Capilla, 'Las Grandes Horas de Rohan: Miniaturas y decoración para una obra maestra,' in *Grandes Horas* (as in note 1), 261–353; E. König, *Die Grandes Heures de Rohan* (Simbach am Inn, 2006).

3. Musée de Laon, Inv. 990.1731, was attributed to the Rohan Master in G. Ring, *A Century of French Painting 1400–1500* (London, 1949), 202–04, and Meiss, *Limbourgs* (as in note 2), 272–74. The attribution was questioned in I. Villela-Petit, 'L'Ange au chanoine, fragment d'un retable laonnois du XVᵉ siècle,' *Monuments et Mémoires de la Fondation Piot* 82 (2003), 173–212 ; in Villela-Petit's entry in Taburet-Delahaye and Avril, *Paris 1400* (as in note 2), no. 202, pp. 322–23; in E. Martin and I. Villela-Petit, 'Le Maître du retable de Pierre de Wissant (Colart de Laon?): la technique d'un peintre français au début du XVᵉ siècle,' *Revue des Musées de France–Revue du Louvre* 3 (June 2008), 35–49; and in S. Kemperdick and F. Lammertse, *The Road to Van Eyck*, Exhib. cat. (Rotterdam, 2012), no. 15, p. 145.

4. For the drawing in Braunschweig, Herzog Anton Ulrich Museum, see M. Meiss, 'Un desin par le maître des Grandes Heures de Rohan,' *Gazette des Beaux-Arts* 77 (1935), 65–75; Meiss, *Limbourgs* (as in note 2), 274–76; Capilla, *Grandes Horas* (as in note 2), 346–47. For the drawing in Rotterdam, Museum Boijmans Van Beuningen, inv. 1.526, see M. Dachs, 'Neue Zuschreibungen an den Meister des Rohan-Stundenbuches,' *Wiener Jahrbuch für Kunstgeschichte* 48 (1995), 85–101, figs. 8, 11, 13, where it is attributed to the Rohan Master, and, for its attribution to Pisanello's workshop, *The Limbourg Brothers: Nijmegen Masters at the French Court 1400–1416*, ed. R. Dückers and P. Roelofs, Exhib. cat. (Nijmegen, 2005), nos. 123–24, and Kemperdick and Lammertse, *Road to Van Eyck* (as in note 3), 95–96. For a detailed discussion, with earlier bibliography, of the complex arguments

ated with him tentatively, his hand has been found in four manuscripts: the eponymous Rohan Hours, the Hours of Isabella Stuart,[5] the Paris Hours of René of Anjou,[6] and the Hours formerly in the Martin le Roy collection.[7]

The emergence of the Rohan style at the beginning of the fifteenth century is thought to have preceded the Rohan Master himself by approximately two decades. The large body of work described as 'in the Rohan style' covers the first four decades of the fifteenth century, features in a broad range of texts, from Books of Hours to vernacular history, varies from deluxe commissions to modest workshop products, and is scattered across the globe, including a Book of Hours divided between Princeton and Paris.[8] The birthplace of the Rohan style was—and still is—the subject of debate, with opinions ranging from Bourges, Troyes, or Avignon to the Auvergne or Brittany, and influences have been traced as far as Catalonia, the Netherlands, and Italy.[9] There seems to be a consensus, however, that the Rohan style underwent a decisive development in Paris c. 1415–1420 before spreading to Anjou and Brittany as part of the artistic diaspora that followed the Treaty of Troyes in 1420 and the English occupation of Paris in 1423.[10]

The Rohan Master himself has become the 'Rohan Masters,' as James Marrow summed up in a single 's' the increasing number of hands that are being differentiated within the group of manuscripts illuminated in the Rohan style.[11] Eberhard König proposed that the Office of the Dead miniature in the Rohan Hours (fol. 159[r]) characterizes the hand of the Rohan Master proper, while the Lamentation in the same manuscript (fol. 135[r]) represents a different artist.[12] Outside the Rohan Hours, the personality of the Rohan Master has been split into two with the emergence of the Giac Master. Previously thought of as the young Rohan Master, the Giac Master is now considered one of the earliest proponents of the style, named after a Book of Hours that may have been his first important work.[13] The Giac Hours was completed c. 1410 for Jeanne du Peschin, wife of Louis de Giac, who was at various times in the service of the French King, the Dauphin, and the Dukes of Berry and Burgundy. The early style of the Giac Master is marked by refined elegance and decorative richness, but also by ambiguous spatial relationships. Elaborate furniture or architectural structures seem to aim for three-dimensional effects, while interiors set over green-and-black tiled floors eschew any suggestion of depth. Fluid draperies softly envelop figures with narrow, sloping shoulders and elongated lower bodies. Their rounded heads, with no defined facial structure, have heavy cheeks, full lips, pronounced noses, and lowered, heavy-lidded, beady eyes. Opaque blues and reds are juxtaposed with transparent greens, violets, and pinks stippled with tiny brush strokes in a quasi-pointillist technique, creating a textured, 'shredded' effect and strongly contrasting areas of light and

surrounding the attribution of the Rotterdam drawing and related works, see G. T. Clark, 'The Influence of the Limbourg Brothers in France and the Southern Netherlands, 1400–1460,' in Dückers and Roelofs, *Limbourg Brothers* (cited above), 209–35, esp. 215–21.

5. Cambridge, Fitzwilliam Museum, Ms. 62; M. R. James, *A Descriptive Catalogue of the Manuscripts in the Fitzwilliam Museum* (Cambridge, 1895), 156–74; J. H. Marrow, entry on Fitzwilliam Museum, Ms. 62 in *The Cambridge Illuminations: Ten Centuries of Book Production in the Medieval West*, ed. P. Binski and S. Panayotova, Exhib. cat. (London; Turnhout, 2005), no. 88, pp. 202–04.

6. Paris, BnF, Ms. lat. 1156A; Avril and Reynaud, *Manuscrits à peinture* (as in note 3), no. 122, pp. 226–27; *Splendeur de l'enluminure: Le Roi René et les livres*, ed. M.-É. Gautier and F. Avril, Exhib. cat. (Arles, 2009), no. 1, pp. 200–202.

7. P. Durrieu, *Les heures à l'usage d'Angers de la collection Martin Le Roy* (Paris, 1912); Meiss, *Limbourgs* (as in note 2), fig. 807; Simons, *Rohan Workshop* (as in note 2), 74, 82, figs. 23, 25, 51; König, *Grandes Heures* (as in note 2), 27.

8. Princeton, Princeton University Library, Garrett Ms. 48, and Paris, Bibliothèque de l'Arsenal, Ms. 647. D. C. Skemer, *Medieval & Renaissance Manuscripts in the Princeton University Library*, 2 vols. (Princeton, N.J., 2013), 1: 79–82, pls. 29–31.

9. For a summary of former and current views, see König, *Grandes Heures* (as in note 2), 14–16; E. König, 'Fifteenth-century Illuminations from Angers in Cambridge: The Hours of Isabella Stuart and the Quest for a Local Style,' in *The Cambridge Illuminations: The Conference Papers*, ed. S. Panayotova (London; Turnhout, 2007), 225–232; I. Villela-Petit, 'Les Heures de Jeanne de Peschin, dame de Giac,' *Art de l'enluminure* 34 (2010), 2–63, esp. 8–24.

10. Taburet-Delahaye and Avril, *Paris 1400* (as in note 3), 366–67; *Très riches heures de Champagne: L'enluminure en Champagne à la fin du Moyen Âge*, ed. F. Avril, M. Hermant, and F. Bibolet, Exhib. cat. (Paris, 2007), 41, nos. 6–7.

11. Marrow, entry (as in note 5).

12. König, *Grandes Heures* (as in note 2), 22–27, 33–34.

13. Toronto, Royal Ontario Museum, Ms. 997.158.14; Villela-Petit, 'Jeanne de Peschin' (as in note 9).

shade. Thinly laid colors and areas of losses reveal an extensive amount of under-drawing and considerable deviation from the original design—the Giac Master experimented with patterns and often changed his mind at the painting stages.

The origins of the Giac Master have been traced to Avignon or the Auvergne, followed by a prolific period in Paris *c.* 1415–1420.[14] During his Parisian sojourn he collaborated on the extensive pictorial cycles of vernacular texts, including deluxe copies of Valerius Maximus, Bartholomaeus Anglicus, Boccaccio, and Froissart.[15] The sheer volume of his output may explain the expedient measures in his miniatures. They show repetitive, symmetrical compositions, architecture reminiscent of cardboard props, the green-and-black tiled floors familiar from the Giac Hours, stiff figures with narrow shoulders, often disproportionately elongated or awkwardly foreshortened, and doll-like faces with beady eyes and chubby cheeks.[16] At times they reveal extensive under-drawing and adjustments at the painting stages.[17] The Giac Master's numerous illustrations in these multi-volume sets highlight his immense capacity for work and his penchant for pictorial narrative, both qualities that would stand him in good stead during the production of his most ambitious and mature work, the Hours of Isabella Stuart.

Of some forty manuscripts attributed to the Giac Master, half are Books of Hours. They suggest that the artist might have worked between Paris and Troyes in the late 1410s and early 1420s. Some of his Hours are for the liturgical use of Troyes, others for the use of Rome or Paris. Some of the latter contain saints associated with Champagne,[18] while others, like the manuscript divided between Princeton and Paris, lack any internal evidence for an origin or provenance in Champagne. These variations raise questions about the itinerary of the Giac Master in the late 1410s and early 1420s, while the differences in technical execution and degree of refinement require further scrutiny of the material. Even if we allow for rapid changes of the Giac Master's style and technique within a decade or less, and for adjustments to the level of execution in line with patrons' demands or market forces, it still seems wise to consider the involvement of collaborators in order to explain such prodigious output and its varying quality. While the earlier notion of a 'Rohan workshop' and the ready explanation of aesthetically mediocre products through the involvement of assistants are now questioned by thorough research into the flexible relationships between professionals in the book trade,[19] the newly-emerged picture of artistic collaboration on a project-by-project basis and close familial ties within the profession accords with the itinerant nature of the Rohan style. Its major proponents, whether the Giac or the Rohan Master, could have relied as much on family members trained in different aspects of manuscript production as on other artists whom they encountered in the various centers where their journeys in search of work and patronage took them.

Some of the Books of Hours attributed to the Giac Master demonstrate intimate familiarity with the foremost Parisian illuminators of the time, notably the Boucicaut, Mazarine, and Bedford Masters.[20] Occasional collaboration with some of these artists exposed the Giac Master to innovative compositions and atmospheric effects.[21] These include elements of aerial perspective and spatial depth, such as gold clouds drifting

14. Avril, Hermant and Bibolet, *Champagne* (as in note 11), 41, 43; Villela-Petit, 'Jeanne de Peschin' (as in note 9), 8–24.

15. G. Croenen, 'Le libraire Pierre de Liffol et la production de manuscrits illustrés des Chroniques de Jean Froissart à paris au début du xvᵉ siècle,' *Art de l'enluminure* 31 (2010), 14–23; Villela-Petit, 'Le Maître de Boèce et le Maître de Giac, enlumineurs de la guerre,' *Art de l'enluminure* 31 (2010), 24–45.

16. *Art de l'enluminure* 31 (2010), color illustrations on pp. 4, 8, 11, 15, 18, 21, 75.

17. *Art de l'enluminure* 31 (2010), color illustrations on pp. 34, 36, 49.

18. Paris, Musée des Arts décoratifs, Inv. 40342; Avril, Hermant, and Bibolet, *Champagne* (as in note 10), no. 8, p. 94.

19. R. H. Rouse and M. A. Rouse, *Manuscripts and Their Makers: Commercial Book Production in Medieval Paris, 1200–1500* (Turnhout, 2000), 2 vols.

20. Simons, *Rohan Workshop* (as in note 2); Villela-Petit, 'Jeanne de Peschin' (as in note 9), 12–19.

21. Among the Hours in which the Giac Master is thought to have collaborated with other Parisian Masters are London, British Library, Harley Ms. 2940 of *c.* 1415–1420 (Mazarine Master, with a miniature on fol. 175ʳ in the Rohan style), and Los Angeles, Getty Museum, Ms. 22 of *c.* 1415–1420 (Boucicaut workshop, with Calendar in the Rohan style).

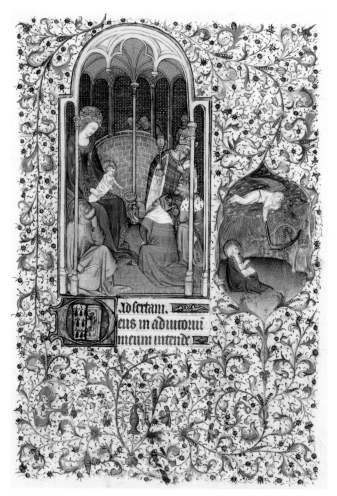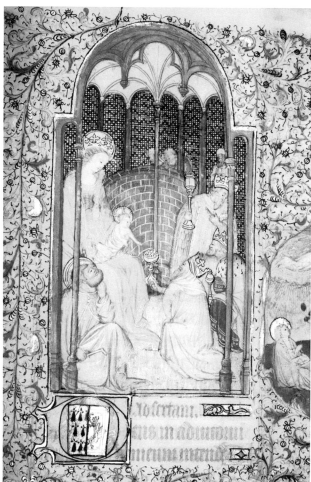

FIGURE 1. Hours of the Virgin, Sext: Adoration of the Magi. Cambridge, Fitzwilliam
Museum, Ms. 62, fol. 76ʳ. Near-infrared image of main miniature.

across the sky, outcrops placed in the foreground, and architecture positioned at oblique angles to the main picture plane. The Giac Master would have assembled a collection of patterns, since Parisian iconographic motifs and compositions found in Rohan-style Hours of *c.* 1415–1420 re-appear in later manuscripts produced by him and his collaborators (Fig. 1).²² Painted by different artists, including the Rohan Master, these later images demonstrate creative experimentation with a stock of shared patterns, often re-combined in innovative compositions and offering us material for endless spot-the-difference games (Figs. 3, 4).²³

22. Numerous examples in the de Buz Hours of *c.* 1420–1425, probably the earliest manuscript in the Rohan style to be illuminated in Anjou (Harvard University, Houghton Library, Ms. Richardson 42; *Late Medieval and Renaissance Illuminated Manuscripts, 1350–1525, in the Houghton Library*, ed. R. S. Wieck, Exhib. cat. [Cambridge, Mass., 1983], no. 4, with earlier bibliography; Dückers and Roelofs, *Limbourg Brothers* [as in note 4], no. 113; see note 23) can be viewed on-line: http://hcl.harvard.edu/libraries /houghton/collections/early_manuscripts/bibliographies/ richardson.cfm. For a peculiar architectural enclosure of the

main pictorial space, typical of the Giac Master, compare FIG. 1 and Princeton, Garrett Ms. 48, fol. 37ᵛ. For the dissemination of motifs from Rohan illuminations to Breton manuscripts from the 2nd quarter of the 15th century, see König, *Französische Buchmalerei um 1450: Der Jouvenel-Maler, der Maler des Genfer Boccaccio und die Anfänge Jean Fouquets* (Berlin, 1982), 1982, 18 n. 64, figs. 299, 314; Clark, *Influences* (as in note 4), 225–226.

23. In addition to the many examples discussed in the literature (see note 2), many more could be listed. For instance, a shepherd from the Annunciation to the Shepherds in the Harley

Several of the Hours associated with the Giac Master and assigned to the 1420s, notably the Princeton-Arsenal and de Buz Hours, demonstrate his skill as a storyteller and introduce a novel page design at major text divisions. Their large miniatures are accompanied by pairs or triads of framed marginal scenes that elaborate on the main theme. These mini-polyptychs would inspire the elaborate cycles of the Rohan and Isabella Stuart Hours, where marginal scenes not only complement the main miniatures, but also unfold into continuous pictorial narratives or allegorical commentaries throughout the volumes.

The Giac Master is thought to have ended his career in Anjou, employed c. 1425–1435 as a court artist by the Dowager Duchess Yolande of Aragon, widow of Louis II of Anjou. Among the works attributed to him during this period are Calendar scenes in the Rohan Hours and the Adoration of the Child in the Hours of Isabella Stuart (Fig. 4).[24] I cannot find his hand in the Rohan Hours,[25] but he played a major role in the illumination of Isabella Stuart's Hours. This volume showcases the repertoire that he had built in Paris,

including the iconography of the Annunciation and the landscapes rising up to the horizon employed by the Boucicaut Master, as well as the Mazarine Master's extension of the main subject-matter into narrative border roundels engulfed in lush foliage (Figs. 3, 5). It is in the Hours of Isabella Stuart that the Giac Master can be clearly observed collaborating with the Rohan Master, as we shall see shortly. A case for their close association, both professional and familial, has been made on the basis of a miniature in René of Anjou's Hours that depicts St. René facing a commemorative portrait of Louis II of Anjou; the different styles, techniques, and scales of work juxtaposed in this image have been interpreted as evidence for the collaboration between an older illuminator, the Giac Master, and a younger painter, the Rohan Master.[26]

René of Anjou's Hours has enjoyed considerable attention in recent decades; its production in Angers, original association with King René, and dating to c. 1435–1436 are now widely accepted.[27] The Rohan Hours has received a continuous stream of articles, monographs, and facsimiles for a century now,[28] but

Hours of c. 1410–1420 (London, British Library, Harley Ms. 2934, fol. 52r; www.bl.uk/catalogues/illuminatedmanuscripts/) turns up within the same miniature in the Paris Hours of René of Anjou of c. 1430–1440 (Paris, BnF, Ms. lat. 1156A, fol. 52r; gallica.bnf.fr/) and in a marginal vignette in the Hours of Isabella Stuart of c. 1430 (Fig. 2). This shepherd finds a close parallel in the Bedford Master's Annunciation to the Shepherds in his eponymous Hours, confirming the origin of the motif in Paris in the 1410s or early 1420s (London, British Library, Add. Ms. 18850, fol. 70v; E. König, The Bedford Hours: The Making of a Medieval Masterpiece [London, 2007], color pl. on p. 12; Royal Manuscripts: The Genius of Illumination, ed. S. McKendrick, L. Lowden, and K. Doyle, Exhib. cat. [London, 2011], no. 142). Another shepherd from a marginal vignette of the Annunciation to the Shepherds in the de Buz Hours (fol. 52r; see note 22) reappears within the main miniature of the same subject in the Hours of Isabella Stuart (Fig. 3). Individual elements from the architecture above the Adoration of the Magi in the Harley Hours (fol. 57r) are re-combined in Christ's Presentation in the Temple in the de Buz Hours (fol. 62r; see note 22), the Annunciation in the Paris Hours of René of Anjou (fol. 23r), and the Madonna in the Church in Isabella Stuart's Hours (Fig. 9), whose architecture and setting on the left-hand side are copied into Christ's Presentation in the Temple in the Rohan Hours (fol. 94v; for the facsimile, see note 1). Many of these elements also feature in works by the Bedford Master dating to the 1410s or early 1420s (Avril, Peinture française [as in note 2], 47–48; König,

Bedford Hours, 45–48). The book shelf behind the Madonna in Isabella Stuart's Hours (Fig. 9), which is based on a Limbourg design (see below and note 33), and the unusual pattern of the tiled floor, resembling the hypocaust system of Roman baths, reappear in the Rohan Hours' Annunciation (fol. 45r).

24. Villela-Petit, 'Jeanne de Peschin' (as in note 9), 22–23.

25. The Rohan Hours' Crucifixion miniature (fol. 27r), Calendar scenes, and Evangelists' portraits (see note 1) may well be by an artist who contributed to the de Buz Hours, for instance, the miniatures of the Annunciation to the Shepherds, Christ's Presentation to the Temple, and the burial scene for the Office of the Dead (fols. 52r, 62r, 118r; see note 22).

26. Paris, BnF, Ms. lat. 1156A, fol. 61r; gallica.bnf.fr/. Villela-Petit, entry on the Rohan Hours in Taburet-Delahaye and Avril, Paris 1400 (as in note 2), 373, suggesting that the Giac and Rohan Masters might have been a father and son; Villela-Petit, 'Jeanne de Peschin' (as in note 9), 22–23.

27. The original campaign of illumination contains the motto and heraldic device adopted by King René in 1434; Avril, Peinture française (as in note 2), 48; C. de Mérindol, Le roi René et la seconde maison d'Anjou (Paris, 1987), 123–24; C. de Mérindol, 'Ducs d'Anjou, rois de Sicile et de Jérusalem: seconde maison d'Anjou,' in Les Valois, ed. P. van Kerrebrouck (Villeneuve-d'Ascq, 1990), III: 269–323; C. de Mérindol, 'L'héraldique des princes angevins,' in Les princes angevins du XIIIᵉ au XVᵉ siècle: un destin européen, ed. N.-Y. Tonnerre and É. Verry (Rennes, 2003), 277–310.

28. See notes 1 and 2.

FIGURE 2. Detail of marginal miniature, Annunciation to a shepherd. Cambridge, Fitzwilliam Museum, Ms. 62, fol. 123ʳ.

FIGURE 3. Hours of the Virgin, Terce: Annunciation to the Shepherds. Cambridge, Fitzwilliam Museum, Ms. 62, fol. 71ʳ.

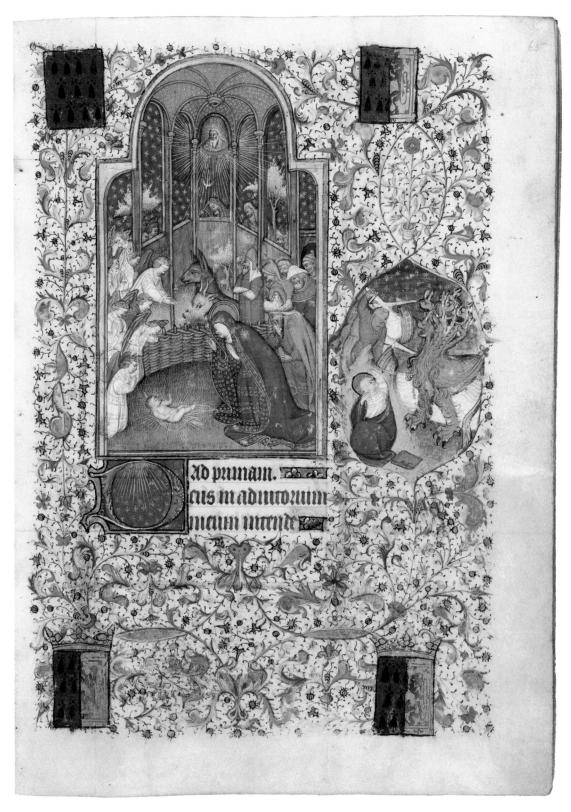

FIGURE 4. Hours of the Virgin, Prime: Adoration of the Child. Cambridge, Fitzwilliam Museum, Ms. 62, fol. 65ʳ.

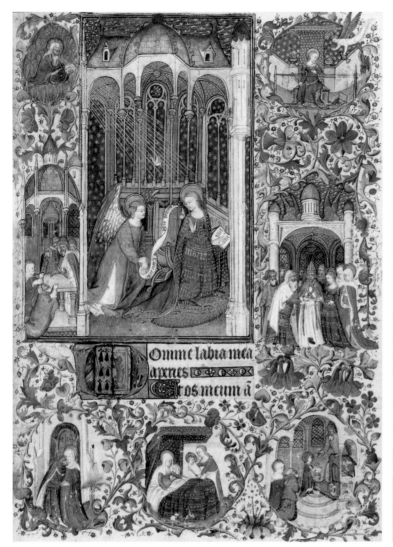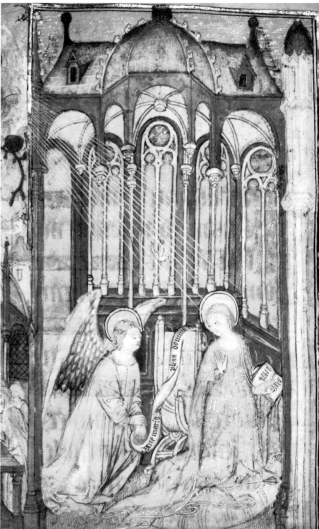

FIGURE 5. Hours of the Virgin, Matins: Annunciation, marginal vignettes from the life of the Virgin. Cambridge, Fitzwilliam Museum, Ms. 62, fol. 29ʳ. Near-infrared image of main miniature.

the single aspect on which scholars have reached a consensus is its place of production. The Angevin origin of the Rohan Hours hinges on its stylistic and iconographic relationship with René of Anjou's and Isabella Stuart's Hours. The intended recipients of the Rohan and Isabella manuscripts remain uncertain, although Yolande of Aragon is credited with their commission; their date of production is still the subject of debate, with opinions ranging from *c.* 1417 to the 1430s.[29]

Arguments about Yolande of Aragon's patronage have focused on motifs and compositions that derive from two manuscripts known to have been at the Angevin court by the second decade of the fifteenth century. The first is the fourteenth-century Neapolitan *Bible moralisée*, which was most probably brought to Angers after one of Louis II's campaigns in southern Italy; it served as the direct exemplar for the Rohan Hours' Crucifixion and extensive cycle of

29. For recent summaries of the state of research, though favoring opposing views on dating, see König, *Grandes Heures* (as in note 3), 13–16, and E. L'Estrange, *Holy Motherhood: Gender,*

Dynasty and Visual Culture in the Later Middle Ages (Manchester, 2008), 114–16, 151–52.

Bible moralisée images.[30] The second is the Limbourg brothers' *Belles Heures* of 1405–1409, which Yolande of Aragon purchased from the Duke de Berry's executors in 1417.[31] The direct visual quotations from the *Belles Heures* in the Rohan, Isabella Stuart, and René of Anjou Hours[32] are sometimes seen as evidence that Yolande of Aragon commissioned all three manuscripts shortly after 1417. Another example of the Rohan Masters' access to designs by the Limbourg brothers, the image of the Madonna in the Church in Isabella Stuart's Hours (Fig. 9), suggests a later date. The church interior surrounding the Madonna echoes a drawing of St. Jerome based on a Limbourg design and added to the *Bible moralisée* commissioned by Philip the Bold from Pol and Jean de Limbourg in 1402.[33] Since the *Bible moralisée* was in René of Anjou's collection by the 1430s, François Avril, followed by others, has argued that the Isabella Stuart and Rohan Hours were produced for weddings planned for two of Yolande of Aragon's children in 1431.[34]

It is conceivable, as scholars favoring an earlier date of *c.* 1417 have suggested,[35] that the Rohan Masters might have known the drawing of St. Jerome (or a related design) before the *Bible moralisée* came into René of Anjou's possession. By the same token, the Rohan Masters could have known the *Belles Heures* (or similar designs) before it was acquired by Yolande of Aragon. Admitting this possibility would undermine the argument for dating the manuscripts to *c.* 1417. Jean Porcher recognized the risk in dissociating the Limbourg designs in the Rohan manuscripts from Angevin patronage: 'Once this connection is broken anything becomes possible and one may surmise whatever one pleases.'[36] If Yolande of Aragon did commission the Isabella Stuart, Rohan, and René of Anjou Hours from the Rohan Masters, her purchase of the *Belles Heures* in 1417 offers no more than a date *post quem* for the three manuscripts.

The heiress of King John I of Aragon, Yolande (1381–1442) married Louis II (1377–1417), Duke of Anjou and King of Naples, Sicily, and Jerusalem in 1400, thus becoming Queen of the Four Kingdoms.[37]

30. Paris, BnF, Ms. fr. 9561. Porcher, *Two Models* (as in note 2); Avril and Reynaud, *Manuscrits à peinture* (as in note 2), no. 4, p. 26.

31. New York, Metropolitan Museum of Art, Cloisters Collection, Ms. 54.1.1; T. B. Husband, *The Art of Illumination: The Limbourg Brothers and the Belles Heures of Jean de France, Duc de Berry*, Exhib. cat. (New York, 2008); Dückers and Roelofs, *Limbourg Brothers* (as in note 4), 97–111, 149–63, nos. 93–102, 209–235. For Yolande of Aragon's acquisition, see Meiss, *Limbourgs* (as in note 2), 268–70.

32. For a recent discussion, with earlier literature, of *Belles Heures'* motifs and compositions replicated in 15th-century manuscripts, see Clark, *Influence* (as in note 4), 209–235. Among the most frequently discussed correspondences are the images of the Virgin and Child in Glory, and the Virgin and Child on the Crescent Moon in the *Belles Heures* (fols. 26ᵛ, 218ʳ), which inspired depictions in Angevin manuscripts, namely, Isabella Stuart's Hours (FIGS. 9–10), the Rohan Hours (fols. 29ᵛ, 33ᵛ, 38ʳ), René of Anjou's Hours (fol. 18ᵛ; gallica.bnf.fr/), and the de Buz Hours (fol. 155ʳ, see note 22), as well as in illuminations by the Paris-based Virgil and Spitz Masters (Paris, BnF, Ms. fr. 414, fol. 1ʳ; Los Angeles, Getty Museum, Ms. 57, fol. 176ᵛ; G. T. Clark, *The Spitz Master: A Parisian Book of Hours* [Los Angeles, Calif., 2003], fig. 23; Clark, *Influence* [as in note 4], 223–224, 231–232, figs. 16–17, 20, 232). While Porcher, *Two Models* (as in note 2), Meiss, *Limbourgs* (as in note 2), and subsequent scholars have overlooked other visual quotations from the *Belles Heures* in Isabella Stuart's Hours, Michael Camille identified further examples: the Calendar scenes on fol. 12ʳ and the Pentecost miniature on fol.

127ʳ, based on fols. 12ʳ and 136ᵛ, respectively, in the *Belles Heures* (M. Camille, 'The Illustrated Manuscripts of Guillaume de Deguileville's "Pèlerinages" 1330–1426,' Ph.D. thesis [Cambridge, 1985], 230, 258 n. 43).

33. Paris, BnF, Ms. fr. 166. O. Pächt, 'Zur Entstehung des "Hieronymus im Gehäus,"' *Pantheon* 21 (1963), 131–42, esp. 135, fig. 2; Avril and Reynaud, *Manuscrits à peinture* (as in note 2), 25–6, 115; Taburet-Delahaye and Avril, *Paris 1400* (as in note 2), 293, 297, figs. 78–79; Gautier and Avril, *Splendeur de l'enluminure* (as in note 6), no. 3, pp. 212–14. For related drawings and their attribution, see note 5 and esp. Clark, *Influence* (as in note 4), 215–21, fig. 7.

34. Avril, *Peinture française* (as in note 2), 47–48; Avril and Reynaud, *Manuscrits à peinture* (as in note 2), 25–6; Taburet-Delahaye and Avril, *Paris 1400* (as in note 2), no. 232, pp. 371–73; König, *Grandes Heures* (as in note 2), 15–16; see also note 12.

35. R. Emmerson, 'A "Large Order of the Whole": Intertextuality and Interpictoriality in the Hours of Isabella Stuart,' *Studies in Iconography* 28 (2007), 53–110, at 103, n. 24.

36. Porcher, *Two Models* (as in note 2), 3.

37. F. Robin, *La cour d'Anjou-Provence: la vie artistique sous le règne de René* (Paris, 1985), 29–32, 71; Mérindol, *Roi René* (as in note 27), 43–48; *Quand le duc s'appelait Louis: Louis I et Louis II, ducs d'Anjou 1360–1417*, ed. É. Verry, B. Pipon, C. Leduc (Angers, 1998); M.-R. Reynaud, *Le temps des princes: Louis II et Louis III d'Anjou, 1384–1343* (Lyon, 2000), 143; C. Ohnesorge, 'Les ambitions et l'échec de la seconde maison d'Anjou (vers 1380–vers 1480),' in *Princes Angevins* (as in note 27), 265–276, at 268.

After her husband's death in 1417, Yolande defended Angevin rights to her vast territories. She was also a major player in the politics of the Hundred Years War, championing the cause of the Armagnac party, which was led by her husband until his death in 1417 and after that centered on Charles VI's son, Charles of Ponthieu, who became Dauphin in the same year. The young Charles had enjoyed Yolande's protection since 1414, when he was engaged to her eldest daughter Marie. They were married in 1422, the year of Charles VI's death, when the English right to the French crown came into force according to the Treaty of Troyes and the disinherited Dauphin was banished from Paris, establishing his court at Bourges. A staunch supporter of the French cause, Yolande of Aragon was also fostering ties with the Dukes of Brittany in order to break their alliance with the Burgundian Dukes and Henry V of England, and to recover her territories in Maine occupied by the English from 1423 onwards. She failed in her attempts to marry her eldest son Louis III of Anjou to the daughter of John V of Brittany, despite their engagement in 1424, or her youngest son Charles of Maine to a daughter of Alan IX, Viscount of Rohan, a Breton family closely associated with the Dukes of Brittany, although a wedding was being planned *c.* 1430. But she succeeded with the union of her second daughter, Yolande of Anjou (1412–1440), and the future Duke of Brittany, Francis I (1414–1450); they were married in 1431.

The purchase of the *Belles Heures* coincided with the death of Yolande's husband and the emergence of the Dowager Duchess as the sole protector of the Angevin dynasty. Yolande's commission of these manuscripts during such a trying period has been interpreted as 'an urgent act of devotion and penitent petition to God.'[38] This is psychologically convincing, but perhaps less plausible in practical terms. The year 1417 marked the beginning of the most turbulent period in Yolande's life. Until the mid-1420s, she was constantly on the move between her territories in Anjou, Maine, Barrois, and Provence, while also supporting her sons' campaigns in Southern Italy. She was busy negotiating the marriage of her son René to Isabelle, the heiress of the Duchy of Lorraine, in 1420, as well as the other politically important unions mentioned above. She was residing at Bourges as the Dauphin's councillor for considerable periods, especially around the time of his wedding to her daughter Marie in 1422. Yolande's time, energy, attention, and resources during this period were seriously over-stretched. One wonders whether she would have had any left for the production of not one, but three of the most richly illuminated fifteenth-century French manuscripts, not to mention the complexity of their pictorial cycles. The making of Isabella Stuart's Hours alone, with over 500 miniatures, may well have spanned a number of years, from the late 1420s onwards. By that time, Yolande was able to turn her attention to art patronage. From *c.* 1425 onwards, she financed an ambitious project at the cathedral in Le Mans, the new stained glass windows, which were completed in the early 1430s.[39]

I would like to focus on the Hours of Isabella Stuart, the least studied of the Rohan Masters' manuscripts. Its ownership has received considerable attention.[40] And so have the cycles of marginal miniatures inspired by the Apocalypse and Guillaume de Deguileville's three *Pèlerinage* poems, all texts that enjoyed popularity at the Angevin court and in Yolande of Aragon's entourage.[41] Unlike the patronage and the marginal cycles, the style, painting technique, and iconography have received little discussion, limited to the three images (Figs. 9–11) traditionally assigned to the Rohan Master[42] and a fourth one (Fig. 4) attributed more recently to the Giac Master.[43] We do not know how many artists painted the remaining miniatures,[44] and what patterns or levels of collaboration they ad-

38. Emmerson, *Large Order* (as in note 35), 55.

39. Mérindol, *Roi René* (as in note 27), 46–48.

40. L'Estrange, *Holy Motherhood* (as in note 29), 114–151, 201–215, with earlier literature.

41. Camille, *Pèlerinages* (as in note 32), 66–98; A.-M. Legaré, 'La reception du Pèlerinage de Vie humaine de Guillaume de Degulleville dans le milieu angevin d'après les sources et les manuscrits conservés,' in *Religion et mentalité au Moyen Âge: Mélanges en l'honneur d'Hervé Martin* (Rennes, 2003), 543–52; Emmerson, *Large Order* (as in note 35), 55.

42. Fols. 136v, 141v, and 199r, first attributed to the Rohan Master by Heimann, *Meister* (as in note 2), 5–6.

43. Fol. 65r; Villela-Petit, 'Jeanne de Peschin' (as in note 9), 22.

44. The manuscript contains two full-page and 20 large miniatures at main text divisions, 24 framed Calendar scenes, 38

opted in order to complete such an ambitious project in a single campaign. Apart from Michael Camille's and Richard Emmerson's insightful comments on the sophisticated alignment of the marginal Apocalypse and *Pèlerinage* cycles with the main texts and images, a detailed examination of the overall method of production has not been undertaken as yet. What follows is a preliminary attempt.

First, I shall offer some clarifications on the ownership. It is well established that the manuscript belonged to Isabella Stuart (1427–after 1494), daughter of James I of Scotland and second wife of Francis I of Brittany (1414–1450). It has long been recognized that Isabella Stuart was not the original owner; she is credited with the insertion of her arms throughout the volume and with the amendment of the miniature for the *Obsecro te* prayer: the portrait of the original owner was over-painted with Isabella's own and she acquired a companion, St. Catherine (Fig. 6). A careful examination of the under-drawing and the painting materials allows for a precise dating of these alterations.[45] The red used for Isabella's *cotte* is the same pigment, vermillion, found in the added arms, while the red found elsewhere in the main image, in the marginal miniature, and in the floral border is minium. St. Catherine's garments were painted in ultramarine and an organic, insect-based pink. The dark, oval area behind Isabella's head conceals what would have been the elaborate headdress of the original patron. The blue of St. Catherine's robe painted over this dark area is not ultramarine as on the rest of the saint's cloak, but azurite. It seems that at first

Isabella retained the original owner's headdress and St. Catherine's cloak was painted around it in ultramarine, but later the headdress was over-painted in azurite and Isabella received a ducal coronet instead. It might have been Francis I of Brittany, rather than Isabella, who ordered these alterations. Eberhard König dated them to *c.* 1440 and attributed them to an artist who worked for Francis in Nantes during the second quarter of the fifteenth century.[46] Francis probably commissioned the alterations in anticipation of his wedding to Isabella on 29 October 1442. In the meantime, on 29 August 1442, he succeeded to the duchy of Brittany. Isabella would have become a duchess upon her marriage two months later and the coronet, a vital signifier of her status, was added perhaps between August and October 1442, or immediately after the wedding.

Isabella Stuart gave the manuscript to her daughter, Marguerite of Brittany (1443–1469),[47] who added a prayer to the Virgin and a small miniature showing her kneeling before the Virgin and Child at a *prie-dieu* draped in the arms of Brittany (Fig. 7).[48] Marguerite probably received the manuscript from her mother *c.* 1455, the year of her marriage to her cousin, the future Francis II of Brittany (1435–1488). She would have made the additions shortly after that and certainly before 1458. Her tall, gold turret with a magnificent veil finds close parallels in manuscripts of the mid-1450s and denotes Marguerite's high rank, but it is no equivalent to a ducal coronet—she would only become a duchess in 1458.[49] The miniature shows the use of an organic green, azurite, and vermillion instead of the

small miniatures within the text of the suffrages and prayers (including the one added later on fol. 28ʳ), seven scenes painted within border foliage (fol. 29ʳ), and 437 framed marginal miniatures.

45. The technical examination undertaken by Dr. Paola Ricciardi included photomicroscopy, near- and shortwave-infrared imaging, x-ray fluorescence and fibre-optic reflectance spectroscopy.

46. König, *Französische Buchmalerei* (as in note 22), 78, 255.

47. The inventory made after Marguerite's death in 1469 describes a large Book of Hours for the use of Paris, decorated with the arms of Isabella Stuart. A. de la Borderie, 'Inventaire des meubles et bijoux de Marguerite de Bretagne, Première femme de duc de Bretagne François II,' *Bulletin de la société archéologique de Nantes et Loire-inferieure* 4 (1864), 45–60, esp. 53, item 73; L'Estrange, *Holy Motherhood* (as in note 29), 216.

48. L'Estrange, *Holy Motherhood* (as in note 29), 215–19, with earlier literature. Scholars have recognized the miniature as an addition, but have seen it as the completion or repainting of an earlier image, assuming that the text of the prayer belonged to the original campaign (L'Estrange, p. 244, n. 27). In fact, the prayer was added after the *O intemerata*, in the space left free by the original campaign. Although the scribe of the added prayer mimicked skillfully the script of the original campaign, his work can be distinguished by the different shapes of individual letters and by the left slant of his *ductus*. The ornamental initial within the prayer (fol. 28ᵛ) is markedly different from the ornamental initials of the original campaign and suggests a date in the 1450s, contemporary with the miniature.

49. When Marguerite's father, Francis I, died in 1450, the duchy passed to his brother Peter II (1418–57), then to his uncle Arthur III (1393–1458), and finally, in 1458, to his nephew Francis

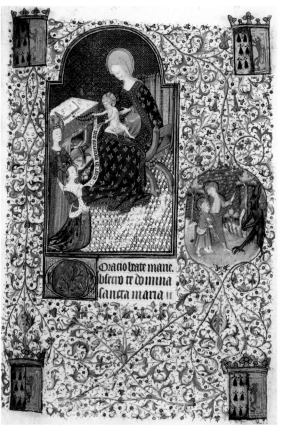

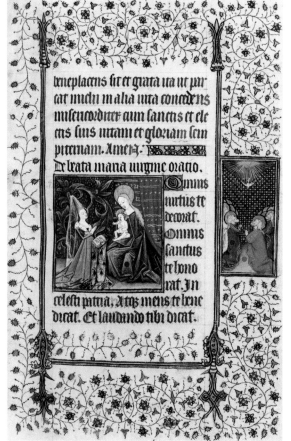

FIGURE 6 (*opposite, top*). *Obsecro te*: Isabella Stuart, accompanied by St. Catherine and praying to the Virgin and Child. Cambridge, Fitzwilliam Museum, Ms. 62, fol. 20ʳ. Near-infrared image of main miniature.

FIGURE 7 (*opposite, bottom*). *Omnis virtus te decorat*: Marguerite of Brittany praying to the Virgin and Child, marginal image of Apostles with the Holy Spirit. Cambridge, Fitzwilliam Museum, Ms. 62, fol. 28ʳ. Spectra of blue and green pigments showing ultramarine and a copper-based green in the marginal image (original campaign) as opposed to azurite and an organic green in the added miniature.

malachite, ultramarine, and minium found in the marginal scene, which belongs to the original campaign. The vermillion was costly, but the blues and greens were cheaper. This may reflect, at least in the case of ultramarine, the disruption of the trade routes in the Middle and Near East caused by the Ottoman occupation in the mid-fifteenth century, as Inès Villela-Petit suggested to me recently. In addition, it may imply that Marguerite did not have access to the resources that were at the disposal of her parents, let alone of the manuscript's original owner.

Who was the original owner of Isabella Stuart's Hours? The *Creator celi* prayer contains female forms and two marginal images of a woman in black praying at an altar.[50] A third portrait shows the woman kneeling at a *prie-dieu* with an open book (this very book) and looking at the two images that illustrate her prayers at the end of the volume (Fig. 8).[51] The

first, a small miniature within the text, depicts Christ seated on a rainbow and extending his hand to the woman, a promise for salvation at the end of time. In the second, a marginal scene, Christ is shown walking away, but extending his hand in the direction of the woman across the page, an eloquent gesture granting her request voiced in the adjacent text. The dominant view follows Michael Camille's suggestion that the woman in black shown in the three miniatures represents Yolande of Aragon after she was widowed in 1417. Most scholars agree that the manuscript was commissioned by Yolande of Aragon, that she gave it to her daughter, Yolande of Anjou, and that following the latter's death in 1440, the volume fell into the hands of Francis' second wife, Isabella Stuart. Opinions on the intended original recipient and the date of production are polarized. Some scholars maintain that Yolande of Aragon commissioned the manuscript for herself shortly after 1417 and only gave it to her daughter later.[52] Others argue that Yolande of Aragon commissioned the Fitzwilliam Hours specifically for Yolande of Anjou's marriage to Francis I in 1431.[53]

Favoring the earlier date, Michael Camille thought that he could see the 'scraped-away outline' of Yolande of Aragon's figure and the 'rubbed-out shape' of the arms of Brittany impaling Anjou beneath the arms of Brittany and Scotland on fol. 20ʳ (Fig. 6).[54] He also believed that St. Catherine had been painted over an original image of St. Radegund, a saint to whom

II (1435–1488), son of Francis I's other uncle, Richard of Brittany, Count of Estampes.

50. The images are on fols. 139ᵛ–140ʳ; Emmerson, *Large Order* (as in note 36), fig. 26; L'Estrange, *Holy Motherhood* (as in note 29), fig. 19. The female forms occur throughout the prayer: *peccatrix non sum digna* and *servam tuam* (fol. 137ʳ), *ego fragilis peccatrix* (fol. 137ᵛ), *famula et serva tua sum ego quamvis mala quamvis indigna et peccatrix quails enim sum sive bona sive mala tua sum* (fol. 138ᵛ), *qamvis mala sum vilis et indigna … luculenta … maculata … ceca … infirma … mortua … in peccatis sepulta* (fol. 139ʳ).

51. The prayer entitled *Antiphona dicenda pro semetipso* and beginning *Domine sancte pater et deus vite mee* is on fols. 230ᵛ–231ʳ, followed on fol. 231ʳ⁻ᵛ by the prayer beginning *Suppliciter te deus omnipotens pater qui es creator omnium rerum* and containing the female form *me famulam tuam* and the phrase illustrated by Christ's extended hand in both images: *manum misericordie tue michi porrigas* (fol. 231ʳ)

52. J. Harthan, *Books of Hours and Their Owners* (London, 1977), 117; Ring, *French Painting* (as in note 4), 204; Heimann, *Meister*

(as in note 2), 10; Meiss, *Limbourgs* (as in note 3), 401; Camille, *Pèlerinages* (as in note 32), 227–28; Legaré, *Pèlerinage* (as in note 41), 545; Emmerson, *Large Order* (as in note 35), 55; C. Reynolds, 'The "Très Riches Heures," the Bedford Workshop and Barthélemy d'Eyck,' *Burlington Magazine* 147 (2005), 526–33. Arguments for Yolande of Aragon being not only the manuscript's commissioner, but also its intended recipient are based on the emphasis on Angevin saints in the suffrages, the prominence of St. Radegund, who received seven images and suffrages (fols. 224ᵛ–230ᵛ), more than any other saint honored in the manuscript, and the marginal cycles inspired by the Apocalypse and *Pèlerinage* poems, which were going out of fashion by the 2nd quarter of the century.

53. Avril and Reynaud, *Manuscrits à peinture* (as in note 2), 25, 178; see note 12; König, *Grandes Heures* (as in note 2), 15–16; Clark, *Influences* (as in note 4), 215, 224.

54. Camille, *Pèlerinages* (as in note 32), 228, 255–56, notes 34–35.

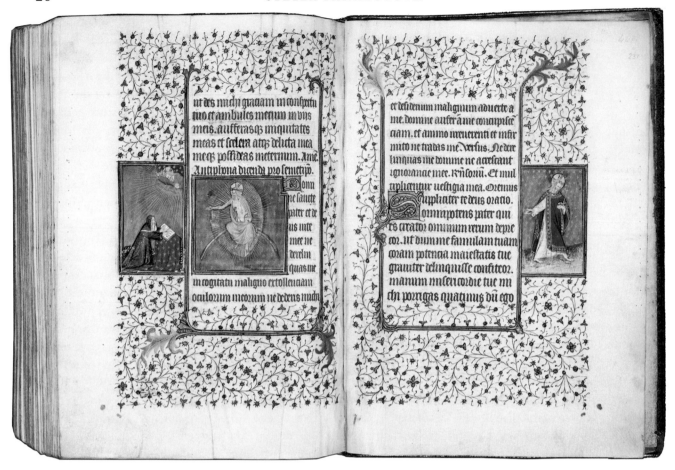

FIGURE 8. Prayers to Christ: the manuscript's patron praying to Christ. Cambridge, Fitz-
william Museum, Ms. 62, fols. 230ᵛ–231ʳ.

Yolande of Aragon was particularly devoted.[55] Short-
wave-infrared imaging reveals, however, that there
were no arms beneath those added by Isabella Stuart
and that there was no saint in the original miniature
either. Remains of ultramarine and gold can be de-
tected beneath St. Catherine's cloak, indicating that the
Virgin's train extended behind the original patron all
the way to the frame. Both the arms and St. Catherine
were added for Isabella Stuart.

Had the original patron on fol. 20ʳ been Yolande
of Aragon, she would have had herself depicted most
probably like the widow in the marginal scenes (Fig.
8). A large area of black pigment is hard to scrape
away or over-paint without a trace. There are no re-
mains of black beneath Isabella Stuart's figure. The
large over-painted area behind Isabella's head suggests

the presence of metal and would have concealed an
elaborate headdress, perhaps a gold henin. Its size and
shape has little in common with the widow's veil and
is more likely to have belonged to a fashionable lady.
I'm inclined to think that Yolande of Aragon intended
the manuscript for her daughter from the start, giving
Yolande of Anjou's portrait pride of place in the *Ob-
secro te* miniature. In line with her Franciscan spiritu-
ality, the older Yolande reserved for herself the three
modest marginal depictions of a devout widow, which
would have kept her in her daughter's thoughts and
prayers both during her lifetime and after her pass-
ing. Although the *Pèlerinage* poems and their pictorial
cycles were past their heyday by the second quarter
of the fifteenth century, they would have preserved
their appeal for an older patron like Yolande of Ara-

55. See note 52.

gon (one remains fond of the music and poetry admired in one's youth). Furthermore, she would have thought them appropriate moral and devotional tools for her daughter at the beginning of her married life, just as the suffrages to Angevin saints and the maternal images would have remained relevant to the young Yolande.[56] A date of completion close to Yolande of Anjou's wedding in 1431 seems most likely, although work on the manuscript, given its extensive and complex illustrative program, may have started earlier, perhaps in the late 1420s.

Let us turn to the method of production. There are no signs of undue haste, compromise, or mistakes. Every aspect of the manuscript reveals careful planning and well-managed execution. The volume consists of five units or building blocks, each accommodating—comfortably, without thrift or extravagance—a distinct group of texts and their imagery.[57] The structure is highly regular, made up of twenty-six quaternions and only three quires of a different, but logical length: twelve leaves for the Calendar (unit one), six leaves to complete the Hours of the Virgin (unit three), and six more at the end of the volume. Following the Calendar, the remaining four units largely coincide with the four cycles of marginal images illustrating the Apocalypse and the *Pèlerinage* poems. Since two of the *Pèlerinage* cycles are shorter than their respective units, they are supplemented with brief marginal cycles illustrating the adjacent texts.[58]

One artist was responsible for the design of all marginal miniatures, including those in the Calendar, and for the execution of most of them. The help of two assistants is discernible in the two longest *Pèlerinage*

cycles: those of the Human Life and of the Soul. The large images for the main texts display a more complex division of labor. The miniatures for the Hours of the Virgin (unit three) were painted by the main artist of the marginal cycles. We recognize the hand of the Giac Master in the gold clouds, the green-and-black tiled floors, the ambiguous architecture, the rounded faces with beady eyes, and the steep golden landscapes framed by rugged outcrops, climbing up to the horizon and surmounted by fairy-tale castles (Figs. 1, 3–5). We also find a substantial amount of under-drawing and evidence of the Giac Master's change of mind at the painting stage (Fig. 5).[59]

The Giac Master was largely responsible for the fourth and fifth units, including the miniatures for the suffrages both within the text block and in the margins. He was assisted by two artists who followed his compositions and replicated his patterns, while trying to introduce more convincing spatial relationships. The first, an accomplished artist, painted scenes densely populated by minute figures for the Hours of the Cross (fol. 119[r]), the Passion according to St. John (fol. 134[r]) and the Office of the Dead (fol. 147[r], Fig. 14).[60] The second, who supplied the Pentecost miniature for the Hours of the Holy Spirit (fol. 127[r]), was one of the assistants involved in the marginal cycles.[61] Or to put it another way, an assistant who helped with the marginal cycles was invited to contribute a large miniature within his section, perhaps as a test or reward for his labor.

In unit four the Giac Master collaborated with a major artist who was responsible for the two full-page miniatures in the volume: the Virgin and Child on the

56. I thank Richard Emmerson for discussing and helping me clarify these aspects of the manuscript.

57. See Appendix.

58. Following the end of the *Pilgrimage of the Human Life* cycle (fols. 99[r]–138[v]), the last quire of unit four (fols. 139[r]–146[v]) contains illustrations for the prayers to Christ and the Virgin, including two of the widow's portraits (fols. 139[v]–140[r]), images of the Resurrection (fol. 139[r]) and Last Judgement (fols. 140[v]–141[r]), and a cycle focused on the Virgin's joys (fols. 142[r]–146[v]). The end of the *Pilgrimage of the Human Soul* cycle (fols. 147[r]–191[v]) coincides with the end of the Office of the Dead in the middle of quire twenty-four; the rest of this quire (fols. 192[r]–194[v]) and the remaining five quires (fols. 195[r]–231[r]) have marginal images illustrating the adjacent prayers and suffrages.

59. Two towers, visible in the near-infrared image, were drawn at the far end of the roof above the Annunciation (fol. 29[r]), but were never painted.

60. For his impact on Breton manuscripts, see König, *Französische Buchmalerei* (as in note 22).

61. The architecture suggests the use of a pattern in which the Giac Master may have conflated compositions by the Limbourg brothers and the Boucicaut Master. Compare the Pentecost miniatures in the *Belles Heures* (fol. 84[r]; Husband, *Art of Illumination* [as in note 31], 144–45) and the Boucicaut Hours (Paris, BnF, Musée Jacquemart-André, fol. 112[v]; Châtelet, *L'Age d'or* [as in note 2], 306–307).

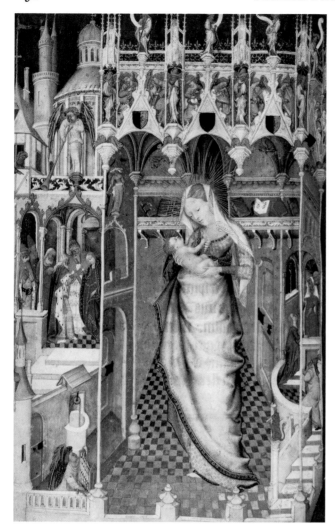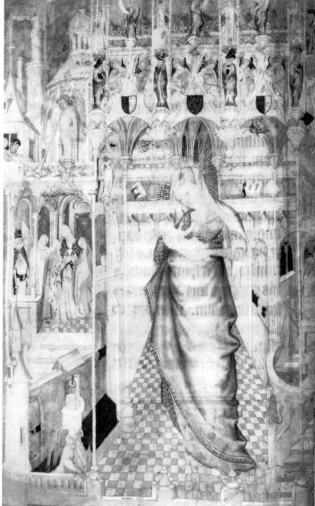

FIGURE 9. Five Joys of the Virgin: Madonna and Child in a Church, subsidiary scenes from
the life of the Virgin. Cambridge, Fitzwilliam Museum, Ms. 62, fol. 141ᵛ. Near-infrared image.

crescent moon, inspired by the Apocalyptic Woman (Rev. 12:4), with Saints Peter and Paul, introduces the *Creator celi* prayer; the Madonna in the Church is the frontispiece to the Five Joys of the Virgin (Figs. 9–10). The Giac Master contributed to both pages. He painted the marginal vignette beside the Apocalyptic Virgin and the scenes from Mary's life within the architecture surrounding the Madonna in the Church. The main images on both pages are routinely attributed to the Rohan Master. I have tried very hard to see his hand in these two miniatures, but admit defeat. I find no trace of his super-sized, dynamic, and powerful figures, bursting out of the pictorial space with the pathos of a cosmic cataclysm. What I see instead is

elegant restraint, calm introspection, and sweet tenderness. Any drama is contained deep inside rather than performed on stage. Even the Madonna, who is propelled towards us from the depth of the picture space, exudes gentle self-control and dignified sophistication. The palpable presence of the Madonna Master's three-dimensional figures, seemingly displacing the matter around them, is hard to find in the Rohan Master's images. The soft modelling of the fabrics, the elegant sway of torsos and limbs, and the Madonnas' minute, demure features hark back to the exquisite finesse of the International Gothic style, while the Rohan Master's bold and expressive images signal a new departure.

The Madonna Master is the most technically ad-

FIGURE 10. *Creator celi* prayer: The Virgin and Child on a Crescent Moon, Saints Peter and Paul, Trinity and angels, marginal miniature of Old Age and Sickness coming to prepare the Pilgrim for his death bed. Cambridge, Fitzwilliam Museum, Ms. 62, fol. 136ᵛ. Near-infrared image of main miniature taken from the recto of the leaf.

vanced artist in Isabella Stuart's Hours. His are the two miniatures in the manuscript that show knowledge of compositions by the Limbourg brothers, and his painting technique seems to emulate their exquisite handling of pigments. He may have been the artist entrusted by Yolande of Aragon with the introduction of designs from the *Belles Heures* into the Rohan circle. The Madonna Master's consummate technical skill, made ever more impressive by the economy of his materials, creates tension between the materiality and spirituality of the image. Rendered in soft grey charcoal over the bare parchment, the Madonna in the Church appears to be either carved out of the page, a statue that has just come to life and miraculously stepped out of its niche, or conjured up by the imagination, a sublime vision in the mind's eye of the devotee (Fig. 9). In the Apocalyptic Virgin we find luminous pigments handled with similar delicacy, creating a pleasing variation between the soft stippling on the saints' cloaks, the fully blended, directional brush strokes on Mary's robe, and the glazes enhancing deep folds (Fig. 10). Surprisingly, the Madonna Master painted both miniatures freehand—neither shows any under-drawing. Perhaps an aesthetic necessity for the

parchment-white Madonna, this was hardly the case for the richly layered pigments of the Apocalyptic Virgin. The confident and highly accomplished work suggests the hand of an experienced painter.

Unlike the Madonna Master, the Rohan Master employed a considerable amount of under-drawing, distinct from that found in the Giac Master's work. Its peculiar nature, including strings of curly loops resembling doodles and often brushed over with a grey ink wash, is visible to the naked eye in areas of thinly applied pigments.[62] The highly unusual style of the under-drawing helps us identify the Rohan Master's hand in the third miniature from Isabella Stuart's Hours that is normally attributed to him: Christ at the Last Judgement (Fig. 11). As in the Rohan Hours, the idiosyncratic under-drawing is visible to the naked eye through the thin washes. Infra-red imaging clearly reveals the festoons of loops cascading down or congregating into pools of drapery folds. The under-drawing aside, the juxtaposition of super-large and extra-small, and the background angels highlighted in gold ink are among the salient features of the Rohan Master's iconic images, while Christ's facial type and skeletal frame bear an unmistakable resemblance to the cadavers (fols. 135r, 159r) and to the Last Judgement Christ (fol. 154r) in the Rohan Hours. Despite these parallels and the re-use of numerous motifs, the Rohan Master's images in Isabella Stuart's Hours do not yet display the epic monumentality or expressive power that characterize his work in the Rohan Hours. The Hours of Isabella Stuart represents an earlier stage in the artist's career, perhaps in the late 1420s, when his signature style was still being defined.

The Rohan Master's hand can be detected in five other images in Isabella Stuart's Hours, all in unit two: the portraits of the four Evangelists and the image of the Virgin and Child at the *Obsecro te* prayer (Figs. 6, 12, 13). All of them reveal the peculiar under-drawing seen in Christ at the Last Judgement (Fig. 11). The figures are characterized by elongated proportions, attenuated limbs and fingers, mannered poses, and a variation of

FIGURE 11 (*opposite, top*). Seven Requests to Our Lord: Christ at the Last Judgement among the rising dead, marginal miniature of Christ as Judge seated on a rainbow. Cambridge, Fitzwilliam Museum, Ms. 62, fol. 199v. Near-infrared image of main miniature.

FIGURE 12 (*opposite, bottom*). Gospel sequence: St. John writing, demon spilling his inkpot. Cambridge, Fitzwilliam Museum, Ms. 62, fol. 13r, detail. Near-infrared image.

complexions—ruddy for the older men, porcelain-like for the Virgin and St. John. The Rohan Master used the same set of pigments in all five images (Fig. 13), but varied their saturation and tonal values through different application and modelling techniques, and perhaps by different proportions of pigment to binder. For instance the ultramarine of Mary and St. John's blue robes evokes a heavy brocade, its deep saturation offering a solid background for the details densely 'embroidered' in liquid gold, while the same pigment in St. Mark's robe is richly modelled with white highlights, its nuanced tonality simulating a lighter, more delicate fabric with gold thread thinly woven through. These five images show an artist experimenting with different painting techniques, still in search of his idiom. The development is clear in Christ at the Last Judgement (Fig. 11), which was probably painted later in the campaign that started with the miniatures for the Gospel sequences.

The Rohan Master was entrusted with the whole of unit two and sketched its last miniature for the prayer *O intemerata*, as the under-drawing reveals (fol. 24r). But he left the painting to an assistant who had not yet mastered the preparation and application of his pigments, as indicated by their poor condition. Aesthetically and technically inferior as this miniature may be, it is an important link between the Rohan and Giac Masters. It shows them sharing an assistant who painted an image designed and sketched by the Rohan Master, but who was trained by the Giac Master, replicating his tiled floors and his bland, plump, beady-eyed faces.

62. In the Rohan Hours the under-drawing is easily observed beneath pink areas, for instance on fols. 154r and 159r. I thank Charlotte Denoël and Inès Villela-Petit in Paris, and William Stoneman in Harvard for confirming that no technical examination of the Rohan, René of Anjou, and de Buz Hours has been undertaken to date, and for discussing the possibilities of future analysis.

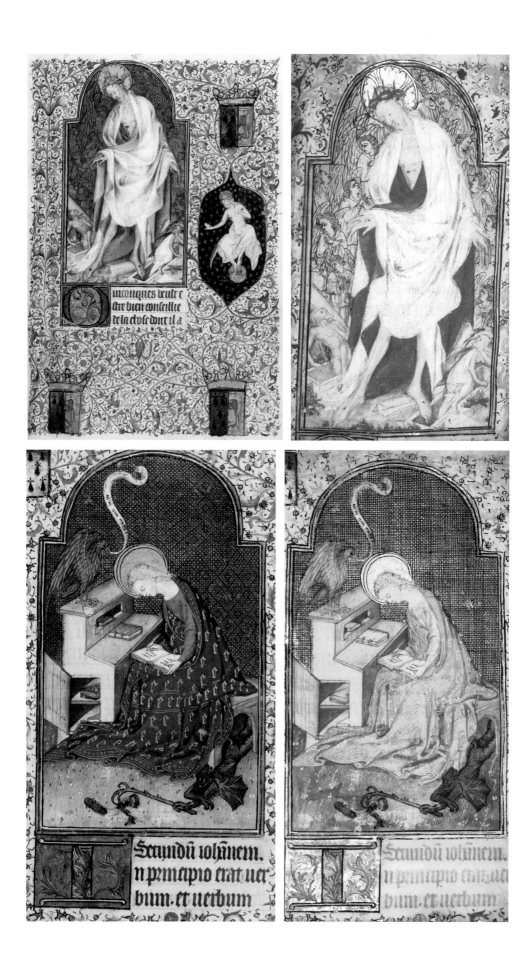

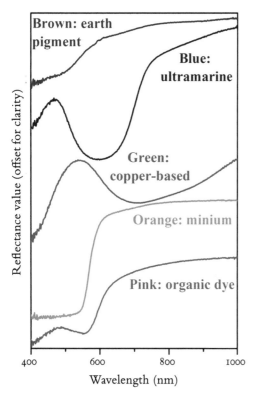
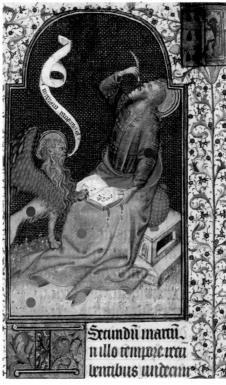
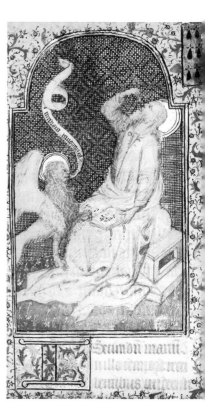

FIGURE 13. Gospel sequence: St. Mark receiving inspiration and ready to write. Cambridge, Fitzwilliam Museum, Ms. 62, fol. 18ᵛ, detail. Spectra of pigments used in the miniature (*left*). Near-infrared image (*right*).

The styles of the Giac, Rohan, and Madonna Masters, and of their collaborators, are comparable in materials and techniques, if not in aesthetics or in level of execution and refinement. All artists favored identical chromatic harmonies and achieved them by employing the same pigments.[63] Their color scheme is dominated by ultramarine, malachite, minium, lead white, brown earth, and an organic, insect-based pink, and occasionally supplemented with vermillion, azurite, organic green, yellow earth, and a light purple admixture of an organic dye and ultramarine. This rich palette is set against a range of metals: gold leaf, gold ink, mosaic gold, and silver. All three artists juxtaposed smooth, solid areas of opaque blues and reds with translucent pinks, greens, and violets applied with minute brush strokes in a pointillist technique, and creating optical mixtures. There are subtle and yet noticeable differences between their use of the same colorants. For instance, the Rohan Master's white areas show an identical pattern of flaking as do the Giac Master's blue pigments, while neither color seems to have caused problems in the Madonna Master's images, even though his are the most frequently displayed miniatures in modern days and were probably just as frequently admired and perused in earlier times. The uneven behavior of the same materials may be due to different methods of preparation or application of the paint, such as individual approaches to the priming of the parchment surface or the painting of the base color layers, varying proportions of pigment to binder, selective use of distinct binders for specific pigments, or a combination of these factors. Detailed technical examination may clarify these points.

Equally telling—and equally promising for future

63. The only exception is the pale, acidic green and yellow favoured by the assistant responsible for the Pentecost miniature (fol. 127ʳ) and numerous marginal scenes illustrating the Pilgrimage of the Human Life.

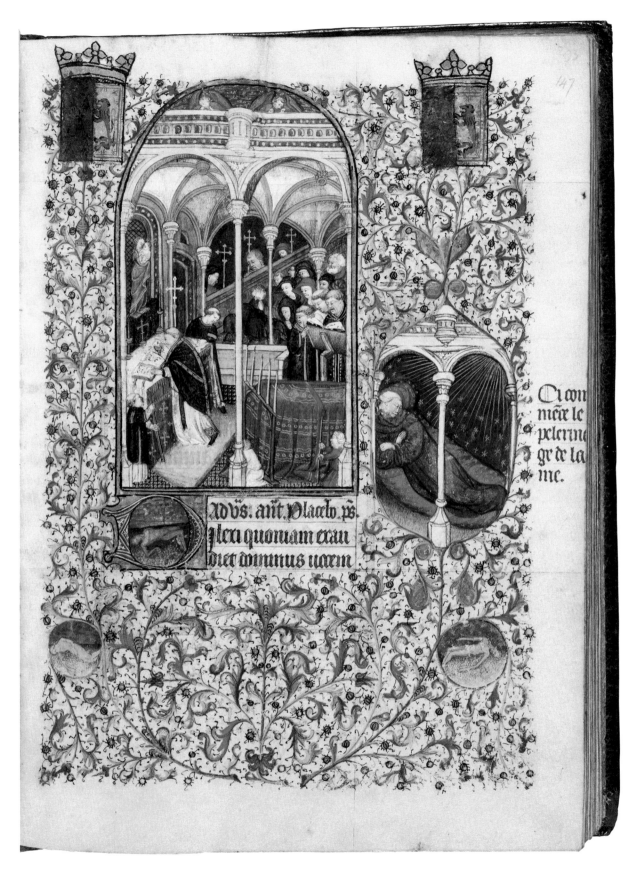

FIGURE 14. Office of the Dead: Mass of the Dead. Cambridge, Fitzwilliam Museum, Ms. 62, fol. 147ʳ.

analysis—are the facial types favoured by the Giac, Rohan, and Madonna Masters, with their down-cast, heavy-lidded, beady eyes, as well as the method of painting flesh tones employed by all three artists and their assistants (Fig. 15). A thin grey wash was laid down as an under-layer. An even pink base tone, an admixture of lead white, red earth, and vermillion, was applied next. The main facial features—the nose, mouth, and eyes—were outlined with brown, iron-based ink, and highlighted in an organic red pigment. The same brown ink and red pigment were used to define the skin texture with emphatically vertical strokes, while greenish-brown earth was used for shaded areas and lead white for highlights. Finally, a thick impasto of lead white simulates the texture of bushy eyebrows. The vertical brown and red strokes are the most characteristic feature shared by all artists in the Fitzwilliam Hours. They were either used sparingly to create youthful, porcelain-smooth complexions or laid down in a dense pattern, resulting in the ruddy faces of older men. Yet again, there are noticeable differences in the quality and behavior of the paint layers, which require further analyses.

The Hours of Isabella Stuart displays the close collaboration between the Giac, Rohan, and Madonna Masters through the meticulously planned and carefully managed execution, as well as the emulation and experimentation that characterize their work. The design and production of the manuscript were led by the Giac Master. He entrusted the Rohan and Madonna Masters with some of the most prominent images, recognizing their exceptional, though different, talents. The most accomplished painter, the Madonna Master, collaborated with the Giac Master in his two full-page miniatures. The Madonna Master also contributed a single marginal vignette, which replicates a pattern used by the Giac Master in other manuscripts (Fig. 2).[64] It occurs at the beginning of quire sixteen (fol. 123r), within unit four, which contains the two full-page miniatures by the Madonna Master. In turn, the Giac Master emulated the Madonna Master's work in his treatment of the Virgin's face and drapery in the miniature for the Fifteen Joys of the Virgin (fol. 192r). The Rohan Master's work reveals his debt to the Giac Master, but his methods of painting flesh and modelling fabrics also demonstrate his attempt to match the achievements of the Madonna Master. The treatment of Christ's face (Fig. 11) follows that of the Madonna in the Church (Fig. 9) so closely that one wonders whether the Rohan Master succeeded in emulating the Madonna Masters' facial type or the two artists collaborated in the Last Judgement miniature. It may be tempting to view both of them as independent artists who made guest appearances, but their images are integral to the volume's structure. The stock motifs, assistants, painting materials, and techniques that they shared with the Giac Master demonstrate that all of them worked in immediate proximity and continuous contact. Unlike the mechanical execution often seen in workshop products or the uneven quality of manuscripts graced by the sporadic, guest appearance of celebrated masters, the Hours of Isabella Stuart has an almost organic feel of collaboration, reciprocal exchange, experimentation, and artistic growth. Fully integrated technical and art-historical analyses may bring us closer to understanding the artists' methods of work and collaboration in all of their masterpieces.

64. See note 23.

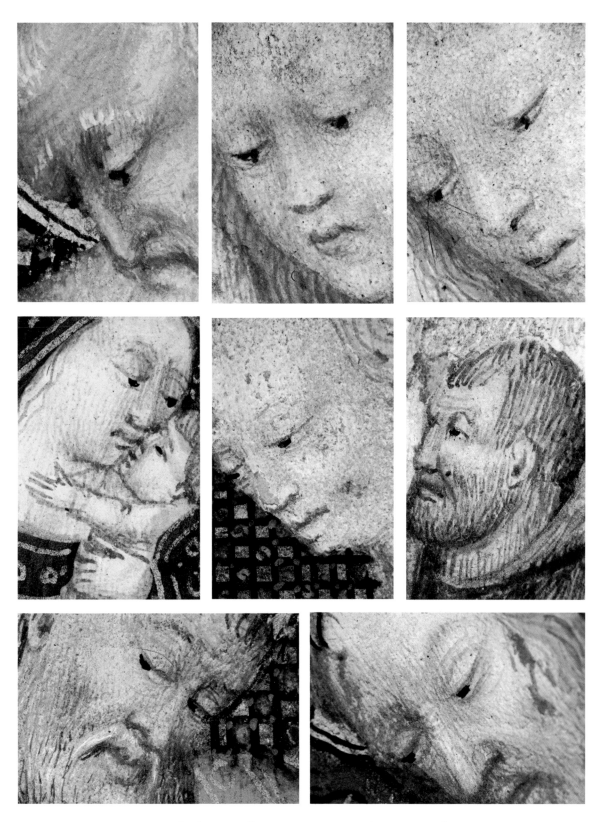

FIGURE 15. Cambridge, Fitzwilliam Museum, Ms. 62, photomicrographs (×16 magnification) of details from fols. 136ᵛ, 141ᵛ (*top row*), 86ʳ, 20ʳ, 134ʳ (*middle row*), 14ᵛ, 199ʳ (*bottom row*).

Appendix

THE QUIRE STRUCTURE OF THE HOURS OF ISABELLA STUART

with diagrams designed by Julia Hrischeva

THE MANUSCRIPT CONSISTS OF FIVE BUILDING BLOCKS:

I. Quire 1, fols. 1–12: Calendar.

II. Quires 2–3, fols. 13–28: Gospel Sequences, *Obsecro te, O intemerata, Omnis virtus.*

III. Quires 4–12, fols. 29–98: Hours of the Virgin.

IV. Quires 13–18, fols. 99–146: Penitential Psalms, Litany, Short Hours of the Cross, Hours of the Holy Spirit, Passion according to St. John, prayers to God, Five Joys of the Virgin.

V. Quires 19–29, fols. 147–232: Office of the Dead, Fifteen Joys of the Virgin, Seven Requests to our Lord, suffrages, prayers to the Trinity, prayer for oneself.

The Hours of Isabella Stuart
Fitzwilliam MS 62

Quire 1, fols. 1-12, Calendar

Calendar cycle

13 R St. John
14 V St. Luke
15
16 V St. Matthew

Quire 2, fols. 13-20, Gospel Sequences, *Obsecro te*

Pilgrimage of Jesus Christ cycle

17
18 V St. Mark
19
20 R Virgin and Child with donor and St. Catherine

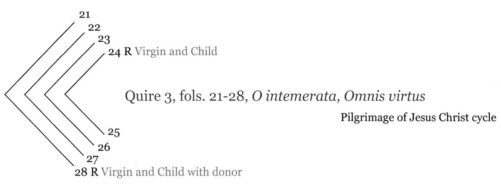

21
22
23
24 R Virgin and Child

Quire 3, fols. 21-28, *O intemerata, Omnis virtus*

Pilgrimage of Jesus Christ cycle

25
26
27
28 R Virgin and Child with donor

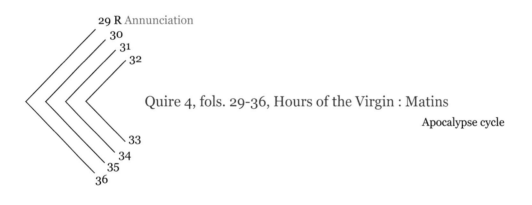

29 R Annunciation
30
31
32

Quire 4, fols. 29-36, Hours of the Virgin : Matins

Apocalypse cycle

33
34
35
36

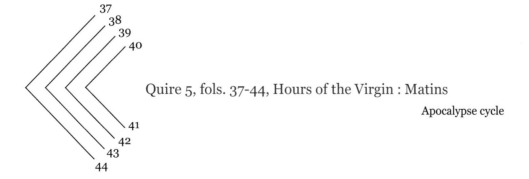

37
38
39
40

Quire 5, fols. 37-44, Hours of the Virgin : Matins

Apocalypse cycle

41
42
43
44

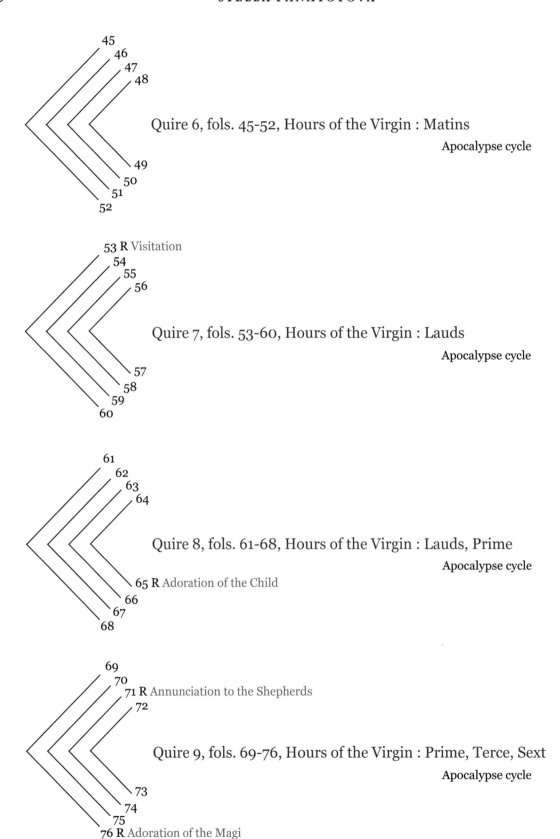

Quire 6, fols. 45-52, Hours of the Virgin : Matins

Apocalypse cycle

Quire 7, fols. 53-60, Hours of the Virgin : Lauds

Apocalypse cycle

Quire 8, fols. 61-68, Hours of the Virgin : Lauds, Prime

Apocalypse cycle

Quire 9, fols. 69-76, Hours of the Virgin : Prime, Terce, Sext

Apocalypse cycle

53 R Visitation

65 R Adoration of the Child

71 R Annunciation to the Shepherds

76 R Adoration of the Magi

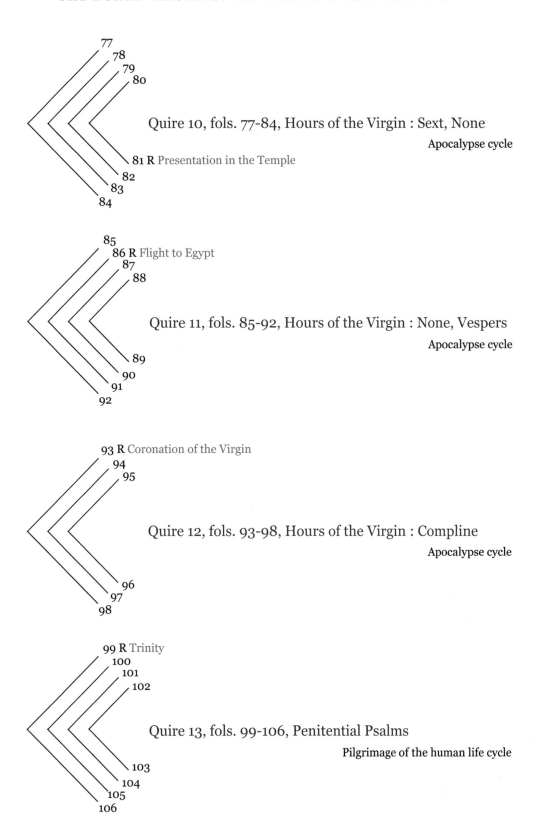

77
78
79
80

Quire 10, fols. 77-84, Hours of the Virgin : Sext, None

Apocalypse cycle

81 R Presentation in the Temple
82
83
84

85
86 R Flight to Egypt
87
88

Quire 11, fols. 85-92, Hours of the Virgin : None, Vespers

Apocalypse cycle

89
90
91
92

93 R Coronation of the Virgin
94
95

Quire 12, fols. 93-98, Hours of the Virgin : Compline

Apocalypse cycle

96
97
98

99 R Trinity
100
101
102

Quire 13, fols. 99-106, Penitential Psalms

Pilgrimage of the human life cycle

103
104
105
106

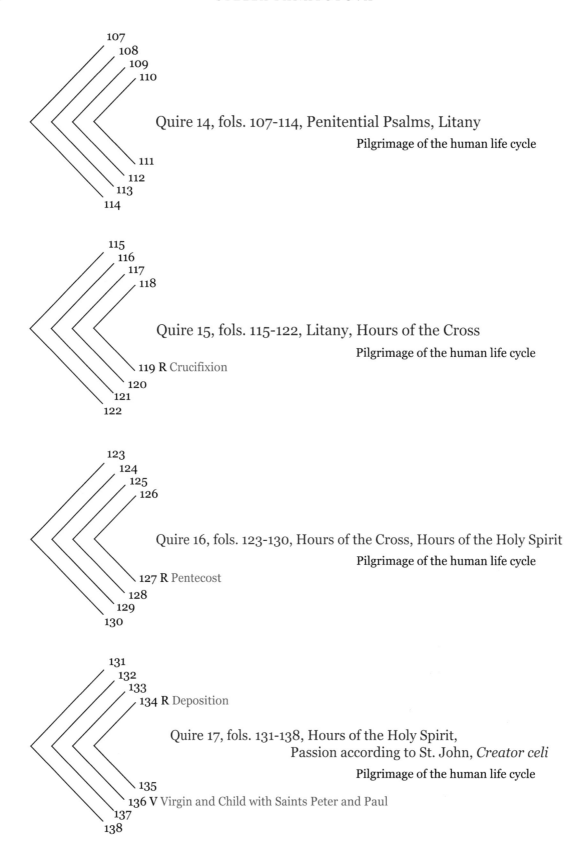

107
108
109
110

Quire 14, fols. 107-114, Penitential Psalms, Litany

Pilgrimage of the human life cycle

111
112
113
114

115
116
117
118

Quire 15, fols. 115-122, Litany, Hours of the Cross

Pilgrimage of the human life cycle

119 R Crucifixion
120
121
122

123
124
125
126

Quire 16, fols. 123-130, Hours of the Cross, Hours of the Holy Spirit

Pilgrimage of the human life cycle

127 R Pentecost
128
129
130

131
132
133
134 R Deposition

Quire 17, fols. 131-138, Hours of the Holy Spirit,
 Passion according to St. John, *Creator celi*

Pilgrimage of the human life cycle

135
136 V Virgin and Child with Saints Peter and Paul
137
138

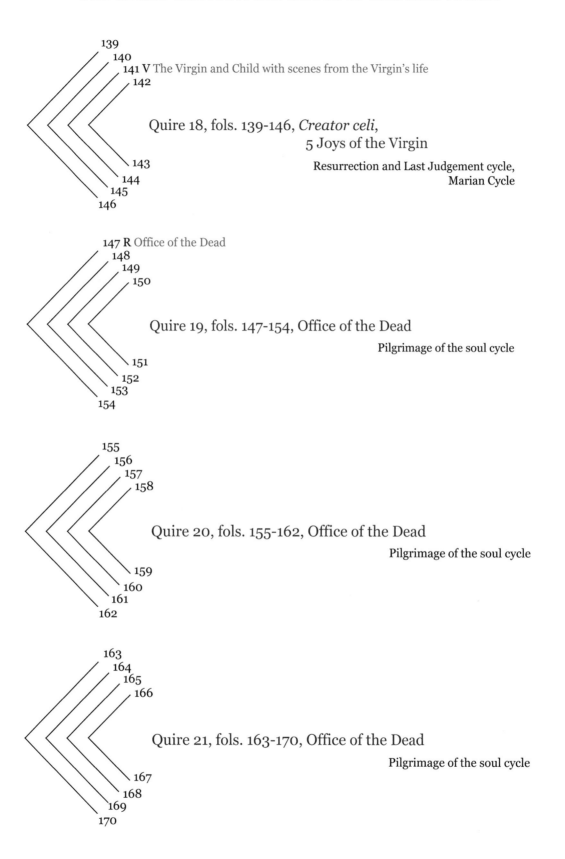

139
140
141 **V** The Virgin and Child with scenes from the Virgin's life
142

Quire 18, fols. 139-146, *Creator celi*,
5 Joys of the Virgin

Resurrection and Last Judgement cycle,
Marian Cycle

143
144
145
146

147 **R** Office of the Dead
148
149
150

Quire 19, fols. 147-154, Office of the Dead

Pilgrimage of the soul cycle

151
152
153
154

155
156
157
158

Quire 20, fols. 155-162, Office of the Dead

Pilgrimage of the soul cycle

159
160
161
162

163
164
165
166

Quire 21, fols. 163-170, Office of the Dead

Pilgrimage of the soul cycle

167
168
169
170

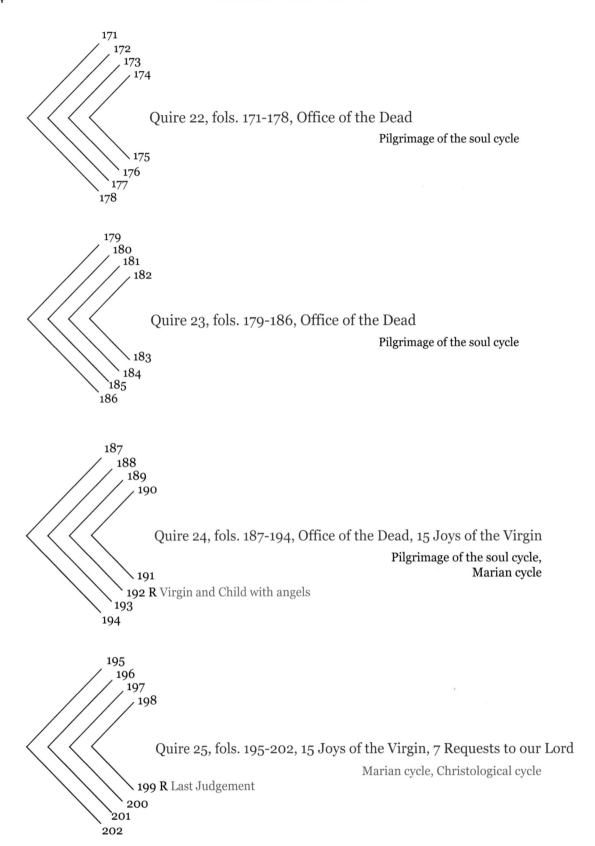

171
172
173
174

Quire 22, fols. 171-178, Office of the Dead

Pilgrimage of the soul cycle

175
176
177
178

179
180
181
182

Quire 23, fols. 179-186, Office of the Dead

Pilgrimage of the soul cycle

183
184
185
186

187
188
189
190

Quire 24, fols. 187-194, Office of the Dead, 15 Joys of the Virgin

Pilgrimage of the soul cycle,
Marian cycle

191
192 R Virgin and Child with angels
193
194

195
196
197
198

Quire 25, fols. 195-202, 15 Joys of the Virgin, 7 Requests to our Lord

Marian cycle, Christological cycle

199 R Last Judgement
200
201
202

Quire 26, fols. 203-210, 7 Requests to our Lord, Suffrages

Christological cycle, Suffrages cycle

203

204 V Trinity
205 R Virgin and Child

206 R St. Michael

207 R St. John the Baptist
207 V St. Peter
208 R St. Paul
208 V St. John
209 R St. James
209 V St. Andrew
210 R St. Stephen

Quire 27, fols. 211-218, Suffrages

Suffrages cycle

211 R St. Lawrence
211 V St. Christopher

212 V St. Denis
213 R Holy Innocents
213 V St. Martin

214 V St. Nicholas

215 R St. Eligius
215 V St. Catherine

216 V St. Margaret
217 R *Noli me tangere*

218 R All Saints

Quire 28, fols. 219-226, Suffrages Suffrages cycle

219 R St. Sebastian
219 V St. Louis of Toulouse

220 V St. Louis IX
221 R St. Anthony

222 R St. Anthony
222 V Saints Mary Jacobi and Mary Salome

223 V St. Mary of Egypt
224 R St. Elizabeth of Hungary
224 V St. Radegund

225 V St. Radegund

226 V St. Radegund

Quire 29, fols. 227-232, Prayers Creation, Trinitarian and Christological cycle, Donor's image

227 R Creation

228 R Baptism of Christ
228 V Pentecost
229 R Transfiguration

230 R Christ appearing to Apostles after Resurrection
230 V Christ - Judge extending hand to donor in margin
231 R Resurrected Christ extending hand to donor in facing margin
232

ELIZABETH J. MOODEY

Variations on Grisaille in a Newly Acquired Prayerbook
(Princeton Ms. 223)

The Uses of Grisaille

A GROUP of grisaille miniatures from the Northern Netherlands, usually blank on the back and inserted, seem to have been made to add to Books of Hours, and they are noticeably repetitive. These so-called Delft grisailles, which are dated c. 1440–1460, have earned a reputation for expediency and thrift. Ink wash is undeniably cheaper than bright pigment, but these grey miniatures often include touches of color and gold;[1] to further complicate the picture, miniatures in the group executed in silverpoint are noticeably finer in execution,[2] suggesting that we may need to uncouple the palette from the medium.[3] The question of economy inevitably comes up when we look at grisaille manuscripts, despite the fact that grisaille debuted at the highest level of patronage.

The Hours of Jeanne d'Evreux is probably the most celebrated of an early fourteenth-century Parisian group of grisailles, though it was not quite the first.[4]

There is no gold or silver in the manuscript.[5] Abigail Quandt has estimated that, although the grey tones that dominate the pages were created simply with dilute ink,[6] which is cheap enough, the palette of the miniatures was hardly limited. Jean Pucelle used as many as twenty-two shades, some mixed and some pure, including the costly pigment lapis lazuli.[7] Certainly a manuscript, however small, made for the Queen of France is not likely to be driven primarily by the need to save money. Speed and ease of execution by a single artist is a more likely motivation in this case. Since the manuscript was described in an inventory of 1402 as 'Item, unes Petites Heures de Nostre Dame, nommées les Heures de Pucelle, enluminées de blanc et de noir, à l'usaige des Prescheurs,'[8] it has been suggested that the palette reflects the black cloak and white habit of the Dominican Order.[9] Michaela Krieger's idea that the technique referred to expensive media like ivory carving, that it 'indicated luxury,'[10] would certainly help explain its popularity, especially considering its

1. M. O. Renger, 'The Netherlandish Grisaille Miniatures: Some Unexplored Aspects,' *Wallraf-Richartz-Jahrbuch* 44 (1983), 145–73, esp. 146.

2. For example, in *Christ as Man of Sorrows*, Loftie Hours, N. Netherlands, mid-15th c. (Baltimore, Walters Art Museum, Ms. w. 165, fol. 79ᵛ).

3. L. M. J. Delaisse noticed a difference in quality between Delft-style grisaille miniatures in gouache and those in silverpoint; see *A Century of Dutch Manuscript Illumination*, California Studies in the History of Art, 6 (Berkeley, Calif., 1968), 30.

4. Barbara Boehm, 'Hallmarks of the Manuscript,' *Stundenbuch der Jeanne d'Evreux*, Commentary volume (Munich, 2000), notes that several manuscripts with a similar palette were produced earlier: *La Vie de S. Denis* of 1317 (Paris, BnF, Ms. fr. 2090-2), another copy of same text (Paris, BnF, Ms. lat. 5286), and *Le Roman de Fauvel* of 1315–20 (Paris, BnF, Ms. fr. 146); 332–3. See also I. Villela-Petit, 'Historié de blanc et de noir: la tradition du "portrait d'encre" dans l'enluminure parisienne des XIVᵉ et XVᵉ siècles,' in M. Boudon-Machuel *et al.*, *Aux limites de la couleur: monochromie & polychromie dans les arts (1300–1650). Actes du colloque international organisé par l'INHA et par le Centre d'Études*

Supérieures de la Renaissance les 12 et 13 juin 2009, *Études renaissantes* (Turnhout, 2011), 25–34.

5. B. Boehm, 'Hallmarks of the Manuscript' (as in note 4), 330.

6. A. Quandt, 'Technical Aspects of the Hours of Jeanne d'Evreux,' *Stundenbuch der Jeanne d'Evreux*, Commentary volume (Munich, 2000), 148.

7. A. Quandt, 'Technical Aspects of the Hours of Jeanne d'Evreux' (as in note 6), 143, 148.

8. This is the item in Jean de Berry's will, reproduced in J. Guiffrey, *Inventaires de Jean, duc de Berry (1401–1416)* (Paris, 1894), 1: 223, no. 850; cited in K. Morand, 'Jean Pucelle: A Re-examination of the Evidence,' *The Burlington Magazine* 103/699 (1961), 206–11, esp. 207.

9. B. Boehm, 'Hallmarks of the Manuscript' (as in note 4), 330, n. 42. She suggests that this 'blanc et noir,' as the technique is referred to in the document, may be associated with Dominicans the way *verre eglomisé* was with Franciscan patrons in the 14th and 15th centuries.

10. *Grisaille als Metapher. Zum Entstehen der Peinture en Camaieu im frühen 14. Jahrhundert. Wiener kunstgeschichtliche Forschungen. Herausgegeben vom kunsthistorischen Institut der Universität*

adoption by an elite clientele. So we may be dealing with a technique that imitates luxury media while evoking mendicant asceticism, that gains cachet from royal patronage but is actually cheaper than standard full-color—this should not be inconceivable to a culture that has paid more for artificially distressed jeans than new ones. Parisian artists produced a spate of grisaille and semi-grisaille manuscripts after the Hours of Jeanne d'Evreux, though the technique seems to have fallen off in popularity after about 1415. When it reemerges *c.* 1450–1480, it is in the Burgundian Netherlands, spurred by the patronage of Philip the Good, and probably driven at least as much by cachet as by economy. I think that is the case with the new semi-grisaille prayerbook in Princeton's manuscript collection, which we shall meet after I have had a chance to lay out the ways Philip's manuscripts use grisaille and the variations on grisaille that were preferred by subsequent court patrons.

Grisaille's resurgence in popularity began in the 1450s. The grisaille palette in the Prayerbook made for Philip and now in The Hague (*c.* 1450–1460)[11] and the other grisaille works in his library may have been inspired by admiration for French royal commissions like the Hours of Jeanne d'Evreux, which was owned by Philip's great-uncle and fellow bibliophile, Jean de Berry, or by examples of grisaille from Paris *c.* 1400 that he himself owned.[12] Some of the grisaille manuscripts in Philip's library by the Bruges illuminator Willem Vrelant and assistants expand on the monochromatic greys used in the duke's Prayerbook in The Hague. Here the grisaille is relieved by gold accents and a strong, flat blue sky set with silver-lit clouds that must have created a wonderfully luxurious effect before the silver oxidized. This was the choice for the duke's copies of *La Vie de Saint Catherine*[13] (Fig. 1) and *La Première guerre punique*.[14] Within that variation on grisaille, however, the manuscripts' coloration is consistent.

The two copies of the *Miracles de Notre-Dame*[15] made for Philip the Good had a more restricted grisaille palette, like his Prayerbook in The Hague. Nancy Turner and Karen Trentelman report that the miniature on an excised leaf from the second Paris copy of the *Miracles de Notre-Dame*[16] (Fig. 2), recently acquired by the Getty, was painted with only ink (presumably carbon black), thinned with water, and white-lead highlights. Which brings up the question that has often been raised about the group of Delft grisailles, namely, of grey as an economical choice. Were they executed in a reduced palette to avoid buying more expensive pigments? As an indirect answer, I would suggest we look at another grisaille manuscript project for Philip, the two-volume Charlemagne Chronicle[17] of about the same time, *c.* 1458–1460, with miniatures by Jean le Tavernier and assistants. There are very slight variations in the shade of grey used during the course of the illustration of the work's two oversized volumes. The tone is grey-beige in the first volume (Ms. 9066), but the second volume includes miniatures in a grey tinted with blue

Wien, vol. 6 (Vienna, 1995), 157; quoted by Boehm, 'Hallmarks of the Manuscript' (as in note 4), 335.

11. Prayerbook of Philip the Good (The Hague, Koninklijke Bibliotheek, Ms. 76 F 2), with additions *c.* 1500.

12. *Jan van Eyck Grisallas* (Madrid, 2009), 302. Pierre Cockshaw, remarking that the Parisian grisailles tend to be more linear than the more softly painted single leaves from the Northern Netherlands, has suggested that the latter inspired the grisaille manuscripts at the Burgundian court; *Miniatures en grisaille* (Brussels, 1986), iv.

13. Written by Jean Miélot in 1457 and now in Paris (BnF, Ms. fr. 6449).

14. This is Jean Lebègue's French translation of Leonardo Bruni's text, now in Brussels (Bibliothèque royale, Ms. 10777), which has no marks of Philip's ownership but was among the books catalogued after his death in 1467. The miniatures were provided by Vrelant and an associate with a similar style who also worked on the Morgan-Mâcon *Legende dorée* (*Miniatures flamandes 1404–1482* [Paris; Brussels, 2011], 248), a Vrelant production discussed below.

15. These are Paris, BnF, Ms. fr. 9198 and its companion volume, now in Oxford (Bodleian, Ms. Douce 374), both with miniatures showing Philip presented to the Virgin and Child, and Paris, BnF, Ms. fr. 9199, which has illustrations copied from the Oxford manuscript. Since one pair of volumes was bound in black and one in white, Hanno Wijsman has proposed that they were made for Philip the Good and his wife Isabella of Portugal; *Luxury Bound: Illustrated Manuscript Production and Noble and Princely Book Ownership in the Burgundian Netherlands (1400–1550)*, Burgundica 16 (Turnhout, 2010), 163, 248.

16. BnF, Ms. fr. 9199. In a talk for KIK-IRPA, Brussels, June 2014.

17. *Les cronicques et conquestes de Charlemaine*, Brussels, Bibliothèque royale, Ms. 9066-8.

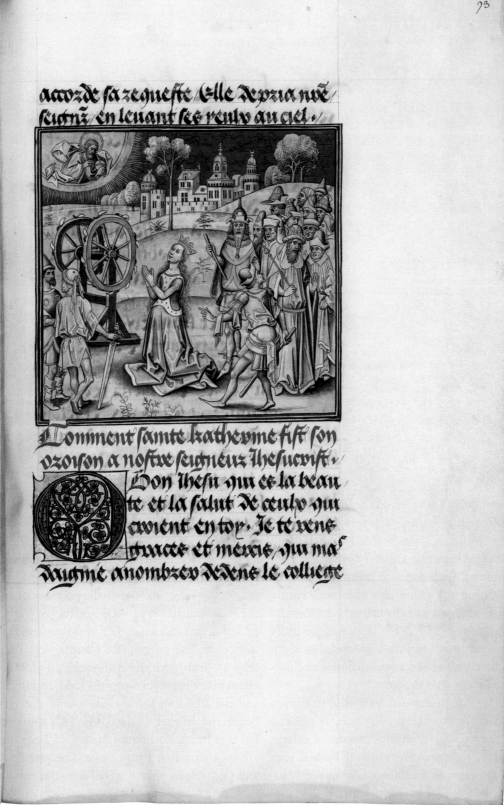

FIGURE 1. Martyrdom of St. Catherine, *Vie de Sainte Catherine*. Paris, BnF, Ms. fr. 6449, fol. 93 (Bibliothèque nationale de France).

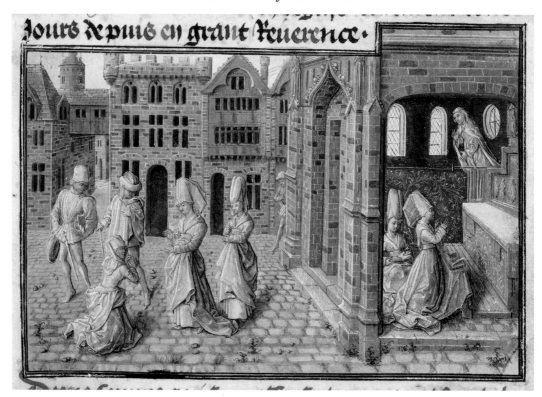

FIGURE 2. Miracle of the Adulterous Woman's Repentance, *Miracles de Notre-Dame, Ghent, c.* 1460. Los Angeles, The J. Paul Getty Museum, Ms. 103 (courtesy of the Getty's Open Content Program).

or olive. These are not discrete additions alongside the grey (the scheme followed in Vrelant's *Vie de Sainte Catherine*, for example), but tints to the grey itself, and it is used consistently within each miniature in the second volume, which is now divided (Mss. 9067 and 9068). We need to remember that a commission for two large volumes, with pages approximately 11 by 16 inches, featuring 105 miniatures and lavish empty borders, does not suggest that the patron is economizing. Nor is the use of gold in the later volume likely motivated by thrift, not when the artists piled as much shell gold on details of armor, swords, shields, and harnesses as the horses could support.[18]

Another large-format manuscript in Philip's library uses grisaille differently—uses it selectively, for didactic effect. Instead of a relatively consistent reduced palette, which is what we have seen previously in Philip's grey manuscripts, the copy of the *Miroir de l'humaine salva-*

tion now in Chicago[19] combines a modified grisaille with full color. This copy was made for the duke after *c.* 1455. Each opening presents the reader with three events, usually from the Old Testament, and less commonly from ancient history, that prefigure an event in the New Testament. The greater importance of each New Testament scene, which is positioned at the far left on the verso, and hence the primacy of the first of the four miniatures in each opening, is indicated by a gilded initial and a panel of acanthus and rinceaux in full color. The opening of Chapter VII, for example (Fig. 3), deals with the Annunciation and three complementary episodes from the Old Testament: Moses and the Burning Bush, Gideon and the Fleece, Rebecca and Eliezer at the Well. The Annunciation at left is in full color, but the three Old Testament scenes are in a variation on grisaille. The stories of Moses and Gideon, of course, detail miracles in which God

18. In the miniature of Charlemagne crossing the Rhine, for example (Ms. 9068, fol. 183).

19. Newberry Library, Ms. 40. I am indebted to James Marrow for bringing this manuscript to my attention.

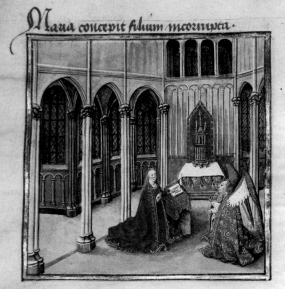

Maria concepit filium incorrupta.

Dñe apparuit moyst in rubo ardenti et incobusto

Luce primo

Exodi iij. ca.

buiant tant saintement q ce nest pas a dire
Car de plus en plus elle desiroit de tout son
auer vie solitaire et contemplatiue. et en despi
tant les soulas de ce monde. elle se desiroit
es choses dunnes ? celestielles Et de ce beau
mystere de la acception Ihuxprist dist psaue...

Vellus gedeonis repletu e rore cu sicca maneret

Judicum. vj. ca.

...enem somme apres sa mort enmenast des
infernaulx gouffres du limbe plain de tene
bres les attendans sa resurrection et les em
...

Genes. xxiiij. ca.

ceste deuote ? prousfitable acception quantes
? quelles loenges seront proferees de nos bou
ches en remerciant dieu de ce signe. Amon...

FIGURE 3. Annunciation, *Miroir de l'humaine salvation, after c.* 1455. Chicago, Newberry Library, Ms. 40, fols. 7ᵛ–8, detail (courtesy of James H. Marrow).

suspends the laws of Nature; Eliezer's story is that of a servant sent, like the angel Gabriel, to find a suitable virgin bride for his master's son. The scheme accomplishes several things. It makes a clear typological distinction between the primary, New Testament subject and the lesser events that the author uses to amplify its importance in sacred history. But grisaille also artfully reinforces the Christian point of view of the Old Testament as a veiled or incomplete truth. The three Old Testament miniatures are in a variation on grisaille, in which Moses and God, for example, who have pale grey flesh and wear shades of grey and ivory, stand in a ghostly landscape with ivory trees. The strongest color is the same vivid blue we saw in Philip's *Vie de sainte Catherine*. In general, the manuscript's palette is inconsistent, but logically so. Grisaille is used in contrast to color, to make a point.

After Philip's death in 1467, we see more manuscripts in what might be called semi-grisaille, many commissioned by members of the court, or for members of his chivalric order, the Order of the Golden Fleece. A copy of the *Histoire ancienne jusqu'a Cesar* of c. 1460, now in the Morgan Library,[20] was made for Jean V de Créquy, one of the founding members of the Order.[21] Like the Old Testament miniatures in Philip's *Miroir*, these are barely grisaille; the only grey elements are the figures of God and Adam and Eve. A copy of Denis the Carthusian's *Traité des quatre dernières choses* with semi-grisaille miniatures, now in Brussels,[22] was made for Charles de Croÿ in the 1470s. The opening miniature is a landscape with medium-blue sky, grey figures and a slightly subdued border of blue, gold, and black to accompany the semi-grisaille, a combination that shows up frequently in the later fifteenth century. A Book of Hours in semi-grisaille for Claude de Toulongeon, who became a member of the Order in 1481, was made in Bruges in the 1480s.[23] The grisaille ten-

dency is almost indiscernible here except for the cool, dark palette of the borders, which are painted in black and gold acanthus with blue flowers. What we seem to have so far is a range of commitments to grey. They run from an almost ascetic palette in commissions for Philip himself (*Les Miracles de Nostre-Dame*) to a full-color landscape with three small grey-complected figures, as in Jean de Crequy's *Histoire ancienne*, each, as far as I can tell, consistent within the chosen palette. Bodo Brinkmann's study of late fifteenth-century Bruges Books of Hours identified a group of small manuscript Hours, and noted that none of them employed the kind of 'pure' grisaille that Jean le Tavernier had used for Philip the Good, but instead preferred a semi-grisaille.[24] This trend toward a less strict form of grisaille mirrors the developments in the palette of monochrome altarpiece wings that we see in the later fifteenth century.

What about the mixed manuscripts, full color plus grisaille, like the *Miroir* in Chicago? I think these may be the key. I am convinced there is meaning to grisaille when it is presented in opposition to full color, for several reasons.[25] The strongest is an established convention of painting the exterior of altarpiece wings in grisaille. This phenomenon is a familiar one in the Southern Low Countries. Grisaille wings are first seen, as far as we know, in Robert Campin's Prado panel of c. 1420, where they bear the likenesses of Sts. James and Clare as simulated free-standing statues in beveled niches, and, on the reverse, the *Betrothal of the Virgin* painted in full color. With a few variations—a bit of carnation for the faces, license for the figures to step off their pedestals, a warmer brown tint to the grey—the practice of equipping altarpieces with wings painted in dull-colored monochrome persisted into the sixteenth century. Grisaille changes: when the altarpiece conventions that seem to spring fully formed c. 1420 with

20. In the scene of Creation, for example (New York, Morgan Library, Ms. M. 212-3, fol. 1).

21. For the Order and brief biographies of the members, see R. De Smedt, ed., *Les chevaliers de l'Ordre de la Toison d'or au XVᵉ siècle*. 2nd ed., *Kieler Werkstücke, Reihe D: Beiträge zur europäischen Geschichte 3* (Frankfurt am Main, 2000).

22. Bibliothèque royale, Ms. 9048, fol. 90, dating from the 1470s. Charles I de Croÿ became a member of the Order of the Golden Fleece in 1491.

23. Sotheby's, London, sale of 17 June 2003, lot 30.

24. *Die flämische Buchmalerei am Ende des Burgunderreichs: der Meister des Dresdener Gebetbuchs und die Miniaturisten seiner Zeit.* 2 vols. (Turnhout, 1997), 1: 59, 62.

25. *The Wizard of Oz* (1939), the most obvious instance in popular culture, for example, uses the distinction between sepia-toned Kansas and the glorious Technicolor world of Oz to great effect.

Campin's Prado panel give way to semi-grisaille and monochromatic painting, does that affect our interpretation? I think we have to assume that the placement of the panels, covering the sculpture or fully colored painting within, indicates that the variations on the exterior do not affect the palette's original purpose. Here I agree with Molly Teasdale-Smith, who believed that they were an accommodation for a liturgical convention.[26] She noticed that altarpieces and sculptures were often fitted with shutters that wrapped around to conceal a sculpted image, citing an instance of the practice depicted in a miniature of the celebration of Mass in a Ghent-Bruges Book of Hours in the British Library.[27] She also noticed evidence of a ritual current during the Lenten season of penitence and self-denial. That is, images were covered during Lent, as if the church were in mourning.[28] She proposed that this choice of a subdued, ashen palette on exterior wings of altarpieces accommodated restrictions on the display of images during Lent. Her proposal takes both the palette, the color of ashes and hence of mourning, and the location of these concealing altarpiece panels as meaningful liturgical choices. It even has the advantage of explaining the preponderance of grisaille Annunciation scenes on these exteriors. Since the feast takes place on 25 March, it usually falls during Lent. Her explanation has been dismissed because we have instances of grey used for something other than Lent, and Lenten decorations in something other than grey, but that may be peremptory. I am not suggesting that the manuscripts we have been looking at were painted in grey in deference to Lent. I bring in the grisaille wings of altarpieces to suggest the complexity of possibilities that emerge when we think about a reduced palette. Whether it was chosen to suggest a distant age or a devotional attitude, or simply to save money, grisaille painting is deliberately artificial. It translates a world that has been sailing along in full color into shades of grey. Black and white photography has done us a disservice in leading us to assume that the translation of reality to a reduced palette is an easy or automatic process, and it may have made us underestimate how much of a conscious choice (let alone a difficult technique) grisaille painting is.

The Prayerbook and its Owner

The prayerbook that Princeton acquired this spring is illustrated in semi-grisaille. I shall discuss only a few of the eleven miniatures now, and then return to argue for their connection to another manuscript, and I shall discuss the reason for the choice of semi-grisaille in relation to the owner. The manuscript was made for a woman, who is shown kneeling in the margin as if regarding one of the miniatures. A prayer to God as sovereign and eternal power[29] has the petitioner identifying herself as unworthy using the feminine form for 'sinner': *je soie tresgrande et detestable pecheresse devant ta digne face.* The manuscript begins with an image of the *Volto Santo of Lucca*, a wooden crucifix miraculously completed by an angel who supplied the face of Christ while the sculptor slept, and a prayer linked to its veneration, the *Ecce agnus Dei* (Fig. 4). Although the manuscript is not a Book of Hours, it does echo the general sequence of texts found in a typical example. After two gospel sequences, John (preceded by a miniature of *John on Patmos*) and Luke (preceded by the *Annunciation*), a long rubric introduces a man named Regnault,[30] who was visited by the Virgin. His story provides the background for the text that follows, the *Missus est angelus Gabriel*,[31] known as the Saturday Prayer. The rubric informs us that those who learn the prayer and recite it every Saturday are guaranteed a vision of the Virgin as she was during five key moments in her life, before the supplicant dies. Regnault is instructed to teach it to as

26. Molly Teasdale Smith, 'The Use of Grisaille as a Lenten Observance,' *Marsyas* 8 (1957–9): 43–54.

27. Book of Hours, *Mass, c.* 1510 (London, British Library, Add. Ms. 35313, fol. 40).

28. Book of Hours, *A Church during Lent, c.* 1492 (London, British Library, Add. Ms. 25698, fol. 9).

29. *O souverainne et et* [sic] *eternelle puissance.* The 'pecheresse' is mentioned on fol. 126.

30. Princeton University Library, Princeton Ms. 223, fols. 12–14. A longer version of the story is told of a certain Ernoul rather than Regnault, but the prayer that follows and the promise of visions is the same. For the prayer and rubric, see V. Leroquais, *Les livres d'heures manuscrits de la Bibliothèque nationale* (Paris, [Mâcon], 1927), II: 88–9.

31. Princeton University Library, Princeton Ms. 223, fol. 14.

FIGURE 4. *Volto Santo, Prayerbook.* Princeton, Princeton University Library, Princeton Ms. 223, fol. 1 (courtesy of Princeton University Library).

many people as he can. Hymns and prayers associated with the events in the life of the Virgin and Christ follow, so that the miniatures that accompany them are in roughly chronological order. We follow their story through the miniatures: *Nativity*,[32] *Crucifixion* (Fig. 5), *Resurrection*,[33] and *Ascension*.[34] The narrative sequence is interrupted by a prayer with the rubric 'Pour le sacrement,' identifying the *Pange lingua gloriosi corporis*, which is accompanied by a miniature of a Corpus Christi procession (Fig. 6). This is the page with the owner's image in the margin. A prayer to John the Baptist follows (preceded by a miniature of the saint),[35] then hymns for the Assumption[36] and the Virgin and All Saints,[37] both with miniatures, followed by suffrages beginning with St. Michael and honoring a total of fourteen male and then four female saints. The last prayers, except for one to a guardian angel, focus on the preparation for and thanks after receiving the Eucharist, beginning with Confession.[38] The last of these Eucharistic prayers, *O souverainne et eternelle puissance*, the one that speaks of the supplicant as a detestable sinner, is introduced with the rubric *Orison quant on veult aler a la table n(ost)resein(neu)r*. The last page bears a note in a sixteenth-century hand about (and possibly by) Étienne de Montmirel, identified here as counsellor to the king in the Parlement of Paris.[39] De Montmirel (d. 1549)[40] is named by that title in a document of 1514 (1515 n.s.) when he accompanied François I on his entry into Paris as one of four *Généraux de la Justice*,[41] again in 1539,[42] and again in 1547.[43] Magistrate and eventually *maître des requêtes*, he

was also provost of the merchants of Paris in 1540.[44] There is unfortunately no evidence of a connection beyond this note, though it is tempting to think he was in the original owner's family.

What can we conclude about the owner, judging from the book? Based on the gendered noun in one of the prayers, we can assume that the book was made for a woman, and her kneeling portrait on the Corpus Christi page (Fig. 6) confirms that. Based on the prominence of the *Volto Santo*, she is likely to be Italian and from the region around Lucca. Based on the fact that there are four suffrages to female saints and half of them are to saints named Catherine, the very common St. Catherine of Alexandria and the less common St. Catherine of Siena, I suspect that her name is a version of Catherine, possibly Catarina. The other two female saints are St. Margaret of Antioch, who is a very common choice, especially for women book owners, and St. Geneviève, whose inclusion especially in a mere list of four suggests a woman with ties to Paris.

The presence of St. Geneviève, and the fact that the rubrics and several prayers in the Princeton Prayerbook are in French, despite the clear devotion to a famous and famously Lucchese icon, does not rule out an Italian owner. One of the most elaborate manuscripts of the *Volto Santo* legend was commissioned by the Rapondi brothers, merchant-bankers originally from Lucca, and it is in French.[45] The Vatican manuscript of the *Légende du Saint-Voult* shows two men, presumably Guglielmo and Dino, identified by their coats of arms as Rapondi and kneeling on either side of the

32. fol. 32. 33. fol. 68. 34. fol. 72.

35. fol. 81ᵛ. 36. fol. 86ᵛ. 37. fol. 89ᵛ.

38. *Per sanctorum omnium angeloru(m) et archangelorum* (fol. 113), introduced with the rubric, 'Devote oroison a dire quant on se veult confesser' (fol. 113).

39. 'Etienne de Montmirel conseillier du roy n(ost)re s(eigneur) en sa court de p(ar)lement a paris,' (fol. 131). I thank Don C. Skemer for taking the photograph under ultraviolet light and for generously sharing his study photographs of the manuscript.

40. F. Blanchard, *Les présidens au mortier du parlement de Paris, leurs emplois, charges, qualitez, armes, blasons et genealogies, depuis l'an 1331 jusques à present*, vol. 2, Catalogue de tous les conseillers du Parlement de Paris, depuis l'an mil deux cens soixante jusques à present (Paris, 1647), 49.

41. A. A. Auger, *Traité sur les tailles et les tribunaux qui connoissent de cette imposition* (Paris, 1788), 241–2.

42. A document in the *Actes* of François Iᵉʳ names him (Noyon, 9 March 1539) as 'conseiller au Parlement de Paris'; no. 11420 of the *Collection des ordonnances des rois de France: 7 mai 1539–30 décembre 1545*, vol. IV (1890), 91.

43. In October 1547, he is one of the king's counselors; *Recherches sur l'organization du Parlement de Paris au XVIᵉ siècle, 1515-89*, 30, n. 1.

44. R. Descimon, 'Élites parisiennes entre XVᵉ et XVIIIᵉ siècle: du bon usage du Cabinet des titres,' *Bibliothèque de l'ecole des chartes* 155/2 (1997), 607–44, esp. 627.

45. For the *Légende du Saint-Voult*, Paris, c. 1400 (Vatican City, Biblioteca Apostolica Vaticana, Ms. Pal. lat. 1988), see H. Maddocks, 'The Rapondi, the Volto santo di Lucca, and Manuscript Illumination in Paris ca. 1400,' in: G. Croenen, P. Ainsworth, eds., *Patrons, Authors and Workshops: Books and Book Production in Paris around 1400* (Louvain; Paris; Dudley, Mass., 2006): 91–122.

FIGURE 5. Crucifixion, Prayerbook. Princeton, Princeton University Library,
Princeton Ms. 223, fol. 36 (courtesy of Princeton University Library).

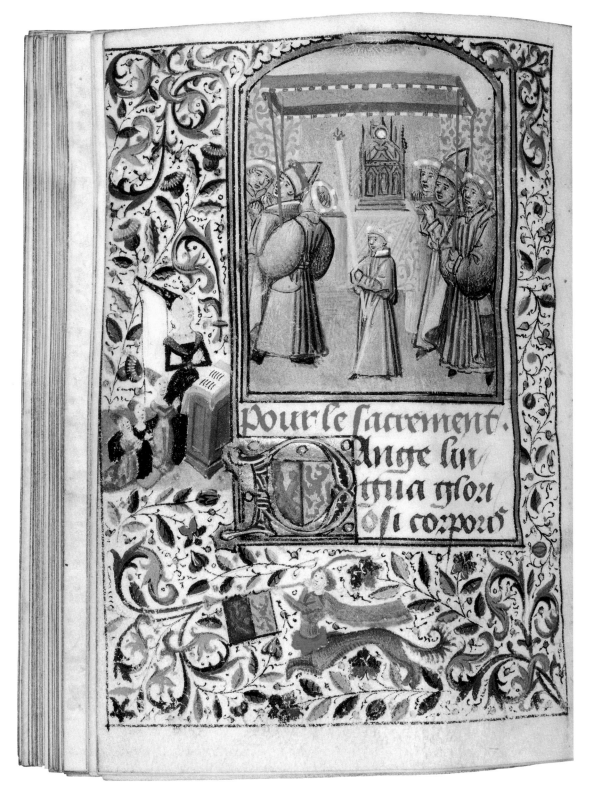

FIGURE 6. Corpus Christi Procession, Prayerbook. Princeton, Princeton University Library, Princeton Ms. 223, fol. 78ᵛ (courtesy of Princeton University Library).

renowned crucifix.[46] Beneath them an inscription asks for the prayers of 'vous qui cestui livre lisiez.' Dino Rapondi was a trusted advisor to Philip the Bold and John the Fearless, Philip the Good's grandfather and father respectively, and the Ra9ondi had operations in Paris and Bruges, where Lucchese devotees of the miraculous sculpture had founded *Volto Santo* branch chapels. In Bruges, the center of Lucchese spiritual life was their dedicated pew and the chapel of the *Volto Santo* in the church of the Augustinian canons regular.[47] The statutes of the Lucchese confraternities in Antwerp and Bruges, written in 1478, show the community's strong identification with the *Volto Santo*.[48]

The coat of arms[49] on the page with the Corpus Christi procession, like the opening miniature of the *Volto Santo*, supports an owner from the region of Lucca. Since the arms are impaled, we can assume that the book was made for a married woman. The dexter half, her husband's (*argent, two lion's paws in saltire azure*), belongs to the branch of the Ammannati banking family from Pescia and Pistoia,[50] cities respectively eleven and twenty-two miles from Lucca and hence from the *Volto Santo*. In 1370, a 'Nicolay Amenati' is listed among the six customers who had a balance of over forty pounds groat in the accounts of Guillaume Ruyelle, a Bruges money-changer,[51] which suggests Niccolò Ammannati was a man of substance. He figures in the accounts of Collard de Marke, one of Ruyelle's competitors,[52] alongside Willaume Raipondi (Guglielmo Rapondi, Dino's brother). The sinister half (*a lion rampant gules*), a very common he-

raldic design, has so far resisted identification.[53] Since the lady kneeling before the Host as it passes in the Corpus Christi procession has three children alongside her, but a husband is nowhere depicted, I suspect she is the manuscript's sole owner.[54]

Despite these indications that the woman in the border had ties to Lucca, she is dressed in fashions more characteristic of France or Flanders. Her dress, necklace, and headdress are comparable to those worn by a wealthy Florentine expatriate, Maria Maddalena Baroncelli (1456–?), in her portrait by Hans Memling (Fig. 7). The portraits depicting Maria and her husband, Tommaso Portinari, originally formed the wings to a triptych featuring the Virgin and Child.[55] Tommaso was the Medici bank's representative in Bruges, and the triptych now in the Metropolitan Museum is thought to have been painted in honor of the couple's marriage in 1470. Like Maria Portinari, our unknown owner wears a long, narrow-sleeved, high-waisted black gown, tightly belted. Both ladies' gowns are trimmed with fur collars that flare out to just beyond the shoulders and descend in a loose curve to a wide belt, leaving a triangle of black partlet exposed. The narrow cuffs and broad, flaring collars are made of short-haired fur. Maria's is made of the white not-quite-ermine known as lettice,[56] and the unknown lady's is brown. Maria also wears a black velvet band, a frontlet, that drapes over the top of her head and falls to her shoulders. Each lady wears a black steeple headdress with a loop at the front and a fine, transparent, white veil, a fashion popular in France and Burgundy but much less commonly

46. Vatican City, Biblioteca Apostolica Vaticana, Ms. Pal. lat. 1988, fol. 1ᵛ.

47. R. de Roover, *Money, Banking and Credit in Medi-aeval Bruges; Italian Merchant Bankers, Lombards and Money-changers* (Cambridge, Mass., 1948), 19.

48. E. Lazzareschi, 'Gli statuti dei Lucchesi a Bruges e ad Anversa,' in: *Ad Alessandro Luzio: Miscellanea di studi storici*, vol. 2 (Florence, 1933), 75–88, esp. 81–2, 87.

49. *Argent, two lion's paws in saltire azure, impaling or, a lion rampant gules.* I am grateful to Christiane Van den Bergen-Pantens, who identified the figure on the dexter side.

50. The Pescia-Pistoia branch of the Ammannati family is listed in the *Raccolta Ceramelli Papiani* (collected by the Florentine archivist, 1896–1976), fasc. 4989, as *d'argento, a due branche di leone decussate d'azzurro*. G. Mazzei, *Stemmi ed insegne pistoiesi con note e notizie storiche* (Pistoia, 1907), lists them among the nobil-

ity of Pistoia before 1300 (p. 17) and reproduces their arms on the plate following.

51. De Roover, *Money, Banking and Credit* (as in note 47), 257.

52. *Ibid.*, 286–7, n. 39.

53. T. de Renesse, *Dictionnaire des figures héraldiques* (Brussels, 1892) lists over a hundred families with that coat of arms, though fifteen of those can be eliminated by cross-checking with Rietstap, *Armorial general*, because they include additions/variations not present in the Princeton manuscript.

54. She may be widowed as well.

55. L. A. Waldman, 'New Documents for Memling's Portinari Portraits in the Metropolitan Museum of Art,' *Apollo* 153/468 (February 2001), 28–33, esp. 28.

56. Anne H. van Buren with Roger S. Wieck, *Illuminating Fashion: Dress in the Art of Medieval France and the Netherlands, 1325–1515* (New York, 2011), 220, 310.

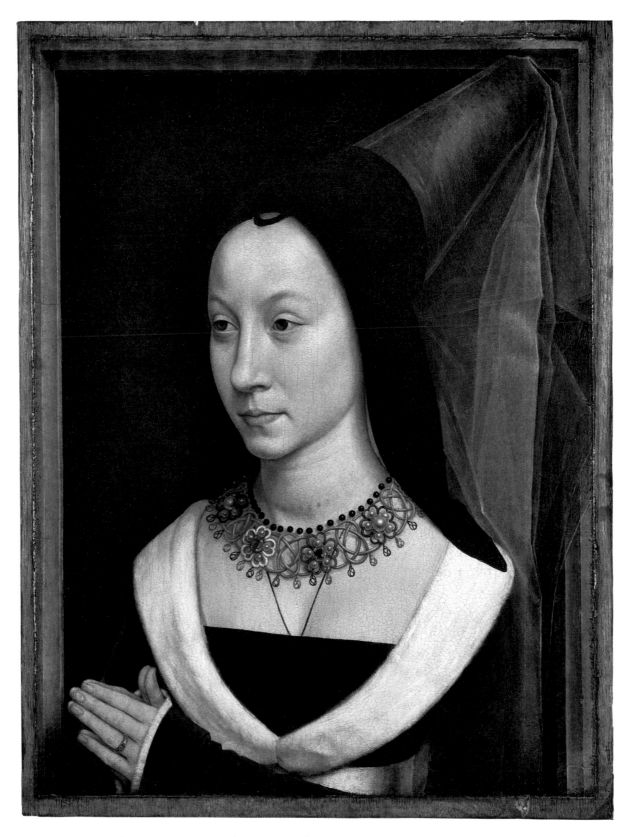

FIGURE 7. Hans Memling, *Portrait of Maria Portinari*. New York, Metropolitan Museum of Art (bequest of Benjamin Altman, 1913 [14.40.626-27]).

seen in Italy. Members of the Italian community in Bruges may have been aliens, technically, but those gifted in administration and especially finance could hold trusted positions at court. Olivier de la Marche remarks on seeing Tommaso in the wedding parade for Charles the Bold and Margaret of York, 'vestu comme les conseillers de Monseigneur le Duc, car il est de son conseil.'[57] Maria Portinari is also dressing to fit in, admittedly at a very high level, in imitation of Charles's wife, the duchess of Burgundy,[58] and our unknown lady may be adopting protective coloration as well. Both Maria and the lady in the margins wear necklaces (colliers) of gold with red accents, possibly in red enamel.[59] Both are conventionally attractive for the early 1470s in Bruges, a city known for its richly dressed women. They have slender bodies and high foreheads, plucked as smooth and hairless as eggs, with their hair pulled back invisibly under the headdress. (The three kneeling girls, of course, are dressed more or less as adults.)

Style, significance, and the Vrelant Circle

It would not be surprising for a well-off foreigner like the woman who owned the Princeton manuscript to acquire hers from one of Bruges's largest and most successful workshops, that of Willem Vrelant, who was active in the city from c. 1454 until his death in 1481.[60] Vrelant's miniatures were included in

manuscripts that appear, from their choice of Sarum Use[61] or execution in Italian script,[62] for example, to have been made according to the tastes or devotional needs of foreigners. One of the draws for a potential patron would certainly have been his high-ranking clientele, and here Vrelant had an impressive record. He furnished books not just for the wealthy Flemish bourgeoisie and for export, but for the Burgundian nobility as well, producing manuscripts for patrons such as Duke Philip the Good (at least ten), three for his son and heir Charles, and two for the noted bibliophile Louis of Gruuthuse, among others.[63]

I would like to concentrate on a single manuscript as a relative of the Princeton Prayerbook, to use it not just to suggest an approximate date and place of origin date but as an indication of how significant the choice of grisaille was. The Princeton manuscript fits comfortably among books made in Bruges, in the circle of Vrelant, in the 1470s, and finds useful comparanda in a copy of the Legende dorée now split between the Morgan Library[64] and the Bibliothèque municipale in Mâcon.[65] The so-called Morgan-Mâcon Legende dorée was made for Jean IV d'Auxy before his death in 1473 by a team of miniaturists thought to have been working under Vrelant's leadership. Jean d'Auxy had been made Philip's counselor and chamberlain and a member of the duke of Burgundy's chivalric order, the Order of the Golden Fleece, in 1446. The opening pages of all three volumes show his arms in the margin

57. De Roover, Money, Banking and Credit (as in note 47), 21.

58. S. Franke, 'Between Status and Spiritual Salvation: The Portinari triptych and Tommaso Portinari's Concern for his memoria,' Simiolus 33, no. 3 (2007–8), 123–144, esp. 136.

59. Judging from the similar collier worn by Margaret of York in her portrait in the Louvre, also dated c. 1470, which has enamel roses alternating red and white above pendant initials in red, black, and gold. For an example of the care with which clothing and accessories were chosen for a portrait, see J. C. Wilson, '"Richement et pompeusement parée": The "collier" of Margaret of York and the Politics of Love in Late Medieval Burgundy,' in Excavating the Medieval Image, edited by D. S. Areford and N. Rowe (Aldershot; Burlington, 2004): 109–33.

60. For Vrelant, see the exhibition catalogue by B. Bousmanne, 'Item a Guillaume Wyelant aussi enlumineur': Willem Vrelant: un aspect de l'enluminure dans les Pays-Bas méridionaux sous le mécénat des ducs de Bourgogne Philippe le Bon et Charles le Téméraire (Brussels; Turnhout, 1997).

61. Los Angeles, The J. Paul Getty Museum, Ms. Ludwig IX 8, the Arenberg Hours, Use of Sarum, which are thought to have been made for an English patron, possibly one working in Bruges; with miniatures by Vrelant (Bousmanne, 'Item' [as in note 60], 274).

62. Baltimore, Walters Art Museum, Ms. W. 181, a Book of Hours written in an Italianate gotica rotunda with inserted miniatures by Vrelant himself, according to Bousmanne ('Item' [as in note 60], 215); L. M. C. Randall, Medieval and Renaissance Manuscripts in the Walters Art Gallery, vol. III, Belgium, 1250–1530, part 1 (Baltimore; London, 1997), notes that these 'small devotional books in Italianate script [were] produced in particular quantity in Bruges c. 1460–80,' 274.

63. Bousmanne, 'Item' (as in note 60), 67–9, with a list of manuscripts by known patron.

64. New York, Morgan Library, Ms. M. 673.

65. Ms. 3.

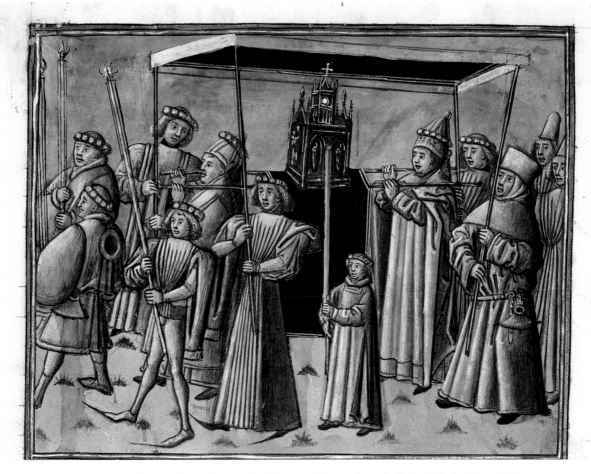

FIGURE 8. Corpus Christi Procession, Morgan-Mâcon *Legende dorée*. Ville de Mâcon, Bibliothèque municipale, Ms. 3, fol. 211 (courtesy of IRHT-CNRS).

hung with the Order's distinctive gold collar and pendant sheep.[66] Perhaps more telling as a mark of favor, Philip chose him as tutor to his son, later Charles the Bold, whom Jean also served as first chamberlain.[67] The manuscript amplifies the standard *Legende dorée* with additional chapters on forty-four saints and eleven on the *Volto Santo*.[68] A series of miniatures details the journey of the crucifix from its miraculous completion by an angel to its installation in Lucca.

The hand in this series of miniatures from the Mor-

gan-Mâcon *Legende dorée* has been identified by Jean Caswell in her study of the manuscript as the Master of the Harley Froissart.[69] His is not the hand responsible for the Princeton Prayerbook, but there are similarities between the two books that suggest we are dealing with the same circle and common patterns of composition—the elegant extended leg of the Savior as he steps out of the tomb in the *Resurrection* miniature, for example, and the rose-lined cloak he wears, the chalky blue sky, and the dark brownish-grey tone

66. Morgan-Mâcon *Legende dorée*, New York, Morgan Library, Ms. M. 672, fol. 1, M. 674, fol. 271, and Mâcon, Bibliothèque municipale, Ms. 3, fol. 2; Jean M. Caswell, 'The Morgan-Mâcon *Golden Legend* and Related Manuscripts,' Ph.D. diss. (University of Maryland, 1978), explains the project's history, 4–22.

67. Caswell 'The Morgan-Mâcon *Golden Legend*,' 28.

68. Jean M. Caswell, 'Two Manuscripts from the *Chroniques*

II Workshop: *Chroniques de Hainaut*, vol. II, and the Morgan-Mâcon *Golden Legend*,' *Revue belge d'archéologie et d'histoire de l'art* 62 (1993), 17–45, esp. 19, n. 11.

69. Named for the British Library copy of Froissart's *Chroniques*, Harley Ms. 4379-80; discussed in Caswell, 'Two Manuscripts,' 38–40.

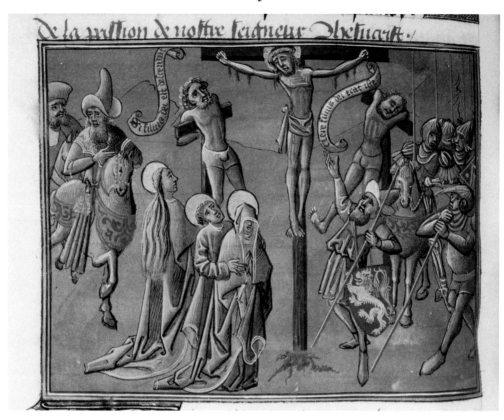

FIGURE 9. Crucifixion, Morgan-Mâcon *Legende dorée*. New York, Morgan Library, Ms. 673, fol. 186ᵛ (© Morgan Library and Museum).

of the miniature that extends to the faces and bodies of the figures. The two manuscripts' miniatures of the Corpus Christi procession (Figs. 6 and 8), for example, arrange individual figures around the Host in a similar oval ring, and staff the scene with some of the same characters: a boy in the center foreground carrying a tall taper, two men in miters shouldering the poles of the litter, and a man at the far left in profile with a purse on his left hip and ballooning sleeves, heading out of the frame with his back turning toward us. Both favor drapery disposed in long tube-like folds. Both depict figures' hands and faces in the same grey tones used for the miniature as a whole, rather than painting the flesh in its proper colors, though the Princeton miniaturist's palette leans characteristically toward bright, opaque pink and pale blue, with a bit of gold and touches of clear red and pale yellow. And there

are details in the Crucifixion miniatures (Figs. 5 and 9), such as the splashy pooling of blood at the foot of the cross and the three rivulets running from each of Christ's arms, and the figure of the pensive soldier at right, leaning on his red spear with his hands under his chin and one leg extended, that are common to both miniatures.

In addition to the semi-grisaille miniatures by the Harley Froissart Master, the ones that most resemble the hand of the Princeton manuscript, there is a whole range of variations on grisaille within the manuscript. They run from the pearl-to-charcoal grisaille plus shell gold of Sts. John Abbot and Episius,[70] to the dark leaden blue-green monochrome *Meeting at the Golden Gate*,[71] to the marginally grisaille *Conversion of Saul*.[72] But there are also many full-color miniatures in the volumes of the Morgan-Mâcon *Legende*

70. Mâcon, Bibliothèque municipale, Ms. 3, fol. 84.
71. Mâcon, Bibliothèque municipale, Ms. 3, fol. 132.

72. New York, Morgan Library, Ms. M. 672, fol. 113ᵛ.

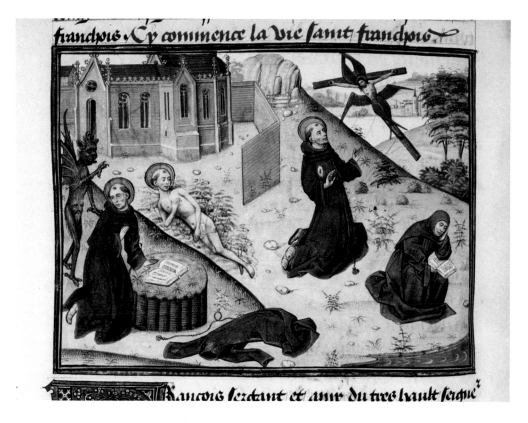

FIGURE 10. Temptation and Stigmatization of St. Francis, Morgan-Mâcon *Legende dorée*.
New York, Morgan Library, Ms. M. 675, fol. 125ᵛ (© Morgan Library and Museum).

dorée, including the *Temptation and Stigmatization of St. Francis*, which is thought to be by the master himself (Fig. 10).[73] We recognize his hand in the miniature's saturated colors and sharp, dark outlines, as if fully realized but isolated figures had been pasted onto a landscape. The color choices cannot be explained by division of hands (since most contributed miniatures in color and grisaille both), nor, as far as I can tell, by subject matter. Caswell's observation that some artists worked independently, by gathering, however,[74] hints at the possibility that we have a group of artists working with minimal supervision and presumably an understanding that there is no strict distinction among the color variations an artist might choose. How should we interpret this variety in the palette of the project as a whole? Does it have anything to do with a mixed

manuscript, like the *Miroir de l'humaine salvation* in Chicago, where it is clear both that we are meant to see a difference between the first and next three scenes, and that the text supports that distinction—that it is a meaningful use of grisaille? The Morgan-Mâcon volumes mix color and grisaille, but seem to follow nothing like that didactic split employed in Philip's *Miroir*. They include plenty of color miniatures, but I have not been able to determine a pattern, and I have had to conclude for the time being that the choice is random, an example of color plus grisaille used without discernible strategy.

I would like to propose looking at another manuscript from the Vrelant circle to test this idea. A Book of Hours in Baltimore[75] includes a cycle of Passion miniatures as illustrations for the Hours of the Cross.

73. New York, Morgan Library, Ms. M. 675, fol. 125ᵛ, attributed to Vrelant by Bousmanne, '*Item*' (as in note 60), 282.

74. Caswell has argued convincingly that the artists she refers to as 'independent' of the shop, including the Master of the

Harley Froissart, simply took a gathering away to work on; 'Two Manuscripts' (as in note 68), 40.

75. Walters Art Museum, Ms. W. 196.

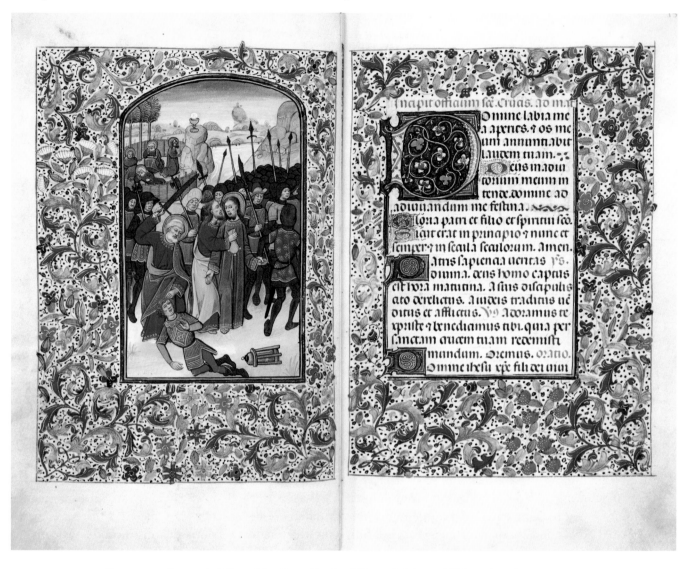

FIGURE 11. Betrayal, Office of the Cross, Book of Hours. Baltimore, Walters Art Museum, Ms.
w. 196, fols. 14ᵛ–15 (photo courtesy of James H. Marrow).

The cycle begins with the *Betrayal* (Fig. 11), which is painted in full color and framed with a border to match. It is followed by *Christ before Pilate* (Fig. 12) in semi-grisaille, which in turn is followed by a full-color *Flagellation*. There is a similar alternating system for the four Evangelist portraits: Luke in color, Matthew grey, Mark in color, John grey. It is admittedly a more regularized system than in the Morgan-Mâcon *Legende dorée*, but, as far as I can tell, equally pointless in

its use of color and grisaille. Another Book of Hours, produced by Vrelant in the 1470s and owned by a Portuguese client named Juan de Cañavate de la Cueva,[76] combines the two, with four of the miniatures in grisaille and the remaining fourteen in color, but apparently more at random than in alternation. The Infancy cycle that accompanies the Hours of the Virgin, for example, begins with a full-color *Annunciation* with a similar border, facing a text page also bordered in full

76. Brussels, Bibliothèque royale, Ms. IV 145, written in a *rotunda* script and bound with the arms of the Cañavate de la

Cueva family; *Quinze années d'Acquisitions* (Brussels, 1969), 95; *Miniatures flamandes 1404–1482* (as in note 14), cat. 48, pp. 249–50.

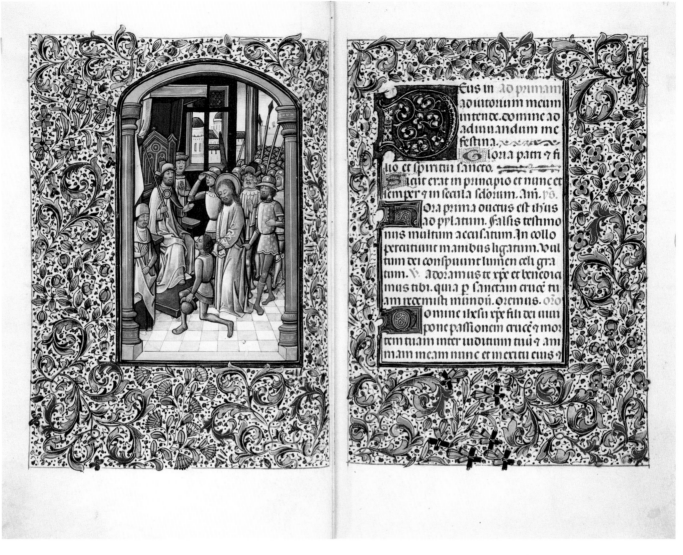

FIGURE 12. Christ before Pilate, Hours of the Cross, Book of Hours. Baltimore, Walters Art Museum, Ms. w. 196, fols. 16ᵛ–17 (photo courtesy of James H. Marrow).

color, then follows that with a *Visitation* in grisaille, framed by grisaille border decoration but opposite a text page with a full-color border. The *Nativity* that follows pairs a full-color miniature with a grisaille border on both verso and recto. This seems to be typical of Vrelant manuscripts: the lack of a discernible strategy other than what appears to be an interest in variety and novelty, and perhaps the knowledge that grisaille had been popular for the duke's library and those of his intimates.

I think the Princeton Prayerbook can be localized within this tradition of a technique probably chosen

not for its cheapness but for its noble associations, commissioned for a woman who kept to the devotions of her husband's family (and probably her own as well), but dressed in Burgundian fashion to rival the ladies of Bruges, and who owned a prayerbook decorated in the style established by the most popular illuminator in Flanders. My last point looks into the next century, when we can see instances of artists in Ghent and Bruges using grisaille to make a point—when miniaturists had brought brown shades of monochrome painting (brunaille) into the conversation—and when monochrome painting again seems to be chosen to

signal the damping down of color in response to Christ's suffering, as it had on altarpiece wings. This is the scheme followed in the Da Costa Hours in the Morgan Library, written and illuminated in Bruges *c.* 1515 by Simon Bening and workshop.[77] The entire book is illustrated in rich, full color, and the miniatures framed in gilded faux-wood frames, sometimes with scroll-work carving at the corners. The illusionistic corner tracery frames all of the calendar scenes,[78] for example, where it acts as a *repoussoir*, so that we seem to be looking through it at a 'real' scene. Only the seven miniatures that illustrate the Hours of the Passion are executed in brown monochrome, the same color as the framing. Instead of a vista in full color

we see *trompe l'œil* wood carved in decorative panels around a scene in low relief, highlighted with touches of gold. It is used for *Christ before Caiaphas* (Fig. 13), *Christ before Herod Antipas*, and *Christ before Pilate*, the *Nailing*, *Crucifixion*, *Deposition*, and *Entombment*. We are immediately returned to full color for the *Celebration of the Mass*, the scene that accompanies the Office of the Five Wounds of Christ.[79] Just as it had in Philip's *Miroir*, the artist has chosen a restricted palette. Here, it is not done for variety or fashion, but to suggest the somber mood of the Passion, to catch our attention with the contrast between full color and a reduced palette, and it highlights the technique's expressive possibilities.

77. New York, Morgan Library, Ms. M. 399. For the Da Costa Hours, see the facsimile with commentary by Gregory Clark, *Das Da Costa-Stundenbuch. Vollständige Faksimile-Ausgabe im Original-format von MS M.399 aus dem Besitz der Morgan Library & Museum, New York. Commentary/Kommentar* (Graz, 2010).

78. For the occupations of the months, on the versos of the opening for each month, fols. 2ᵛ–13ᵛ.

79. Ms. M. 399, fol. 36ᵛ.

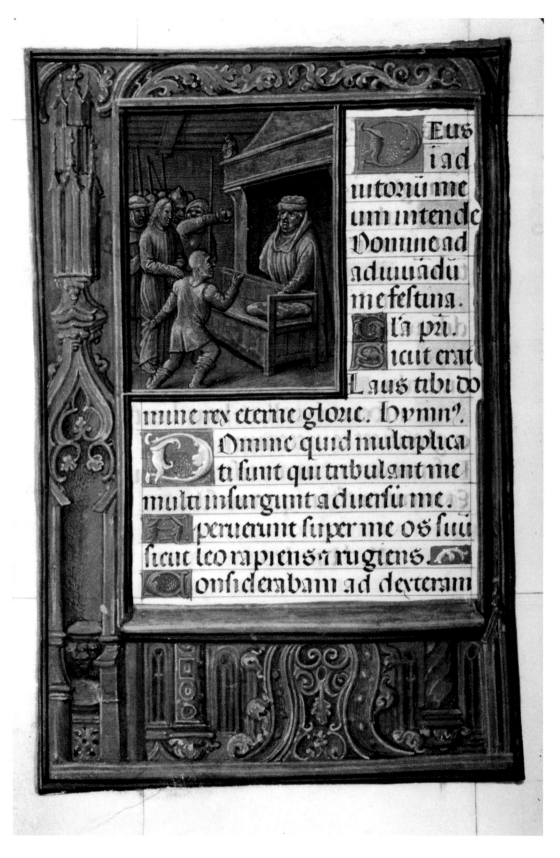

FIGURE 13. Simon Bening, *Christ before Caiaphas, Da Costa Hours.* New York, Morgan Library, Ms. M. 399, fol. 21ᵛ (© Morgan Library and Museum).

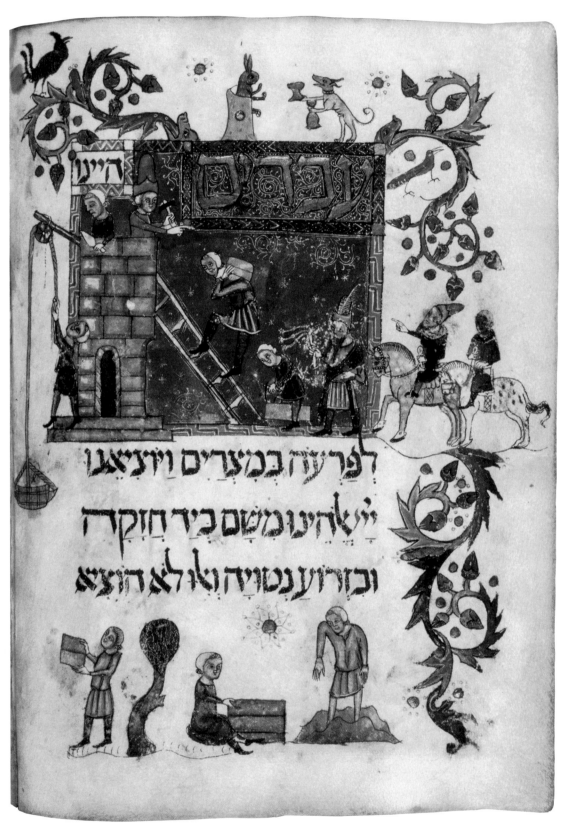

FIGURE 2. Haggadah, Catalonia, Spain, 14th century, London, British Library, Add. Ms. 14761, fol. 30ᵛ (British Library, Public Domain Mark).

MARC MICHAEL EPSTEIN

Thought Crimes: Implied Ensuing Action in Medieval Manuscripts Made for Jewish Patrons & Audiences

FOR WALTER CAHN

IT WAS IN 1986, while in a graduate seminar at Yale on medieval Paris with Walter Cahn, that I wrote my first scholarly article. In tribute to Professor Cahn, I want to revisit from a new perspective some iconography I originally considered in that article. The image I wish to discuss comes from a manuscript made in Catalonia in the late fourteenth century. It shows a hare being served a drink by a dog, and seems at first blush to be a typical example of *mondus inversus* iconography (Fig. 1).

In my original article, I contended that the depiction of a hare—a normally timid animal—in a situation of dominance should be read politically in the context of this particular work of art. For the image is from a manuscript made for Jewish patrons, an illuminated haggadah—a liturgical book containing the text used at the Seder, the home service for the eve of Passover. Since Jews were a minority population—sometimes despised, occasionally persecuted, usually misunderstood—in the European Middle Ages, I argued that this iconography—an example of self-expression on the part of the Jewish minority—does not merely mirror and adopt the *topoi* and symbols found in Christian iconography. Rather, it actively appropriates and adapts them.

The image appears as an upper marginal illustration of a page on which the *bas-de-page* depicts the Israelites slaving in Egypt. The text rubric reads, 'We were slaves to Pharaoh in Egypt' (Fig. 2, *opposite*). The implication here seems to be, 'We were slaves, but one day the Egyptian dogs will serve us!'

This reading is strongly corroborated by the correlation between the bent-over position of laboring man ascending the ladder towards the taskmaster at the top of the tower, and the reversal of this iconography in the image of the laboring dog bowing down to hand a drink to the seated hare. This is but one example of

FIGURE I. Haggadah, Catalonia, Spain, 14th century, London, British Library, Add. Ms. 14761, fol. 30ᵛ, detail (British Library, Public Domain Mark).

very many from medieval manuscripts made for Jews in which a different perspective on history—a world seen from the end of time—allowed patrons to envision a future in which the pursued could triumph over their pursuers.

Twenty-seven years later, in working on a new book that will deal, *inter alia*, with margins and marginality in Jewish visual culture over the *longue durée*, including the Middle Ages, I have returned to this illumination, although with new considerations. I find that now I am interested in the ways in which time works in these images. In the various registers of this single page, the viewer is confronted with the past (the Egyptian slavery) the present (contemporary dress) and the future (the eschatological hare and dog). The illumination, thus, simultaneously unfolds in three different though interrelated chronological spheres.

This sort of anachronic simultaneity is somewhat less common than the chronological advancement of the narrative over time by means of repetition that is more typical in medieval manuscripts made for Jews and Christians alike. This occurs when depicting several

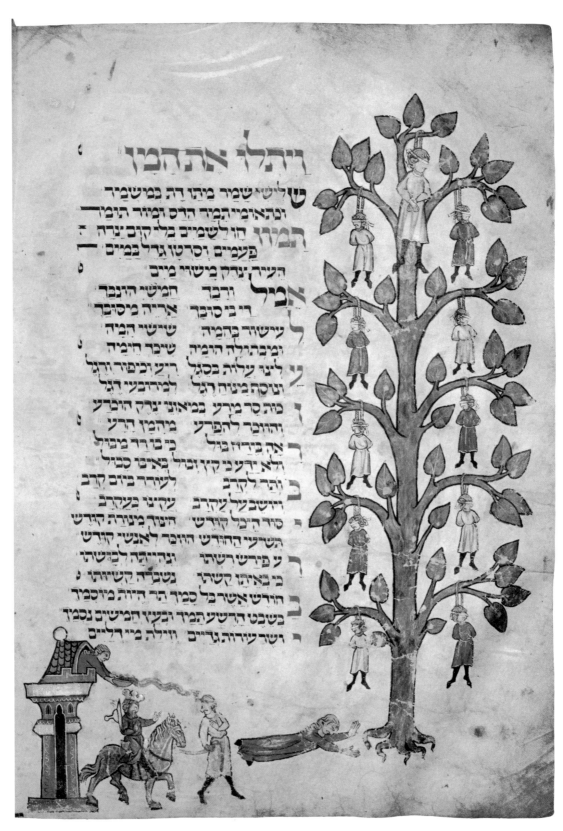

וַיִּתְלוּ אֶת־הָמָן

שְׁלִישִׁי שָׁמֵר מֵהוֹרֵדַה בְּמִשְׁמֵיד
וְנִתְהַלֶּמְיָה תֶּמֶד הֶרֶס וְכָּמֵד תַּמֵד
תֶּמֵד הֶלְשֶׁמֵיב בְּלִי קוֹם צֶרֵה
פַעֲמֵיָם וּסְרֵטוּ גֶרֶל בְּמֵיָם
הַעִיר יֶנֶק מִשׁוּרֵ מֵיָב
וָדְבֶרֶד חֲמִישִׁי הַנֶּבֶר
רִי בִּי סוֹבֵר אֲרֵיה מִסוֹבֵך
עֵישׁוֹד בְּהֵמֵיָה שִׁישִׁי הָמֵיה
וּמֵנְתַּרְלָה הַיֻמְיָה שִׁיבֵּר הֵיִמְיה
לַצוֹ עֲלֵית בְּסֵגַל רֶע וּבִכֵּפוֹר וְדָגַל
וְתוֹסְכֵּה מֵצוֹה רֶגֶל לַמֵּירְבֵּעֵי רֶגֶל
מַוּה סֵר מֵרֵע בְּמֵיאֲנֵי יָצֵק הוֹבֵרֵע
וְהוֹבֵר לֵהַפְרֵע מֵהָמֵץ הֵרֵע
אַה בְּיָדוֹ זוֹבֵל בִּ תוֹרֵד מֵתַיל
וְלֹא יְדַעֲנֵי קָז וְזָמֵל בָּאֵנֶת כְּמֵל
וְהֵר לֶקָרֵב לַעֵירֵד בְּזוֹב קֵרֵב
וַיּוֹשֵׁב בֵּל לַעֵקָרֵב עֵקָצוֹ בְּעַקָרֵב
סוֹד הֵיבֵל קוֹרֵשׁ הֵצוֹץ מֵנוֹרֵת קוֹדֵשׁ
תַּשֵׁירֵעִי הַהוֹרֵשׁ הוֹזֵר לְאַנְשֵׁי קוֹרֵשׁ
עַ פֵּירֵשׁ רֵשׁוֹתוֹ וְגֵה רֵיאַתַּה לַבֵּיטֵתוֹ
מֵ בָּאֵתוֹ קֵשֵׁתוֹ מֵשֵׁבֵרָה קֵשֵׁיתֵתוֹ
חוֹרֵשׁ אֲשֵׁר בֵּל כְּמֵך הֵר הֵיוֹת מֵיזֵכְמֵר
בְּשֵׁבֵט הֵרְשֵׁע הֵמֵיד וּבְעֵצֵי חֲמֵישִׁים נֵכְמֵד
וְשֵׁר עֵדְוֹת גֵּדֵיָם וְזֵילֵה מֵיּרֵלֵיָם

FIGURE 3. Maḥzor, Worms, *c.* 1300, Leipzig, University Library, Ms. v. 1102, Vol. 11b, fol. 31ᵛ (courtesy Leipzig University Library).

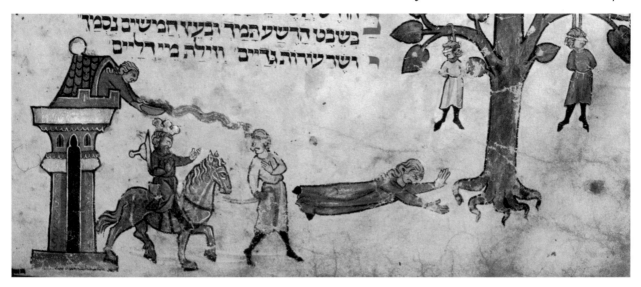

FIGURE 4. Maḥzor, Worms, *c.* 1300, Leipzig, University Library, Ms. V. 1102, Vol. 11b, fol. 31ᵛ, detail (courtesy Leipzig University Library).

actions taking place not over the broad span of historical, present, and eschatological time, as in the case of the image in the Barcelona Haggadah, but rather within a fairly circumscribed time frame, as in the illustration of the triumph of Mordechai from the Leipzig Maḥzor, made in Worms around 1300, for example. Here, Haman's daughter is shown—according to the rabbinic elaborations of the Book of Esther— emptying the chamberpot on the head of the man she thinks is Mordechai, discovering, too late, that it is, in fact, her own father who is being humiliated and Mordechai who is being celebrated. This realization leads to her own humiliation, her despair, and her death when she leaps from the window, committing suicide. According to convention for depicting sequential action, she appears twice in this illumination, once at the window, the second time on the ground, actually at the base of the tree on which the sons of Haman are hanged (Fig. 3).

Katrin Kogman-Appel has discussed the iconography of the hanging of Haman in manuscripts made for Jews as a reaction to or a parody of the tree of Jesse in Christian iconography.[1] I would extend this argument to note that this sequential depiction situ- ates Haman's daughter, a parody of Jesse himself, as the incestuous root of this tree of criminality, in which the hanged sons of Haman represent a 'death wish' for the descendents of Amalek—the living oppressors of medieval Jews.

The critical function of the daughter of Haman is to pour excrement on the head of Haman and thus to contribute to the inevitable trajectory of his humiliation. She becomes an object lesson: a woman—who is, after all, a source of filth and impurity—is depicted as a conveyer of filth and impurity, and, as a result of the filthiness and impurity of her motives, comes to an ignominious end. By means of the double depiction, the viewer is invited to imagine a sequence of action and consequence, simultaneously tragic narrative and somber warning that emplaces this (literally) fallen woman as a perversion of Jesse at the foot of a tree that bears—instead of the revivified, living bodies of the (in historical actuality, dead) ancestors of Christ— the (wishfully) lifeless bodies of the contemporary (in historical actuality, living) enemies of the Jews.

In the Leipzig Maḥzor, both the action of Haman's daughter, and its ensuing consequence are depicted within the same frame (Fig. 4). There are other images

1. K. Kogman-Appel, 'The Tree of Death and the Tree of Life: The Hanging of Haman in Medieval Jewish Manuscript Painting,' in *Between the Picture and the Word: Manuscript Studies* *from the Index of Christian Art,* ed. C. Hourihane (University Park, Pa., 2005), 187–208.

in medieval Jewish iconography that invite us to contemplate transformative action without depicting—but only implying—the ensuing consequence.

For instance, the North French Miscellany depicts the giant bird, the Bar Yokhni—as a sort of cross between a goose and and ostrich—comic, rather stupid-looking, and none too graceful (Fig. 5).

Its gracelessness corroborates the Talmudic report that the Bar Yokhni once dropped a rotten egg out of its nest. The egg cracked, and its contents were so voluminous that they swamped sixteen cities and uprooted three hundred cedar trees (BT *Bekhorot* 59b). By illustrating the bird along with its egg in this image, the authorship of this manuscript signals its familiarity with the Talmudic account.

Furthermore, by playing with the parameters of the roundel within which the depiction appears,[2] the authorship further hints at the denoument of the rabbinic tale of the Bar Yokhni, transforming the image from a static one to one that betokens implied, ensuing action: The bird's feet appear to slip as it navigates the rounded inner surface of the frame. Attempting to gain a foothold on this unfortunately smooth surface, it will soon fall backwards, crushing the giant egg or pushing it out of the frame. This image seems to be designed so that the eye and the mind collaborate in a game of 'imagine what happens next.'

The double iconography of Haman's daughter embodies the medieval convention for temporal sequencing in which the consequence of an action is explicitly displayed as ensuing from that action. The iconography of the Bar Yokhni signifies a witty anticipation of an imminent but not yet manifest moment—a moment, in this case, of considerable revulsion.

The illustration in the Barcelona Haggadah represents yet another temporal modality, one in which—as we have noted—past, present, and future converge. What was conventional in one instance, witty in another, has become something political here, specifically because it combines—and thus exceeds—the tempo-

ral zones it represents. The sum of its whole is greater than that of its parts.

In a loose trilogy of fascinating works, Alexander Nagel and Christopher Wood have been probing the 'anachronicity of the images.'[3] Nagel and Wood argue convincingly for what they call 'a web of paths traveled by works and artists—a landscape obscured by art history's disciplinary compulsion to anchor its data securely in time.' They maintain that although works of art are necessarily 'of a particular time'—the time of their creation—they also exist in a state of temporal instability—pointing away from that moment, backward to a remote ancestral origin, to a prior artifact or image, even—as in the case of acheiropoietic images—to an origin outside of time, in divinity.[4]

While I am certainly compelled by this typology of temporality as it applies to Western art in general, I want to consider what it might mean in the case of art produced by Europe's major medieval minority. Medieval Jews lived in a valley of reality between the twin peaks of memory and expectation—the reality of their subjugation to the nations. The cognitive dissonance between this reality and the historical memories and future hopes of the Jewish people is what breeds in Jewish art—as far back as the ancient frescos in the synagogue of Dura Europas, and probably before—unique religious and political sensibilities. Jewish illumination mirrors Jewish texts in making the connection between past redemptions and the great redemption yet to come.

Obviously, Christians also awaited a great redemption yet to come in the Second Coming, and medieval Christian art abounds in eschatological themes and images—from illuminations of the Apocalypse, to scenes of the Last Judgement.[5] But visual manifestations of temporality created for Jews differ from those created for Christians. Time seems to make a habit of warping itself forward for Jews in the Middle Ages. Medieval Jewish iconography is replete with fantasies of a redeemed and redemptive future in which the present

2. Much as it does in the case of the image of David and Goliath (North French Miscellany, Northern France, *c.* 1278–1298. London, British Library, Add. Ms. 11639, fol. 523ᵛ), where Goliath exceeds the boundaries of the roundel in order to emphasize his great height.

3. C. S. Wood, *Forgery, Replica, Fiction: Temporalities of German*

Renaissance Art (Chicago, Ill., 2008); A. Nagel and C. S. Wood, *Anachronic Renaissance* (New York, 2010); A. Nagel, *Medieval Modern: Art out of Time* (New York, 2012).

4. Nagel and Wood, *Anachronic Renaissance* (as in note 3), 13.

5. See R.K. Emmerson and B. McGinn, eds., *The Apocalypse in the Middle Ages* (Ithaca, N.Y., 1992).

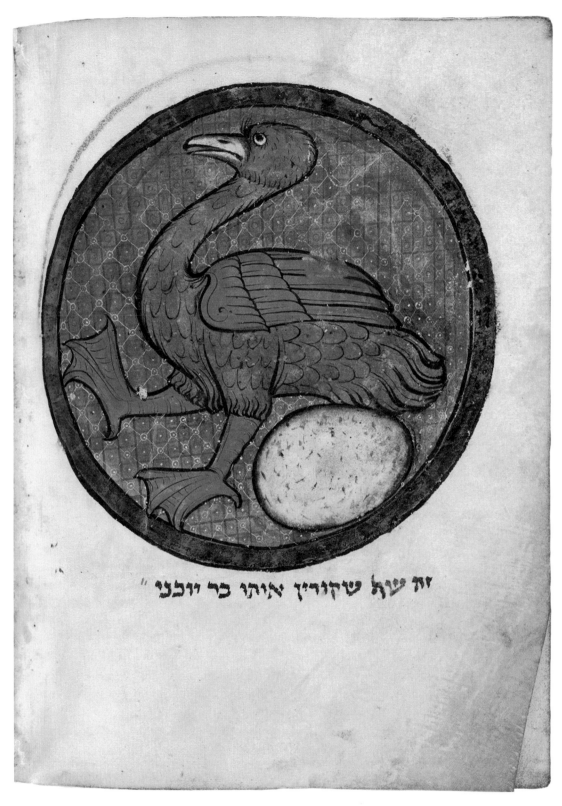

זה עוף שקורין אותו בר יוכני

FIGURE 5. Miscellany, Northern France, *c.* 1278–1298, London, British Library, Add. Ms. 11639, fol. 517ᵛ (British Library, Public Domain Mark).

reality is overturned in a way that, obviously, advantages the Jews and discomfits their oppressors.[6] Such redemptive fantasies often appear in conjunction and contrast with depictions of abjection in the biblical past or the unredeemed present in a mode that might be termed 'eschatological projection.' Recall that in the case of the Barcelona Haggadah, this projection is accomplished within the bounds of a single page. And while it is politically subversive, it is only semi-explicit in the sense that the marginal imagery that comments on the main action of the page could be dismissed as a *drollerie* or a phantasmagoric example of *mondus inversus* iconography.

So, to begin a list of medieval Jewish visual typologies of temporality: the illumination of the hare served a drink by a dog in the Barcelona Haggadah is an eschatological projection that occurs within different registers on the same page. It is politically subversive, but only semi-explicit. But there are other typologies of temporality that develop not on the same page, but in which—*à la* Nagel and Wood—images respond to each other over the course of the historical unfolding of image-making itself.

Witness the scene of the Israelites leaving Egypt in the mid-fourteenth-century Brother Haggadah (Fig. 6). In the center of the upper register, on one of the rooftops or ramparts of the complex of buildings representing Egypt, a lone trumpeter sounds the alarm, alerting Egypt that the Israelites are fleeing.

Compare this with the analogous illustration from the Rylands Haggadah, a work created under the influence of the Brother Haggadah only a few years after the completion of that manuscript (Fig. 7). It contains all of the same scenes as the Brother Haggadah, but it is configured in interestingly different ways that respond to the iconography of the Brother Haggadah scene for scene and detail for detail.[7]

In the depiction of the Exodus in the Rylands Haggadah, four figures appear on the ramparts of 'Egypt,' pointing towards the departing Israelites. One of these figures, though still pointing left, turns his head towards the right, and looks upward and back, calling our attention to a fifth figure, at the far right, who looks up in expectant alertness without pointing at all. When I first encountered these illuminations decades ago, it occurred to me that the Egyptians who watch and point from the ramparts of the city in the Rylands Haggadah look—for all the world—as if they have been summoned by the trumpeter in the earlier Brother Haggadah (Fig. 8).

At the time, I could not say why this occurred to me, except to note that perhaps it was the fact that while the three of the four other figures on the parapet in the Rylands illumination face left, that is to say, in the direction of the action; our eye is led by the single figure who does not face left, to the figure at the extreme right—distinguished from all the other figures in the illumination, and indeed, from all the other figures in the entire manuscript, by his striking baldness—who looks up and towards the right (the direction of the 'past' given that things move from right to left in medieval manuscripts written in Hebrew), apparently at nothing. But there was no theoretical work to support such a reading of an action unfolding, as it were, over a series of distinct (even if admittedly related) works of art, and so I let the conjecture of a connection between the images lie fallow, knowing it would sound highly fanciful.

Returning to the images in the light of the work of Nagel and Wood, looking at them also from the perspective of viewer response theory, and, perhaps, most importantly, from the vantage point of my discovery of a meticulous point for point response in the iconography of the Rylands Haggadah to that of the Brother Haggadah, I find that my instinctive reading is supported by a number of facts.

6. See M. M. Epstein, *Dreams of Subversion in Medieval Jewish Art and Literature* (University Park, Pa., 1997).

7. Note, for instance, the youthful and very heavily armed Israelites in this illustration, in distinct and intentional contrast with the more elderly and primarily unarmed Israelites in the Brother Haggadah (Brother Haggadah [Catalonia, Spain, 1330–1340] London, British Library, Ms. Or. 1404, fol. 6ᵛ, detail). Here there are only four armed figures, and neither of the two sword-sheathes shown actually contain swords. The difference between the manuscripts amounts to a distinct quietism in the iconography of the Brother Haggadah and a vengeful activism in the Rylands Haggadah's responses to that iconography, which betokens differing political concerns on the part of the authorship of each manuscript. See M. M. Epstein, *The Medieval Haggadah: Art, Narrative & Religious Imagination* (New Haven, Conn., 2011), 223–245.

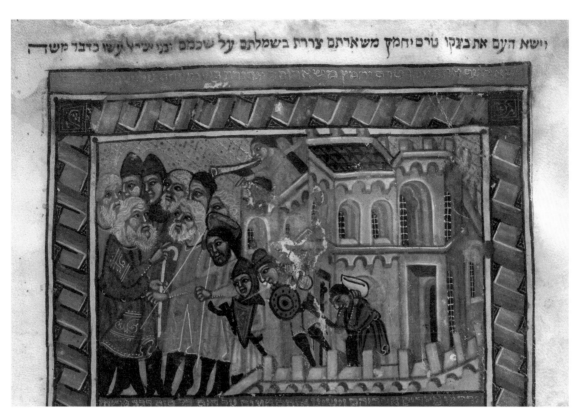

FIGURE 6. Haggadah, Catalonia, Spain, 14th century ('Brother'), London, British Library, Ms. Or. 1404, fol. 6ᵛ, detail (British Library, Public Domain Mark).

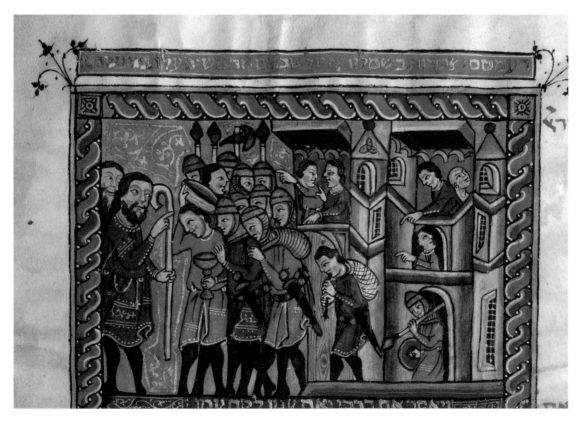

FIGURE 7. Haggadah, Catalonia, Spain, 14th century ('Rylands'), Manchester, John Rylands Library, Hebrew Ms. 6, fol. 18ᵛ, detail.

Bald figure in later Ms. 'looks back' on the trumpeter in the earlier Ms.:

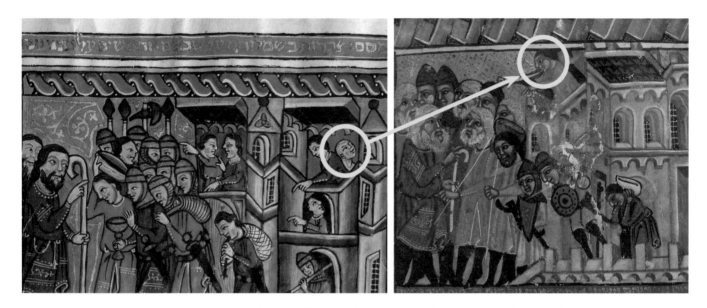

FIGURE 8. Comparison: Haggadah ('Brother'), Catalonia, Spain, 14th century (London, British Library, Ms. Or. 1404, fol. 6ᵛ, detail). Haggadah ('Rylands'), Catalonia, Spain, 14th century (Manchester, John Rylands Library, Hebrew Ms. 6, fol. 18ᵛ, detail).

The Rylands and Brother haggadot are two manuscripts in a Hebrew linguistic context in which texts and images are read from right to left, with events in the narrative that are earlier in time appearing to the right, and events later in time appearing on the left. If one were to mirror the right-to-left narrative directionality in arranging the two Exodus images in sequence of production history, one would place the image from the older manuscript (the Brother Haggadah) on the right, and the one from the newer manuscript (the Rylands Haggadah) on the left. When one does this, the distinctively bald, rightward-facing figure in the later Rylands Haggadah indisputably seems to be 'looking back' and looking upwards not towards noth-

ing, but rather, towards the leftward facing trumpeter from the earlier Brother Haggadah (Fig. 8).

These facts preclude a facile dismissal of the possibility of viewer response—or in this case, more accurately, creator response—on the part of the authorship of the later Rylands Haggadah. Viewer response theory emphasizes the importance of the role of the audience of readers as active agents who impart 'real existence' to art and complete its meaning through interpretation. Art is thus considered to be a kinetic construct not only referring backward to its antecedents, but also casting itself forward in time towards *nachleben* in which each viewer not only creates new meaning, but completes original meanings. While one could write

off the idea that the meaning of, say, Leonardo's *Last Supper* is 'completed' *via* its latter-day reproductions on velvet in the homes of the working-class faithful, viewer response is—as Leo Steinberg points out—more difficult to ignore when the respondent is not merely a copyist, but a thoughtful interpreter.[8] And viewer response is not only difficult to ignore, but extremely relevant in cases where the respondent is very nearly contemporary with the creator of the work responded to, and is, moreover, known to be directly responding to the earlier work.

The authorship of the Rylands Haggadah was indisputably aware of the iconography of the earlier Brother Haggadah. In fact, the Rylands authorship modeled its iconography on that of the Brother Haggadah at many junctures, responding, in each case, to the approach of the Brother Haggadah. This response is manifested in differences—subtle or explicit—between the iconography of the two works.[9] In the case of this comparison, we need to account for two things: why five Egyptians appear on ramparts in the Rylands Haggadah, which—in the previous recension in the Brother Haggadah—were empty save for the trumpeter, and why one of these figures—the only bald-headed figure in the entire manuscript—faces right, while three of the others face left, and one visually cues us to look at the bald-headed figure.

While many of the differences between the iconography of the Brother and the Rylands haggadot betoken variances between the political stances of the respective manuscripts, I'm not sure that one could or should read a political message into the relationship between these two particular images as one could in the case of, say, the Rylands Haggadah's treatment of the illustrations of the plagues, which it adopts from the Brother Haggadah but adds in much more *schadenfreude*. Rather than being political, the iconography of the Rylands Haggadah may be a sort of jocular homage to the Brother Haggadah authorship: the authorship of the earlier manuscript depicts a trumpeter sounding the alarm, and the authorship of the later manuscript

responds, depicting the consequences of the alarm—people appearing on the parapets—acknowledging its debt to the authorship of the earlier manuscript.

This is, of course, not made explicit, nor could one prove it. Still, I hope that, understood in the light of the facts and background I've presented, my reading of iconography over a sequence of related manuscripts forms a useful parallel to the iconographic readings of Nagel and Wood. For this is precisely what they mean when they speak about anachronicity. This reading combines anachronicity with what I call ensuing action—action that takes place after the moment frozen in time in a given illumination. In this case, the ensuing action is extended anachronically or crossmonumentally—over the space of two monuments proximate but slightly separated in time in a manner that is not explicit when one views either monument on its own, but which makes sense when viewing the monuments together. Though speculative, this reading reveals the imaginal mechanics of the visual turn—in this case, motion that ensues or unfolds across monuments in time—imaginal mechanics that, although used here in jocular homage, can be harnessed for purposes more explicitly political, as we shall soon see.

So to review: We've thus far considered two typologies of temporality. First, in the iconography of the dog serving a drink to a hare in the Barcelona Haggadah we examined eschatological projection occurring within a single monument. This eschatological projection is politically subversive since it predicts the downfall of the dominant power, but—because of its marginal placement—it is only semi-explicit. Then we explored a potential, though not provable, sequence of events over two closely related and roughly contemporaneous manuscripts—the Brother and Rylands haggadot—in which the latter seems wittily to acknowledge the former, without recourse to discernable political meaning.

But the most potentially politically subversive typology of temporality goes beyond eschatalogical projection because it devolves upon a contemporary

8. Leo Steinberg, *Leonardo's Incessant Last Supper* (New York; Cambridge, 2001). This is an anachronic treatment in parallel with those of Nagel and Wood: while most interpreters have understood Leonardo as wishing to freeze a single moment in time, Steinberg asserts convincingly that the scene portrays 'successiveness and duration.' For thoughtful (and controversial) interpretation, one can do no better than *Yo Mama's Last Supper*, a photographic work by Renée Cox, first exhibited 2001.

9. Epstein, *The Medieval Haggadah* (as in note 7), 223–45.

FIGURE 9. *Haggadah shel Pessah*, Prague: Gershom Cohen, 1526.

critique—primarily in the medieval 'here and now.' A particular situation, motion, or action is depicted that represents the abjection of Jews in the present age. This is followed by the proposal or presentation of a solution to this abjection *via* a certain deftness and virtuosity of visual imagination.

I beg the indulgence of the reader in taking my example from the realm of early printed books rather than from manuscripts, as the phenomenon is manifest most clearly in the relationship between the following illustrations. A depiction of a hare-hunt appears on the first page of one of the earliest printed haggadot, the Prague Haggadah of 1526 (Fig. 9)—as it did in many previous manuscript versions of the haggadah. This occurs for a particular reason involving Jewish liturgy and Judeo-German puns. The iconography is simple: a hunter drives a group of hares into a net. But given the fact that the hare became an unlikely, though ubiquitous symbol for Jews, it should surprise no one that the next illustrated haggadah printed, the Augsburg Haggadah of 1534, depicts the hares in the process of escaping the net (Fig. 10).[10]

These two illustrations, in the identical position in two different books separated by several years in time, seem intended to be read together, just as—I believe—are the two illustrations in the same position in the Rylands and the Brother haggadot. In the case of the Rylands and the Brother haggadot, the motivation is jocular homage. In the printed haggadot, the impetus is explicitly political and contemporary. This juxtaposi-

tion presents a hopeful message, and a statement of defiance, very much in the spirit of the Haggadah's own famous articulation of theodicy and history: 'More than one nation has attempted to destroy us, but God has saved us from their hand.'

Now, a hunt is an enterprise of indeterminate outcome: it isn't over until it's over. And it can end in one of two ways: it can be successful or it can be unsuccessful. But it is also highly subjective: the measure of its success is gauged by the perspective of the particular protagonists. Hunters and the prey, obviously, hope for different outcomes, and what is a successful hunt for the hunters is unsuccessful for the prey and *vice versa*.

Read separately and from the perspective of the hunter, the Prague and Augsburg images simply represent a successful and an unsuccessful hunt. But read together and from the prospective of the quarry, they represent something very different indeed. They represent a third typology of temporality: they are semi-explicit in that one needs to know that one should read them together, and they extend the statement they are making over two consecutive printings of the haggadah—two separate monuments. Yet read together, they form a very strong and explicit statement of protest and represent a dream of subversion and escape from their contemporary circumstances. This is not a reference to some national memory of Egyptian slavery or to some hope for messianic redemption. It is a wish of which the explicit articulation—'You gentiles are the hunters, we Jews are your quarry, but you are not

10. Epstein, *Dreams of Subversion* (as in note 6), 38.

FIGURE 10. *Haggadah shel Pessaḥ*, Augsburg: Ḥayyim b. David Shaḥor, 1534.

clever enough to prevent us escaping you'—might have been risky for Jews during the period of its creation.

In considering ideas of which the explicit articulation might have been risky for Jews, I come, finally, to what I find are the most interesting of visual expressions of temporality in medieval manuscripts made for Jews. These are images that imply the ensuing action without explicitly depicting it.

A case in point is an illumination in the Hebrew Bible painted by Joseph the Frenchman in Cervera, Spain, 1299–1300, and now housed in the Biblioteca Nacional de Portugal, Lisbon. The image I wish to discuss stretches across the upper margin of bifolium 444ᵛ–445. This opening is part of the appendix to the Bible that is comprised by a grammatical work, *Sefer HaNikkud*, by David Kimchi, but the illuminations are—as far as I can determine—unrelated to the text (Fig. 11).[11]

In an article celebrating the display of this manuscript at the Metropolitan Museum in New York in the fall of 2011, author Robin Cembalest described the image in question as a 'courtly hunting scene … a falconer and a crossbow-aiming figure converge on a bird perched on a crenelated tower.' She asked 'Do such motifs hold larger symbolism for Sephardic Jews?'

and cited Barbara Boehm, curator of Medieval Art and the Cloisters at the Metropolitan Museum as asserting that 'sometimes a crossbow is just a crossbow.'[12]

I am, in fact, in agreement with Dr. Boehm that sometimes a crossbow is just a crossbow. Just not in this case. The iconography deserves a closer look. Again, as in most Hebrew manuscripts, the action moves from right to left. On the right-hand page, we witness a commotion. An armed man is drawing a sword and running towards what we can only presume is the scene of some great battle, or of the hunt of some dangerous beast requiring the *coup de grâce* of the sword. He is urged on by another man who points him in the direction of the left-hand side of the bifolium. There, expecting to see some scene of carnage or of a dangerous beast cornered and needing to be subdued and dispatched by the sword, we are surprised to see nothing but two hunters stalking a little black bird that seems to have come momentarily to rest on a parapet, just having folded its wings.

This tiny creature is about to be shot at from the left with an almost grotesquely large crossbow. This is a direct attack with an overly powerful weapon for such a little bird. Crossbow bolts, after all, are designed to pierce heavy armor, not to shoot ravens. And this is

11. Cervera Bible, Spain, 1299–1300, Lisbon, Biblioteca nacional de Portugal, Ms. IL. 72, fols. 444ᵛ–445. The text is often cited as *Sefer Mikhlol*, but that is incorrect. The confusion is probably due to the fact that *Sefer Mikhlol* is the grammatical text that appears in the (similar) Kennicott Bible. I don't mean to say that the illustrations that appear in the margins of Kimchi's *Sefer HaNikkud* are actually unrelated to the text—the fact that

I cannot discern any relationship will (hopefully) not preclude other more discerning viewers from apprehending them.

12. R. Cembalest, 'Everything Is Illuminated: Three rare medieval Hebrew Bibles on display at the Metropolitan Museum in New York reveal the affinity between Sephardic and Islamic texts,' Tablet, 23 November, 2011, 7:00 A.M., http://www.tabletmag .com/jewish-arts-and-culture/83906/everything-is-illuminated.

FIGURE 11. Bible, Spain, Cervera 1299–1300, Lisbon, Biblioteca Nacional de Portugal, Ms. IL.72, fols. 444ᵛ–445 (Biblioteca nacional de Portugal).

a substantial specimen, almost as big as the man who so improbably wields it. One imagines the bolts are quite heavy.

At right, a falconer prepares to fly his hawk. This is an indirect attack upon the bird *via* an intermediary, a method that is both less direct and generally the province of more socially elite hunters. This, too, is a disproportionate and unrealistic attack: one flies hawks to hunt hares or small mammals, or even edible smaller birds. But a raven is a troublemaking scavenger, a 'garbage' bird, a gallows bird beloved of nobody (except, perhaps the Warders in the Tower of London). No one eats ravens. One wants to rid oneself of them, not pursue them. As anyone who has trained or hunted with raptors knows, sending a hawk to capture a raven is a ludicrous waste of time and effort. The whole thing seems to be a bit of comedy on the theme of outrageously overdetermined violence, with the expenditure of so much firepower against so small a menace.

What is the upshot of all of this hubbub? The little black bird, as noted, has just come momentarily to rest. But one of its feet is already off the parapet, and it tilts its head, inclining a beady eye in the direction of the crossbow-wielder, while simultaneously turning towards the hawker. The angle of the bird's head and the

position of the black iris of its eye within the white give it an incredulous, slightly and mockingly ironic and skeptical look. In a second it will be off, eluding the deadly but too-heavy crossbow bolt. The hawk, which—expecting to be launched at a hare—will be momentarily confused, and therefore, although swift, it will not be swift enough to catch the little raven, assuming it would even try to do so.

The urgent summons of the gesturing gentleman will seem foolish and superfluous, as the sword-bearing protagonist, yet breathing out threatenings and slaughter, arrives on the scene, sword drawn, earthbound, only to watch the little black bird sail away on the breeze, cawing in triumph at its escape.

In such a circumstance it is difficult to agree that a crossbow is just a crossbow. Indeed, this scene fairly cries out to be read politically: In the medieval liturgical poetry of Jewish Spain, Israel was often configured as the *ahot ketanah ve-sheharhoret*, the *niña morena*—the little black girl—downcast and darkened by her sins, and awaiting redemption.[13] In this illumination, Israel is figured as the abject raven, and hunted by various means: On the one hand, it is subject to heavy-handed and overblown assaults coming from a weapon in the shape of a cross, perhaps representing the Church.[14]

13. Cf. Song of Songs 1:5, and the *piyyut Ahot K'tanah* by R. Avraham Hazzan Girundi, Spain, 13th century.

14. The weapon is indisputably cross-shaped, but obviously

'cross-bow' is an English term, in Spanish it is 'ballesta,' and in my continuing work on this image I am exploring the use of that term in puns and proverbs.

On the other hand, it is pursued by a method more conventional in the hunting of birds—a courtly prerogative and pleasure. As opposed to the blunt directness of the crossbow assault, hawking is an indirect method of hunting—pursuit by means of intermediaries. If the hunters represent the secular nobility oppressing the Jews, their hawks might signify their agents, perhaps Jewish informers (that is, other, captive, birds).

Finally, the knight drawing his sword represents either the army or the mob—in any event militarized onlookers—ready to sweep down even more heavy-handedly at a moment's notice from informers to administer a *coup de grâce*, a fatal blow which is unnecessary and would be almost comedically exaggerated were it not so cruel.

Such a political reading is reinforced by its parallels in another manuscript that is correlated with the Cervera Bible. It has long been acknowledged that the authorship of this second manuscript was both aware of and actively imitated the design conventions of the Cervera Bible, but I hope to demonstrate that that authorship was conceptually attuned to the ideological subtleties of the Cervera Bible as well.

Just as the Brother Haggadah has a younger sibling—the Rylands Haggadah—that pays it homage, the Cervera Bible has a younger sibling that iconographically references it as well. The Kennicott Bible, now in the Bodleian Library (Ms. Kennicott 1), was illuminated in Coruña, Spain, in 1476. It is almost exactly the same size and has just about the same number of leaves as the Cervera Bible. In style, the manuscript, with its many horseshoe arches, is much more nostalgically Mooresque than the predominantly gothic-arched Cervera Bible.

The fact that the manuscripts are 'siblings' is evident in a number of ways. The anthropomorphic and zoomorphic letters of the colophon of the Kennicott Bible, for instance, imitate those in the highly unusual colophon of the Cervera Bible. And like the Cervera Bible, the Kennicott Bible also contains the text of scripture followed by a grammatical text written by David Kimchi—in this case, *Sefer HaMikhlol*. Finally, and most importantly for our purposes, just as in the Cervera Bible, the Kimchi grammar is illustrated with images that can be read as descriptive of—or perhaps

protesting against—aspects of the contemporary situation of Jews in Spain. (Fig. 12).

Here, a variety of stronger animals—dogs, hawks, and foxes—hunt and devour weaker animals—hares and chicks. It seems, then, that along with the many other ways in which scholars have already noted the dependence of the authorship of the Kennicott Bible upon the Cervera Bible as a model, the authorship also looked back to the Cervera Bible as a template for where to physically situate iconography that articulated messages of protest against the depredations of the contemporary regime.

In both manuscripts, that 'commentary space'—so to speak—appears not in the more regularly-consulted scriptural pages that make up the bulk of the manuscript, but in the figurative margins or the conceptual *'bas de page'* of the book as a whole and integral object—in other words, in the grammatical works at the end of each manuscript. In both Bibles, it is obvious—both from what we know about the requisite daily religious practice of studying scriptural text, and from the relative lack of signs of wear to the pages of the grammatical works, as compared with the main text—that these grammars were consulted far less often than the Scriptural bulk of the Bibles.

The images thus appear in each case in the margins of a work that is marginal to the larger work. It appears to have seemed prudent to the authorship of both manuscripts to conceal iconography with a critical message in a less-often perused, secondary, admittedly dry grammatical work, than, say, to critique the king iconographically in the obvious places: in the illustrations of the scriptural passages describing the Egyptian oppression, in the explicit and bold manner of, say, the Barcelona Haggadah.

In spite of their similarities, the Kennicott Bible differs from the Cervera Bible in that while the Kennicott Bible contains many more images of protest, they are devoid of solution or resolution. Not only do they lack the bold explicitness of the Barcelona Haggadah, where the illustrations depict both the oppression of Jews by gentiles and its resolution in the reverse servitude of the gentiles to the Jews, but they even lack the subtly subversive element that is so elegantly hidden in the implied ensuing action in the earlier Cervera Bible. Nothing is implied here; there is only oppression.

ולמד הפועל כסגול או למר
הפועל בקמץ והם בשבא פהדד פחני

FIGURE 12. Bible, Coruña, Spain, 1476, Oxford, British Library, Ms. Kennicott 1, fol. 888ᵃ (© The Bodleian Libraries).

And the outcome is obvious, and devastating. There are only two occasions in the Kennicott Bible on which this protocol is breached, but they are very striking, both in their explicitness, and in their subtle differences from one another.

On folios 442ᵇ and 443ᵃ, we note not only messages of protest, but, finally, dreams of subversion as well. Folio 443ᵃ depicts a castle of mice attacked by an army of ten cats (Fig. 13). The cat leading the attack wears a crown—not a particularly subtle iconography. But interestingly, only he and one other cat are armed with swords and shields. The remaining eight are shown in military ranks but unarmed. By way of contrast, the six mice are armed with twelve spears between them. The weak, thus, appear in a defensive position, but holding the position nicely. The contest thus seems reasonably equal in spite of expectations, so the outcome, while still indeterminate, looks cautiously hopeful.

In the illustration on the opposite page, an army of fourteen hares attack a wolf's castle (Fig. 14). The hares are more numerous than the cats in the illustration on the opposite page—and they are well-armed, with spears as opposed to swords. Interestingly, there are two crowned hares. One sits on a throne at the rear, and the other leads the army. The castle is inhabited by a lone, apparently unarmed wolf.

As opposed to the other illustrations in the Kenni-cott Bible, which depict the depredations of the world as seen through the eyes of Jews of the Kingdom of Castile in 1476, and perhaps messages of protest about these depredations, these images, by way of contrast, express dreams of subversion in a *mondus inversus* mode, more akin to the eschatological images in the Barcelona haggadah.

The battle of the mice with the cats represents the world as it is: The years 1475–1476 were extremely tumultuous in Spain, given the invasion of the Portuguese under Alfonso V, and the war for the Castilian throne. The Jews, represented by the mice, are a besieged minority, but they remain confident that they can hold their position. According to the typology of implied ensuing action, the explicit action in the image is a siege, the prospective ensuing action—not shown, but implied only—is that the Jews will weather the siege. In this sense, the image has much in common with the 'before and after' typology of the Prague and Augsburg haggadot.

The battle of the hares with the wolf, on the other hand, has more in common with the eschatological projection of the Barcelona Haggadah. The hares—the Jewish people—are led by one crowned leader—the Messiah of the House of Joseph, the warrior Messiah. Behind him, sitting on the throne, is the Messiah the son of David, the ruler and leader of the redeemed

FIGURE 13. Bible, Coruña, Spain, 1476, Oxford, British Library, Ms. Kennicott 1, fol. 443ᵃ (© The Bodleian Libraries).

FIGURE 14. Bible, Coruña, Spain, 1476, Oxford, British Library, Ms. Kennicott 1, fol. 442ᵇ (© The Bodleian Libraries).

Jews. Against such an army, with such leadership, the gentiles have no hope, and the lone wolf against whom they march had better give up sooner rather than later, for it will not go well for him. The explicit action in the image is again a siege, but here—because the siege is undertaken by Jewish warriors—the implied, ensuing action is the ultimate total overthrow of gentile overlordship.

The corroboration of both protestant and actively subversive imagery in the Kennicott Bible attests to the fact that the authorship of that iconography, at least, read the images in the earlier Cervera Bible, on which they based their iconography, as messages of subversion. Again, the authorship of each manuscript places this iconography in the identical position in the manuscript—in the marginal or 'commentary space' of the grammatical works. Both bibles, then, project subversive responses to contemporary political circumstances, *via* implied, ensuing action. Each does so within its own context, but also—because of the relationship between the earlier Cervera Bible and the later Kennicott Bible that emulates and re-presents its iconography—across monuments as well.

To summarize again: The Barcelona Haggadah embodies eschatological projection. The Brother and Rylands haggadot demonstrate how ambiguous ensuing action may be sustained over related, roughly contemporaneous, but sequential works. Less ambiguous ensuing action sustained over related, roughly contemporaneous, but sequential works is demonstrated in the Prague and Augsburg haggadot. When read together these images have the cumulative effect of subversive political critique. Finally, implied ensuing action representing subversive dreams is evident both within the Cervera Bible itself (the raven hunt) and in the relationship between the Cervera and Kennicott Bibles.

I'd like to conclude with one more image that seems to me to concisely exemplify the employment of implied ensuing action to present subversive dreams. This seems at first glance to be a 'merely decorative image.' It is a depiction, from the so-called Leipzig Maḥzor, made in the very early fourteenth century, of four stylized flowers surrounding the word 'Shoshan,' which means 'rose' or 'lily.' It is the initial word for the liturgical poem 'Shoshan Emek Ayumah, Shabbat Shabbaton Le-Kaymah' ('The rose [or lily] of the valley trembled [in her zeal] to observe the Sabbath of Sabbaths [Yom Kippur], the Day of Atonement') recited at the additional service or *Mussaf*, on the morning of Yom Kippur (Fig. 15). These stylized flowers, so flat and symmetrical, with a single uniformly-sized point at the center may bring to mind volvelles, the free-rotating wheels of parchment or paper laid into manuscripts and early printed books to save the reader the trouble of turning the entire volume in order to view a part of a chart.[15] Upon closer scrutiny, it becomes clear why these flat images conveyed the impression of potential motion.

Although the two flower roundels above the initial word are bounded with very handsome diamond-shaped decoration, the two flower roundels below the initial word have—in place of those diamonds—distinctly 'directional' arrows, making them seem as if they should revolve. Moreover, these lower flowers are supplemented with a further iconography: A dog stands—rather precariously—on the right-hand roundel, while a hare, looking off to the left, balances equally unstably on the left-hand roundel. In the center, with its tail hanging down into the most narrow space between the roundels, a dragon opens its mouth, and roars with its head and body positioned upward, as if it is trying to ascend towards the word *Shoshan*. What is depicted here is most definitely a moment frozen in time. As in the case of the Bar Yokhni bird about to tip over and crush its egg, the illuminators are humorously toying with the shapes on the page to create a precarious balance that will be upset in the next moment. Yet the stakes are greater in this case.

15. The first known volvelle is applied to a manuscript of Matthew Paris, from 1250. Most early volvelles presented, tabulated, and as time went on, helped to calculate astronomical information, but they are also occasionally used to diagram magical or other practices as well. The element of motion added to the static framework of the book transforms it into an entirely different kind of medium. It becomes a hybrid of book and machine, a low-tech parchment or paper 'calculator.' See J. Helfand, *Reinventing the Wheel* (New York, 2002).

Figure 15. Maḥzor, Worms *c.* 1300, Leipzig, University Library, Ms. v. 1102, Vol. 11b, fol. 129ʳ (courtesy Leipzig University Library).

For fourteenth-century Jews the iconography of the hare pursued by dogs can represent the pursuit of Israel by her gentile persecutors. Likewise, for that same population, the dragon represents a quasi-divine force of great evil that is perpetually attempting to harm the Jewish people (here troped as the trembling rose or lily of the valley, per *Song of Songs* 2:1, and represented by the word '*Shoshan*') and even to usurp the place of God.[16]

Although the hare turns to the left, seeking to jump off its 'treadmill,' it appears, for all intents and purposes, to be locked into the seemingly endless cycle of its pursuit by the dog. The dog, too, seems inevitably doomed to continuously carry out its ultimately futile hunt. One can imagine the Jews for whom this image was created sighing under what they perceived as the boundless and immeasurable burdens of Exile, and what they felt was the interminable saga of their pursuit by the nations of the world.

But in spite of this, the illumination sounds a couple of hopeful notes. First, the dog will never actually capture the hare for good and for all. In other words, while suffering is inevitable, to quote Jeremiah, "'Yet even in those days," declares the LORD, "I will not destroy you completely"(5:18). "I am with you and I will save you (30:11).'" For there is a deeper, more theological observation being made by this iconography—a theodicy of exile and the pursuit of Israel by the nations.

As the result of the very same, frustrating, apparently futile process of history—which consists here of the seemingly endless cycle of the pursuit of Israel—when, in other words, those wheels begin to move—the forces of Evil in the universe, as represented by the dragon, will be brought down and crushed. One can imagine the wheels moving, the tail catching, the dragon being pulled under, and never having the opportunity to seize and harry the inviolate Israel, the *Shoshan*—the rose or lily. The message in a nutshell: Israel will suffer, the suffering will seem endless, but as a result of the very process of history set into mo-tion by that suffering, redemption will come and evil will be—quite literally—crushed.

In a context where iconography speaks to political and theological concerns, implied ensuing action—displaying a present state of an object while helping the viewer project a future state for that object—can transform what at first appears to be a frozen scene into an articulation of potentiality or consequence.

Readings taking into account the implied ensuing action of protagonists and/or objects can thus expand our horizons regarding the potential meanings of such iconography. The view of the object at rest is a snapshot, as it were, of the extant state of theological and political affairs in a given iconographic expression. But as soon as we notice that ensuing action is implied, it becomes clear that the *status quo* of political and theological meaning may also hint at or imply a potentiality or consequence that remains inchoate when one merely looks at the image as it is frozen in time.

But when one considers the image as a snapshot of something more kinetic—of a single moment in a continuum—the ultimate (and often dissident or questionably orthodox) political and theological messages implied but not articulated in the image reveal themselves. The strategy of implied ensuing action has the advantage of allowing the image itself to remain 'innocent' to the eyes of a similarly innocent viewer. At the same time, for those whose eyes have been opened to the strategy, the image's static present is simply a doorway to imagining its potential once it 'gets moving,' so to speak. And since the potentialities and consequences of the implied ensuing action are constructed only in the mind of the enlightened viewer, there is no trail of evidence that could lead to the indictment of such a viewer on charges of sedition or heresy. Images employing a strategy of implied ensuing action enable intelligent readers with a thirst for uncovering subversive agendas to commit the perfect crime, a thought-crime only, one for which there is no visual—but only imaginal—evidence.

16. See Epstein, *Dreams of Subversion* (as in note 6), 70–95.

ANNE RUDLOFF STANTON

Design, Devotion, and Durability in Gothic Prayerbooks★

FOR MEDIEVAL READERS, books were both more precious and more mutable than they are for modern owners of mass-produced printed books. The texts and images of prayerbooks in particular were often customized to reflect the geographical and familial ties, religious interests, and gender of their original owners, who could see themselves in their books in a way we can now only superficially understand.[1] These books, significant investments for their original purchasers, often formed part of the household goods that were passed from generation to generation, or transmitted by sale to other owners.[2] Many later medieval owners inscribed themselves into the books as well. For the most part, they added obituaries or other notes of ownership to the calendars and flyleaves of their inherited books, but at times their alterations more substantially reshaped the old books to reflect their own identities or interests.[3] This essay consists of reflections on the durability of the original designs of a few thirteenth-century prayerbooks made for English owners, and the range of ways in which these books were modified to better suit the interests of later owners.

The best-known medieval manuscripts are generally those with the most complex pictorial programs, or the most illustrious pedigrees. For example, the Psalter made for Louis IX around 1260, and the Book of Hours made for the use of his great-granddaughter, Jeanne d'Évreux, both survived essentially unchanged as they passed from heir to heir during the fourteenth and fifteenth centuries.[4] As Harvey Stahl and Joan Holladay have suggested, each book may have quickly

★ I thank Colum Hourihane for giving me the opportunity to contribute to the conference from which these collected papers were developed, for otherwise I would not have turned my thoughts to these particular prayerbooks. The published version has benefitted from comments at the conference and subsequently by Adelaide Bennett, Mildred Budney, Rabia Geha Gregory, Dierdre Jackson, Michael A. Michael, Nigel Morgan, Stella Panayotova, Virginia Reinburg, Lucy Freeman Sandler, Don Skemer, Patricia Stirnemann, and Alison Stones. I am also very grateful to Kathleen Doyle at the British Library, London, and Alison Metcalfe at the National Library of Scotland, Edinburgh, for their help with the Alphonso Psalter and the Murthly Hours.

1. Recent studies include A. Bennett, 'Issues of Female Patronage: French Books of Hours, 1220–1320,' in *Patronage: Power and Agency in Medieval Art*, ed. C. Hourihane (Princeton, N.J., 2013), 233–55, and *eadem*, 'Making Literate Lay Women Visible: Text and Image in French and Flemish Books of Hours, 1220–1320,' in *Thresholds of Medieval Culture: Liminal Spaces*, Boydell Studies in Medieval Art and Architecture, ed. E. Gertsman and J. Stevenson (Woodbridge, 2012), 125–58; A. Stones, 'Some Portraits of Women in their Books, Late Thirteenth-Early Fourteenth Century,' in *Livres et lectures de femmes en Europe entre moyen âge et renaissance*, ed. A.-M. Legaré (Turnhout, 2007), 3–27; N. Morgan, 'Patrons and their Devotions in the Historiated Initials and Full-Page Miniatures of 13th-Century English Psalters,' in *The Illuminated Psalter: Studies in the Content, Purpose and Placement*

of its Images, ed. F. O. Büttner (Turnhout, 2004), 309–22; K. A. Smith, *Art, Identity and Devotion in Fourteenth-Century England: Three Women and their Books of Hours* (London, 2003).

2. V. Reinburg, *French Books of Hours: Making an Archive of Prayer, 1400–1600* (Cambridge, 2012), esp. 53–83; E. Duffy, *Marking the Hours: English People and Their Prayers, 1240–1570* (New Haven, Conn., 2006), esp. 23–52; S. G. Bell, 'Medieval Women Book Owners: Arbiters of Lay Piety and Ambassadors of Culture,' *Signs* 7 (1982), 742–68, and reprinted multiple times.

3. Many types of books were completed or remodeled by later owners, and I thank M. Budney for sharing her essay on '"St Dunstan's Classbook" and its Frontispiece: Dunstan's Portrait and Autograph,' in *St Dunstan: His Life, Times and Cult*, ed. N. Ramsay, M. Sparks, and T. Tatton-Brown (Woodbridge, 1992), 103–42. For a later example, see L. F. Sandler, 'Notes for the Illuminator: The Case of the Omne bonum,' *The Art Bulletin* 71 (1989), 551–64, and *eadem*, *Omne bonum: A Fourteenth-Century Encyclopedia of Universal Knowledge. British Library MSS Royal 6 E VI–6 E VII*, 2 vols. (London, 1996).

4. For the Psalter of Louis IX (Paris, BnF, Ms. lat. 10525), see H. Stahl, *Picturing Kingship: History and Painting in the Psalter of Saint Louis* (University Park, Pa., 2008). For the Psalter in full, see the digital portal of the BnF: http://gallica.bnf.fr/. The Hours of Jeanne d'Évreux is now, New York, Metropolitan Museum of Art, the Cloisters, Ms. 54.1.2. J. A. Holladay addresses the cult status of both manuscripts in 'Fourteenth-century French

attained a cult status through its contact with, or evocation of, the famous king.[5] They may have been viewed less as working books than as relics, or perhaps reliquaries, objects whose worth resided in their original contact with the saint, and in their ability to enhance his veneration.

Some English prayerbooks were viewed by their early modern owners as ancestral relics, even when those ancestors were not saints. Around 1700, Nicholas Saunder wrote in the mid-thirteenth-century Wilton Psalter that 'This was my great-grandmother's father's booke and therefore for the antiquity's sake I keep it.'[6] Nicholas's ancestors had kept the Wilton Psalter unchanged, perhaps also 'for the antiquity's sake,' as did the later medieval owners of the early fourteenth-century Queen Mary Psalter, which also survived in its original form, other than two notations of later ownership.[7] Otherwise, these books do not display the kind of intentional changes to their textual or pictorial programs that might provide strong evidence of continued devotional engagement; they were not amended or updated to reflect changing devotional trends, and indeed the folios of the Queen Mary Psalter that contain its core devotional texts are very clean.

The complex design of the Tickhill Psalter is comprised of a dense sequence of captioned narrative scenes that illustrate the life of King David in its historiated initials and *bas-de-page* scenes.[8] But its decoration was never completed (Fig. 1). Work on the lengthy sequence of vignettes was likely abandoned around 1314, when John Tickhill, named as the patron in a fifteenth-century inscription, was removed from his position as prior of Worksop Abbey because of fiscal malfeasance.[9] The book remained at Worksop at least well into the fifteenth century, when someone, presumably one of the canons, inscribed folio 1 with a note asking readers to remember and pray for Tickhill's soul.[10] This is quite a memorial for a disgraced prior who was sacked a century before the inscription was written, and it suggests that the Psalter may already have become a treasured object even though its illumination, and thus its complex program, was never completed.

Many other medieval prayerbooks, however, display evidence of continued physical intervention from successive owners. The 'devotional accretions' that interest me here go beyond additions to the calendar or inscriptions of ownership, and include added liturgical or devotional texts or an enhanced decorative framework.[11] A preliminary survey of Psalters, Psalter-Hours, and Books of Hours illuminated in England between *c.* 1250 and *c.* 1350, as described in the Gothic volumes of the *Survey of Manuscripts Illuminated in the British Isles*, shows a variety of such accretions.[12] These

Queens as Collectors and Readers of Books: Jeanne d'Évreux and her Contemporaries,' *Journal of Medieval History* 32 (2006), 69–100, particularly 76–81.

5. Stahl, *Picturing Kingship* (as in note 4), 6, and Holladay, 'Fourteenth-Century Queens as Collectors' (as in note 4), 76–81.

6. London, Royal College of Physicians, Ms. 409. See N. Morgan, *Early Gothic Manuscripts 1250–1285*, A Survey of Manuscripts Illuminated in the British Isles, 5, ed. J. J. G. Alexander, 2 vols. (London, 1988), II: 55–57, no. 99.

7. For the Queen Mary Psalter (London, British Library, Ms. Royal 2 B. VII), see A. R. Stanton, *The Queen Mary Psalter: A Study of Affect and Audience* (Philadelphia, Pa., 2001); *Royal Manuscripts: The Genius of Illumination*, ed. S. McKendrick, J. Lowden, and K. Doyle (London, 2011), 272, no. 85; L. F. Sandler, *Gothic Manuscripts 1285–1385*, A Survey of Manuscripts Illuminated in the British Isles, 5, ed. J. J. G. Alexander, 2 vols. (London, 1986), II: 64–66, no. 56; G. Warner, *Queen Mary's Psalter* (London, 1912). Notations of 16th-century ownership were written on fols. 84 and 319[v], and something was clearly pasted in, and removed, from fol. 83[v]. For the manuscript in full, see the British Library Digitised Manuscripts portal: http://www.bl.uk/manuscripts/.

8. New York, New York Public Library, Ms. Spencer 26; see D. D. Egbert, *The Tickhill Psalter and Related Manuscripts* (New York, 1940); Sandler, *Gothic Manuscripts* (as in note 7), vol. 2, cat. no. 26; *eadem, The Splendor of the Word: Medieval and Renaissance Illuminated Manuscripts at The New York Public Library*, ed. J. J. G. Alexander, J. H. Marrow, and L. F. Sandler (New York; London, 2006), 201–07, and A. R. Stanton, 'Turning the Pages: Marginal Narratives and Devotional Practice in Gothic Prayerbooks,' in *Push Me, Pull You: Imaginative and Emotional Interaction in Late Medieval and Renaissance Art*, ed. S. Blick and L. Gelfand (Leiden, 2011), 75–122.

9. Egbert, *Tickhill Psalter* (as in note 8), 7. M. Michael, in 'Urban Production of Manuscript Books and the Role of the University Towns,' in *The Cambridge History of the Book in Britain II: 1100–1400*, ed. N. Morgan and R. M. Thomson (Cambridge 2008), 182, notes another instance in which a cathedral canon spent too heavily on an illuminated book.

10. Sandler, *Splendor of the Word* (as in note 8), 207.

11. For the phrase, see Duffy, *Marking the Hours* (as in note 2), 44, 83.

12. Morgan, *Early Gothic Manuscripts* (as in note 6), II: 66–67,

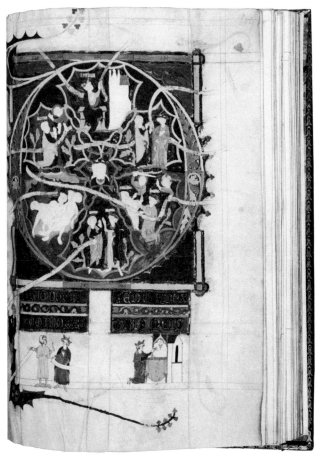

FIGURE I. Psalm 109. The Tickhill Psalter, *c.* 1303–1314. New York Public Library, Spencer Ms. 26, fol. 104 (New York Public Library).

range from the insertion of marks that restructured the psalms for monastic use, or the replacement of a litany with one for a different region, to the addition of prayers and charms in Latin and vernacular lan-

guages and the inclusion of substantial sequences of full-page illuminations. As case studies, I shall examine two Psalters catalogued in these volumes, and a Book of Hours that came to light subsequent to their publication.

The Tewkesbury Psalter, which was produced around 1260, is so named because of an obituary added to its calendar marking the death of Richard Cheltenham, abbot of Tewkesbury Abbey, in 1509.[13] Its psalms are grouped into the ten-part organization typical of English Psalters, each division set off by an enlarged historiated initial, often framed with the incipit in a gilded block (Fig. 2). The Psalter is otherwise elaborated by decorated initials and lovely, feathery penwork extensions into the margins.

The historiated initials provide word-pictures that illustrate or interpret the psalm incipits they occupy, following a long tradition of Psalter decoration.[14] Some present subjects common in contemporary English Psalters—Psalm 80 (Fig. 2) opens with an image of Jacob wrestling the angel—while in other initials King David acts out the incipit, an approach that was more common in French Psalters.[15] For example, the king kneels at the start of Psalm 101, hands raised in supplication in concert with the words *Domine exaudi orationem meam:* 'Hear my prayer, O Lord' (Fig. 3).[16] As Adelaide Bennett has noted, the increasing importance of David in psalm initial imagery over the course of the thirteenth century was linked not only to the king's presumed authorial role, but also to the growing emphasis on the penitential function of the psalms in lay devotion.[17]

no. 104, 82–85, no. 114, 135, no. 149, 149–50, no. 157, 162–64, no. 165, 164–66, no. 166, 182–83, no. 179, 191–92, no. 185; and Sandler, *Gothic Manuscripts* (as in note 7), II: 13–14, no. 1, 16–17, no. 5, 20–22, no. 11, 24, no. 14, 34–35, no. 29, 47–48, no. 41, 49–51, no. 43, 51–52, no. 44, 53–55, no. 47, 56–58, no. 50, 61–62, no. 53, 75–76, no. 67, 113–15, no. 104, 125–26, no. 112, 129–30, no. 116, 135, no. 121, and 143–45, no. 130. Books discussed by Duffy in *Marking the Hours* and Reinburg in *French Books of Hours* (as in note 2), demonstrate that book owners continued to remodel their prayerbooks well into the early modern period.

13. Princeton, Princeton University Library, Garrett Ms. 34. D. C. Skemer, *Medieval & Renaissance Manuscripts in the Princeton University Library* (Princeton, N.J., 2013), I: 32–35, Morgan, *Early Gothic Manuscripts* (as in note 6), II: 122–23, no. 138, and D. D. Egbert, 'The "Tewkesbury" Psalter,' *Speculum* 10 (1935), 376–86.

14. G. Haseloff, *Die Psalterillustrationen im 13. Jahrhundert* (Kiel, 1938); more recently, F. O. Büttner examined the subjects for each of the major psalm initials in 'Der Illuminierte Psalter im Westen,' in *The Illuminated Psalter* (as in note 1), 1–106 (for this topic, see 9–35).

15. For summary descriptions of typical psalm initials in English Psalters in the 13th and early 14th centuries, see Morgan, *Early Gothic Manuscripts* (as in note 6), II: 14, and L. F. Sandler, *The Peterborough Psalter in Brussels and Other Fenland Manuscripts* (London, 1974), 98–99.

16. All English Biblical translations are from the *Douay-Rheims Bible* (Baltimore, 1899).

17. A. Bennett, 'The Transformation of the Gothic Psalter in Thirteenth-Century France,' in *The Illuminated Psalter* (as in note 1), 211–21.

FIGURE 2. Psalm 80. The Tewkesbury Psalter, *c.* 1260s. Princeton, Princeton University Library, Garrett Ms. 34, fol. 71ᵛ (Princeton University Library).

FIGURE 3. Detail, Psalm 101. The Tewkesbury Psalter, *c.* 1260s. Princeton, Princeton University Library, Garrett Ms. 34, fol. 85ᵛ (Princeton University Library).

FIGURE 4. Detail, Canticle of Isaiah. The Tewkesbury Psalter, *c.* 1260s. Princeton, Princeton University Library, Garrett Ms. 34, fol. 123ᵛ (Princeton University Library).

Psalm 101 was the most common location for owner portraits in English Psalters of this period.[18] In Garrett Ms. 34, the image of the woman who likely was the first owner of the book appears instead at the beginning of the Canticles, kneeling with her hands raised as she acts out the incipit of the Canticle of Isaiah, *Confitebor domini* (Fig. 4). This initial is similar in composition to the initial that depicts David in prayer, and both images model for their viewer a physical response as well as an interior spiritual understanding of the words of the penitent David.[19] While our devotee appears to hold her hands in the same open gesture as David, she kneels, however, before a cross on an altar, and directs her wide-eyed gaze down and to the side; David on the other hand looks directly at the face of the incarnate God who appears in answer to his prayer. The pose of the owners, and their gestures, provided important visual cues regarding their prayers; for example, Nigel Morgan suggested that open hands may imply the modeling of a visionary experience.[20] Like the Tewkesbury David, an owner-image of a monk that opens Psalm 101 in the contemporary 'Map' Psalter gazes directly at the face of

the Christ-Logos and holds his hands high and open, touching the halo and almost the mouth of the figure, in a pose that foregrounds the relationship between the devotee and the Deity as a representation of his spiritual vision (Fig. 5).[21]

In his study of owner images in English Psalters from this period, Morgan mentions the Tewkesbury

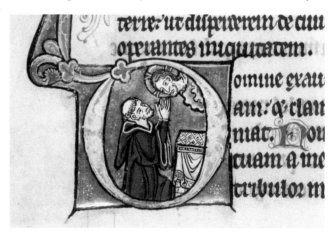

FIGURE 5. Detail, Psalm 101. The 'Map' Psalter, *c.* 1260s. London, British Library, Ms. Add. 28681, fol. 118ᵛ (© The British Library Board).

18. Morgan, 'Patrons and their Devotions' (as in note 1), 311, also notes that in contemporary French Psalters, images of David in prayer, and the owner in prayer, are sometimes interchangeable.

19. For more on the way that outward behavior and demeanor influenced the interior success of prayers, see K. A. Smith, *The Taymouth Hours: Stories and the Construction of the Self in Late Medieval England* (London; Toronto, 2012), 66–68.

20. Bennett, 'Issues of Female Patronage' (as in note 1), 234–35,

and Morgan, 'Patrons and their Devotions' (as in note 1), 317, both address relationships between the pose and gesture of the owner figures, with additional references.

21. For the 'Map' Psalter (London, British Library, Add. Ms. 28681), best known for the paintings of maps added to the original core of the book, see Morgan, *Early Gothic Manuscripts* (as in note 6), II: 82–84, no. 114, and *idem*, 'Patrons and their Devotions' (as in note 1).

initial in the context of confession, the critical first step toward true penitence.[22] The Canticle, drawn from Isaiah 12, is most often read now as 'I shall give thanks to you, o Lord.' Yet the word *confitebor* can be and was read as 'I shall *confess*,' as shown by its translation in Richard Rolle's *Psalter*, 'I sall shrif til the lord for thou ert wrethid til me.'[23] The downward gaze of the devotee in Garrett Ms. 34, which is not directed at a book as is almost always the case when owners look down rather than up, may suggest such a confessional or penitential reading, even though there is no confessor present. Unlike the pose of the David figure that opens Psalm 101, the owner's image might rather represent an *internal* process of envisioned and enacted confession, a prayer of the heart mediated only by the presence of the unadorned cross on her altar. Alcuin's assessment of the devotional guidance provided by the psalms seems appropriate here: 'In the Psalms, if you look carefully, you will find an intimacy of prayer such as you could never discover by yourself. In the Psalms you will find an intimate confession of your sins and a perfect application of divine mercy.'[24]

While we do not know the identity of this woman, a spate of obits added to the calendar in the fifteenth century demonstrates that the Psalter was handed down to members of the Beauchamp and Despenser families, who followed the de Clares as the main patrons of Tewkesbury Abbey.[25] Some of these obits, which link the Psalter to three of the most powerful families in late medieval England, suggest that the book may have been handed from mother-in-law to daughter-in-law, at least twice: there are entries for

Johanna FitzAlan, wife of William Beauchamp, and her daughter-in-law Isabel Despenser, and then for her daughter-in-law Cecily Neville. It is not unreasonable to suggest, as did Egbert and Skemer, that the woman giving praise—or confessing—in the *Confitebor* initial might be an earlier member of one of these families.[26]

For the women who used the Tewkesbury Psalter in the following decades, its psalms and canticles, Litany, and Office of the Dead—the core texts of most Gothic Psalters—were not enough, even decorated with the image of a penitent woman with whom they could self-identify. Around 1300, one of these owners added a gathering to the back of the book, on which were written two collects. Another owner returned to the gathering at the end of the fourteenth century and added two more texts. The first was an Anglo-Norman version of St. Gregory's Trental, an *exemplum* that illustrated the power of saying a series of trentals, or triads of Masses, for the deliverance of sinful souls.[27] The next two pages contain, in the same hand, seven very short Latin prayers, the number surely not a coincidence, which were to be addressed to the Virgin and other holy figures by a female supplicant.[28] The image of the devotee opening the Canticles, the feminine voice of these texts, and the pattern of transmission indicated in the obits, support the idea that this Psalter was used by women for most of its devotional life.

The multi-generational life of the Tewkesbury Psalter may reflect a certain flexibility in its basic design, which, in spite of the unusual composition of the owner portrait, represented relatively standard choices on the part of its designer. Perhaps subsequent own-

22. Morgan, 'Patrons and their Devotions' (as in note 1), 313 n. 23, cites other manuscripts in which figures in patronal images kneel, often before confessors. A. Kumler, in *Translating Truth: Ambitious Images and Religious Knowledge in Late Medieval France and England* (New Haven, Conn., 2011), 230, discusses the initial to this canticle in a Psalter in Oxford, Bodleian Library, Ms. Douce 131, fol. 126[r], which shows a devotee confessing to a priest.

23. H. R. Bramley, *The Psalter; or Psalms of David and Certain Canticles with a translation and exposition in English by Richard Rolle of Hampole* (Oxford, 1884), 494.

24. Here quoted from C. M. Kauffmann, *Biblical Imagery in Medieval England, 700–1550* (London, 2003), 118.

25. For a full list of the obits, see Skemer, *Medieval & Renaissance Manuscripts* (as in note 13), 1: 34–35. For more on Tewkesbury Abbey and its patrons, see M. Lawrence, 'Secular Patronage and Religious Devotion: The Despensers and St Mary's Abbey,

Tewkesbury,' in *Fourteenth-Century England*, ed. N. Saul (Woodbridge, 2008), V: 78–93.

26. Skemer, *Medieval & Renaissance Manuscripts* (as in note 13), 1: 34; Egbert, '"Tewkesbury" Psalter' (as in note 13), 377–79.

27. Fols. 146–148[v]; Skemer, *Medieval & Renaissance Manuscripts* (as in note 13), 1: 34; on the Trental, see R. Dean and M. Boulton, ed., *Anglo-Norman Literature: A Guide to Texts and Manuscripts* (London, 1999), no. 642. As Skemer notes, the Trental in the Tewkesbury Psalter, although it is in Anglo-Norman, follows English form in some respects; see Richard Pfaff, 'The English Devotion of St. Gregory's Trental,' *Speculum* 49 (1974), 75–90.

28. Skemer, *Medieval & Renaissance Manuscripts* (as in note 13), 1: 33–34, identified the fourth prayer, 'O maria piisima stella maris' in Ulysse Chevalier, *Repertorium hymnologicum*, Bibliothèque liturgique, Subsidia hagiographica, no. 4 (Louvain, 1892–1921), no. 13213.

ers were more free to read themselves into the book, and free to augment its devotional texts as needed, because it was not as clearly tailored to, or tethered to, a particular program. Several other prayerbooks included in the Morgan and Sandler *Survey* volumes, first illuminated with historiated or decorated initials at the major divisions in the late thirteenth or early fourteenth centuries, were similarly augmented with additional devotional texts by later owners.[29] A Psalter made initially for a lady of the Bohuns of Midhurst in the 1270s, for example, was in Italy by the fifteenth century, where prayers were added 'in a humanist hand,' and a fifteenth-century owner added Latin prayers to the Psalter of Queen Philippa, made around the 1330s.[30]

While these Psalters, like the Tewkesbury Psalter, were essentially complete in their first iteration, other manuscripts were left unfinished when circumstances prevented their completion for their first owners. A prime example of this is the Tickhill Psalter, mentioned above, with its ambitious decorative scheme of hundreds of scenes from the life of David, abandoned around the time that its patron, John Tickhill, was let go of his post as Prior of Worksop Abbey (Fig. 1). But this seems to be unusual; unfinished prayerbooks were more often completed by subsequent owners.[31]

One well-known example is the Alphonso Psalter, so called because it was begun in anticipation of the marriage of Prince Alphonso, son and heir of Edward I, to Margaret of Holland.[32] By the time the prince died, a few months before the wedding in 1284, the psalms, canticles, and Litany appear to have been written out, and illuminated in the first two gatherings with an abundance of naturalistic detail that has been celebrated in the scholarly literature (Fig. 6).[33] The project was taken up again around 1297 when the book was completed for Alphonso's youngest sister Elizabeth, who in that year married John I of Holland, the brother of the nearly-widowed Margaret. Around this time a calendar was added, in which Elizabeth's own name would be inserted after her death, and the embellishment of the texts was completed with decorated initials at the main psalm divisions. These decorations were not as *de luxe* as those of the first gathering, with its richly-colored birds and delicate gold brushwork on top of the burnished gold leaf of the Beatus initial. The completed Psalter also lacked the full suite of pictorial initials that, like those of the Tewkesbury Psalter, might have served as spiritual mirrors for its owner.

Elizabeth was widowed in 1299, and in 1302 she married Humphrey de Bohun, the fourth Earl of Hereford. By the time she died in 1316 from the complications of childbirth, she had borne at least ten children.[34] During this period a small gathering of four leaves was inserted in front of the calendar. Three of its folios were quartered and filled with a total of twelve

29. See note 12.

30. Morgan, *Early Gothic Manuscripts* (as in note 6), II: 164–66, no. 166, and Sandler, *Gothic Manuscripts* (as in note 7), II: 122–23, no. 110.

31. The St. Omer Psalter, London, British Library, Yates Thompson 14, Sandler, *Gothic Manuscripts* (as in note 7), II: 113–15, no. 104, was begun in the 2nd quarter of the 14th century, but the texts and decoration were completed in the 15th. On the other hand, Oxford, Bodleian Library, Ms. Laud Lat. 114, in Morgan, *Early Gothic Manuscripts* (as in note 6), II: 144–50, no. 157, was begun in the 13th century, but only one initial was completed at that time, and while others were illuminated in the mid-14th century, some were left unfinished.

32. London, British Library, Add. Ms. 24686. *Royal Manuscripts: The Genius of Illumination,* ed. S. McKendrick, J. Lowden, and K. Doyle (London, 2011), cat. no. 17; Sandler, *Gothic Manuscripts* (as in note 7), I: 22 and 27, and II: no. 1; G. E. Hutchinson, 'Attitudes toward Nature in Medieval England: The Alphonso and Bird Psalters,' *Isis* 65 (1974), 5–37, esp. 29–33; E. A. Bond, 'Description of an Illuminated Latin Psalter, formerly in the library founded by Archbishop Tenison, in the Parish of St. Marin in the Fields, London,' *Fine Arts Quarterly Review* 1 (1863), 77–96. For the manuscript in full, see the digital portal of the British Library: http://www.bl.uk/manuscripts/FullDisplay .aspx?index=0&ref=Add_MS_24686.

33. P. Tudor-Craig, 'Patronage, Iconography and Franciscan Thought in the Alphonso Psalter, BL Additional MS 24686,' in *Tributes to Nigel Morgan: Contexts of Medieval Art: Images, Objects and Ideas,* ed. J. M. Luxford and M. A. Michael (London, 2010), 77–92; J. A. Givens, *Observation and Image-Making in Gothic Art* (Cambridge, 2005), p. 164; and Hutchinson, 'Attitudes toward Nature' (as in note 32).

34. J. Lowden, 'The Royal Manuscript as Idea and Object,' in *Royal Manuscripts* (as in note 32), 32. The most complete biography of Elizabeth remains the chapter in M. A. E. Green, *Lives of the Princesses of England from the Norman Conquest* (London, 1857), III: 1–59; for her Bohun progeny, see L. F. Sandler, *The Lichtenthal Psalter and the Manuscript Patronage of the Bohun Family* (London, 2004), 15.

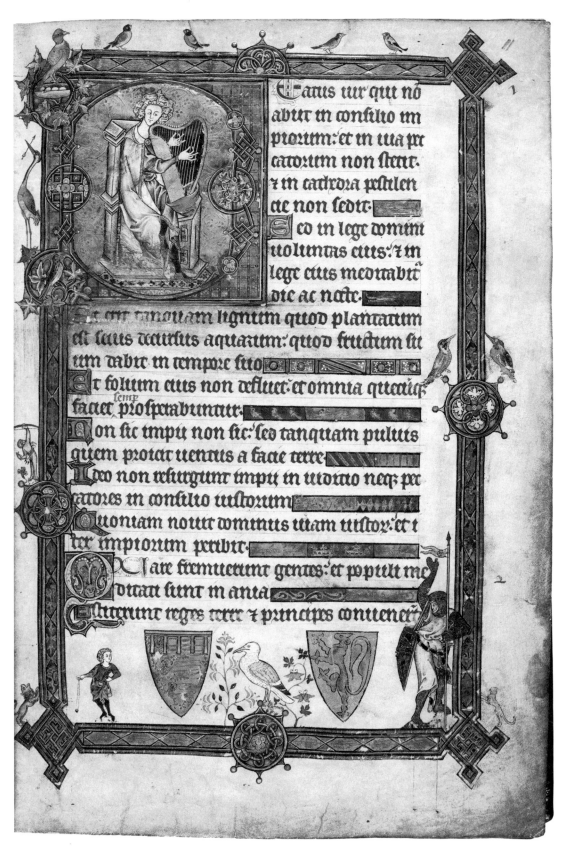

FIGURE 6. Psalm 1. The Alphonso Psalter, begun *c.* 1284; completed by 1316. London, British Library, Ms. Add. 24686 (©The British Library Board).

smaller illuminations, painted by an early fourteenth-century artist. Here Elizabeth would find a total of twelve saints, eight of which are women, in a series that includes St. Catherine with her wheel, St. Margaret with her dragon, and St. Anne, who is teaching the Virgin from an open version of the same prayerbook that nearly all of the other saints hold (Fig. 7).[35] The next three folios are each divided into six compartments that all together hold a total of eighteen smaller illuminations, cut from another source and then pasted down and painted into diapered backgrounds that feature, in one instance, the arms of the Bohun family (Fig. 8). Rows of holes in the top margins of each of these leaves indicate that these illuminations were veiled, a measure doubly useful for the protection of the patched-in Passion scenes.[36]

The origin of the tiny Passion illuminations, each around 32 mm in height, is unclear. In a 2010 essay, Pamela Tudor-Craig suggested that the scenes were in fact relics of the original campaign, part of a sequence begun by the first artist that was cut up and 'clumsily mounted' after 1302.[37] And indeed they are oddly placed; in the compositions on folios 4 and 4ᵛ the miniatures all are mounted toward the outer borders of their respective compartments (Figs. 8, 9). These miniatures might have been cut out from borders,

columns, or compartments of larger folios, but it is more likely that they were separate leaves from a diminutive manuscript, for their margins, visible beneath the paint of the backgrounds, are often wider on one side than another. Alison Stones has catalogued several very small Books of Hours, illuminated in the late thirteenth and early fourteenth centuries in northern France and Paris, and indeed the style and iconography of the miniatures may suggest a northern French origin.[38] John Lowden suggested that the leaves were taken from another manuscript owned by Elizabeth, and indeed the choice to include them may indicate that they were from a favorite book.[39]

Whatever its origin, this Passion sequence is relatively long, and its depiction of the Virgin helping to support the weight of the Cross—perhaps another indication of the miniatures' Continental origin—marks the introduction of this iconography to English manuscripts (Fig. 8).[40] The final scenes of the narrative, at the bottom of folio 4ᵛ, are the three Marys at the Tomb, and the *Noli me tangere* (Fig. 9). This story may have ended with these two scenes for many practical reasons—perhaps there were not enough scenes in the original source to fill another six compartments—but the effect was to emphasize the role of the women of the Gospels as the only witnesses to the

35. Sandler, *Gothic Manuscripts* (as in note 7), II: 13–14, no. 1. For more on the image of St. Anne teaching the Virgin to read, see P. Sheingorn, '"The Wise Mother": The Image of St. Anne Teaching the Virgin Mary,' *Gesta* 32 (1993), 69–80, and W. Scase, 'St Anne and the Education of the Virgin: Literary and Artistic Traditions and their Implications,' in *England in the Fourteenth Century: Harlaxton Medieval Studies III*, ed. N. Rogers (Stamford, 1993), 81–96.

36. For more on such veils, see C. Sciacca, 'Raising the Curtain on the Use of Textiles in Manuscripts,' in *Weaving, Veiling, and Dressing: Textiles and their Metaphors in the Late Middle Ages*, ed. K. Rudy and B. Baert (Turnhout, 2007), 161–90.

37. In 'Patronage, Iconography and Franciscan Thought' (as in note 33), 80, where she notes that the style of the tiny paintings is very similar to initials in another manuscript by the same artist.

38. The French origin of these miniatures was proposed in Deirdre Jackson's catalogue entry in *Royal Manuscripts* (as in note 34), 130. In a personal communication, Alison Stones (December 2013) agreed that the proportions of the margins suggests that they were originally leaves from an unusually tiny manuscript, and further connected them on the basis of their style with a

group of northern French manuscripts, an issue that calls for more scrutiny. I am grateful to Prof. Stones for sending material from her forthcoming *Survey of Gothic Manuscripts 1260–1360*, part 2 (Turnhout), in which she discusses a group of tiny Books of Hours, one of which retains a set of full-page prefatory miniatures focusing on scenes of the Passion.

39. Lowden, 'The Royal Manuscript as Idea and Object' (as in note 34), 32.

40. Reference to a chart comparing Passion scenes in 13th-century English contexts in Kauffmann, *Biblical Imagery in Medieval England* (as in note 24), 167, suggests that the sequence in Add. 24686 presents a more comprehensive narrative of the Passion than most contemporary cycles. On the image of Mary helping carry the cross, see Stanton, *Queen Mary Psalter* (as in note 7), 132, where I note its occurrence in the Queen Mary Psalter, the Taymouth Hours, and the De Lisle Hours. It was discussed most recently by Smith, *The Taymouth Hours* (as in note 19), 211 and 280 n. 21. Early 13th-century examples do however appear in books from France and the Mosan region, for example in a series of roundels depicting the life of Christ in a Psalter-Hours illuminated in the region of Paris (New York, Morgan Library, Ms. M. 153, fol. 21).

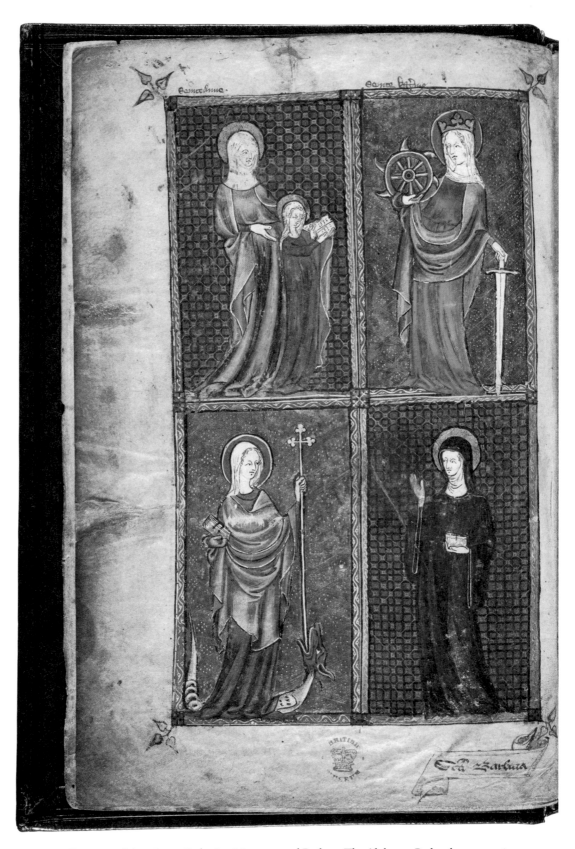

FIGURE 7. Saints Anne, Catherine, Margaret, and Barbara. The Alphonso Psalter, begun *c.* 1284; completed by 1316. London, British Library, Ms. Add. 24686 (©The British Library Board).

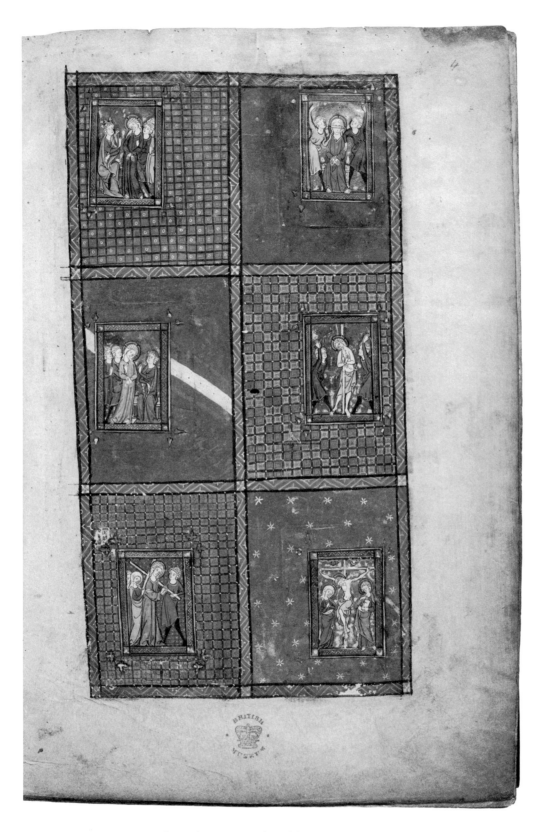

FIGURE 8. Scenes from the Passion. The Alphonso Psalter, begun *c.* 1284; completed
by 1316. London, British Library, Ms. Add. 24686, fol. 4 (©The British Library Board).

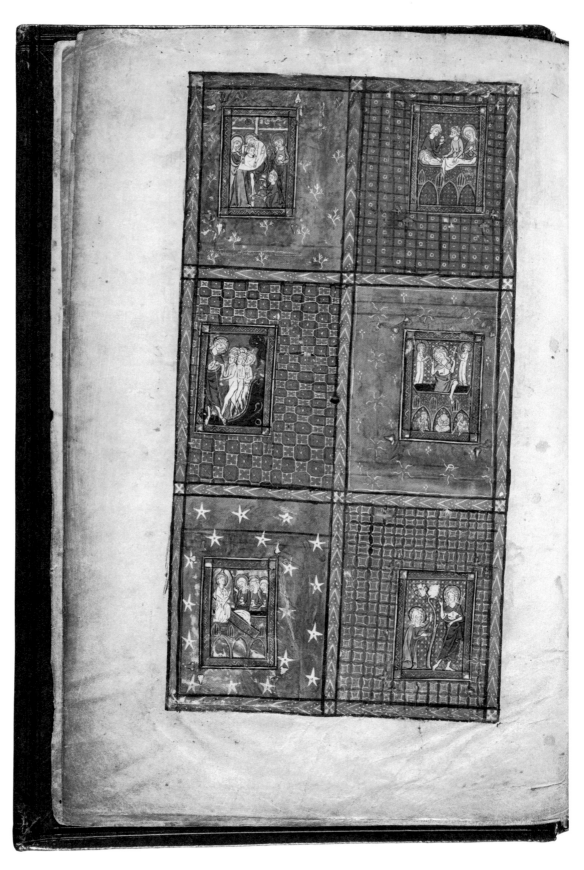

FIGURE 9. Scenes from the Passion. The Alphonso Psalter, begun *c.* 1284; completed by 1316. London, British Library, Ms. Add. 24686, fol. 4ᵛ (©The British Library Board).

Resurrection.[41] The impact of this story is heightened by the placement of its scenes. Each postage-stamp-sized painting is isolated in a relatively large decorative field that, particularly with the off-center placement of the paintings in their respective compartments, seems to telescope the viewer's gaze more deeply into the miniscule image. Further, the choice of scenes seems aimed at a viewer for whom the participation of the compassionate Virgin, and other biblical women, would have enhanced her own contemplation of the Passion. Elizabeth's own participation was further enhanced by the need to lift a veil to view each set of images.[42]

Pictorial prefaces were a component of many Psalters produced in England, especially, in the late twelfth and thirteenth centuries.[43] Princeton Garrett Ms. 35, the subject of Lucy Freeman Sandler's essay elsewhere in this volume, was produced around 1300 with fourteen full-page illuminations that culminated with an opening that displayed the Trinity, now defaced, and the Triumph of the Virgin.[44] In the case of the Alphonso Psalter, the addition of the prefatory gathering reframed the calendar, psalms, and litany of the original book in the context of devotion to the saints and meditations on the Passion, and enhanced the pictorial impact of this Psalter.

The immediacy of this preface was heightened by the Anglo-Norman prayer, in the voice of its female supplicant, that was written on a blank folio after the end of the Collects (Fig. 10). E. A. Bond, who transcribed the text in 1863, judged it 'a curiously superstitious prayer—calling to mind the half prayer, half charm of still earlier times.'[45] Ruth Dean characterized it more recently as a 'spontaneous, informal, somewhat panicky' prayer, written in an unprofessional hand.[46] And it is roughly written—which is one reason it is illustrated here—but it may not be spontaneous. The first portion is a previously unidentified Anglo-Norman translation of the prayer 'Deus Propicius Esto,' which appears in Psalters, Psalter-Hours, and Books of Hours and was, indeed, half prayer, half charm.[47] It consists of a series of invocations to God, Jesus, the archangels, and the angels, and concludes with invocations to the Cross, marked with tiny cross symbols that prompted the reader to make the sign of the cross herself.[48] The last several lines of the prayer reflect either a second prayer or an unusual continuation of the first, and invoke the power of the sign of the

41. On the importance of Passion imagery in the 13th century, see Kauffmann, *Biblical Imagery in Medieval England* (as in note 24), Ch. 5; Morgan, *Early Gothic Manuscripts* (as in note 6), II: 13; for more on the iconography of Mary at the Passion at this time, see N. Morgan, 'Texts and images of Marian Devotion in Thirteenth-Century England,' in *England in the Thirteenth Century: Proceedings of the 1989 Harlaxton Symposium*, ed. W. M. Ormrod (Stamford, 1991) 69–103, and *idem*, 'Texts and images of Marian Devotion in Fourteenth-Century England,' in *England in the Fourteenth Century: Proceedings of the 1991 Harlaxton Symposium*, ed. N. Rogers (Stamford, 1993), 34–47.

42. Sciacca, 'Raising the Curtain' (as in note 36), 185–86.

43. One of the most comprehensive examinations of the development of prefatory Psalter images is still I. Ragusa, 'A Gothic Psalter in Princeton: Garrett Ms. 35,' Ph.D. diss. (New York University, 1966), 2–107, but Kauffmann also surveys the incorporation of full-page narrative illumination cycles in England, from their appearance in the eleventh-century Tiberius Psalter (London, British Library, Ms. Cotton Tiberius C. VI), their efflorescence in 12th-century luxury Psalters, and their augmentation in the 13th century with additional devotional images of saints, in *Biblical Imagery in Medieval England* (as in note 24), chapters 4 and 5 in particular. A more recent study, which expands the history of prefatory sequences in English manuscripts to include the small number of royal French manuscripts in which

they occur, is Stahl's *Picturing Kingship* (as in note 4), esp. pp. 133–39.

44. See L. F. Sandler's chapter in the present volume; Skemer, *Medieval & Renaissance Manuscripts* (as in note 13), I: 35–37, and Sandler, *Gothic Manuscripts* (as in note 7), II: no. 35; fols. 12ᵛ–13; Ragusa, 'Gothic Psalter in Princeton' (as in note 43).

45. Bond, 'Description of an Illuminated Latin Psalter' (as in note 32), 96.

46. Dean and Boulton, *Anglo-Norman Literature* (as in note 27), 448, no. 854.

47. For more on this 'magical' prayer, see E. Duffy, *Stripping the Altars: Traditional Religion in England 1400–1580* (New Haven, Conn., 1992), 269–71, and Smith, *Art, Identity and Devotion* (as in note 1), 252–56 and 305, where she discusses its inclusion in the De Bois Hours (New York, Morgan Library, Ms. M. 700). It is also found in the Psalter-Hours of Comtesse de la Table de Coeuvres, formerly identified as Yolande of Soissons (New York, Morgan Library, Ms. M. 729); see K. K. Gould, *The Psalter and Hours of Yolande of Soissons* (Cambridge, Mass., 1978), 117, and Bennett, 'Making Literate Lay Women Visible' (as in note 1), 145 n. 47.

48. D. Skemer, *Binding Words: Textual Amulets in the Middle Ages* (University Park, Pa., 2006), 94. I am grateful to D. Skemer and to V. Reinburg for directing me to references on these symbols.

cross for the orphaned woman who is to make the sign after each invocation. The final 'Amen' at the end of the prayers is followed by another, more roughly-rendered cross prompt and an illegible script written in an extremely shaky hand. As the petitioner refers to herself as an orphan in the last legible line, Dean suggests that the leaf may have been inscribed by Elizabeth herself after the death of her father, Edward I, in 1307.[49]

If Elizabeth did not write out the bulk of the prayer, she might well have added the final shaky, unreadable lines in the extremis of grief or fear. It is very tempting to read the intensely personal and almost breathless, chanting quality of these words in the context of a woman who was constantly pregnant, who by the end of 1307 had recently lost not only her father but her sister, Joan of Acre, and at least three of her children.[50] While the sequence of additions is unclear—we do not know whether the prefatory gathering was added before, or after, the prayer was written—they are certainly complementary. The images of St. Catherine holding the wheel of pain she shattered by prayer, and of St. Margaret, destroying the dragon by making the sign of the cross (visualized as a cross-topped weapon) illustrated the power of this very prayer, which called upon the sign of the cross to protect the supplicant from many dangers.[51] Furthermore, images and texts that invoked St. Margaret were frequently used to ensure a safe delivery for women in labor.[52] These additions, in other words, appear to have been tailored to Elizabeth's ongoing use of this Psalter as a devotional, magical, and practical aid, updating the ancient psalms with penitential images and vernacular prayers. Indeed, the Alphonso Psalter was so reshaped by the

materials added in the early fourteenth century that we should now remember it instead as the Elizabeth Psalter, for the calendar commemorates Elizabeth and her household, not her long-dead brother, and it is her voice that we hear, and her gestures that we imagine, in that final prayer.[53]

While Elizabeth's Psalter was remodeled for use over a couple of decades, John Higgitt excavated evidence of a longer active life for a Book of Hours now known as the Murthly Hours, after its location at Murthly Castle in the early nineteenth century.[54] The devotional core of this prayerbook was produced in Paris in the 1280s, with fine historiated initials and marginal decoration, but the texts show that it was intended for an English devotee, who is represented with her open book—its incipit fully visible—in the initial that opens the Gradual Psalms (Fig. 11). The incipit of Matins of the Virgin is now missing, perhaps with the heraldry that would have identified our devotee. Higgitt suggested that it may have been made for the use of Joan de Valence, the daughter of the French knight William de Valence and wife of the Scottish lord John Comyn, given the remarkable convergence of French, English, and Scottish elements in the book as it survives today.[55]

The prayerbook received by this young woman in the late thirteenth century held fully decorated versions of the texts typical for these newly-fashionable *Horae*: a calendar, the Hours of the Virgin, the Hours of the Holy Spirit, the Penitential Psalms, the Litany, the Gradual Psalms, and the Office of the Dead.[56] The historiated initials that marked out the different hourly prayers to the Virgin provided the young woman with scenes from the Infancy of Christ, a popular form of decoration here presented in luxurious form, with the

49. Dean and Boulton, *Anglo-Norman Literature* (as in note 27), 448, no. 854.

50. As above, note 34.

51. Fol. 136ʳ, lines 22–25: 'Par icest signacle Ihesu Christ [†], e par la vertue ke de vouz prist moun cors e malme, huy sauvez e gwiez de pecche, e de vilaynie me defendez.'

52. Skemer, *Binding Words* (as in note 48), 236; see Smith, *Art, Identity and Devotion* (as in note 1), 254–56, for a discussion of protective charms and prayers for childbirth included in the De Bois Hours.

53. Obits record Robert and Margaret de Haustead and Joan de Mereworth, who were with Elizabeth in Holland and, at least in the case of Robert, are recorded as caring for one of the

Bohun children after Elizabeth's death. Bond, 'Description of an illuminated Latin Psalter' (as in note 32), 85. Deidre Jackson will provide further discussion of this Psalter in Elizabeth's hands in her forthcoming book on *Medieval Women*.

54. Edinburgh, National Library of Scotland, Ms. 21000. J. Higgitt, *The Murthly Hours: Devotion, Literacy and Luxury in Paris, England and the Gaelic West* (Toronto, 2000); Bennett, 'Issues of Female Patronage' (as in note 1), 243. For the manuscript in full, see the digital portal of the National Library: http://digital.nls.uk/murthlyhours/.

55. Higgitt, *Murthly Hours* (as in note 54), 23–26.

56. For a full description, see Higgitt, *Murthly Hours* (as in note 54), Appendix 4.

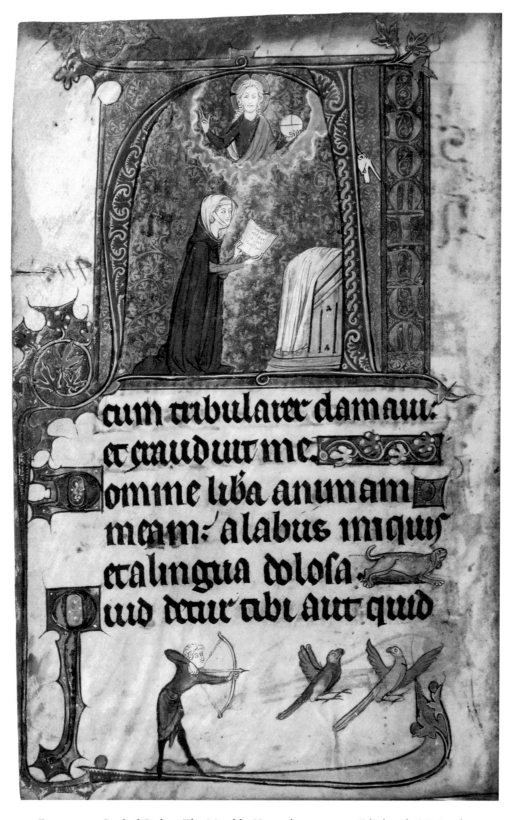

FIGURE 11. Gradual Psalms. The Murthly Hours, begun 1280s. Edinburgh, National Library of Scotland, Ms. 21000, fol. 149ᵛ (The National Library of Scotland).

same kind of gold-on-gold decoration found in the Beatus initial of the Alphonso Psalter.[57]

At some point in the manuscript's early history, however, its usefulness was enhanced by the addition of a substantial sequence of full-page prefatory miniatures, originally around forty in number, that were presented with short Anglo-Norman captions (Figs. 12, 14). The series of illuminations depicting scenes from Genesis and the Infancy of Christ were painted on the recto of each leaf, with the verso left blank, while the Passion sequence shifts to a different presentation in which openings showing two images facing one another as a diptych alternate with blank openings. As Higgitt reconstructed the original structure of this part of the book, as many as half of the original illuminations were lost, probably early in their existence. He argued that these miniatures were painted in England, perhaps in two stages, in the two decades before the devotional texts were produced.[58]

Given their likely English origin, the paintings bound into the Murthly Hours may have been planned as a Psalter preface or a separate picture-book. Yet the codicological analysis performed when the book was rebound in 1987 showed that the illuminations were not bound as a group, or with another group of gatherings, before they were combined with the Parisian Book of Hours.[59] I would imagine that the pictorial preface was combined with the *Horae* if not by the original owner herself, then fairly soon after, given that the thirteenth-century fashion for pictorial prefaces in English devotional books dropped sharply after the first decades of the fourteenth century. In any event, other evidence shows that they were certainly together by the late fourteenth or early fifteenth century. The Genesis sequence ends abruptly with a depiction of Joseph presented to Potiphar on folio 8, indicating that at least one gathering of further Old-Testament miniatures was probably lost by the time that a damaged and largely illegible Latin poem to the Virgin

was written on its verso, facing the painting of the Annunciation on folio 9 (Fig. 12). This poem has not been identified with any other texts, but it addresses the Virgin as an intercessor, 'the power of whose prayer can snatch those who turn to her from the torments of hell,' as Higgitt translates the last portion.[60] As was the case with the Alphonso Psalter, linen curtains were attached above each of the English miniatures and the French historiated initials, likely around the same time—although Higgitt leaves open the question of whether they were yet bound together when these were attached.[61]

Around 1300, soon after the marriage of Joan de Valence and John Comyn in the early 1290s, another prayer to the Virgin was written in Anglo-Norman on the last leaf of the original Book of Hours, again in the voice of a female supplicant. Just below, a different but still early fourteenth-century hand has added a short prayer in Latin to a guardian angel, again for a female supplicant (Fig. 13).[62] A few decades later, another hand added texts in Scottish Gaelic around these two prayers, and also on the front flyleaf of the original manuscript. These texts, probably written in the late fourteenth or early fifteenth century, record additional prayers and also charms that may have reflected the use of this book in healing; for example, the lines at the top of folio (ii)ᵛ have been translated as a charm to stanch bleeding that was used on the head of Jesus.[63] So it appears that the book was in Scotland by the late fourteenth century, and obits for several Scottish owners who died in the 1420s and 1430s indicate a provenance that Higgitt followed down to its nineteenth-century owner, George Stewart, and its location at Murthly Castle. The book was rebound after the middle of the sixteenth century, when English captions were added to the prefatory paintings, showing that it was used, if perhaps primarily as a Bible picture-book, into the Reformation.[64]

The decoration of the core texts of the Tewkesbury

57. Higgitt discusses the Parisian milieu in which the initials were illuminated in *Murthly Hours* (as in note 54), 131–64; Bennett, 'Issues of Female Patronage' (as in note 1), 243, continues the discussion.

58. For his conclusions, see *Murthly Hours* (as in note 54), 267–68. Higgitt also noted a marked similarity between the first sequence and the reliefs in the Chapter Hours at Salisbury Cathedral; see 231–49.

59. Higgitt, *Murthly Hours* (as in note 54), 31–33.

60. For more on this poem, see Higgitt, *Murthly Hours* (as in note 54), 27 and 246–47; for the poem, see 333–35.

61. Higgitt, *Murthly Hours* (as in note 54), 27.

62. For the marriage date, see Higgitt, *Murthly Hours* (as in note 54), 24; for the prayer, see 14–15 and 332–33.

63. R. Black, Appendix 6, in Higgitt, *Murthly Hours* (as in note 54), 336–45.

64. Higgitt, *Murthly Hours* (as in note 54), 26–36.

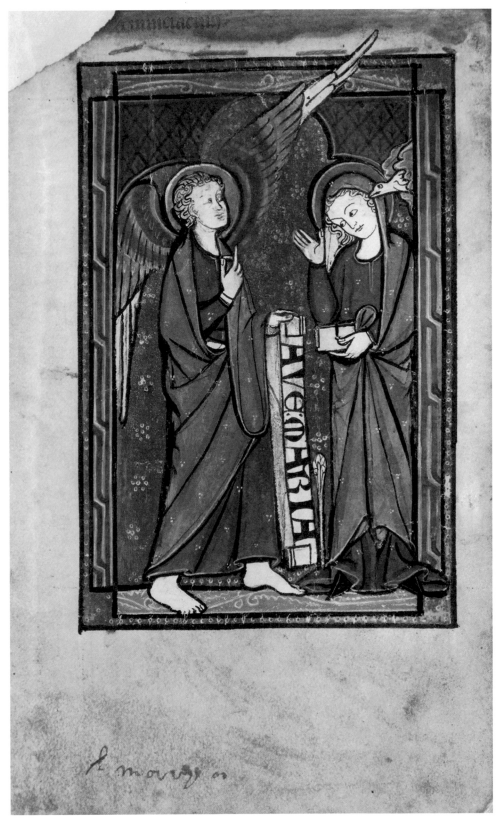

FIGURE 12. Annunciation. The Murthly Hours, begun 1280s. Edinburgh, National Library of Scotland, Ms. 21000, fol. 9 (The National Library of Scotland).

FIGURE 13. Prayers in Anglo-Norman, Latin, and Scottish Gaelic. The Murthly Hours, begun 1280s. Edinburgh, National Library of Scotland, Ms. 21000, fol. (ii)ᵛ (The National Library of Scotland).

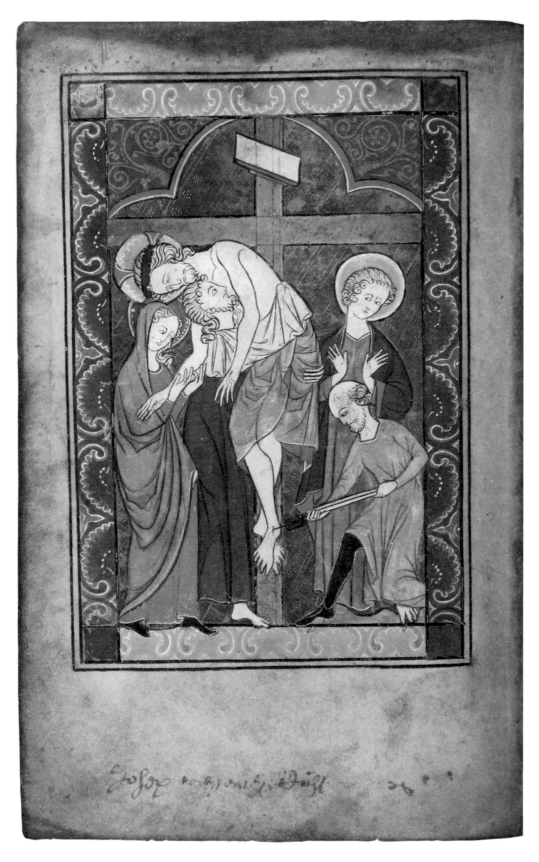

FIGURE 14. Deposition. The Murthly Hours, begun 1280s. Edinburgh, National Library of Scotland, Ms. 21000, fol. 20ᵛ (The National Library of Scotland).

Psalter, the Alphonso Psalter, and the Murthly Hours initially involved the very basic apparatus of medieval page design, in which the hierarchy of texts was indicated by a hierarchy of initials. This page design had been extremely durable over centuries of use in Psalters, and had become more pictorial in nature, and increasingly iconographically consistent, in the context of growing lay ownership during the thirteenth century. The initials in the Tewkesbury Psalter reflect the influence of French-inflected subjects that goes along with contemporary devotional trends and, as I argued earlier, may have heightened for its reader the impact of her representation in the initial of the Canticle of Isaiah (Fig. 4). The completion of the Alphonso Psalter's illumination with decorated rather than historiated initials echoes a frequent approach to the embellishment of prayerbooks, in which patrons lavished as much spending as possible on that opening page, and less on subsequent decoration. In the Murthly Hours, the large historiated initials painted by the French artist at the incipits of the Hours of the Virgin map the prayers into events from the Infancy of Christ, following an approach becoming common in Books of Hours. And the devotee herself is depicted, as were many prayerbook owners, at the start of the Gradual Psalms, reading her prayers from a book— this book—while the Christ-logos answers her prayers with a blessing (Fig. 11).

Original and later owners of these manuscripts found it necessary to augment this primary mode of navigation with the addition of prayers that provided a more direct, and closer, mode of address, often in the vernacular language of the devotees. In the Tewkesbury Psalter, the texts written in by subsequent generations of owners provided not only additional devotions, in the short Latin prayers, but also additional storytelling, in the form of the vernacular *exemplum* that accompanied them. In the Alphonso Psalter and the Murthly Hours, substantial care was taken to incorporate additional imagery, sequences of narrative

illuminations that appear to have been originally made for other contexts, perhaps even using bits of books already owned by the devotee (Figs. 9, 12). Furthermore, in both cases linen or silk curtains were sewn over the illuminations, certainly intended in part to protect the gold leaf and expensive pigments of the miniatures. Yet these curtains also may have increased the revelatory impact of the images, as the reader needed not only to turn the pages, as she would have done to move through her prayers, but to unveil the illuminations that provided her with saints to venerate and stories to devour.[65]

As I noted earlier, the Passion images in the Alphonso Psalter include an early representation of Mary helping Christ to carry the cross (Fig. 8). In both this Psalter and the Murthly Hours, the Virgin is also prominently at the side of her son in the depiction of the Deposition (Figs. 9, 14). While the composition of these two miniatures is in no way unusual, the depiction of Mary's hands on the flesh of her son reflects the late medieval emphasis on affective engagement with the story of the Passion, and may have reminded the viewer that the parchment of her book was, like the flesh of Christ, an incarnate version of the word of God.[66]

Bennett has argued that the system of word-illustration at the major divisions in French thirteenth-century Psalters provided enhanced guidance to the processes of 'penitence, deliverance, prayer, and salvation' for the burgeoning lay ownership of these books.[67] Textual and pictorial elements added to the Tewkesbury and Alphonso Psalters reflect a continued process of enhancement, and it is clear that even in the Murthly Hours, a new book type, additional devotional prompts in the form of the prefatory images were desirable. What Duffy termed 'devotional accretion' thus continued to reshape these books as they changed hands, from owner to owner, until they became relics held in our own libraries, unchanged 'for the antiquity's sake.'[68]

65. Sciacca, 'Raising the Curtain' (as in note 36), 185–86.

66. See K. A. Smith, 'The Neville of Hornby Hours and the Design of Literate Devotion,' *The Art Bulletin* 81 (1999), 72–92; here 80–81.

67. Bennett, 'Transformation of the Gothic Psalter' (as in note 1) 216–17.

68. For Duffy, see *Marking the Hours* (as in note 2), 44, 83; for the quote from Nicholas Saunder's *c.* 1700 inscription in the Wilton Psalter, see Morgan, *Early Gothic Manuscripts* (as in note 6), II: 55–58, no. 99.

FIGURE 1. Exeter Cathedral, West Front. Engraving from J. Britton, *The History and Antiquities of the Cathedral Church of Exeter* (London, 1826), pl. 2 (courtesy of the Princeton University Library).

DON C. SKEMER

Words Not Written in Stone: John Shirwood's Verse Epitaph for a Canon of Exeter Cathedral, c.1462

DEATH was a consuming preoccupation of late medieval society, beset by recurrent cycles of famine, pestilence, and war. England and the Continent were deluged with daily reminders of mortality, as a veritable cult of death led to the proliferation of death-related texts and art. The present article explores this societal obsession as seen in a group of epitaphs and images in the Princeton University Library's recently acquired Taylor Ms. 22, dating from the third quarter of the fifteenth century. Emphasis will be on the *Epitaphium Magistri Johannis Sowthel*, a verse epitaph (see Appendix) by John Shirwood (d. 1494), the English humanist, author, and book collector. He wrote it around 1462 while serving as chancellor of Exeter Cathedral (Cathedral Church of St. Peter), one of nine secular cathedrals in medieval England (Fig. 1).[1] Shirwood had been appointed chancellor by his patron George Neville (*c.* 1432–1476), then bishop of Exeter (r. 1456–1465), who was a younger brother of the powerful Yorkist leader Richard Neville (1428–1471), sixteenth earl of Warwick, known to history as Warwick the Kingmaker for his critical role in elevating two kings to the English throne during the Wars of the Roses. The manuscript was formerly in

the library of the recusant Giffard (or Gifford) family of Chillington Hall, near Brewood, northwest of Wolverhampton, Staffordshire. Their family seat was near two Brewood-area religious houses: Black Ladies Priory (Benedictine Priory of the Virgin Mary); and White Ladies Priory (Augustinian Canonesses Regular, or Priory of St. Leonard). After the Dissolution, the two convents and their property came into the possession of the Tudor courtier and landowner Sir Thomas Giffard (*c.* 1491–1560), whose family protected the Catholic enclave around Brewood for centuries.[2]

Taylor Ms. 22 contains thirty ascetic, mystical, and meditative texts in Latin and Middle English (East Midland dialect). Its main text is the Latin translation of Walter Hilton's Middle English *Scala perfectionis* (fols. 2ʳ–89ᵛ), also known as *De vita contemplativa,* by the Carmelite friar Thomas Fishlake (*fl. c.* 1375–1400), who made textual alterations for style or clarity.[3] Since the first book of Hilton's Middle English text was written for a 'ghostli sustir in ihesu christ,' one might assume the suitability of the present manuscript for meditative reading at the two Brewood priories. But there is no provenance evidence supporting this. Moreover, the Latin translation attracted fewer women readers

1. Princeton, Taylor Ms. 22 (Manuscripts Division, Princeton University Library, Department of Rare Books and Special Collections). The Library purchased the manuscript at a Sotheby's, London, auction in 2011 with acquisition funds endowed by Robert H. Taylor (1908–85), Princeton Class of 1930. For the Sotheby's description, see *Western and Oriental Manuscripts ... 6 December 2011* (London, 2011), no. 45. The engraved bookplate of Thomas Giffard (d. 1827) is on the front pastedown ('Chillington'). It is possible that the manuscript was considered for sale in 1937 or 1938, when the London antiquarian bookseller William H. Robinson broke up and sold another Chillington Hall manuscript (see note 4). The Sotheby's catalogue in 2011 speculated that the present manuscript and another Chillington manuscript (lot 35, Isidore of Seville, *Etymologies*) might have been 'from the library of the Benedictine Priory of Brewood

or the Augustinian Priory of St. Leonard, Brewood (both suppressed in 1537–8, their buildings and contents passing to Sir Thomas Giffard by 1550).' When the manuscript went to auction in 2011, David Rundle commented on it in a blog-post (27 November 2011), 'Up for Auction: New Light on John Shirwood and English Humanism,' in *Bonae litterae* (at http://bonaelitterae .wordpress.com).

2. M. W. Greenslade, *Catholic Staffordshire, 1500–1850* (Leominster, 2006), 17, 19, 154 n. 2.

3. The manuscript is not found in published lists of fourteen extant manuscripts of Fishlake's translation. R. Sharpe, *Handlist of the Latin Writers of Great Britain and Ireland before 1540* (Turnhout, 1997), 656–57, no. 1748; S. S. Hussey, 'Latin and English in *The Scale of Perfection*,' *Mediaeval Studies* 35 (1973), 456–76 (esp. 456–57).

than did the Middle English original. The Giffards'
Georgian country house was built in the eighteenth
century, with library additions designed by Sir John
Soane (1753–1837), and the family continued acquir-
ing manuscripts until the beginning of the nineteenth
century.[4] The Wolverhampton printer and publisher
William Parke (1797–1876) uniformly rebound Taylor
Ms. 22 and other manuscripts for the Giffards.[5]

In Taylor Ms. 22, Hilton's *Scala perfectionis* is written
in Anglicana formata and Bastard Anglicana hands of
the mid-fifteenth century. The manuscript is related
textually to a London group of six manuscripts of
the Latin translation, which include a colophon with
Hilton's death date and a summary at the end of Book
2. A contemporary hand added the title 'Breuis reca-
pitulacio tocius operis precedentis' to the summary in
Taylor Ms. 22, fol. 89[r]. Included in the London group
are manuscripts that Hilton specialists have designated
B2 (Oxford, Bodleian Library, Bodley Ms. 584); B4
(Bodleian Library, Lat. Th. E. 26); H2 (London, British
Library, Harley Ms. 330); and H8 (Harley Ms. 6576).

The exemplar for this group may have been altered in
part by separate consultation of the original Middle
English text.[6] Manuscript B4 was copied around 1440
by John Feriby (d. 1444), a Carthusian monk at Sheen
Priory (Charterhouse of Jesus of Bethlehem), in what
is now the Borough of Richmond, Greater London.
He may have used an earlier Sheen manuscript of the
Fishlake translation.[7] The translator's name is spelled
Ffyslake, as in some other manuscripts, in the colophon
of Hilton in Taylor Ms. 22, fol. 2[r], part of the rubric
preceding the list of chapters in Book 1. Like B4, the
colophon incorrectly states that Walter Hilton died in
1395/6 on the Vigil of the Feast of the Assumption of
the Virgin Mary (14 August), rather than the Vigil of
the Feast of the Annunciation (24 March). This incor-
rect date is also given in the Latin colophon added by
the Carthusian monk James Grenehalgh (d. 1529/30)
of Sheen Priory to a 1499 manuscript including the
Middle English *Scala perfectionis,* copied by Robert
Benet (d. 1517/18), procurator of Sheen (Cambridge,
Trinity College Library, Ms. 354 [B.15.18]).[8] In Taylor

4. It was not until 1807 or later that the Giffards acquired their
best-known manuscript for the library of Chillington Hall. This
manuscript was a *c.* 1420 volume originally owned by Sir Wil-
liam Clopton (1382?–1445), with various owners over the next
three centuries, including Roger Twysden (d. 1672) and the
Sebright family of St. Albans. Thomas Arthur Walter Giffard
(1882–1965) sold it to the London antiquarian bookseller Wil-
liam H. Robinson, who broke it into three parts and sold them
separately: (1) Washington, D.C., Folger Shakespeare Library, Ms.
v.b.236 (Robert Manning, *Handlyng Synne; Meditations on the Sup-
per of Our Lord*). (2) Princeton University Library, Taylor Ms. 10
(*Mandeville's Travels*); (3) London, University of London Library,
Ms. S.L. v.17 (*Piers Plowman*, C Version; *La Estorie del Euange-
lie;* and *Assumption of Our Lady*). Concerning the manuscript's
provenance and breakup, see N. R. Ker, *Medieval Manuscripts
in British Libraries* (Oxford, 1969), 1: 376–77; T. Turville-Petre,
'The Relationship of the Vernon and Clopton Manuscripts,' in
D. Pearsall, ed., *Studies in the Vernon Manuscript* (Woodbridge,
1990), 29–44; G. Russell and G. Kane, eds., *Piers Plowman: The
C Version: Will's Visions of Piers Plowman, Do-Well, Do-Better and
Do-Best* (London, 1997), 1–2.

5. Parke's printed binder's ticket is on the front pastedown.
Gilt- and black-tooled parchment over pasteboard, with marbled
paper endleaves in black and rose; edges of text block stained to
match the marbling. Another Chillington Hall manuscript in a
matching Parke binding was sold at the same sale as Taylor Ms. 22:
Sotheby's, London, 6 December 2011, lot 35, Isidore of Seville, *Et-
ymologies.* The original binding of Hilton's *Scala perfectionis* might

have resembled that of a 1450s manuscript containing Fishlake's
translation and other texts. See Christie's *Valuable Printed Books
and Manuscripts … 12 June 2013* (London, 2013), 30–33, no. 31:
'Contemporary binding: sewn on six double alum-tawed bands
and bound in white "doeskin" over oak boards with cushioned
edges, the remains of two clasps at the fore-edge of the upper
board each held in place by two nails.'

6. Hussey, 'Latin and English in *The Scale of Perfection,'* 457–59
(as in note 3); V. Gillespie, 'Hilton at Syon Abbey,' in J. Hogg, ed.,
'*Stand Up to Godwards': Essays in Mystical and Monastic Theology in
Honour of the Reverend John Clark on His Sixty-Fifth Birthday*, Ana-
lecta Cartusiana, no. 204 (Salzburg, 2002), 10–11. For a description
of Bodleian Library, Lat. Th. E. 26, see J. P. H. Clark and C. Taylor,
eds., *Walter Hilton's Latin Writings*, Analecta Cartusiana, no. 124
(Salzburg, 1987), 1: 34–35. Clark and Taylor cite B4 as *siglum* L2.

7. P. J. Patterson, 'Preaching with the Hands: Carthusian Book
Production and the *Speculum devotorum,'* in C. Cannon and M.
Nolan, eds., *Medieval Latin and Middle English Literature: Essays
in Honour of Jill Mann* (Cambridge, 2011), 142.

8. M. G. Sargent, *James Grenehalgh as Textual Critic*, Analecta
Cartusiana, no. 85 (Salzburg, 1984), 1: 49; K. Kerby-Fulton, M.
Hilmo, and L. Olson, *Opening up Middle English Manuscripts: Lit-
erary and Visual Approaches* (Ithaca, N.Y., 2012), 326–35, esp. fig.
25; M. R. James, *The Western Manuscripts in the Library of Trinity
College, Cambridge: A Descriptive Catalogue* (Cambridge, 1900),
1: 481–82; M. Deanesley, ed., *The Incendium Amoris of Richard
Rolle of Hampole*, University of Manchester Publications, vol.
97 (Manchester, 1915), 82–83. The incorrect date in the Trin-

FIGURE 2. Princeton, Taylor Ms. 22, fol. 4ʳ (courtesy of the Princeton University Library).

Ms. 22, like two manuscripts of the London group (B2, H2, but not B4), the explicit is between the summary and enumeration of chapters.[9]

Taylor Ms. 22 and B4 probably used related exemplars, since *Scala perfectionis* is followed in both by the same five ascetic and mystical texts. The order in Taylor Ms. 22 (slightly different in B4) is as follows: (1) Walter Hilton, *Epistola de utilitate et prerogativis religionis*; (2) an extract from St. Macharius, *Epistola ad filios* (*Epistola* IVa); (3) *Epistola aurea*, corresponding to Peter of Blois (c. 1135 – c. 1211), *Fragmentum epistolae de silentio servando*; (4) Pseudo-St. Jerome, *Secreta*, cor-

responding to St. Peter Damian, *De anima*; and (5) an anonymous Middle English translation of St. Bernard of Clairvaux, *Duodecim gradus humilitatis*. Most of the texts found in Taylor Ms. 22 could probably be found in the library holdings of Sheen Priory, as well as of the Charterhouse of London (House of the Salutation of the B.V.M.) and Syon Abbey (Monastery of St. Savior, B.V.M., and St. Bridget).[10] In Taylor Ms. 22, Hilton's *Scala perfectionis* begins on fol 4ʳ with a two-sided border of light spraywork and acanthus leaves (Fig. 2). While this decoration does not resemble that of B4, it is similar to the three-sided border for the

ity College Library Ms. 354 [B.15.18]), fol. 115ʳ, reads, 'obitus fuit in Vigilia Intemerate assumptionis Intemerate Virginis Dei genitricis Marie anno domini M.CCC.lxxxxv.' Grenehalgh also added this date to a Wynkyn de Worde *editio princeps* (1494) that he corrected and annotated for Sister Joan Sewell, a novitiate of Syon Abbey (Philadelphia, Rosenbach Library). The spelling 'Fyslake' is found in some manuscripts with the correct date, such as Oxford, Bodleian Library, Ms. 584, fol. 71ʳ ('obiit anno Domini Mº ccc lxxxxvº in vigilia Annunciationis…'). F. Madan and H. H. E. Craster, *A Summary Catalogue of Western Manuscripts in the Bodleian Library at Oxford* (Oxford, 1922), vol. 2, pt. 1, 326.

9. Princeton University Library, Taylor Ms. 22, fol. 2ʳ: 'Incipit

prima pars libelli magistri Walteri Hiltonis canonici de thurgarton' qui obiit anno domini millesimo CCC lxxxxv in vigilia assumpcionis beate marie quem libellum magister et frater Thomas Ffyslake(!) ordinis beate marie de monte carmeli translulit de anglico in latinum. Incipiunt capitula prime partis que sunt…'; fol. 89ᵛ: 'Ad hec gaudia perducat nos saluator noster dominus noster ihesus cristus. Amen. Explicit liber qui vocatur scala perfectionis. Prima pars huius secunde partis habet xvii capitula. Secunda pars xv capitula. Tertia pars novem capitula. Quarta pars septem capitula, et sic in toto sunt quadraginta septem capitula.'

10. Other texts include most of Thomas à Kempis, *Imitatio Christi*; extracts from Peter of Waltham, *Remediarium conversorum*,

table of contents in a Sheen Priory manuscript of 1474/5, which is stylistically closer to the 1440s, as in Glasgow, University Library, Hunter Ms. 77 [T.3.15], fol. 1ʳ: Nicholas Love, *Mirror of the Blessed Life of Jesus Christ*.[11]

Vincent Gillespie has noted that among 'London group' manuscripts of Hilton's *Scala perfectionis*, 'copies owned and made in metropolitan charterhouses play such a significant role.'[12] A third of the extant manuscripts of Hilton's original Middle English text and an even larger portion of Fishlake's Latin translation are associated by provenance with the Charterhouse of London, Sheen Priory, and Syon Abbey. A similar pattern is seen with the *editio princeps* of the text in English (1494).[13] Hilton's works were so closely associated with Sheen Priory that some people mistakenly believed he was from that charterhouse, though not founded until after his death.[14] Manuscripts were copied at the London, Sheen, and Syon houses from books in

their own libraries or privately owned books available to them. There was textual exchange between these monasteries and with Carthusians and Bridgettines beyond metropolitan London. Sheen was able to produce manuscripts for Syon, less than two kilometers away across the River Thames. Some manuscripts were copied for the laity. English Recusants preserved a fair number of Carthusian manuscripts.[15] Hilton was far more popular with Carthusians and Bridgettines than Augustinians. But no physical or historical evidence in Taylor Ms. 22 or extant library catalogues with *secundo folio* connects the patronage, production, or ownership of the manuscript with any religious house. While early ownership of Taylor Ms. 22 is unknown, the margins of *Scala perfectionis* have fifteenth-century annotations quoting Latin texts found in many English monastic libraries.[16] The manuscript was probably produced in metropolitan London, perhaps for a monastery or cleric influenced by the London,

and Alexander of Canterbury, *Liber Anselmi* or *Liber ex dictis beati Anselmi*; brief extracts from other Latin texts, such as the *Regula Sancti Benedicti* and *Imitatio Christi*; and Middle English poetry, including William Litchfield, 'Our Gracious God Prince of Pity' (*Index of Middle English Verse* [hereinafter *IMEV*] 2714), Richard of Caister, 'Jesu Lord that Madest Me (*IMEV* 1727), and 'By a Wey Wandering as I Went' (*IMEV* 562); and Latin verses. For a full description, see D. C. Skemer, *Medieval & Renaissance Manuscripts in the Princeton University Library* (Princeton, N.J., 2013), 1: 447–52. For B4, see O. Pächt and J. J. G. Alexander, *Illuminated Manuscripts in the Bodleian Library, Oxford*, vol. 3, *British, Irish and Icelandic Schools* (Oxford, 1973), 81–82, no. 935, pl. LXXXIX; *Bodleian Library Record* 2/27 (1948), 227–28.

11. K. L. Scott, *Dated and Datable English Manuscript Borders, c. 1395–1499* (London, 2002), 94–97, esp. plate XXXa. 'There is no certainty that the decoration was made by a limner resident in the house' (94).

12. Gillespie, 'Hilton at Syon Abbey' (as in note 6), 11.

13. W. Hilton, *Scala perfecc[i]onis* [Westminster: Wynkyn de Worde], 1494. M. G. Sargeant, 'Walter Hilton's *Scale of Perfection*: The London Manuscript Group Reconsidered,' *Medium Aevum* 52/2 (1983), 189–216; esp. 189–90, 206–7; Gillespie, 'Hilton at Syon Abbey' (as in note 6), 9–60; E. M. Thompson, *The Carthusian Order in England* (London, 1930), 325.

14. Sargent, *James Grenehalgh as Textual Critic* (as in note 8), 1: 48–49.

15. Patterson, 'Preaching with the Hands' (as in note 7), 134–51; V. Gillespie, '1412–1535: Culture and History,' in S. Fanous and V. Gillespie, eds., *The Cambridge Companion to Medieval English Mysticism* (Cambridge, 2011), 171; M. Hedlund, '*Liber Clem-*

entis Maydeston: Some Remarks on Cod. Ups. C 159,' in P. Beal and J. Griffiths, eds., *English Manuscript Studies 1100–1700*, vol. 3 (London, 1992), 73–101; A. I. Doyle, 'An Unrecognized Piece of *Piers the Ploughman's Creed* and Other Work by Its Scribe,' *Speculum* 34 (1959), 431 n. 20; Sargent, *James Grenehalgh as Textual Critic* (as in note 8), 1: 53–54.

16. In the lower margin of fol. 12ᵛ, a contemporary hand has written a 4-line annotation, largely quoting a commentary on the Pauline Epistles by the French Dominican Nicolas de Gorran (d. c. 1295), 'Enarratio in epistolam ad Hebraeos' (12:29). See *R. Gorrani … In omnes divi Pauli epistolas enarratio*, edited by Jacobus LeGall (Lyon, 1692), 2: 272: 'Etenim Deus noster, ignis contumens est … mittere in terram.' In the upper margin of fol. 30ʳ, the same hand copied verses 3–4 of a 45-line poem on chanting: 'ffenestre est Egressum nobis ostendunt per uiciosum | Dyna, cain, corius, esau, judas, semeia,' with interlinear scriptural references. A tie-mark connects the annotation to the word 'ffenestre' in Walter Hilton, *Scala perfectionis* (as in note 13), bk. 1, chap. 77. The verses are preserved in London, British Library, Lansdowne Ms. 763, fol. 60ʳ, a monastic miscellany of treatises and textual extracts on music, copied in c. 1460 by John Wylde, precentor of Waltham Abbey, an Augustinian monastery: 'Vnde Versus sancti Augusti, De forma Psallendi.' See *Thesaurus musicarum latinarum* (www. chmtl.indiana.edu/tml/14/ANOSPEC_MLBLL.763.html), and *British Library Catalogue of Illuminated Manuscripts* (at www.bl.uk/ catalogues/illuminatedmanuscript). In Princeton University Library, Taylor Ms. 22, fol. 96ᵛ, the same hand noted in the margin of Hilton, *Epistola aurea de utilitate et prerogativis religionis*: 'Hic videtur quod ille deuotus et uenerabilis pater Walterus hylton qui composuit hanc epistolam duxit vitam solitariam.'

Sheen, and Syon houses, or for someone within their extended readership network.[17]

Epitaphs in Taylor Ms. 22

After the bulk of Taylor Ms. 22 had been written, a scribe added three Latin poems in a Bastard Anglicana hand, possibly in the late 1460s or early 1470s (fols. 189ᵛ–190ʳ, 191ʳ–192ʳ), two of which were illustrated.[18] Two of the three poems are labeled *epitaphium*, and the third follows the form of an epitaph. All three are written in the first person, allowing the deceased to address the living, a literary device found in English epitaphs for over a century. A notable example of such an epitaph is the French *memento mori* verses for Edward of Woodstock, the Black Prince (1330–1376), at Westminster Abbey.[19] The longest of Taylor Ms. 22's three epitaphs is an anonymous eighty-eight-verse religious poem, which in late medieval manuscripts from England and Germany, including several from charterhouses, was usually written in twenty-one quatrains and had titles such as *Contemptus mundi*, *Speculum peccatorum*, *Planctus animae damnatae*, and *Ammonitio notabilis in persona damnator*.[20] In Taylor Ms. 22, a sixteenth-century hand labeled it 'Epitaphium' in the upper margin of fol. 189ᵛ. The text's opening ('O vos omnes qui transitis figuram hanc inspicite...') is reminiscent of late medieval *memento mori* epitaphs addressed to passersby.[21] In the verses, as with cadaver tombs (or transi-tombs), worms devour bodies of the dead, whose earthly lives violated divine law by succumbing to pride, greed, and other temptations of the material world ('Quondam eram gloriosus | Habens aurum et argentum | Nunc a vermibus sum corrosus | Quam horrendum testamentum'). Eternal damnation is the inevitable result ('Sine fine sum dampnatus').[22]

17. T. Webber and A. G. Watson, eds., *The Libraries of the Augustinian Canons*, Corpus of British Medieval Library Catalogues, no. 6 (London, 1998), 414, 418. Concerning convents owning Hilton's *Scala perfectionis*, see A. C. Bartlett, *Male Authors, Female Readers: Representation and Subjectivity in Middle English Devotional Literature* (Ithaca, N.Y., 1995), 8–9, 86, 166.

18. The scribe responsible for the epitaphs in Taylor Ms. 22 wrote with long ascenders and descenders, upright without beaks (*b, h, l, f*, and long-*s* in initial and medial positions). The hand displays a Secretary influence in the angularity of lobes of many majuscules (D, E, G, O, Q) and lowercase letters (Uncial *d* with short staff, as well as *e* and *g*); and calligraphic treatment to the majuscules beginning most lines. See M. B. Parkes, *English Cursive Book Hands, 1250–1500* (Oxford, 1969), xvii–xxi, 8, no. 8 (ii); A. I. Doyle, 'William Darker: The Work of an English Carthusian Scribe,' in *Medieval Manuscripts, Their Makers and Users* (Turnhout, 2011), 199–211; esp. 201: '...predominantly with the upright and angular pen-strokes of *littera textualis* yet with some anomalous letter forms, most obviously both *f* and long-*s* reaching below the base line, final-*s* commonly of the Secretary ('kidney-shaped') form; and *h* often or occasionally, *b* and *l*, chiefly in English, with hooks (incomplete loops) not however in most Latin text on their ascenders.'

19. J. Weever, *Antient Funeral Monuments of Great-Britain, Ireland, and the Islands Adjacent, with the Dissolved Monasteries therein Contained...* (London, 1767), 9; C. Box, *Elegies and Epitaphs: A Comprehensive Review of the Origin, Design, and Character of Monumental Inscriptions* (Gloucester, 1892), 12.

20. Taylor Ms. 22, fols. 189ᵛ–190ʳ: 'O vos omnes qui transitis | ffiguram hanc inspicite | Memores mei semper sitis | Et mundum hunc despicite | Quondam eram gloriosus | Habens aurum et argentum ... propter varios reatus | sine fine sum dampnatus.' H.

Walther, *Initia carminum ac versuum medii aevi posterioris latinorum* (Göttingen, 1959), no. 13072; M. W. Bloomfield *et al.*, *Incipits of Latin Works on the Virtues and Vices, 1100–1500 A.D.*, Publications of the Mediaeval Academy of America, no. 88 (Cambridge, Mass., 1979), no. 3560. G. M. Dreves and C. Blume, eds., *Analecta rythmica medii aevi* (Leipzig: O. R. Reisland, 1904), 349–50; M. Lutolf, ed., *Analecta hymnica medii aevi: herausgegeben von Guido Maria Dreves, Clemens Blume und Henry Marriott Bannister: Register: in Zusammenarbeit mit Dorothea Bauman....* (Bern, 1978), no. 19824; R. Rudolf, *Ars Moriendi: Von der Kunst des heilsamen Lebens und Sterbens*, Forschungen zur Volkskunde, 39 (Cologne, 1957), 42–43. The poem is found in a 15th-century miscellany: Oxford, Bodleian Library, Douce Ms. 54, fols. 43ʳ–44ᵛ. See *Catalogue of the Printed Books and Manuscripts Bequeathed by Francis Douce, Esq. to the Bodleian Library* (Oxford, 1840), pt. 2 (Manuscripts), 6. It is followed on fol. 45ʳ by 'Brunonis Carthusiani versus elegiaci de morte.' The poem ('O vos omnes') is also found in a manuscript miscellany from the Charterhouse of Cologne, c. 1430–40 (Darmstadt, Hessische Landes- und Hochschulbibliothek, Hs 1830, fol. 53ʳ⁻ᵛ). See G. Achten, L. Eizenhöfer, and H. Knaus, *Die Handschriften der Hessischen Landes- und Hochschulbibliothek Darmstadt. vol 3, Die lateinischen Gebetbuchhandschriften der Hessischen Landes- und Hochschulbibliothek Darmstadt* (Wiesbaden, 1972), 81. Fols. 31ʳ–52ᵛ also include 'Ars bene moriendi.'

21. Weever, *Antient Funeral Monuments* (as in note 19), 25, 129.

22. K. Cohen, *Metamorphosis of a Death Symbol: The Transi Tomb in the Late Middle Ages and the Renaissance* (Berkeley, Calif., 1973), 31–32, 122, 127; S. Oosterwijk, 'Food for Worms—Food for Thought: The Appearance and Interpretation of the "Verminous" Cadaver in Britain and Europe,' *Church Monuments* 20 (2005), 40–80, 133–40.

The accompanying illustration in brown and red ink (Fig. 3) shows two bestial demons attacking the soul, depicted as a naked child.[23] The soul emerges from the skeletal corpse of a man whose feet are already in the fires of Hell, with no hope of salvation in the Battle for the Soul.[24] To the right, a hairy horned demon, with claw feet and a nose in the shape of a hook, pulls firmly on the arms of the dead man's soul. To the left, a smaller demon, with grotesque faces on each knee, uses two weapons to attack the soul: a hilted pole-arm or bill hook, with three sharp hooks, ensnaring its torso; and a spear, pulling on its head. Three text scrolls allow the harrowing demons and the dead man to speak in turn and remind readers that torments of the body and soul await those who serve the Devil. The words of the demons in the uppermost text scroll are also recorded in Cambridge, Gonville and Caius College Library, Ms. 230 (116), fol. 25[r]: 'Those who serve us will be tormented in this way without end' ('Hii qui nobis seruiunt sic sunt honorati | Sine fine taliter erunt cruciati.').[25] Below, the corpse speaks in two text scrolls (right, left): 'Oh, that I was born to such torments' and 'The Devil and fires of Hell torment me with these manifest signs' ('Heu quod fui natus tantis penis cruciatus'; 'Me patulis signis tormentant demon et ignis').[26]

The illustration on fol. 189[v] is related to English death art depicting the eternal struggle for all souls, good or bad. Bestial horned demons attack departing souls, usually indistinguishable from one other, personified as a naked child or young man, just as they emerge from the mouths of unrepentant sinners, usually on their deathbeds, and then hastening their descent into the fires of Hell, sometimes depicted as a cauldron over flames or as the Hell Mouth, attended by demons. The latter was the fate of Dives's soul as illustrated in the Parable of Dives and Pauper (Gospel of Luke, 16:19–31) in the Huntingfield Psalter (Fig. 4), possibly Oxford, c. 1210–1220 (New York, Morgan Museum and Library, M. 43, fol. 21[r]).[27] Also comparable are tinted drawings in red, blue, and green in a Middle English miscellany of c. 1460–1470 (British Library,

23. M. Barasch, 'The Departing Soul: The Long Life of a Medieval Creation,' *Artibus et historiae* 52 (2005), 13–28, esp. 15–20.

24. Late medieval English death art sometimes depicted angels using processional crosses to battle demons, take possession of the deceased's soul, and bear it to heaven. See C. Hourihane, *The Processional Cross in Late Medieval England: The 'Dallye Cross'* (London, 2004), 29–30, figs. 19–20.

25. See M. R. James, *A Descriptive Catalogue of the Manuscripts of the Library of Gonville and Caius College* (Cambridge, 1907), 1:271.

26. The Sotheby's catalogue suggests that the border decoration (fol. 3[r]) and drawings (fols. 189[v], 191[r]) were similar to those found in two manuscripts that Thomas Chaundler (1418–90) had commissioned in Oxford in the early 1460s for presentation to his patron, Thomas Beckington [Bekynton] (c. 1390–1465), bishop of Bath and Wells: Thomas Chaundler, *Liber apologeticus de omni statu humanae naturae* (Cambridge, Trinity College Library, Ms. R.14.5); and Thomas Chaundler, *Collocutiones septem et allocutiones duae de laudibus Willelmi de Wykeham, Wintoniensis episcopi* (Oxford, New College Library, Ms. 288). The Oxford illustrator responsible for these drawings was possibly Flemish or influenced by the Flemish school. See K. L. Scott, *Later Gothic Manuscripts, 1390–1490*, Survey of Manuscripts Illuminated in the British Isles (London, 1996), 285–88, no. 103, 310–12, no. 114; D. Enright-Clark Shoukri, ed., *Liber apologeticus de omni statu humanae naturae: A Defence of Human Nature in Every State (c. 1460): A Moral Play*, Publications of the Modern Humanities Research Association, no. 5 (London, 1974), 25–26; drawings reproduced on frontispiece and plates 1–14. Despite Sotheby's assertion, the illustrations in Taylor Ms. 22 lack the fine execution of those in the Chaundler manuscripts.

27. C. Hourihane, ed., *Abraham in Medieval Christian, Islamic, and Jewish Art* (Princeton, N.J., 2013), fig. 88 (image reversed); Index of Christian Art (at http://ica.princeton.edu). Upper register: On the left, a nimbed angel emerges from cloud and lifts the nude soul of Lazarus, who is covered with leprous sores and lies on the ground. To the right, a white-haired Abraham, representing Paradise, holds the soul of Lazarus, which is in an orant pose. Lower register: To the left, a naked Dives lies in bed, while his soul emerges from his mouth and rises between the horns of a green demon that grasps the soul and Dives. Another bestial horned demon pulls the soul by a chain around its neck. To the right, at the foot of the bed, another bestial devil (upper part green) pushes the soul of Dives down into the flaming Hell Mouth, while another horned devil uses a hook to force the soul down. English manuscript illuminators of the 15th century depict demons or personifications of death using similar weapons to threaten or attack the living and claim souls; for example, British Library, Stowe Ms. 39, fol. 32[r] (Richard Rolle of Hampole[?], *Debate for the Soul*), and Egerton Ms. 615, fol. 34[r] (Middle English translation of Guillaume de Deguileville, *The Pilgrimage of the Soul*). Images in *British Library Catalogue of Illuminated Manuscripts* (at http://www.bl.catalogues/illuminated/manuscripts). Concerning the use of unconventional sources of visual representation in late medieval art, see M. Curschmann, 'Marcolf or Aesop? The Question of Identity in Visio-Verbal Contexts,' *Studies in Iconography*, 21 (2000), 1–45, esp. 1–3.

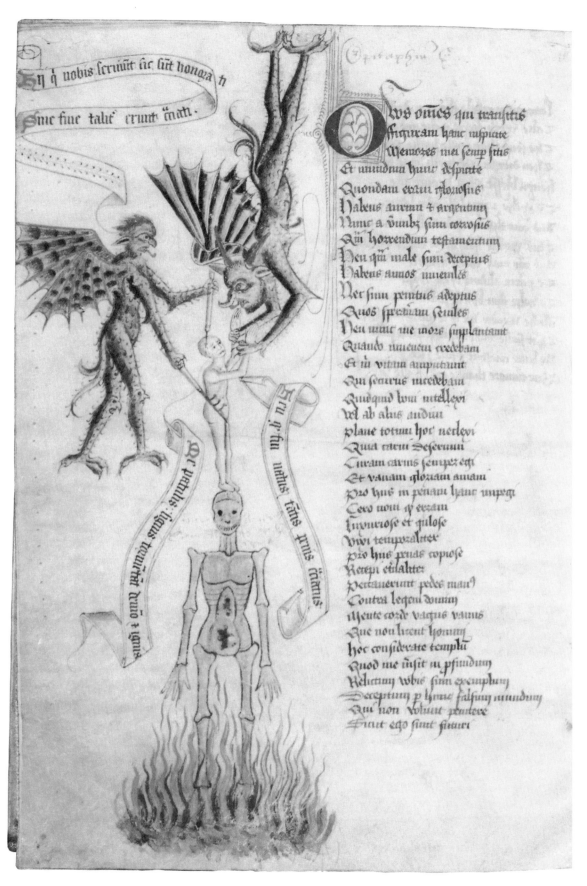

FIGURE 3. Princeton, Taylor Ms. 22, fol. 189ᵛ (courtesy of the Princeton University Library).

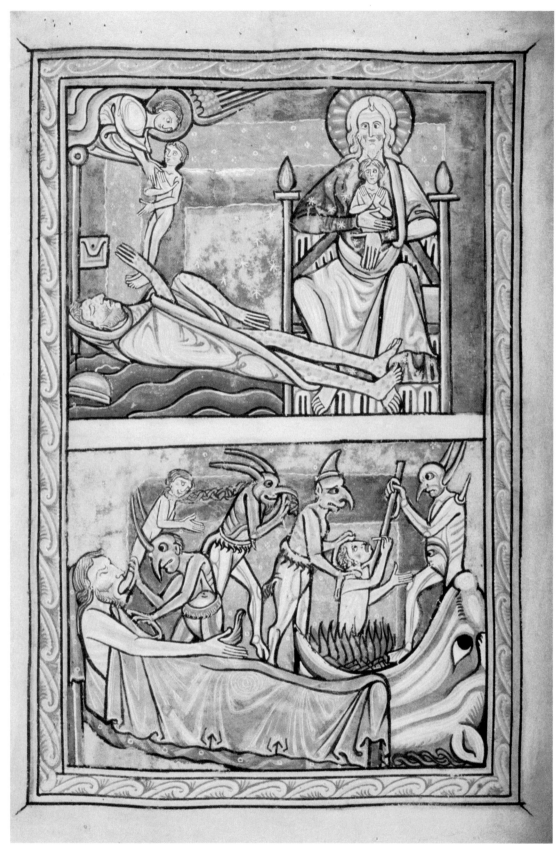

FIGURE 4. Morgan Library, Ms. M.43, fol. 21ʳ. Huntingfield Psalter (courtesy of the Morgan Library and Museum).

Add. Ms. 37049), which probably served as devotional reading in a northern English charterhouse. Its best-known illustration (fol. 32ᵛ) shows a noblewoman in a tomb with heraldic decoration, beneath which worms attack her rotting corpse (Fig. 5). An eight-line *memento mori* epitaph reminds readers, 'Take heed unto my figure here above' (*IMEV* 3252.5). The tomb image illustrates 'A Disputacion betwyx the Body and Wormes' (*IMEV* 1563), a mid-fifteenth-century northern didactic poem in the form of a dialogue between a noblewoman's corpse and the worms eating her flesh. Other images include Death as a grinning skeleton, spearing a man on his deathbed (fol. 38ᵛ), illustrating 'Debate for the Soul,' sometimes attributed to the hermit mystic Richard Rolle of Hampole (d. 1349); and two horned, winged demons attacking Pride, a vainly attired young man (fol. 47ᵛ).[28]

Jessica Brantley has argued that the recurrent interplay of text and images in British Library, Add. Ms. 37049 was closely related to Carthusian meditative practice. But she allows that meditative texts could be visual enough to render illustrations unnecessary. Words alone could help the meditative reader conjure up appropriate images.[29] She also notes similarities to didactic and moralistic wall paintings in late medieval English churches, which, while once far more numerous, often did not survive English climate, Protestant reformers, and Victorian restorers. Among wall paintings that survive, albeit in degraded condition, death and demons are illustrated in connection with the Doom (Last Judgment), Seven Deadly Sins, and the Three Living and Three Dead Kings. For example, demons attack sinners in the Ladder of Salvation wall painting of *c.* 1200 in the Chaldon, Surrey, Church of St. Peter and St. Paul. The Seven Deadly Sins are illustrated in the lower right (Fig. 6), where two demons with forked polearms hold down a personification of Avarice, with his coins and money bags, in a cauldron over the fires of Hell. A wall painting of *c.* 1420 in St. Peter's Church, Raunds, Northamptonshire, portrays Death as a grinning skeleton with a lance, attacking Pride and thus making other sins flow forth.[30]

The second epitaph in Taylor Ms. 22, at the top of

28. P. Binski, *Medieval Death: Ritual and Representation* (London, 1996), 144–45; D. Gray, 'Medieval English Mystical Lyrics,' in W. F. Pollard and R. Boenig, eds., *Mysticism and Spirituality in Medieval England* (Cambridge, 1997), 210; J. Hogg, *An Illustrated Yorkshire Carthusian Religious Miscellany: British Library London Additional MS. 37049: The Illustrations*, Analecta Cartusiana, vol. 98 (Salzburg, 1981), *passim*; J. R. Rytting, '"A Disputacioun betwyx þe Body and Wormes': A Translation,' *Comitatus: A Journal of Medieval and Renaissance Studies* 31/1 (2000), 217–32. For a full description of British Library, Add. Ms. 37049, which includes innumerable images of men attacked by Death personifications and demons, see the *British Library Manuscripts Catalogue* (at http://www.bl.uk/catalogues/manuscripts). One of the texts in the manuscript is a poem in twenty-nine couplets on the Carthusian order (fol. 22ʳ⁻ᵛ). For these and other references to Middle English poetry in the *IMEV*, go to the *Digital Index of Middle English Verse* (or *DIMEV*) (at http://www.cddc.vt.edu/host/imev).

29. J. Brantley, *Reading in the Wilderness: Private Devotion and Public Performance in Late Medieval England* (Chicago, Ill., 2007), 92–93, 152–54, 220. Brantley uses W. J. T. Mitchell's term 'image-texts' to refer to such illustrated manuscripts. Nikolaus Henkel used the term *Bildetexte* to refer to manuscript illustrations using text scrolls. See N. Henkel, 'Die Spruchbänder in der Berliner Handschrift von Heinrichs von Veldeke Eneasroman,' in S. Füssel and J. Knape, eds., *Poesis et pictura: Studien zum Verhältnis von*

Text und Bild in Handschriften und alten Drucken. Festschrift für Dieter Wuttke zum 60. Geburtstag, Saecula spiritualia, Sonderband (Baden-Baden, 1989), 1–47.

30. F. Kendon, *Mural Paintings in English Churches during the Middle Ages: A Introductory Essay on the Folk Influence in Religious Art* (London, 1923), 124, 129; E. W. Tristram, *English Wall Painting of the 14th Century* (London, 1955), 95, 101–107; R. Rosewell, *Medieval Wall Paintings in English and Welsh Churches* (Woodbridge, 2005), 72–73 (fig. 90), 79, 83–84 (fig. 102), 276, 347; A. Reiss, 'Beyond "Books for the Illiterate": Understanding English Medieval Wall Paintings,' *The British Art Journal* 9/1 (2008), 4–14; A. Kinch, *Imago mortis: Mediating Images of Death in Late Medieval Culture*, Visualising the Middle Ages, vol. 9 (Leiden, 2013), 166–69; A. Marshall, *Medieval Wall Painting in the English Parish Church: A Developing Catalogue*, at www.paintedchurch.org/raundsds.htm. Beyond wall paintings, the illustration in Taylor Ms. 22 has a general relationship to the *Ars moriendi*, where the Devil makes an appearance in a chapter (no. 4) on spiritual pride. The related illustration (no. 7) in the *c.* 1450 blockbook shows five horned demons attacking a dying man (*moriens*), who is guilty of the cardinal sin of Pride, symbolized by the crowns that the demons used to tempt him ('Temptacio dyaboli de vana gloria'). W. H. Rylands and G. Bullen, eds., *The Ars moriendi (Editio princeps, circa 1450). A Reproduction of the Copy in the British Museum* (London, 1881), 13–14. N. L. Beaty, *The Craft of Dying: A Study in the Literary Tradition of the Ars moriendi in England* (New

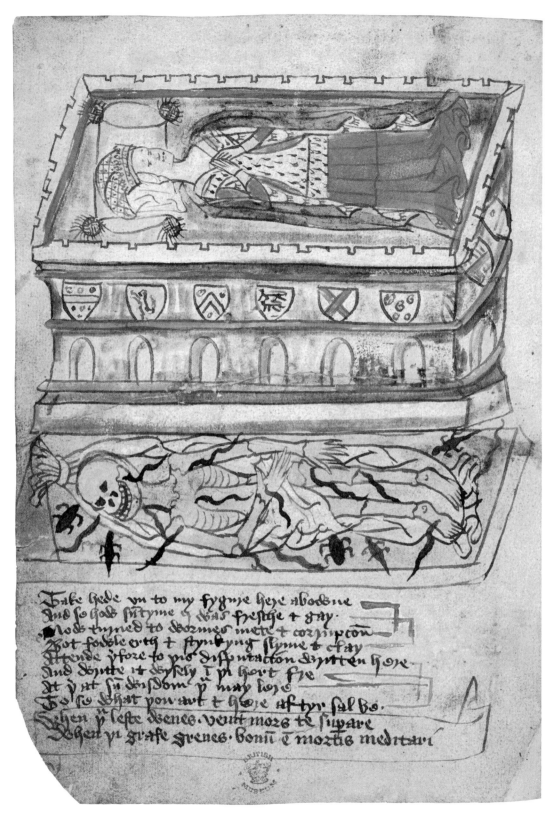

FIGURE 5. British Library, Add. Ms. 37049, fol. 32ᵛ (by permission of the British Library).

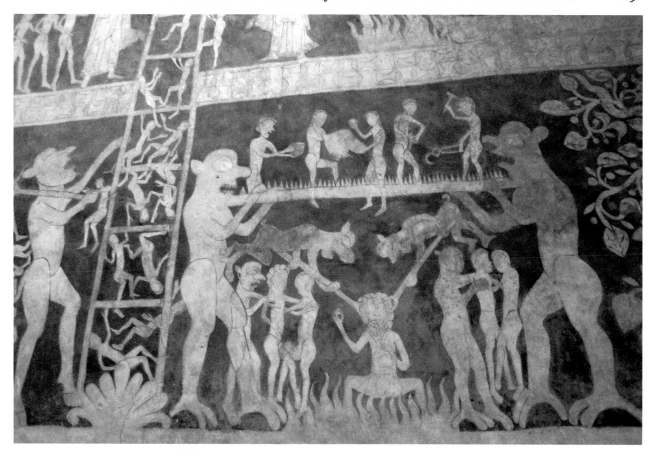

FIGURE 6. Chaldon, Surrey, Church of St. Peter and St. Paul. Ladder of Salvation wall painting (detail) (image Copyright by John Steedman).

fol. 191ʳ (Fig. 7), follows a page in a different hand, with brief extracts from three Latin text.[31] The five-verse epitaph, primarily in monorhyme, allows the deceased to speak. Since his name is not given, the verses might have been copied from a collection of epitaph exemplars rather than from a particular tomb inscription: 'Ecce necis speculum speculare frequenter et ora | Mors veniet sed quando latet furtim venit hora | Esto memor timor atque tremor sunt mortis in hora | Talis eris qualis ego sum pro me precor ora | Ut michi solamen celi donet deus. Amen.' ('Behold the mirror of death. Gaze upon it and pray often | Death will come but lies hidden, the hour creeping stealthily | Remember, fear and trembling accompany the hour of death | As I am now, so shall you be. Pray to God for my heavenly rest. Amen').[32] Accompanying

Haven, Conn., 1970), 15–16. For the two 1490 English versions, see D. W. Atkinson, ed., *The English Ars moriendi*, Renaissance and Baroque Studies and Texts, vol. 5 (New York, 1992), 1–35.

31. Pseudo-Bernard of Clairvaux, *Meditationes piissimae de cognitione humanae conditionis*, chapters 11(5) and xv(38); Thomas à Kempis, *Imitatio Christi*, similar to 2:1–3:24; Pseudo-Augustine, *De rectitudine catholicae conversationis tractatus*, 21.

32. Verses 1–2 in this epitaph are also found in Lincoln Cathedral on a brass monument for John Southam (*c.* 1368–1441), a canon residentiary of the cathedral (1436–41) and archdeacon of Oxford (1404–41), then in the diocese of Lincoln. Southam's

brass effigy has the two verses at his feet, as well as a text scroll ('Misere mei Deus secundum Misericordiam tuam') over his head. Concerning Southam and his brass monument, see F. Peck, *Desiderata curiosa...* (London, 1779), 1: 315–16, no. 79; 'Notes and Queries: John Southam,' in *The Berks, Bucks and Oxon Archaeological Journal*, 3/3 (1897), 94–96; A.B. Emden, *A Biographical Register of the University of Oxford to A.D. 1500* (Oxford, 1959), vol. 3, 1732–1733. Verses 3–5 in the epitaph are similar to a portion of a 6-line epitaph on a 17th-century stone monument for John Sheppey, dean of Lincoln Cathedral. R. E. G. Cole, ed., *Lincolnshire Church Notes Made by Gervase Holles, A.D. 1634 to A.D.*

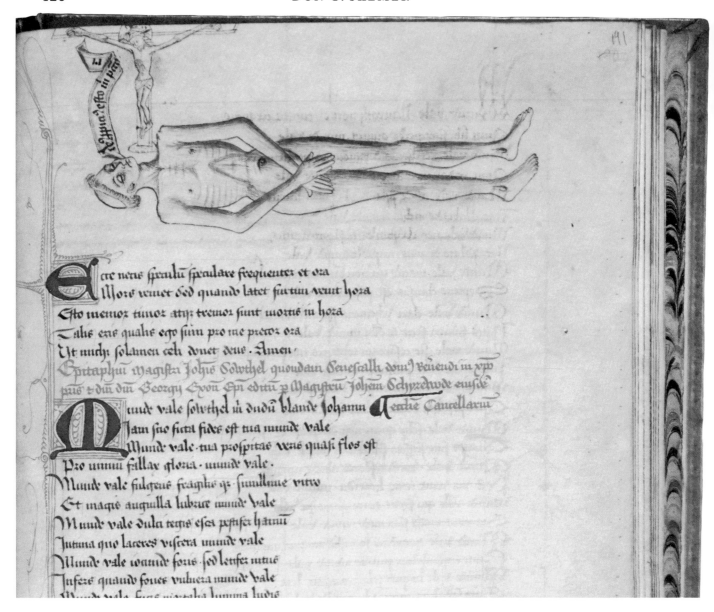

FIGURE 7. Princeton, Taylor Ms. 22, fol. 191ʳ (courtesy of the Princeton University Library).

the epitaph in the upper margin is a horizontal illustration drawn in brown ink with touches of red by the same artist responsible for fol. 189ᵛ. We see a dead cleric without a burial shroud or habit, viewed almost at the oblique angle at which a visitor might see a tomb effigy. Despite the epitaph's *memento mori* message, we do not see a decomposing body like a cadaver tomb. The corpse has crossed arms and a full tonsure, leaving a thin, almost-Carthusian 'crown' of hair. The Crucifix above the deceased offers the Cross, representing divine salvation, as the last thing a dying person needed to see for a good death.[33] A text scroll

1642, Publications of the Lincoln Record Society, vol. 1 (Lincoln, 1911), 63: 'Esto memor, timor atque tremor sit mortis in hora, | Talis eris, qualis ego sum: pro me (precor) ora.'

33. The Crucifix is similar to one in a Syon Abbey manuscript

(Uppsala University Library, Ms. c 159, fol. 12ʳ). Reproduced in M. Hedlund, 'Liber Clementis Maydeston: Some Remarks on Cod. Ups. c 159,' 78, pl. 4.

rising from the corpse's lips contains a brief prayer to Christ from the Gospel of Luke 18:13, 'Deus propicius esto michi peccatori' ('God have mercy on me, a sinner').[34] We are reminded that text scrolls could present 'speech acts' to readers and passersby in the form of statements made by or directed to God and saintly intercessors. In effect, there were two levels of speech when the dead appealed to the living to pray on their behalf to sacred figures.[35]

Immediately after this brief epitaph is the rubric for John Shirwood's eighty-line verse epitaph, arranged in forty elegiac distichs or couplets. Shirwood did not adhere to the classical scheme of alternating hexameter (or Alexandrine) and pentameter verses, with the action rising in the first verse of each distich and falling in the second.[36] Each of Shirwood's couplets is framed with the plaintive refrain 'Munde vale' ('Farewell world'). The act of bidding farewell had classical antecedents and was not uncommon in epitaphs, albeit without framing.[37] Shirwood's first-person verses speak to the living, offer moral advice, and appeal for prayers. In giving voice to the Exeter Cathedral canon, the verse epitaph combines a medieval *contemptus mundi* worldview with glints of the classical interests and learning shared by the author and his patron. Shirwood identifies the canon as Master John Sowthel, an old man on his deathbed (verses 51, 78), who seems to be alone at the hour of his passing, unattended by a priest, cathedral associates, or family. Good angels and demons do not struggle to claim his

soul, as in *ars moriendi* deathbed scenes. The epitaph begins with the canon's realization that worldliness is inimical to Christianity. Seductive material temptations are condemned for being as fragile as glass and more slippery than an eel. It conceals poisonous barbs in sweet dishes and venom in honey, inflicts wounds on those it seems to favor, and, moving swifter than the wind, injures people for its own amusement (verses 5–15). The Exeter canon bemoans his old age and physical decline, observing metaphorically that the fresh flowers of youth are long gone, and summer has turned to winter (verses 39–40). Through the stormy seas of old age, the canon wearily steers close to shore (verses 49–50).

The vivid imagery of Shirwood's verses could help stimulate readers to form mental images from their imagination and memory.[38] This imagery is complemented by a performative aspect that was a characteristic of Carthusian spirituality.[39] The epitaph can be seen as a deathbed dialogue in which the Exeter canon bids farewell with every breath to the cruelty, deceit, and treachery of the material world. But unlike most Middle English ascetic texts that revolve around a dying or deceased person's conversation with the living or with worms, the world in Shirwood verse epitaph responds with deathly silence. The Exeter canon rejects a lifetime of accomplishment in church administration and surrenders his ecclesiastical offices and possessions, once the source of personal pride and perhaps covetousness, including ample assets and finery (verses

34. E. Hoskins, ed., *Horae Beatae Mariae Virginis, or, Sarum and York Primers with Kindred Books and Primers of the Reformed Roman Use* (London, 1901), 114, 116, 117, 189, 211, 394.

35. A. R. Flett, 'The Significance of Text Scrolls: Towards a Descriptive Terminology,' in *Medieval Texts and Images: Studies of Manuscripts from the Middle Ages,* ed. by M. M. Manion and B. J. Muir (Melbourne, 1991), 43–56, esp. 47; N. Morgan, 'What Are They Saying? Patrons and Their Text Scrolls in 15th-Century English Art,' in C. Hourihane, ed., *Patronage: Power and Agency in Medieval Art,* Index of Christian Art, Occasional Papers, 15 (Princeton, N.J., 2013), 175–93, esp. 189–93.

36. D. Norberg, *An Introduction to the Study of Medieval Latin Versification,* translated by G. C. Roti and J. Skubly (Washington, D.C., 2004), 56, 58; N. G. L. Hammond and H. H. Scullard, eds., *The Oxford Classical Dictionary,* 2nd ed. (Oxford, 1970), 378; A. Preminger, *Princeton Encyclopedia of Poetry and Poetics* (Princeton, N.J., 1963), 196, 215.

37. J. Scodel, *The English Poetic Epitaph: Commemoration and*

Conflict from Jonson to Wordsworth (Ithaca, N.Y., 1991), 96. Examples are found in funerary inscriptions or copied in manuscripts, including in two Middle English epitaphs, respectively seven and twelve lines in length: 'Farewell my friends the tide abideth no man' (*IMEV* 765); and 'Farewell this world I take my leave forever' (*IMEV* 769).

38. Reiss, 'Beyond "Books for the Illiterate": Understanding English Medieval Wall Paintings' (as in note 30), 8: 'Richard Rolle, one of the most prolific English authors of devotional texts, also uses strikingly visual terms to express his version of late medieval affective piety.… This seeing through the imagination is like seeing physical imagery, with the suffering and pain of Christ represented visually by his blood.' Many Lollards also argued for the superiority of words over images, of hearing sermons over seeing paintings. A. Hudson, ed., *Two Wycliffite Texts,* Early English Text Society, Original Series, no. 301 (Oxford, 1993), 59–61.

39. Brantley, *Reading in the Wilderness* (as in note 29), 6.

69–70). The verses give examples of the vanity of life in scriptural, mythological, and historical figures, from Nimrod, Agamemnon, and Helen of Troy, to Alexander the Great, Julius Caesar, and Marc Antony (verses 20–34).[40] The up-and-down course of their public lives underscore the transience of worldly power and personal glory. No doubt, the educated religious community of Exeter Cathedral understood these oblique biographical references and could summon additional details from memory. Shirwood's verses are surprisingly free of religious references to death rituals, such as the Sacrament of Extreme Unction. Yet the Exeter canon presumably would have enjoyed divine favor and the hope of salvation, perhaps like the unrelated monk depicted on folio 191[r], since he condemned pride and other cardinal sins.

The Exeter canon appears to have died on or around 8 January 1461/2, according to the chronogram and astrological reckoning in the epitaph (verses 77–80), which though cryptic has a precision about the death date that was uncommon in England before the late Middle Ages.[41] A *terminus a quo* is also provided by a reference to the Yorkist reversal of fortune not long after the death of Bishop Neville's father, Richard Neville, fifth earl of Salisbury, on 31 December 1460 (verses 56–58), a day after the Battle of Wakefield. On 4 March 1460/1, Edward IV (r. 1461–1470) was proclaimed king in London, with the help of Warwick the Kingmaker and Bishop Neville, who deliv-

ered an overtly political sermon from the pulpit at St. Paul's Cross in support of Yorkist claims to the throne. Bishop Neville served as the king's chancellor and presided over the royal council.[42] There was no evidence that Shirwood was with Neville in London, a four- or five-day journey on horseback from Exeter,[43] until 6 June 1461 (three weeks before Edward IV's coronation), when he purchased a thirteenth-century manuscript of Peter Cantor's *Commentary on the Psalter.* Shirwood was there again on 20–22 December 1464, buying two contemporary Italian humanistic manuscript miscellanies.[44]

The *Epitaphium Magistri Johannis Sowthel* warns about the challenges that an active life poses to the soul if one succumbs to pride and other cardinal sins. The author's asceticism seems to have taken some religious inspiration from *The Pricke of Conscience,* an anonymous fourteenth-century Middle English poem of northern origin, probably originating in Yorkshire, formerly attributed to Richard Rolle of Hampole. The exclamation 'Munde vale' is among the poem's Latin verses (book 2, verses 1149–51), though not in all extant manuscripts of the work. In a section devoted to 'Men in Prosperity,' the author praises the ascetic life and scorns the material world as the enemy of God: 'Munde vale! tibi ve! fugiens me, dum | sequerer te, Tu sequeris modo me, | iam respuo despiciens te.' ('Farewell world. Have strength. You flee from me, then I from you. You follow me, then I turn away, disdaining you').[45] Sum-

40. Alexander the Great and Julius Caesar were two of three pagans among the 'Nine Worthies' who exemplified chivalric ideals during the 14th and 15th centuries. J. Huizinga, *The Autumn of the Middle Ages,* trans. by R. J. Payton and U. Mammitzsch (Chicago, Ill., 1996), 76–77. *The Pricke of Conscience* observes that the worldly glories of such men would be swept away by death: 'Emperour, kyng, duke, ne caysere … And wormes sale ryve hym in sondre.' *The Pricke of Conscience (Stimulus Conscientiae), A Northumbrian Poem by Richard Rolle de Hampole,* edited by R. Morris (Berlin, 1863), 25 (bk. 1, vv. 882, 888).

41. C. Daniell, *Death and Burial in Medieval England, 1066–1550* (London, 1997), 12. See note 132.

42. C. A. J. Armstrong, 'The Inauguration Ceremonies of the Yorkist Kings and Their Title to the Throne,' *Transactions of the Royal Historical Society,* series 4, vol. 30 (1994), 55–58; M. Hicks, 'George Neville (1432–1476),' *Oxford Dictionary of National Biography* (Oxford, 2004); S. B. Chrimes and A. L. Brown, eds., *Select Documents of English Constitutional History, 1307–1485* (London, 1961), 320–21. Neville was also head of the English diplomatic

delegation to the tripartite conference at St. Omer in 1463 and with Scotland in 1464 and 1465.

43. N. Orme, *The Cathedral Cat: Stories from Exeter Cathedral* (Exeter, 2008), 104–5.

44. P. S. Allen, 'Bishop Shirwood of Durham and His Library,' *English Historical Review* 25 (1910), 447; Hicks, 'George Neville' (as in note 42). The manuscripts bought in 1464 were British Library, Burney Ms. 145, fol. 118[r]: 'Liber [] | emptus Londoni circiter xiii kalendas januarias anno domini 1464'; and Oxford, Corpus Christi College, Ms. 84, 'Quod ego Jo. Dunelmensis episcopus emi Londoniis circiter xi kalendas Januarii anno domini 1464. Scriptum anno domini 1491.' H. O. Coxe, *Catalogus codicum manuscriptorum qui in collegiis aulisque Oxoniensibus hodie advervantur,* pars II (Oxford, 1852), 49 (Ms. D.2.4), 84 (Ms. F.2.11). See detailed record for Burney Ms. 145 in *British Library Catalogue of Illuminated Manuscripts* (at www.bl.uk/catalogues/illuminatedmanuscripts).

45. The words 'Munde vale' are not found among the thousands of epitaphs, many no longer extant, that John Weever

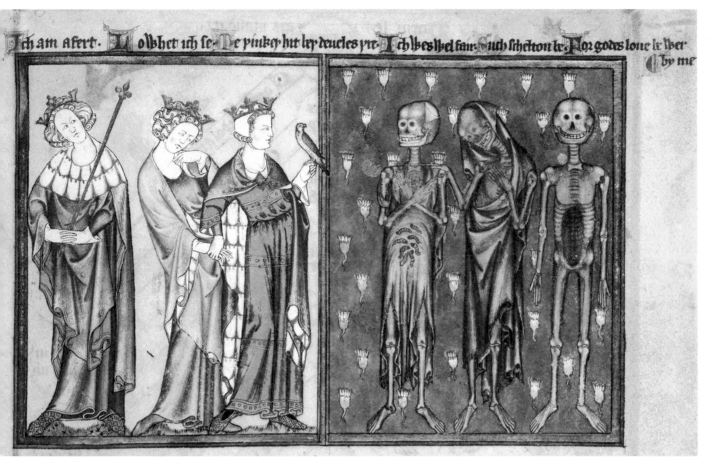

FIGURE 8. British Library, Arundel Ms. 83, part II, fol. 127ʳ. De Lisle Psalter (by permission of the British Library).

ming up contemporary ascetic beliefs, *The Pricke of Conscience* finds most people, including clerics, guilty of 'pride of lyf,' vanity, and the false worship of the world, personal riches, honors, and fame. Worms devour the bodies of emperors, kings, and princes (verses 863–888) just as they would humble folk. Riches and glory were nothing but 'pride and pompe and covatyse' (verse 1180), which death would sweep away. In late medieval England, this *memento mori* theme found popular expression in the legend of the Three Living and Three Dead Kings, illustrated in manuscripts and wall paintings of the fourteenth to sixteenth centuries. Three young kings on a hunt encounter three worm-eaten corpses or skeletons, who urge them to mend their worldly ways and warn, 'As we are, so shall you be.' The earliest known English example is a framed diptych of *c.* 1310, attributed to the Madonna Master, in the Psalter of Robert de Lisle (1288–1344), in British Library, Arundel Ms. 83, part II, fol. 127ʳ (Fig. 8).[46]

collected over decades and published in 1631 as *Antient Funeral Monuments of Great-Britain, Ireland, and the Islands Adjacent.* Yet it is similar to some liturgical expressions of the hour of death, such as 'Valete res, | valete spes! | immunde | vale munde!' U. Chevalier, *Repertorium hymnologicum: Catalogue des chants, hymnes, proses, tropes en usage dans l'église latine depuis les origines jusqu'à nos jours,* vol. 4 (Louvain, 1912), no. 41414. R. C. Trench, ed., *Sacred Latin Poetry, chiefly Lyrical, Selected and Arranged for Use...*

3rd ed. (London, 1874), 285: 'Vale, immunde munde!' | Instabilis et labilis | Vale, orbis rotunde! | Mendaciis, fallaciis....'

46. Binski, *Medieval Death* (as in note 28), 134–38, 143–45, fig. viii; A. Kinch, 'Image, Ideology, and Form: The Middle English Three Dead Kings in Its Iconographical Context,' *The Chaucer Review* 43/1 (2008), 48–81; Kinch, *Imago mortis,* 45–84. For a description of the manuscript, see L. F. Sandler, *The Psalter of Robert de Lisle in the British Library* (London, 1983), 42, plate 5; *British*

Robert E. Lewis and Angus McIntosh characterized the *Pricke of Conscience* as 'a storehouse of information to which a medieval reader could go for various kinds of religious lore and from which a medieval writer could borrow as he saw fit.' It circulated widely in the Main Version (97 extant manuscripts); the Southern Recension (18); substantial extracts (8); a derivative Middle English text, *Speculum huius vite* (2); and a Latin translation, *Stimulus conscientiae* (6). The Latin verses that include 'Munde vale' were also quoted and paraphrased.[47] Shirwood could also have been influenced by Walter Hilton's belief in the possibility of a 'mixed life' or middle way between active and contemplative lives. Ecclesiastical administrators, secular clergy, and lay landowners with lordship over tenants could still set aside time for the inner life of contemplation. Michael G. Sargent argues that English readers of *Mixed Life*, written for a secular lord, saw it as a 'mediating text that allowed them to appropriate the *Scale*, which was initially written for a woman living a hermitic life, for their own uses.'[48] Shirwood could take comfort in the belief that asceticism was reconcilable with an active career in church administration.

Author and Epitaph

John Shirwood first studied at the University of Cambridge, earning *magister artium* and *baccalaureus theologiae* degrees by 1450, and then became a *proctor* in 1450/1. He moved to Oxford in 1456 to pursue the degree of *doctor theologiae*. There his interest in classics and Greek learning blossomed under the influence of George Neville, chancellor of the University of Oxford (1453–1457), who with his circle was interested in international scholarship, Shirwood probably studied Greek with Emanuel of Constantinople and George Hermonymos. But English humanism was conservative, as Roberto Weiss argued, subordinating classical learning to medieval culture and to the practical interests of church careers.[49] Shirwood showed an early predilection for asceticism and considered entering the Carthusian Order in 1458, according to a papal letter to Bishop Neville in 1458, a year before Shirwood became a canon of Exeter Cathedral. The letter responds to a petition by Shirwood (misspelled Chiellod) to leave the cathedral and become a Carthusian. He is described as a priest (*presbyter*), celebrating Mass and with other priestly duties.[50] But Shirwood remained at Exeter

Library Catalogue of Illuminated Manuscripts (at http://www.bl.uk/catalogues/illuminatedmanuscripts). The miniature directly precedes an Anglo-Norman abridgment of the 13th-century Old French poem, *Le dit des trois morts et trois vifs*.

47. *The Pricke of Conscience* (ed. Morris), 32 (as in note 40). For a survey of extant manuscripts, see R. E. Lewis and A. McIntosh, *A Descriptive Guide to the Manuscripts of the 'Prick of Conscience,'* Medium Ævum Monographs, n.s., 12 (Oxford, 1982), 1–15; quotation at 14. The verses are in Cambridge, Peterhouse Library Ms. 104, fol. 210ʳ, late 14th-century sermons attributed to Ralph Acton, presented by Thomas Beaufort, first duke of Exeter (c. 1377–c. 1426), brother of King Henry IV. See M. R. James, *A Descriptive Catalogue of the Manuscripts in the Library of Peterhouse* (London, 1899), 121: 'Munde vale tibi ve fugiens me dum sequerer te | Te sequeris modo me munde vale tibi ve.' They are also found in a 15th-century manuscript, Cambridge, Trinity College, O.2.53, fol. 54ʳ. See Walther, *Initia carminum* (as in note 20), no. 11414.

48. M. G. Sargent, 'Mystical Writings and Dramatic Texts in Late Medieval England,' *Religion and Literature* 37/2 (2005), 84–85; S. J. Ogilvie-Thomson, ed., *Walter Hilton's 'Mixed Life,'* Edited from Lambeth Palace MS 472, Salzburg Studies in English Literature, 92/15 (Salzburg, 1986), viii–x, 14–16. Sargeant, 'Walter Hilton's *Scale of Perfection*: The London Manuscript Group Reconsidered' (as in note 13), 206–7. Early printed edi-

tions of *Scala perfectionis* even included *Mixed Life* as a 'third book.'

49. R. Weiss, *Humanism in England during the 15th Century*, 3rd ed. (Oxford, 1967), 275–77; M. Lowry, 'John Rous and the Survival of the Neville Circle,' *Viator* 19 (1988), 332–36.

50. A. J. Pollard, 'John Shirwood,' *Oxford Dictionary of National Biography* (at http://www.oxforddnb.com/) 'Before his career under Neville took flight Shirwood was attracted to the Carthusian order, which he considered joining in 1458—a leaning which suggests an outlook akin to that of later Christian humanists like John Colet and Sir Thomas More.' John Fisher described Shirwood as a 'Carthusian Friar' on the basis of an unpublished history, 'The Lives of the Most Reverend Fathers the Archbishops and the Right Reverend Bishops of the Church of England...' c. 1670): British Library, Add. Ms. 21089. See J. Fisher, *The History and Antiquities of Masham and Mashamshire...* (London, 1865), 328. Emden, *Biographical Register* (as in note 32), vol. 3, 1692: '...subsequently fearing that he had broken his vow by pronouncing the words of the benediction indistinctly after a sermon and was liable to resign all his benefices and enter the Carthusian Order, obtained a papal mandate for the commutation of his vows into other works of piety 8 Oct. 1458.' J. A. Twemlow, ed., *Calendar of Papal Registers Relating to Great Britain and Ireland*, vol. 11: *A.D. 1455–1464* (London, 1921), 366–67: 'Exhibita siquidem nobis nuper pro parte dilecti filii Johannis

Cathedral and became Bishop Neville's chancellor in November 1460, possibly the bishop's only non-local appointee. The chancellor ranked just below the dean and precentor, and was responsible for preparing official letters for the bishop and for other duties pertaining to writing and education.[51] He was listed among Exeter's prebendaries and canons from the Michaelmas term (October-December) 1459 until the Christmas term ('Natus domini') 1469/70. Shirwood also served as archdeacon of Richmond (1465–1484), prebendary of Masham (1471–1484), and bishop of Durham (1484–1493), as well as having a long career at the Papal court in Rome.[52] Bishop Neville was too preoccupied with royal politics and service to Edward IV to devote much time to the bishopric of Exeter. Before being translated to York in 1465, Neville was Lord Chancellor to Henry VI (r. 1422–1461, 1470–1471), from whom he received the Great Seal of the Realm on 25 July 1460, and to Edward IV, whom he served from 5 March 1461, to 8 July 1467. Neville may have visited Exeter only once during his nine years as bishop.[53]

Shirwood began collecting books around 1461 and amassed a substantial personal library over his lifetime, like several other prominent English clerics of this period. His busy career did not always afford him enough time to be a thorough reader, as attested by his limited annotation of books. By 1474 he was at the Roman curia, becoming an apostolic protonotary in Rome two years later. In 1477 he became Edward IV's first royal envoy (*proctor*) to the Papal court and two years later the king's *orator*. He served three English kings in Rome and by 1487 had acquired at least thirty-three Roman, Venetian, and other Italian printed editions of classical Latin texts. Twenty-seven of them are preserved in Oxford, Corpus Christi College Library, having been received as part of the library of Bishop Richard Cox (*c.* 1448–1528). Most of Shirwood's books have his *ex libris*. He also owned manuscripts, including Theodore of Gaza's Greek grammar (Cambridge, University Library, Ms. Ii.iv.16) and the two humanistic miscellanies.[54] There is no evidence that Shirwood owned Taylor Ms. 22, and the *Epitaphium Magistri Johannis Sowthel* is not in his hand.[55]

Chiellod [*sic!*] presbyteri Exoniensis diocesis magistri in theologia peticio continebat quod olim ipse...' (at http://www.british-history.ac.uk/).

51. Chancellors at England's nine secular cathedrals, according to Kathleen Edwards, 'kept the chapter's seals; acted as its secretary; supervised the schools of grammar and theology; was frequently cathedral librarian and keeper of the archives, arranged the reading of the lessons in choir, and the sermons.' K. Edwards, *The English Secular Cathedrals in the Middle Ages: A Constitutional Study*, 2nd ed. (Manchester, 1967), 136. A. Compton Reeves, 'Bishop John Booth of Exeter (1465–78),' in D. Biggs, S. D. Michalove, and A. Compton Reeves, eds., *Traditions and Transformations in Late Medieval England* (Leiden, 2001), 137–38: 'Shirwood would have been thoroughly competent himself or through his deputies to discharge the necessary secretarial work of the cathedral as chancellor, to give or arrange for lectures on theology or canon law for local clergy, and to carry out other administrative duties.' Bishop John Veysy (r. 1519–51, 1553–54), *Statuta Ecclesie Exoniensis*, in G. Oliver, *Lives of the Bishops of Exeter and a History of the Cathedral...* (Exeter, 1861), 474–75.

52. 'John Shirwood,' *A Cambridge Alumni Database* (at http://venn.lib.cam.ac.uk/Documents/acad/). A. J. Pollard, 'John Shirwood' (as in note 50). Shirwood's surname was also spelled Shirwode and Sherwood.

53. Hicks, 'George Neville' (as in note 42). Work on the East Window of the Chapter House and its stained-glass, including three donor portraits, began during Bishop Neville's tenure. R.

Marks, *Stained Glass in England during the Middle Ages* (London, 1993), 161.

54. Allen, 'Bishop Shirwood of Durham and His Library' (as in note 44), 445–56, books listed on 455–56; J. R. Liddell, 'The Library of Corpus Christi College, Oxford, in the Sixteenth Century,' *Library*, series 4, vol. 18, no. 4 (1938), 385–416; esp. 387–91; Weiss, *Humanism in England during the 15th Century* (as in note 49), 141–53; R. Masek, 'The Humanistic Interests of the Early Tudor Episcopate,' *Church History* 39/1 (1970), 5–17, esp. 12–13; E. Armstrong, 'English Purchase of Printed Books from the Continent, 1465–1526,' *English Historical Review* 94 [371] (1979), 270–71; J. B. Trapp, 'The Humanist Book,' in L. Hellinga and J. B. Trapp, eds., *The Cambridge History of the Book in Britain*, vol. 2 (Cambridge, 1999), 302, 305. D. Rundle and A. J. Lappin have revised R. Weiss's references to Shirwood in *Humanism in England*, 4th ed., for the Society for the Study of Medieval Languages and Literature, 2010, Medium Ævum Monographs, Original Series, IV (online at http:mediumaevum.modhist.ox.ac.uk/documents/Weiss_Instalment_VI.pfr).

55. Shirwood's script is personal in style, similar to some late 15th-century university scribes, incorporating Secretary and humanistic features. See M. B. Parkes, *English Cursive Book Hands, 1250–1500* (London, 1979), no. 18 (ii). His *ex libris* in his copy of Cicero, *De oratore* (Rome: Sweynheym and Pannartz, 1468), read 'Liber Jo. Shirwood sedis apostolice praetorii emptus Romæ anno domini 1477'; and in his copy of St. Augustine's *Confessiones* (Milan: Johannes Bonus, 1475), purchased in Rome on 15 May,

As George Neville's Latin secretary, Shirwood oc-
casionally prepared letters, such as one written in 1469
when he was archdeacon of Richmond.[56] He was
known as an author, chiefly for *Epitome de ludo arith-
momachie* (Rome: [Stephan Plannck(?)], after 1 April
1482), his treatise on rithmomachia ('battle of num-
bers'), a medieval board game based on Greek number
theory. Shirwood learned the game as a student from
an early teacher and believed it had been invented
by Archytas of Taranto (*fl. c.*400–350 B.C.E.). Around
1475, Shirwood taught the game to George Neville,
then in exile at Calais, and at the latter's urging set
down the rules in a treatise printed with a dedica-
tion to the author's Roman patron Marco Cardinal
Barbo (1420–1491).[57] Shirwood was well regarded as
a poet, to judge from passing references by British an-
tiquarians. John Leland (1506?–1552) learned from the
English cleric and jurist Anthony Belasyse (d. 1552)
that Shirwood had authored a poem, *De laudibus An-
gliae*. Leland reported that at Fountains Abbey, North
Yorkshire, he had read verses attributed to Shirwood
but thought that their author could have been the
Carthusian monk Richard Roche (d. 1515), who was
Shirwood's friend and shared his interests in poetry.[58]

Roche was the ninth prior of the Charterhouse of
London (r. 1488–1490) and amassed a substantial li-
brary, including fourteen volumes lent to the monk
Roger Montgumre in 1500.[59] Hilton's texts were not
among them, but Roche is the sort of person who
would have been interested in an ascetic miscellany like
Taylor Ms. 22 and in Shirwood's verses. The English
Catholic scholar John Pits [Pitseus] (1560–1616) also
emphasized the close relationship of Shirwood and
Roche, who was an author of Latin verse, epigrams,
dialogues, and letters.[60]

Who was Master John Sowthel of the verse epitaph?
Shirwood describes him as a former seneschal to the
bishop of Exeter. In English cathedrals and monaster-
ies, the duties of a seneschal (or chief steward) included
being judge of manorial courts; administrator of lands,
liberties, and privileges; collector of seigneurial rev-
enues; and supervisor of bailiffs and lesser officials re-
sponsible for routine administration. The office had
existed since the Anglo-Saxon period, and its duties
were spelled out in the anonymous Anglo-Norman
treatise *De seneschaucie* (*c.* 1250s or 1260s). By the thir-
teenth century, Exeter Cathedral had two seneschals
(*senescalli scaccarii*), more commonly called stewards of

1481, read 'Liber Jo Shirwood se[dis] ap[ostoli]cae protonotarii
archidia[con]i Richemu[n]diae; emptus ligatus Romae ... Augusti
A[nn]o Do[mini], 1481.' Oxford: Corpus Christi College Library,
pt. 1: 'A Trilingual Library in 16th-Century Oxford,' no. 31 (at
http://www.ccc.ox.ac.uk/Catalogue-to-Part-1/).

56. J. Tait, 'Letters of John Tiptoft, Earl of Worcester, and
Archbishop Neville to the University of Oxford,' *English His-
torical Review* 35[140] (1920), 570–74: 'Epistola transmissa per
prenobilem [virum] archiepiscopum Eboracensem Georgium
Nevill, ex compositione tamen magistri mei archidiaconi Rich-
mondi grauissimo' (571 n. 5).

57. A. E. Moyer, *The Philosophers' Game: Rithmomachia in Me-
dieval and Renaissance Europe* (Ann Arbor, Mich., 2001), 65–66;
D. E. Smith and C. C. Eaton, 'Rithmomachia: The Great Medi-
eval Number Game,' *Teachers College Record* 13/1 (1912), 29–38;
T. F. Dibdin, *Bibliotheca Spenceriana, or a Descriptive Catalogue of
the Books Printed in the 15th Century...* (London, 1815), vol. 4
(*Miscellaneous Authors*), 1–5, no. 776. John Argentine (d. 1507)
owned a *c.* 1482 manuscript copy of Shirwood's treatise (Ox-
ford, Bodleian Library, Ashmolean Ms. 344, fols. 24ʳ–39ᵛ); see
D. E. Rhodes, John Argentine, *Provost of King's: His Life and His
Library* (Amsterdam, 1967), 18.

58. Weiss, *Humanism in England* (as in note 49), 151 n. 5. J.
Leland, *De uiris illustribus: On Famous Men*, ed. and trans. by J.
Carley, with assistance of Caroline Brett (Toronto, 2010), 442–43.

'...et carmina quam lubentissime cecinit coniunctissimus erat.
Huius crediderim uersus esse, quos nuper Shirouodi titulo in
Fontensi coenobio legi.' J. Leland, *Joannis Lelandi antiquarii de rebvs
britannicis collectanea*, edited by T. Hearne (London, 1770), 4: 221;
*Catalogi veteres librorum ecclesiae cathedralis Dunelm. Catalogues of the
Library of Durham Cathedral, at Various Periods, from the Conquest
to the Dissolution, Including Catalogues of the Library of the Abbey
of Hulne, and of the Mss.*, Publications of the Surtees Society, vol.
7 (London, [1838]), xxii: 'D. Bellous [Bellasis] significavit mihi
Joannem Shirovodum scripsisse opusculum *De laudibus Angliae*
carmine.' T. Tanner, *Bibliotheca Britannico-Hibernica: sive, de scrip-
toribus, qui in Anglia, Scotia, et Hibernia...* (London, 1748), 669.

59. Thompson, *Carthusian Order in England* (as in note 13),
326, 341.

60. J. Pits, *Ioannis Pitsei Angli, S. theologiae doctoris, Liverduni in
Lotharingia, Decani, Relationum historicarm de rebus anglicis...* (Paris,
1619), 1: 661, no. 868: '[Rochus] erat ei tum temporis frequens
consuetudo, et multa familiaritas cum Ioanne Shirvvodo. Nam
aequalitas aetatis, morum similtudo, studiorum societas magnam
inter eos ecerat amicitiam. Uterque pietatem, uterque doctri-
nam, maxime politiorem impense dilexit. Tamen idem utrique
postea non eras successus. Nam Carthusianus Carthusianorum
quidem in quodam Conventu factus est Prior. Shirvvodus autem
ad Dunelmensem evectus est Episcopatum.'

the exchequer, chosen from among the residentiary canons for two consecutive quarterly terms (Michaelmas, Christmas, Easter, and Midsummer), similar in length to those in the English legal calendar (Michaelmas, Hilary, Easter, Trinity). Stewards were responsible to the dean and chapter for the operation of the cathedral's exchequer, including disbursements, supervision of manorial lands, rent and tithe collection, storage of monies in the cathedral treasury, and keeping account rolls and other records, including books listing obit (*obitus*) celebrations and some funerals. Based in the Chapter House, they were assisted by a clerk and sub-clerk of the exchequer, members of the minor clergy of the cathedral.[61] Despite their worldly duties, the stewards were most likely ordained. The cathedral's statutes required its twenty-four canons to be in priestly orders. Most were experienced secular clergy from the Exeter area or southwestern England.

The canons were men of mature years, whose stone houses (*mansiones*) clustered within the walled precincts of the Cathedral Close. Many canons were tonsured and held benefices, prebends, and other dignities, sometimes simultaneously.[62] The Exeter canon's title *magister* points to a university education, if not necessarily an advanced degree. An Oxford education can be traced for about two-thirds of the 222 canons who served at Exeter Cathedral in the 1300–1455 period, including those educated at Exeter College, Oxford, founded in the early fourteenth century as Stapleton Hall.[63] Shirwood refers to the Exeter canon's legal expertise (verse 65).[64]

The canon's surname Sowthel could have been a variant spelling of the place name Southwell, either indicating a village on the Isle of Portland, County of Dorset, about 120 kilometers southeast of Exeter; or the distant Nottinghamshire cathedral town.[65] But

61. A. M. Erskine, 'The Medieval Financial Records of the Cathedral Church of Exeter,' *Journal of the Society of Archivists* 2:6 (1960), 254–66 (esp. 257–60); J. A. Givens, 'The Fabric Accounts of Exeter Cathedral as a Record of Medieval Sculptural Practice,' *Gesta* 30/2 (1991), 112; A. R. Myers, ed., *English Historical Documents, 1327–1485* (New York, 1969), vol. 4:, 771–74 (no. 459); D. Lepine and N. Orme, eds., *Death and Memory in Medieval Exeter*, Devon and Cornwall Record Society, n.s., 47 (Exeter, 2003), 346; N. Orme, *The Minor Clergy of Exeter Cathedral: Biographies, 1250–1548*, Devon and Cornwall Record Society, n.s., 54 (Exeter, 2013), 9–10. E. Lamond, ed., *Walter of Henley's Husbandry, Together with an Anonymous Husbandry, Seneschaucie and Robert Grosseteste's Rules* (London, 1890), 83–119; D. Oschinsky, ed., *Walter of Henley and Other Treatises on Estate Management and Accounting* (Oxford, 1971). R. A. L. Smith, 'The Financial System of Rochester Cathedral Priory,' in R. A. L. Smith, *Collected Papers* (London, 1947), 51: 'A distinction grew up between the steward of the liberty (*senescallus libertatis* or *senescallus curiarum*), who held the courts of the monastery, and the steward of the lands (*senescallus terrarum*), who supervised the collection of rents and the conduct of agricultural operations on all the manors.'

62. D. Lepine, *A Brotherhood of Canons Serving God: English Secular Cathedrals in the Later Middle Ages*, Studies in the History of Medieval Religion, 8 (Woodbridge, 1995), 70–75; D. Lepine, 'The Origins and Careers of the Canons of Exeter Cathedral, 1300–1455,' in C. Harper-Bill, ed., *Religious Belief and Ecclesiastical Careers in Late Medieval England: Proceedings of the Conference Held at Strawberry Hill, Easter 1989*, Studies in the History of Medieval Religion, 3 (Woodbridge, 1991), 87–120. For documents making reference to their mansions, see W. J. Harte, J. W. Schopp, and H. Tapley-Soper, eds., *The Description of the Citie of*

Excester by John Vowel alias Hoker (Exeter, 1919), pt. 2, 164–71, 211–15; S. A. Moore, ed., *Letters and Papers of John Shillingford, Mayor of Exeter, 1447–5*, Publications of the Camden Society, n.s., 2 (Westminster, 1871), 89, 103.

63. The percentage of such canons and dignitaries increased steadily in Exeter and other English secular cathedrals between 1300 and 1500. In the third quarter of the 15th century, 36 Exeter canons and dignitaries (93 percent of total) had some university education. The largest number had studied canon and/or civil law, a valuable preparation for careers in church administration, and the remainder theology and the arts. Lepine, 'The Origins and Careers of the Canons of Exeter Cathedral' (as in note 62), 87–120.

64. D. M. Owen, *The Medieval Canon Law: Teaching, Literature, and Transmission* (Cambridge, 1990), 2: 'A bishop's or archdeacon's affairs could only be carried out with legal advice from men skilled in the law (*iuris periti*).'

65. Variant spellings of Southwell also include Southell, Southele, Sothwell, Southill, Sowtell, Sowthell, Siwell, Sudwell, Suthwell, Suell, and Suttle. P. H. Reaney, *A Dictionary of English Surnames*, 3rd ed. by R. M. Wilson (London, 1991), 419; J. Throsby, *Thoroton's History of Nottinghamshire Republished with Large Additions by John Throsby* (London, 1797), 2:71; *The Devon Wills Project* (at http://www.genuki.org.uk). A certain 'Elena Sowctele, sister' in the early 14th century has the closest surname. See Lepine and Orme, *Death and Memory in Medieval Exeter* (as in note 61), 266. The southern coastal area of Devon attracted internal migration to the Exeter as the regional capital. See D. Postles, *The Surnames of Devon*, English Surname Series, 6 (Oxford, 1995), 62–64, 72–74.

nobody surnamed Sowthel or Southwell can be found among the major officeholders of Exeter Cathedral, which included the cathedral chapter's dean and canons, from whose ranks seneschals were drawn. The name is not in Bishop Neville's *Registrum commune* or in the cathedral's published records, extant wills, registers of burials and funerals, obit lists, or surveys of extant monuments and inscriptions.[66] While most Exeter canons enjoyed the privilege of burial inside the cathedral's hallowed space, few of its medieval ledger stones have survived and still fewer are deciperable.[67] There are no archival references to anyone by this name in the extant stewards' accounts (Devon Record Office), recording stewards' names for each term, though these accounts are fragmentary or nonexistent for some years, especially around the Exeter canon's death.[68]

Two Oxford graduates named Master John Southwell were active in the third quarter of the fifteenth century. One was a *baccalaureus iuris canonici* (1446) who served as principal or a fellow of Peckwater Inn (1456), held various church rectorships, including that of Clifton Reynes, Bedfordshire, and was dead by

1460. The other was a rector and canon of churches in Yorkshire and Worcestershire from 1441, finally serving as dean of Warwick, St. Mary's Collegiate Church and its chapter, 1470–1481. Warwick the Kingmaker nominated him dean of St. Mary's in 1469.[69] But he died in 1481, two decades later than the Exeter canon, and was unconnected with Exeter Cathedral. It seems unlikely that Shirwood penned a fictive epitaph or literary invention about an imaginary canon who never existed; for the verses do not conceal the names of the author or his patron and read as though intended for public viewing by the Exeter cathedral community.[70]

Most likely, Shirwood's Master John Sowthel is known by a different surname in extant records. In the late 1450s and early 1460s, several Exeter canons were named 'Master John,' one of whom served as steward. But their death dates are not close to that of the canon in Shirwood's verse epitaph, and they also had no reason to be known as Southwell.[71] The canon under Bishop Neville with the closest death date is Master John Stevenys (variant spellings include Stevens and Stephens), so it is possible that Stevenys was simply misread as Sowthel at some point in the transmission

66. Admittedly, English tomb inscriptions did not often survive though written in stone and brass, the most durable of materials. The antiquarian John Weever (1576–1632) condemned those responsible for 'having already most sacrilegiously stolen, erazed, and take away, almost all inscriptions and epitaphs, cut, writ, inlaid, or engraven upon the sepulcher of the deceased, and most shamefully defaced the glorious rich tombs, and goodly monuments of our worthy ancestors.' Weever, *Antient Funerary Monuments* (as in note 19), xviii.

67. J. W. Hewett, 'Remarks on the Ornamental Brasses, and Certain Decorative Remains, in the Cathedral Church of St. Peter, Exeter,' *Transactions of the Exeter Diocesan Architectural Society* 3 (1849), 90–100; Hewett, 'A Complete Monumentarium of the Cathedral Church of St. Peter, Exeter' (app. IV), *Transactions of the Exeter Diocesan Architectural Society* 3 (1849), 107–38. Lepine and Orme, *Death and Memory in Medieval Exeter* (as in note 61), 25, 30.

68. A. M. Erskine, 'Account Rolls of the Stewards of Exeter Cathedral,' unpublished document provided to the author by Ellie Jones, Exeter Cathedral Archivist, June 2012.

69. Emden, *Biographical Register* (as in note 32), 3: 1730–31. D. Styles, ed., *Ministers' Accounts of the Collegiate Church of St. Mary, Warwick, 1432–85* (Oxford, 1969), 126 n. 2; C. Fonge, ed., *The Cartulary of St. Mary's Collegiate Church, Warwick*, Studies in the History of Medieval Religion, 23 (Woodbridge, 2004), 397, 445. The Nevilles also had had a chaplain named Sir John Southwell,

unconnected with Exeter Cathedral, not long before 1460. See J. Fenn, ed., *Paston Letters: Original Letters Written during the Reigns of Henry VI, Edward IV, and Richard III* (London, 1859), 59 (Letter no. 77). Warwick the Kingmaker wrote from Middleham, Yorkshire, in a letter dated 13 August (before 1460) to John Paston (1421–66), concerning the Rectory of Little Snoring, Norfolk, 'And moreover I pray to give credence in this matter to my well-beloved chaplain Sir John Southwell, bearer of this my letter.'

70. Concerning the use of fictive names by John Gower and others, see E. Steiner, 'Naming and Allegory in Late Medieval England,' *The Journal of English and Germanic Philology* 106/2 (2007), 248–75; esp. 264–65. S. L. Newstok, *Quoting Death in Early Modern England: The Poetics of Epitaphs beyond the Tomb* (New York, 2009), 86.

71. Among them were Master John Germyn or Germeyn, who served as chancellor, died between 21 February and 24 June 1460, and was to be buried in the cathedral. Others include Master John Burneby (d. 1459), treasurer. Master John Rowe (or Rawe), who died by November 1463, served as steward during the Michaelmas and Christmas terms of 1459. Rowe had a B.A. (1427) from Oxford and was a M.A. student as well. He owned six books and bequeathed them to Exeter College. See Emden, *Biographical Register* (as in note 32), 3: 1598–99; C. W. Boase, *Registrum Collegii Exoniensis: Register of the Rectors, Fellows and Other Members of the Foundation of Exeter College, Oxford* (Oxford, 1893), 34–35; J. M. Horn, *Exeter Diocese*, vol. 9 of J.

of the verse epitaph, much as a papal clerk had garbled Shirwood's name. Stevenys was an Oxford-educated *magister* who was collated as a canon and prebendary of Exeter Cathedral in 1413, remained there during the long rule of Bishop Edmund Lacy (r. 1420–1455), and died under Bishop Neville at the advanced age of about 80. Old age was then believed to have two stages, beginning respectively at 56 and 68. The latter ushered in the winter of life, associated with Saturn and the Zodiacal sign Capricorn.[72] It was under this sign, coincidentally, that the Exeter canon died (verses 79–80). Stevenys had a long career in cathedral administration, though financial records are too incomplete under Bishops Lacy and Neville to identify his terms of service as seneschal. He held various prebends and rectorships, including that of the parish church of St. Michael at Blackawton, Devon. In 1457, he founded St. Catherine's Almshouse and Chapel, near the cathedral and canons' houses, and later petitioned King Henry VI for a license of mortmain to benefit it. Stevenys's will

(dated 3 February 1457/8; proved 27 February 1460/1) made provisions for charitable donations, prayers for his soul, and the gift or sale of his moveable goods, including manuscripts, two of which survive. His funeral was in Exeter Cathedral during the Christmas term 1460/61, and an obit was celebrated by the cathedral community a year later, close to the date of death given in Shirwood's verse epitaph.[73]

Tomb Inscriptions & Portable Epitaphs

Whoever Master John Sowthel might have been, the appropriate tomb for a canon of Exeter Cathedral in the fifteenth century would have been a workshop-produced, incised stone slab or engraved brass plate laid into the floor as a grave cover. Canons were far too numerous to be remembered with expensive limestone, sandstone, or alabaster monuments with life-size effigies and inscriptions encouraging collective memory for high-status individuals,[74] such as that

Le Neve, *Fasti Ecclesiae Anglicanae, 1300–1541* (London, 1964), 6, 52; Madan and Craster, *Summary Catalogue* (as in note 8), vol. 2, pt. 1, 275. Beyond the canons, there is no similar name among Exeter Cathedral's minor officeholders listed in N. Orme, *The Minor Clergy of Exeter Cathedral, 1300–1548* (Exeter, 1980); and Orme, *The Minor Clergy of Exeter Cathedral: Biographies, 1250–1548*.

72. J. T. Rosenthal, *Old Age in Late Medieval England* (Philadelphia, Pa., 1996), 96–98; H. Peters, 'Jupiter and Saturn: Medieval Ideals of 'Eide,'' in A. Classen, ed., *Old Age in the Middle Ages and the Renaissance: Interdisciplinary Approaches to a Neglected Topic* (Berlin, 2007), 283–84. R. Steele, ed., *Lydgate and Burgh's Secrets of Old Philisoffres: A Version of the 'Secreta secretorum,' Edited from the Sloane MS. 2464*, Early English Text Society, Extra Series, no. 66 (London, 1864), pp. 46–47 (vv. 1436–70), 109.

73. Neville, *Registrum commune*, fols. 118$^{r–v}$, 124r–125r (Exeter, Devon Record Office, chanter 12, pt. 1). This death date is suggested by Horn, *Exeter Diocese* (as in note 71), 45, 47; Lepine and Orme, *Death and Memory in Medieval Exeter* (as in note 61), 108, 326, 328. Emden, *Biographical Register* (as in note 32), 3: 1774. Emden says that Stevenys died in 1459. Horn, Lepine, and Orme suggest the later death date. The two extant manuscripts were Oxford, Bodleian Library, Ms. 315 (Richard Rolle of Hampole, *Tractatus super Job* [or *Expositiones notabiles*] and other texts, including a transcription of Middle English and Latin verses displayed at the Augustinian Canons' Priory of St. Stephen of Launceston, Cornwall, which came to Exeter Cathedral after the death of Roger Keyes [d. 1477], a canon of Exeter); and Oxford, All Souls College, Ms. 182, an Anglo-Norman manu-

script. See Madan and Craster, *Summary Catalogue* (as in note 8), vol. 2, pt. 1, 508–9, no. 2712; R. H. Robbins, 'Wall Verses at Launceston Priory,' *Archiv für neueren Sprachen und Literaturen* 200 (1963), 338–43; E. F. Jacob, 'Verborum florida venustas,' in E. F. Jacob, *Essays in the Conciliar Epoch* (Manchester, 1953), 200 n. 4; D. Legge, ed., *Anglo-Norman Letters and Petitions from All Souls ms. 182* (Oxford, 1941), xii–xviii; E.K. Prideaux and E. Lega-Weekes, *Sutcombe Church and Its Builders* (Exeter, 1913), 69; E. Lega-Weekes, *Some Studies in the Topography of the Cathedral Close, Exeter* (Exeter, 1915), 71. Stevenys made a bequest to Richard Horygg, keeper of the cathedral library; and bequeathed a manuscript (*Vite patrum*, *Speculum ecclesie*, and *Testamentum patriarcham*) to John Luffyncote, a member of the minor clergy, who in 1452 and 1457 had served as sub-clerk of the exchequer, assisting the stewards. Orme, *The Minor Clergy of Exeter Cathedral: Biographies, 1250–1548* (as in note 71), 158, 183.

74. Some late medieval moralists had qualms about what they saw as the pridefulness of elaborate tombs and effigies, which simple stone slabs avoided. Jacques Legrand (1360–1415) observed in *Le livre des bonnes moeurs* (1404) that they could show pride and vanity. J. Legrand, *Archiloge sophie. Livre de bonnes meurs*, edited by E. Beltram, Bibliothèque du XVᵉ siècle, no. 4 (Geneva, 1986), 395 (chap. 34, 'Comment nul ne doit estre curieux de sa sepulture. Sepulture curieuse puet estre segnifiance de orgueil et de vanité, singulierement quant on la fait faire en son vivant et ordener curieusement et quant on y prant vain plaisir. Et en ce faisant on met son ame en grant peril.'). J. E Inglis, *Faces of Power and Piety* (London, 2008), 80–81; Binski, *Medieval Death* (as in note 28), 88–89, 146.

FIGURE 9. Exeter Cathedral, Tomb of Bishop Walter Branscombe (Geograph Image Copyright by Julian P. Guffogg).

of Bishop Walter Branscombe (r. 1258–1280) in Exeter Cathedral's Lady Chapel (Fig. 9), which combines the original stone effigy surrounded by an elaborate later tomb-chest and canopy (1442); and the Chantry of Precentor William Sylke (d. 1508), in the North Transept, a cadaver tomb within an architectural stone screen with tracery, which encloses contemporary wall paintings of the Resurrection and Entombment.[75] Stone slabs and brass plates could be decorated with a simple cross or a two-dimensional frontal effigy, spare memorials with formulaic 'hic iacet' epitaphs that briefly identified the deceased. Exeter canons could request particular tomb inscriptions, appealing for prayers, as we see in the 1464 will of John Pyttes (d. 1467).[76] Incised stone slabs with brief epitaphs are documented for six Exeter canons in the fifteenth century and for Shirwood's own tomb (1494) in the church of the English Hospice of St. Thomas the Martyr in

75. B. Cherry and N. Pevsner, *Devon*, Buildings of England, Pevsner Architectural Guides, 2nd ed. (New Haven, Conn., 1991), 50, 382, 480; Lepine and Orme, *Death and Memory in Medieval Exeter* (as in note 61), 30.

76. Lepine and Orme, *Death and Memory in Medieval Exeter* (as in note 61), 96: 'Subiacet hoc lapide Johannes Pyttes musicus ille, | Qui fuit ecclesie quondam canonici huius | Presulis Edmundi Lacy cantor que capella, | Rector de Tavy Petri Parkham simul extans, | Pro quo mente pie rogo dicite sancta Marie.'). Another example is Richard Preston, parson of Mersham, Hartest, and Boxstede, who specified in his will (3 October 1521),

proved at Canterbury, that his body be wrapped in a winding cloth and interred in the chancel of his church, covered by a marble monument with an epitaph, 'well engraven in brass or let into the stone, and thus set: 'Te moneat pietas strato succurrere morti; | Nam simili sorte serus cadit omnis et aetas.' And I will that my name and the day of my deathing be graven as aforesaid, and well set in the stone.' N. H. Nicolas, *Testamenta vetusta: Illustrations from Wills of Manners, Customs, &c. as well as of the Descents and Possessions of Many Distinguished Families from the Reign of Henry the Second to the Accession of Queen Elizabeth* (London, 1826), vol. 2, 595–96.

Rome.[77] Stone slabs allowed a limited number of words along the perimeter, brass monuments occasionally slightly longer epitaphs.[78] For example, the four-line inscription on the brass monument for Master William Langeton (d. 1413/14), a canon of Exeter Cathedral and cousin of Bishop Edmund Stafford (r. 1395–1419), in its Chapel of St. John the Evangelist (Fig. 10), depicts the deceased in processional vestments, kneeling in prayer. A text scroll rising from his hands has a responsory from the Office of the Dead, appealing to Christ not to judge him for his unworthy deeds ('Domine Ihesu secundum actum meum noli me iudicari').[79] Longer epitaphs were possible on elaborate tombs or if epitaphs were written on or incised into separate tablets displayed on the tomb or at the back of its canopy.[80]

The primary meaning of epitaph (*epitaphium*) is 'tomb inscription,' as the etymology from the Greek ἐπιτάφιος ('on a tomb') suggests. John Trevisa's Middle English translation (1387) of Ralph Higden's *Polychronicon* glosses the word *epitaphium* to explain that it was a tomb inscription remembering the deceased.[81] But

FIGURE 10. Exeter Cathedral, Brass Monument for Master William Langeton (Geograph Image Copyright by Julian P. Guffogg).

77. Hewett, 'Complete Monumentarium' (as in note 67), 108–9: Master John Cobworthe (d. 1433), Master Martin Lercedekne (d. 1433), Master Major Parys (d. 1438), Master Richard Helyer (d. 1446), Master Henry Webber (d. 1476), and Master David Hopton (d. 1481). Shirwood's epitaph reads, 'Hic jacet R. Pater Joannes Shirwode episcopus Dunelmensis serenissimi Regis Angliae Orator, qui obiit xii Januarii 1493, cujus anima in pace quiescat.' The funeral after his death on 14 January 1494 was quite elaborate as befitting the archbishop of Durham. J. T. Fowler, ed., *Memorials of the Church of S.S. Peter and Wilfrid, Ripon*, Publications of the Surtees Society, 79/2 (Durham, 1886), 218; J. Allen, *The English Hospice in Rome* (Leominster, 2005), 102–3.

78. Scodel, *English Poetic Epitaph* (as in note 37), 51; Box, *Elegies and Epitaphs* (as in note 19), 232–38.

79. Cherry and Pevsner, *Devon* (as in note 75), 49, 380; Lepine and Orme, *Death and Memory* (as in note 61), fig. 13. 'Hic iacet Willielmus Langton' consanguineus magistri Eduardi Stafford' Exoniensis episcopi quondam canonicus huius ecclesie qui obit xxix die mensis Januarii anno domini millesimo mmmm terdecimo, cuius anime propicietur omnipotens deus. Amen.'

80. R. E. Latham and D. R. Howlett, *Dictionary of Medieval Latin from British Sources*, Fascicule III, D–E (London, 1986), 787; Binski, *Medieval Death* (as in note 28), 112–15; R. Houlbrooke, *Death, Religion, and the Family in England, 1480–1750* (Oxford, 1998), 343–48. The word *epitaphium* could refer to a 'framework over a tomb.' Latham and Howlett, *Dictionary of Medieval Latin*, fascicule III, 787; R. E. Latham, *Revised Medieval Latin Word-*

List from British and Irish Sources (London, 1965), 167. Among extended epitaphs is a 26-line Latin epitaph formerly attached to the Lincoln Cathedral cadaver tomb of Archbishop Richard Fleming (c. 1385–1431) of York in which the deceased tells readers that death had swept away his academic and ecclesiastical attainments. K. Cohen, *Metamorphosis of a Death Symbol: The Transi Tomb in the Late Middle Ages and Renaissance* (Berkeley, Calif., 1973), 16–17.

81. This can be seen in a reference to the tomb of Pallas, who was slain by King Turnus, based on Virgil's *Aeneid* (x: 474–487). R. Higden, *Polychronicon Ranulphi Higden monachi Cestrensis; together with the English Translations of John Trevisa and of an Unknown Writer of the 15th Century*, ed. by C. Babington, Rolls Series, 41 (London, 1865), 1: 225 (bk. 1, chap. 25): 'Þis geauntes epitaphium, þat is, þe writynge of mynde of hym þat lay þere, was suche. "Pallas Evander his sonne lyeþ here | Him Turnus þe kny3t wiþ his spear | Slowe in his manere."' Trevisa's translation

the word was also used less strictly to signify memorial verses not written on tombs, such as those occasionally found in English mortuary rolls (*rotuli* or *brevia defunctorum*) of the twelfth to early sixteenth centuries. Special messengers or roll-bearers (*breviator, rotularius, rolliger*) carried mortuary rolls between monasteries to honor the memory of deceased abbots and monks with prayers and other texts.[82] By the end of the Middle Ages, *epitaphium* could refer not only to tomb inscriptions, but also to elegies, eulogies, funerary sermons, and collective memorials.[83] In the fifteenth and sixteenth centuries, when it was not unusual to display moralistic Latin and Middle English wall verses inside churches, extended memorial texts were a way to remember the dead and offer religious lessons to the living.[84] What have been called 'portable epitaphs'

made it easy to exceed the limited text-bearing capacity of stone and brass monuments, whether or not they were included text scrolls.[85] Written on single sheets or rolls of a flexible writing support (usually parchment), these auxiliary epitaphs could be temporarily displayed on walls or columns near the tomb or on the hearse, a metal stand holding the remains during the funeral service.[86] They could also be affixed to wooden plaques or tablets (*tabulae*) with paste, wax, or tacks, and then hung on hooks for display near the tomb during the funeral or an anniversary service or obit.[87] They might even be incised directly into reusable wax writing tablets. Such epitaphs became far more common during the Renaissance, as we see in Shakespeare's references in *King Henry the Fifth* and *Much Ado About Nothing* to epitaphs written on paper

goes beyond a literal translation of Higden's text (1:224):'Hujus gigantis tale erat epitaphium. "Filius Evandri Pallas, quem lancea Turni | Militis occidit more suo, jacet hic."'

82. A. G. Rigg, *A History of Anglo-Latin Literature, 1066–1422* (Cambridge, 1992), 15–16, 18–19, 36–37. The most elaborate mortuary roll that circulated in England, incorporating numerous Latin verses, was one for William the Conqueror's daughter Mathilda (d. 1113), abbess of the Holy Trinity, Caen. See L. Delisle, *Rouleaux des morts du IXᵉ au XVᵉ siècle* (Paris, 1866), 177–279. See also J. G. Nichols, 'On Precatory or Mortuary Rolls, and Particularly One of the Abbey of West Dereham, Norfolk,' *Memoirs Illustrative of the History and Antiquities of Norfolk and the City of Norwich* (London, [1851]), 99–114. C. Cheney, 'Two Mortuary Rolls from Canterbury: Devotional Links of Canterbury with Normandy and the Welsh March,' in D. E. Greenway, C. J. Holdsworth, and J. E. Sayers, eds., *Tradition and Change: Essays in Honour of Marjorie Chibnall Presented by Her Friends on the Occasion of Her Seventieth Birthday* (Cambridge, 2002), 110; W. H. St. John Hope, 'The Obituary Roll of John Islip, Abbot of Westminster, 1500–1532, with Notes on Other English Obituary Rolls,' *Vetusta monumenta*, vol. 7, pt. 4 (London, 1906), 39–51, pls. xv–xxiv.

83. I. D. McFarlane, 'The Renaissance Epitaph,' *The Modern Language Review* 81/4 (1986), xxv–xx; esp. xxv–xxxv. In *Acta sanctorum*, Jean Mabillon (1632–1707) used the word *epitaphium* to mean a funerary sermon, as in the case of St. Gregory of Nazianzus, *Funebris oratio in laudem Basilii Magni Caesareae in Cappadocia episcopi* (*Oratio* xliii); Migne, *PG* 36:493–606. C. du Fresne, Sieur du Cange, *et al.*, *Glossarium mediæ et infimæ latinitatis* (Niort, 1883–87), vol. 3, col. 281a.

84. Robbins, 'Wall Verses at Launceston Priory' (as in note 73), 338–39. Robbins focuses on a series of five Middle English and Latin proverbs that in the first half of the 15th century were displayed on the walls of the dining hall (*aula*) of the Augustinian Canons' Priory of St. Stephen of Launceston. No longer extant,

the priory's moralizing wall verses survived by being transcribed in a manuscript (Oxford, Bodleian Library, Ms. 315 [Madan and Craster, *Summary Catalogue* (as in note 8), vol. 2, pt. 1, 508–9, no. 2712]) that Magister John Stevenys gave to the Dean and Chapter of Exeter Cathedral. See also M. D. Anderson, *Drama and Imagery in English Medieval Churches* (Cambridge, 1963), 60. Anderson notes in her discussion of late medieval *Pater Noster Plays* and wall paintings on the Seven Deadly Sins, which could serve as supplements to sermons for the moral instruction of parishioners, that the text of morality plays was 'sometimes painted on boards, or on the walls of churches, but this was a later practice when literacy had become more common.'

85. L. Campbell and P. Attwood, *Renaissance Faces: Van Eyck to Titian*, National Gallery, Exhib. cat. (London, 2008), 56: 'The German humanist Conrad Celtis [1459–1508], fearing that he was about to die in 1507, commissioned a woodcut from Hans Burgkmair based on a Roman tombstone as a sort of portable epitaph to distribute to friends as a memento.'

86. Concerning hearses, see S. Hope, *The Obituary Roll of John Islip* (as in note 82), 9, 24; Daniell, *Death and Burial* (as in note 41), 47–48; S. Schell, 'The Office of the Dead in England: Image and Music in the Book of Hours and Related Texts, *c.* 1250–*c.* 1500,' Ph.D. diss. (University of St. Andrews, 2011), 88, 109 n. 106 (at http://hdl.handle.net/10023/2107).

87. Chance survival of handwritten memorial plaques suggests how portable epitaphs might be displayed. For example, a consecration tablet of 1482 in the Austrian Tyrol (Princeton University Library, Princeton Ms. 96), with 21 long lines of Latin on a parchment sheet measuring 34.5 × 25.4 cm, pasted onto a wooden tablet that was mounted in a double frame fitted with an iron loop, which allowed it to be hung on a wall. See E. Panofsky, 'A Consecration Tablet of the 15th Century,' *Princeton University Library Chronicle* 8/2 (1947), 63–66, and plate; Skemer, *Medieval & Renaissance Manuscripts* (as in note 10), 2:312–13.

rolls and wax tablets.[88] Some epitaphs were printed as broadsides or published in collections of tributes to recently deceased authors, such as the *Epitaphia in mortem* for Sir Philip Sidney (1554–1586).[89]

Unlike stone or brass inscriptions, portable epitaphs were not made to be permanent and only survive as chance transcriptions in manuscripts and printed books. An early example is the *Epitaphium eiusdem ducis Gloucestrie*, a 104-line Middle English verse epitaph for Humphrey of Lancaster, first duke of Glouces-ter (1390–1447). Twelve of the stanzas end with the refrain 'hym buried in this sepulchre,' suggesting dis-play near the tomb around the time of interment. Formerly misattributed to the poet John Lydgate (*c.* 1370–*c.* 1451), whose own epitaph was brief, the *Epi-taphium eiusdem ducis Gloucestrie* may have been written originally on a roll but only survives in a manuscript copy from the third quarter of the fifteenth century (British Library, Harley Ms. 2251).[90] Another exam-ple is the *Epitaphium Ricardi ducis Eboracensis*, written for the 1476 reinterment of Duke Richard of York (*c.* 1410–1460) at Fotheringhay, Northamptonshire. The Chester Herald of Arms in Ordinary at the Col-lege of Arms, London (possibly Thomas Whiting) au-thored or at least copied the 34-line French epitaph, displayed over the tomb.[91] Perhaps the best known is the *Epitaphium Galfredi Chaucer*, a 30-line Latin epi-taph for Geoffrey Chaucer (*c.* 1343–1400), which the Milanese humanist Stephanus Surigonus (*fl. c.* 1454–1478) composed in England, long after the poet's death. William Caxton (d. *c.* 1492) claims to have had these verses displayed on a tablet in Westminster Abbey, 'wreton on a table hongyng on a pylere,' adjacent to the poet's tomb. Surigonus's *Epitaphium* ends with the hope that a two-line Latin epitaph would be inscribed on the poet's tomb. The text of the *Epitaphium* sur-vived because Caxton printed it in his 1478 edition of Chaucer's translation of Boethius's *De consolatione philosophiae*.[92]

Most likely, the *Epitaphium Magistri Johannis Sowthel* was written for temporary display near the tomb at the time of interment and possibly at the first com-memoration of the canon's death a year later. A single-column parchment roll of two or three membranes could accommodate an 80-line epitaph, serving as the canon's imagined speech, with appeals to friends and passersby for their prayers and remembrance (verses 74–76). Shirwood's partisan reference to the Wars of

88. W. Shakespeare, *King Henry the Fifth*, 1: ii ('Not worship'd with a paper epitaph'; later changed to 'Not worship'd with a waxen epitaph'); *Much Ado About Nothing*, 4: i ('On your fam-ily's old monument | Hang mournful epitaphs'); *Much Ado About Nothing*, 5: i, 293–94 ('Hang her an epitaph upon her tomb | And sing it to her bones, sing it to-night'); *Much Ado About Nothing*, 5: iii ('Hangs up the scroll. Hang though there upon the tomb, | Praising her wen I am dumb'). See *William Shakespeare: The Complete Works*, edited by C. J. Sisson (New York, 1953), *passim*; *Shakespeare's Henry the Fifth*, ed. by W. A. Wright, *Shakespeare: Select Plays* (London, 1882), 114–15.

89. *Epitaphia in mortem obilissimi et fortissimi viri D. Philippi Sid-neii equitis* (Leiden, 1587). Sidney's tomb at St. Paul's Cathedral, London, had a 10-line epitaph on a wooden tablet. Edward, Lord Herbert of Cherbury (1582/3–1648), later noting the lack of a monument for Sir Philip Sidney, penned an epitaph designed to be fastened to the door of St. Paul's. W. H. Bond, 'The Epitaph of Sir Philip Sidney,' *Modern Language Notes* 58/4 (1943), 253–57; J. C. Collins, ed., *The Poems of Lord Herbert of Cherbury* (London, 1881), 80; A. J. Colaianne and W. L. Godshalk, eds., *Elegies for Sir Philip Sidney (1587)* (Delmar, N.Y., 1980); Weever, *Antient Funeral Monuments* (as in note 19), 114.

90. R. H. Robbins, 'An Epitaph for Duke Humphrey (1447),' *Neuphilologische Mitteilungen* 56: 7–8 (1955), 241–49. For John Lydgate's own epitaph, see J. O. Halliwell-Phillipps, ed., 'A Se-lection from the Minor Poems of Dan John Lydgate,' in *Early English Poetry, Ballads, and Popular Literature of the Middle Ages*, vol. 2 (London, 1840), vii: 'Mortuus seclo, superis superstes, | Hac iacet Lidgat tumulatus urna, | Qui fuit quondam celebris Britannie fama poesis.'

91. Three manuscripts preserve the text. R. F. Green, 'An Epitaph for Richard, Duke of York,' *Studies in Bibliography* 41 (1988), 218–24; epitaph transcribed and translated on 222–23.

92. G. Chaucer, *The Complete Works of Chaucer: Edited, from Numerous Manuscripts ... Romaunt of the Rose, Minor Poems*, ed-ited by W. W. Skeat (Oxford, 1899), 1: xlvii; J. A. Dane, 'Who is Buried in Chaucer's Tomb?: Prolegomena,' *Huntington Library Quarterly* 57/2 (1994), 99, 101–2; S. Lerer, *Chaucer and His Read-ers: Imagining the Author in Late Medieval England* (Princeton, N.J., 1993), 147–75. Surigonus taught Latin rhetoric at Oxford in 1454–62 and possibly 1465–71, and began studying canon law at Cambridge in 1475–76. Surigonus hoped his epitaph would be on Chaucer's tomb: 'Galfridus Chaucer vates et fama poesis | Materne hac sacra sum tumulatus humo.' Concerning use of the English word 'table' to mean 'tablet,' see P. Stallybrass, R. Chartier, J. F. Mowery, and H. Wolfe, 'Hamlet's Tables and the Technologies of Writing in Renaissance England,' *Shakespeare Quarterly* 55/4 (2004), 414–15.

the Roses and obsequious praise for Bishop Neville (verses 52–58) includes two lines written in red for emphasis (verses 53–54). This seven-line political excursus served as dynastic propaganda, somewhat like contemporary genealogical chronicle rolls, to proclaim the Yorkist allegiance of the author and cathedral community, for whom the epitaph was primarily intended.[93] The latter was comprised of about seventy-five major and minor clerics, as well as more than a hundred lay servants (about six per canon) and clerics from other religious institutions in Exeter and environs. They would have accompanied the canon's remains in a solemn funeral procession from his nearby house to the cathedral's high altar, and then were mourners at the funeral and interment.[94] Perhaps in attendance were clerics from churches in the diocese of Exeter (Devon and Cornwall) that were associated with individual canons through prebends and rectorships. After the funeral, as long as the portable epitaph remained on view, it could be seen by passersby, pilgrims, and other visitors. But there is no evidence that it was read aloud to mourners like modern eulogies, whose function is to praise the deceased rather than letting them speak from the grave.

One can appreciate the possibility of a portable epitaph or other writings on display in a cathedral by reference to the *Itineraria* of the pious antiquarian William Worcester [or Botoner] (1415–1482?), an Oxford-educated member of the Neville Circle and former secretary and estate manager of Sir John Fastolf (*c.* 1378–1459). Worcester visited Exeter Cathedral while traveling from East Anglia to Cornwall in 1478–1480, often following pilgrimage routes. At Exeter in September 1478, he transcribed two prayers that were probably on display near the tomb of Bishop Edmund Lacy, whose reputation for saintliness drew pilgrims to Exeter for more than a generation after his death in 1455. Worcester wrote in a rapid Anglicana cursive hand, with many abbreviations and corrections on unruled folded paper sheets of varying sizes, which were later bound together in notebook. The two prayers are 'Oratio ad beatum Edmundum Lacy Excestrie | O Edmunde pastor bone | Cleri pastor et patrone...'); and a Latin intercession to Lacy for pilgrims to the bishop's tomb ('Ora pro nobis beate Edmunde...'), with a space left for specific requests for intercession. Elsewhere, Worcester copied the epitaphs of William the Conqueror, Sir William Elmham (d. 1403), and Abbot Thurstan de Ludham of St. Benet Hulme (d. 1064).[95]

In conclusion, epitaphs were material texts, whether written in stone or on parchment. Their physical presentation had a direct impact on their form, function, readership, interpretation, and rate of survival. Portable epitaphs permitted fuller expression of the late medieval obsession with death than was possible in

93. During the Wars of the Roses, genealogical chronicle rolls were created and displayed as political propaganda to support rival Yorkist or Lancastrian claims to the throne and show a personal or baronial family allegiance to York or Lancaster. See R. Radulescu, 'Yorkist Propaganda and the Chronicle from Rollo to Edward IV,' *Studies in Philology* 100, no. 4 (2003), 401–24; J. Hughes, *Arthurian Myths and Alchemy: The Kingship of Edward IV* (Stroud, 2002), 98–99, 125–29, 137–39; G. L. Harriss, introduction to *The Scroll Considerans (Magdalen MS 248) Giving the Descent from Adam to Henry VI*, ed. and trans. by John E. T. Brown, Magdalen College Occasional Papers (Oxford, 1999), 4.

94. M. Kowaleski, *Local Markets and Regional Trade in Medieval Exeter* (Cambridge, 1995), 73, 172, 371 n. 4. The estimates are for 1377.

95. William Worcester's notes on Exeter Cathedral are in a 334-page notebook (Cambridge, Corpus Christi College Library, Ms. 210, 14–15). W. Worcester, *Itineraries*, ed. and trans. by J. H. Harvey, *Oxford Medieval Texts* (Oxford, 1996), 116–17; online in *Parker Library on the Web* (at parkerweb.stanford.edu/parker/). During his journey, Worcester measured buildings and took notes on what he observed and read in manuscripts about history, biography, saints' days, and other subjects, including three epitaphs. Worcester, *Itineraries*, 42–43, 162–63, 224–25. Nicholas Orme has suggested that the two prayers were probably on display near Bishop Lacy's tomb and says that Worcester also took notes from 'the board displaying in Latin the major dates in the cathedral's history and the list of bishops—the earliest guidebook, as it were, for visitors.' Orme, *The Cathedral Cat* (as in note 43), 75–76. Exeter Cathedral pilgrimage and cults are discussed in N. Orme, 'Two Saint-Bishops of Exeter: James Berkeley and Edmund Lacy,' *Analecta Bollandiana* 104 (1986), 403–18; U. M. Radford. 'The Wax Images Found in Exeter Cathedral,' *Antiquaries Journal* 29 (1949), 164–68. For English antiquarians and the Neville Circle, see T. D. Kendrick, *British Antiquity* (London, 1950), 18–33; Lowry, 'John Rous and the Survival of the Neville Circle,' 327–38; J. Hughes, 'Stephen Scrope and the Circle of Sir John Fastolf: Moral and Intellectual Outlooks,' C. Harper-Bill and R. Harvey, eds., *Medieval Knighthood IV: Papers from the Fifth Strawberry Hill Conference, 1990* (Woodbridge, 1982), 109–46; esp. 130–33.

conventional tomb inscriptions on stone or brass. In a sense, portable epitaphs in which the dead addressed the living functioned as extended speech scrolls, though configured as medieval rolls, *transversa charta*, rather than as text scrolls with pithy messages written in display script along their length. Roll format worked well with epitaphs, poetry, prayers, and other texts of modest length, facilitating portability and practical use, including open display on walls, plaques, and other surfaces.[96] There is a hint of this display function in the Prayer Roll of Henry VIII, *c.* 1485–1509, which shows two unfurled amulet rolls, really rolls-within-a-roll, held aloft by angels beside Christ on a Tau Cross and about the length of his body.[97] Non-documentary rolls kept and used outside the relative safety of institutional libraries rarely survive. But the temporary

nature of portable epitaphs did not undermine their immediate use, and display of the text in an ephemeral format might even reinforce the ascetic theme of worldly impermanence. The text of Shirwood's *Epitaphium* survived through scribal copying, perhaps making its way to London through an intermediate transcription, and was added to Taylor Ms. 22, along with unrelated Latin and Middle English *contemptus mundi* texts, for the benefit of a religious house or cleric associated with or influenced by the Carthusian and Bridgettine houses of Greater London. In an age preoccupied with death, the verse epitaph's theme and vivid imagery made it meaningful, without accompanying illustration, to distant readers who never knew the canon of Exeter Cathedral.

96. Concerning the use of rolls for poetry, see R. H. Rouse, 'Roll and Codex: The Transmission of the Works of Reinmar von Zweter,' in *Paläographie 1981: Colloquium des Comité International de Paléographie, München, 15–18 September 1981,* ed. by G. Silagi, Münchener Beiträge zur Mediavistik und Renaissance-Forschung, no. 32 (Munich, 1982), 107–123. For an overview of medieval English text rolls, see P. Robinson, 'The Format of Books: Books, Booklets and Rolls,' in N. Morgan and R. M. Thomson, eds., *The Cambridge History of the Book in Britain,* vol. 2 (Cambridge, 2008), 43–46; D. C. Skemer, 'From Archives to the Book Trade: Private Statute Rolls in England, 1285–1307,' *Journal of the Society of Archivists* 16/2 (1995), 193–206; D. C.

Skemer '*Frater* Richard Bury's Roll: Ownership and Use of an Early Genealogical Chronicle of the Kings of England,' *English Manuscript Studies,* vol. 17 (Chicago, Ill., 2012), 60–106.

97. London, British Library, Add. Ms. 88929; formerly Durham, Ushaw College, Ms. 29. The first text is based on the Measure of Christ (*Thys cros xv tymes moten ys the length of our lord ihesu criste…*); the second is a Latin prayer (*Deus qui gloriosis martyribus tuis cirico et iulitte tribuisti…*) to St. Cyricus and St. Julitta. See D. C. Skemer, *Binding Words: Textual Amulets in the Middle Ages,* Magic in History (University Park, Pa., 2006), 264–67. Description and images in *British Library Digitised Manuscripts* (at http://www.bl.uk/manuscripts).

Appendix

John Shirwood, *Epitaphium Magistri Johannis Sowthel.*[98]

[Princeton University Library, Taylor Ms. 22, fol. 191ʳ].

Epitaphium Magistri Johannis Sowthel quondam Senescalli domus Reuerendi in christo patris et domini domini Georgii Exoniensis Episcopi editum per Magistrum Johannem Schyrewode eiusdem ecclesie Cancellarium.[99]

Epitaph of Master John Sowthel, formerly Seneschal of the Chapter House of the Lord Bishop George of Exeter, most reverend in Christ father and lord; authored by Master John Shirwood, chancellor of the same church.

[1] Munde vale. Sowthel mihi dudum blande Johanni
Farewell world. Not long ago, tempting to me, John Southwell,

[2] Iam scio ficta fides est tua. Munde vale.
Now I realize your good faith is a deception. Farewell world.

[3] Munde vale. Tua prosperitas veris quasi flos est.[100]
Farewell world. Your good fortune is like a spring flower.

[4] Pro unum fallax gloria.[101] Munde vale.
False glory for awhile. Farewell world.

[5] Munde vale. Fulgens fragilisque simillime vitro
Farewell world. Gleaming and fragile like glass

[6] Et magis anguilla lubrice.[102] Munde vale.
And more slippery than an eel. Farewell world.

98. The transcription retains original spelling. Abbreviations and contractions have been silently expanded. In the interest of clarity, the first letter in each sentence and in proper names has been capitalized. Punctuation has been normalized. Italics indicate the rubric and verses written in red ink. Folio and verse numbers have been inserted within square brackets. English translation by Don C. Skemer.

99. Epitaphs for English clerics commonly use *quondam* with the title of the office last held by the deceased, as we can see in innumerable references in Weever, *Antient Funeral Monuments* (as in note 19). As chancellor of Exeter Cathedral, John Shirwood here uses a formulaic rendering of George Neville's name and title, which is similar to the form used in the latter's episcopal register (Exeter, Devon Record Office, chanter 12, pt. 1); for example, fol. 31ʳ: 'Registrum commune Reuerendi in christo patris et domini Domini Georgii Nevylle dei gratia Exoniensis Episcopi inceptum decimo Die mensis Aprilis Anno domini Millesimo ᴄᴄᴄᴄᵐᵒ Quinquagesimo sexto Et Anno Electionis et confirmacionis ipsius Georgii primo.' The word *domus* refers to the chapter house. J. Britton, *A Dictionary of the Architecture and Archaeology of the Middle Ages* (London, 1837), 70: 'In a roll of Exeter Cathedral, dated 1412–13, this room is called *domus capitularis.*' The word *editus* in the present context means authored

or composed. Latham and Howlett, *Dictionary of Medieval Latin from British Sources*, Fascicule III, ᴅ–ᴇ (as in note 80), 746–47.

100. *The Pricke of Conscience,* citing the Book of Job, compares man to a flower, which in time loses its beauty and withers. *The Pricke of Conscience* (ed. Morris) (as in note 40), 20 (I: 695–97): 'þat son fayles and fades, als dos þe flour | for a flour þat semes fayre and bright, | thurgh stormes fades, and tynes þe myght…' The popular religious poem *De contemptu mundi,* sometimes attributed to sometimes attributed to St. Bernard of Clairvaux (1190–1153) or Jacopone da Todi (c. 1230–1306), begins 'Cur mundus militat | sub vana gloria | cuius prosperitas est transitoria.…' Walther, *Initia carminum* (as in note 20), no. 3934. It is found Taylor Ms. 22 on fol. 192ʳ.

101. The expression *fallax gloria* in reference to the world's deceit and trickery is found in Byrhtferth (c. 970–c. 1020), *Vita Sancti Oswaldi,* 5:15). See M. Lapidge, ed., *Byrhtferth of Ramsey: The Lives of St Oswald and St Ecgwine* (Oxford, 2009), 186–87 ('…fallax gloria huius mundi, et quam turpis est…').

102. Probably taken from ancient or medieval proverbs about things being as 'slippery as an eel' or 'slippery as an eel's tail.' W. C. Hazlitt, *English Proverbs and Proverbial Phrases…* (London, 1907), 81. W. Baker, *The Adages of Erasmus* (Toronto, 2001), 82–83.

[7] Munde vale. Dulci tegis esca pestifer hamum
Farewell world. In a sweet dish you conceal a poisonous barb

[8] Intima quo laceres viscera. Munde vale.
With which you tear apart a man's insides. Farewell world.

[9] Munde vale. Iocunde foris, sed letifer iutus
Farewell world. Appealing on the outside, pleasing but deadly,

[10] Infers quando foues vulnera. Munde vale.
Inflicting wounds upon those whom you favor. Farewell world.

[11] Munde vale. Fucis mortalia lumina ludis
Farewell world. You deceive mortal eyes with pretences.

[12] Mobilis es vento tu mage. Munde vale.
You are swifter than the wind. Farewell world.

[13] Munde vale. Cuius sequitur post oscula morsus
Farewell world. Whose bite follows after kisses,

[14] Post risus lacrime perfide. Munde vale.
False tears after laughter. Farewell world.

[15] Munde vale. Virus condens sub melle.[103] Quot heheu
Farewell world. Venom hidden in honey. Alas! How many

[16] Decipis? O demum, desine. Munde vale.
you deceive? Stop, at long last! Farewell world.

[17] Munde vale. Iuuenes, grandes natu, mediocres
Farewell world. The young, the old, the middle aged.

[18] Ha tua decipiunt ludicra. Munde vale.
Ah! Your trifles deceive them all. Farewell world.

[19] Munde vale. Tibi mos reges senosque tirannos
Farewell world. It is your wont to deceive old kings, tyrants,

[20] Pontificesque sacros fallere.[104] Munde vale.
And high priests. Farewell world.

[20] [fol. 191ᵛ] Munde vale. Nemroth[105] non est tutata tirannis
Farewell world. Nimrod is not aided by other tyrants

103. Ovid's *Remedia amoris* (i: viii, 104) refers to venom hidden in honey, in the sense of seductively charming speech: '... impia sub dulci melle venena latent.' Chaucer quoted Ovid in the *Tale of Melibee* (2605): 'Under the hony of the goodes of the body is hyd the venym that sleeth the soule.' One can fine a similar sentiment in Jean Gerson's treatise against the *Le roman de la rose*. See C. McWebb, ed., *Debating the Roman de la rose: A Critical Anthology* (New York, 2007), 288–89 (vv. 338–339).

104. Possibly refers to as King Herod the Great (*c.* 74–4 B.C.E.) and to Caiaphas and other Jewish high priests.

105. Nemroth is another name for Nimrod, the evil king of Babylon, who during the Middle Ages was considered to have been the builder of the Tower of Babel. He was generally described as a murderous tyrant, whose pride made him try in vain to build a tower to heaven. The reference to the other tyrants is probably to the other tribal leaders, who like Nimrod were the sons of King Cush of Babylon (Genesis 10:7–8). See B. Murdoch, *The Medieval Popular Bible: Expansions of Genesis in the Middle Ages* (Cambridge, 2003), 17–48, esp. 129, 133; J. Scattergood, *The Lost Tradition: Essays on Middle English Alliterative Poetry* (Dublin, 2000), 236.

[22] Quin sibi surriperes omnia. Munde vale.
Indeed, you take everything away from him. Farewell world.

[23] Munde vale. Nec honos Agamennona protegit ingens
Farewell world. Public esteem does not protect Agamemnon

[24] Quin cadat uxoris vulnere.[106] Munde vale.
From being slain because of his wife's wound of love. Farewell world.

[25] Munde vale. Nitide prestans vbi forma Lacene[107]
Farewell world. Brilliantly extraordinary, like Helen of Troy's beauty

[26] Aut Alcibiadis[108] inclita. Munde vale.
Or the glorious deeds of Alcibiades. Farewell world.

[27] Munde vale. Nec Aristotiles[109] te flexit acutus
Farewell world. Neither did the wise Aristotle persuade you,

[28] Nec Plato diuinus,[110] improbe. Munde vale.
Nor did the divine Plato, improperly. Farewell world.

[29] Munde vale. Macedo cui non sat erat teres orbis[111]
Farewell world. Alexander the Great, for whom the whole world was not enough,

[30] Septeno clausus est pede.[112] Munde vale.
Is confined to a seven-foot tomb. Farewell world.

[31] Munde vale. Clari vehemens facundia Marci[113]
Farewell world. The vigorous eloquence of the renowned Marc Antony

[32] Haud fidum fecit te sibi. Munde vale.
Does not make you loyal to him. Farewell world.

106. Agamemnon, king of Mycenae or Argos, was murdered by Aegisthus with the connivance of Agamemnon's wife Clytemnestra, as the story is told by Aeschylus in the *Orestia*.

107. The Spartan woman (*lacena*), from Lacedemonia (Sparta), refers to Helen of Troy, wife of King Menelaus of Sparta and later of Paris, son of King Priam of Troy. Concerning the ancient reputation of Spartan women for their beauty, see Sarah B. Pomeroy, *Spartan Women* (New York, 2002), 132–33.

108. Alcibiades (*c.* 450–404 B.C.E.), the Athenian statesman and general responsible for major victories during the Peloponnesian War.

109. The reference to Aristotle (384–322 B.C.E.) is probably related to his theory of rhetorical persuasion in the *Ars rhetorica*.

110. Plato (424/423–348/347 B.C.E.) was considered divine since antiquity. For example, Cicero, *Cato Maior* de Senectute, 13 [44], refers to the divine Plato in connection with the notion of pleasure as fish bait for human evil: 'divine enim Plato 'escam malorum' appellat voluptatam, quod ea videlicet homines capiantur ut pisces …'

111. The Macedonian (*Macedo*) refers to Alexander the Great (356–323 B.C.E.). Similar sentiments are expressed in an often-quoted epitaph that Box, *Elegies and Epitaphs* (as in note 19), 237, claims was from Alexander the Great's tomb: 'Sufficit huic tumulus cui non suffecerit orbis.' In the ancient world, visitors to this tomb, such as Julius Caesar and the Emperor Augustus, were moved by Alexander the Great's fallen glory. Weever, *Antient Funeral Monuments* (as in note 19), lx–lxi. *The Pricke of Conscience* described his worldly power as weakness in the Heavenly City: '…alle þae mygh þat Alexander had aywhare, | war noght tald bot wayknes þare.' The *Pricke of Conscience* (ed., Morris) (as in note 40), 243 (7: 9043–44).

112. Shirwood must have been estimating the size of Alexander the Great's golden casket, which had been placed within a golden sarcophagus in his tomb in Alexandria. For the medieval English use of the Latin word *pes* as a measure of 'feet,' see R. E. Zupko, *Dictionary of Weights and Measures for the British Isles: The Middle Ages to the 20th Century*, Memoirs of the American Philosophical Society, vol. 168 (Philadelphia, 1985), 149.

113. Mark Antony [Marcus Antonius] (83–30 B.C.E.) delivered a funeral oration for Julius Caesar, after the latter's body had been cremated in the Roman Forum, and roused Roman citizens against Brutus and his co-conspirators.

[33] Munde vale. Sic Cesaream terit ars tua pompam[114]
Farewell world. In this way, your cunning wears down Caesar's splendor

[34] Julius ecce iacet puluere. Munde vale.
Behold, Julius lies reduced to ashes. Farewell world.

[35] Munde vale. Quot sic? O quot dixere priores?
Farewell world. How many others are the same way? Oh, how many
　　　forebears have said so?

[36] Quot post hoc dicent milia? Munde vale.
How many thousands say so after this? Farewell world.

[37] Munde vale. Felix quem non deceperis. O si
Farewell world. Blessed is the man whom you do not deceive. Oh, if

[38] Quanta fuit scissem fraus tua. Munde vale.
I had only known how great was your trickery. Farewell world.

[39] Munde vale. Virides flores abiere iuuente
Farewell world. The fresh flowers of youth are gone.

[40] Post ver venit iems(!) horrida.[115] Munde vale.
After summer comes the grim winter. Farewell world.

[41] Munde vale. Qui fortis eram qui corpore velox
Farewell world. Once I was strong, fleet of foot.

[42] Examinis massa sum modo. Munde vale.
Now I am weighed down with a heavy burden. Farewell world.

[43] Munde vale. Quondam fortassis amatus amabam
Farewell world. Once perhaps beloved, I have loved.

[44] Nunc inamabiliter putreo.[116] Munde vale.
Now I putrify disagreeably. Farewell world.

[45] Munde vale. Linquor solus, conuiuia leta[117]
Farewell world. I depart alone, where there are now joyful banquets,

114. The lavish funeral procession (*pompa*) of Julius Caesar (100–44 B.C.E.) in Rome was interrupted by a plebian crowd that took control of the public ceremony and funeral pyre, then attacked the conspirators' homes. See G. S. Sumi, *Ceremony and Power: Performing Politics in Rome between Republic and Empire* (Ann Arbor, Mich., 2005), 101–8. As Shirwood uses the word *pompa*, it could also mean pomp or splendor, in the sense of vain display, much as *The Pricke of Conscience* uses the word in Middle English. This is how the word seems to be used in the will of Thomas de Montacute, fourth earl of Salisbury (1388–1428), who coincidentally was grandfather of Warwick the Kingmaker. Thomas de Montacute did not want 'any large or sumptuous lights for me at my funeral or that any large or sumptuous lights for worldly pomp be then provided.' Nicholas, *Testamenta vetusta* (as in note 76), 1: 215. It is also the way the word is used in an epitaph for William Beck-ley, 1437. Weever, *Antient Funeral Monuments* (as in note 19), 62.

115. That is, *hiems horrida*. On the basis of Pythagoras's teaching about the four ages of man, Ovid depicts winter as a hideous old man (*Metamorphoses*, 15: 212: 'inde senilis hiems tremulo venit horrida passu'), who during spring and summer had been strong and swift (15: 225: 'inde valens veloxque fuit spatiumque iuventae'). Ovid, *Metamorphoses*, in *The Latin Library* (http://www.thelatinlibrary.com/ovid/ovid.met15.shtml).

116. *The Pricke of Conscience* (ed. Morris) (as in note 40), 24 (1: 695–97): '...when þem lye of hym passes oway | þan es he noght bot erthe and clay | þat turnes till mare corrupcion, | þan ever had stynkand carion...'

117. The banquet reference may be explained by the Exeter canon's death in January (vv. 78–80). The month is associated with banquets and feasts in the Labors of the Month in Books of

[46] Grata sodalicia nunc vbi.[118] Munde vale.
Grateful communities. Farewell world.

[47] Munde vale. Quid habes quo nunc delecter in euum
Farewell world. May I now be eternally charmed by what you possess.

[48] Non tua gustabo gaudia. Munde vale.
I will not experience your joys. Farewell world.

[49] Munde vale. Senis tamquam mare plene procellis
Farewell world. Through the stormy seas of old age,

[50] Iam teneo lassus litora.[119] Munde vale.
I wearily steer close to shore. Farewell world.

[51] Munde vale. Morior quem ᶰᵘᵖᵉʳ magna fouebat
Farewell world. I am dying, a man who recently cherished great things

[52] Presulis insignis gracia. Munde vale.
Thanks to an esteemed bishop. Farewell world.

[53] *Munde vale. Sed episcopus ipse Georgius oro*
Farewell world. Indeed, I pray, may Bishop George

[54] *Multa Nevil viuat secula. Munde vale.*
Neville live forever. Farewell world.

[55] Munde vale. Sit et ille sua pater Exoniensis[120]
Farewell world. May the father of Exeter and his church be,

[56] Felix formosa coniuge.[121] Munde vale.
A man blessed with a beautiful wife

[57] [fol. 192r] Munde vale. Tali quod cito post tristia[122] patri
Farewell world. Such that soon after lamentations for his father

Hours of the 13th to 15th centuries. Aquarius depictions some-times contrast youth and old age. See C. Hourihane, ed., *Time in the Medieval World: Occupations of the Months and Signs of the Zodiac in the Index of Christian Art* (Princeton, N.J., 2007), 55–66; T. B. Husband, *The Art of Illumination: The Limbourg Brothers and the Belles Heures of Jean de France, duc de Berry* (New York, 2008), 82. The expression *convivia laeta* is found in the *Cuculus sive veris et hiemis conflictus*, an anonymous text that has been attributed to Alcuin, Bede, and others. In verse 25, Winter says, 'Sunt mihi divitae, sunt et convivia laeta.' Migne, *PL* 121: 983.

118. Probably refers to the cathedral chapter and other reli-gious bodies with which the Exeter canon was connected.

119. The Roman poet Catullus (*c.* 84–54 B.C.E.) wrote in Poem no. 4 about his old boat, which like a person, had weath-ered a lifetime of raging seas before reaching sheltered waters, where it could retire and grow old. D. F. S. Thomson, ed., *Catullus* (Toronto, 1997), 101–2, 217.

120. Formulaic references to the bishop of Exeter include 'venerabilis pater et ecclesia sua Exoniensis.' See G. Oliver and J.S. Attwood, eds., *Monasticon Dioecesis Exoniensis: Being a Collec-tion of Records and Instruments Illustrating the Ancient Conventual, Collegiate, and Eleemosynary Foundations, in the Counties of Corn-wall and Devon, with Historical Notices, and a Supplement, Com-prising a List of the Dedications of Churches in the Diocese* (London, 1846), 211, 397.

121. In canon law, the relationship between a bishop and his church (*ecclesia cathedralis*) could be likened to the mystical union with a spiritual spouse. A. M. Boudinhon, 'Cathedral,' in C. G. Herbermann *et al.*, eds., *The Catholic Encyclopedia* (New York, 1913), 3: 439. Scripture taught that the union of husband and wife was like that of Christ and the church (Ephesians 5:22–33).

122. Shirwood uses the word *tristia* in the sense of mourning someone's death. Ovid's *Tristia*, comprised of mournful letters in elegiac couplets, likening his exile from Rome to death, even includes the poet's own epitaph (iii.3.76): 'Hic ego ui iaceo ten-erorum lusor amorum … dicere Nasonis molliter ossa cubent.' See J. F. Gaertner, ed., *Ovid, Epistulae ex Ponto, Book I* (Oxford, 2005), 363, 471, 491.

[58] Grata superveniant omnia.[123] Munde vale.
All welcome events come to pass. Farewell world.

[59] Munde vale. Perplene[124] dolis sapiencia cuius
Farewell world. Whose wisdom by total deceit

[60] Nil nisi stulticia, callide. Munde vale.
Is nothing but folly, through and through. Farewell world

[61] Munde vale. Feror huic curarum grandia deinceps
Farewell world. I thus bear great worries hereafter,

[62] Linquo superstitibus pondera. Munde vale.
And I leave burdens to my survivors. Farewell world.

[63] Munde vale. Regimen[125] alios et magna fatigent
Farewell world. Would that fiscal administration and the large

[64] Ipsa Senescalli munera. Munde vale.
Revenues of the seneschal could overcome everything. Farewell world.

[65] Munde vale. Viuis det celsa pericia iuris[126]
Farewell world. My advanced knowledge of the law brought me

[66] Laudem culmen opes, nil michi. Munde vale.
High praise and wealth when I was alive, but nothing for me now. Farewell world.

[67] Munde vale. Tibi prebendam[127] vel morte resigno
Farewell world. To you, I resign my prebend or by death,

[68] Ecclesiasque meas corripe.[128] Munde vale.
And take away my churches. Farewell world.

123. Verses 57–58 refer to the Yorkist successes just months after the execution of Richard Neville, fifth earl of Salisbury (1400–60), father of Warwick the Kingmaker and of Bishop George Neville. The earl of Salisbury was beheaded on 31 December 1460, a day after the Battle of Wakefield, one of the most significant battles during the Wars of the Roses. In the next few months, Yorkist military victories over the Lancastrians lead to the accession and coronation of King Edward IV (r. 1461–70, 1471–83), son of Richard of York, third duke of York (c. 1410–60), who was slain at the Battle of Wakefield. He was married to Cicely Neville (1415–95), the aunt of Warwick the Kingmaker and George Neville, and mother of Edward IV and Richard III of England. See C. D. Ross, *Edward IV* (Berkeley, Calif., 1974), 32–38.

124. The English church used the adjective *perplena* to mean total or full; for example, 'perplena responsio' in a 1345 letter from Durham Priory to Richard de Bury, archbishop of Durham (r. 1333–45). See G. W. Kitchin, ed., *Richard D'Aungerville of Bury: Fragments of His Register, and Other Documents*, Surtees Society, 119 (Durham, 1910), 262.

125. The word *regimen* here probably is a reference to *regimen*

scaccarii; that is, administration of the cathedral exchequer, including fiscal administration and estate management. See R. A. L. Smith, 'The *Regimen Scaccarii* in English Monasteries,' in Smith, *Collected Papers* (as in note 61), 54–73.

126. This refers to expertise in canon law or perhaps in canon and civil law. In 1239 the sub-dean of York described the bishop of St. Andrews as 'utriusque iuris peritus.' See Great Britain, Historical Manuscripts Commission, *14th Report, Appendix, Part III: The Manuscripts of the Duke of Roxburghe, Sir H. H. Campbell, Bart., the Earl of Strathmore, and the Countess Dowager of Seafield* (London, 1894), 184.

127. The noun *prebenda* is used here in accordance with English ecclesiastical law to refer to an annual stipend paid to particular church officials, such as canons, in return for their official services. Prebends were supported fiscally by the cathedral church's rents and other income. H. C. Black, *Black's Law Dictionary*, 6th ed. (St. Paul, Minn., 1990), 1175.

128. This refers to church benefices, prebends, and rectories held in addition to being a member of the cathedral chapter. See Lepine, *Brotherhood of Canons Serving God* (as in note 62), 72–74.

[69] Munde vale. Faleratus equus, decus, atria, vestes,
Farewell world. My ornately harnassed horse, adornment, houses, wardrobe,

[70] Predia, delicie sint tua.[129] Munde vale.
Estates, and luxuries are yours. Farewell world.

[71] Munde vale. Tibi cuncta vorax et auare relinquo
Farewell world. To you, insatiable and greedy, I surrender everything,

[72] Vt rapias aliis hec dato. Munde vale.
I give everything to you that you may take it away. Farewell world.

[73] Munde vale. Triplicis culpe[130] sator huic rogo pro me
Farewell world. Though I am the sower of three-fold error, I ask

[74] Qui legat ista preces fundito.[131] Munde vale.
Whoever reads these verses, pray for me. Farewell world.

[75] Munde vale. Sed vos in quis sum fisus amici
Farewell world. Still, I trust in those who are my friends.

[76] Este mei memores obsecro. Munde vale.
Remember me, I beseech you. Farewell world.

[77] Munde vale. Semel M, post C quater, l, semel i.que
Farewell world. One thousand, four hundred, fifty, and

[78] Ac x[132] in lectum decido. Munde vale.
Eleven. I am dying in bed. Farewell world.

129. The epitaph for the Black Prince has the deceased de-
clare, 'Greate riches here did I possesse, | Whereof I made great
noblenesse; | I had gold, silver, wardrobes and | Great treasure,
horses, houses, land.' Weever, *Antient Funeral Monuments* (as in
note 19), 9; Box, *Elegies and Epitaphs* (as in note 19), 12.

130. Pride is seen as the root of all sin, leading to the *triplex
culpa* of boastfulness, vainglory, and failing to love God. See
Joannes Cassianus [John the Ascetic] (360–435), *De coenobiorum
institutis*, in Migne, *PL* 49:409: 'Sed elevatum est cor ejus, id est,
superbia elatum. Initium enim omnis peccati superbia (Eccle-
siasticus x); atque ex ea triplicis culpae notam incurrit: 1° in-
gratitudinis … 2° jactantiae, ostentatiois et inanis gloriae … 3°
neglectae charitatis erga proximorum salutem…'

131. Readers of epitaphs were routinely asked to pray for the
deceased ('pro me funde preces'). Weever, *Antient Funeral Monu-
ments* (as in note 19), 73, 126, 192, 364. But the precise prayers
to be said by tomb visitors and passersby are not indicated in
Shirwood's epitaph. Some brass monument supply prayers in one
or more text scrolls. Later Latin usage occasionally allowed 'ista
preces' as though neuter plural. Two 16th-century epitaphs use
the words 'ista preces.' We see this in an epitaph for Prior John
Blakemore (d. 1518), St. Mary's Priory of Augustinian Canons, at
Little Dunmow, County of Essex. Weever, *Antient Funeral Monu-
ments* (as in note 19), 390 ('Ergo preces cineri dones quicumque
viator | Ista preces tantum stebilis urna petit'). The same two
verses are used in an epitaph for Christophe Boucher (d. 1530), a

Benedictine who was a member of the theological faculty at the
University of Paris, 1518–30; and was sub-prior of the Collège de
Cluny, 1524. É. Raunié, ed., *Épitaphier du vieux Paris* (Paris, 1899),
vol. 3 (Chartreux–Saint-Etienne-du-Mont), 142, no. 1089; J. K.
Farge, *Biographical Register of Paris Doctors of Theology, 1500–1536*,
Subsidia mediaevalia, 10 (Toronto, 1980), 52, no. 54.

132. The Roman numerals in the chronological formula may
be transcribed as 'semel mille, post centum quater quinquaginta,
et semel undecem.' Weever, *Antient Funeral Monuments* (as in
note 19), includes many epitaphs with chronological formulas
for English clerics, public officials, and aristocrats from the 13th
to 16th centuries; for example, 151, Roger the Black, Bishop
of London (d. 1241); 194, William Lichfield (d. 1447); 201, 263,
Abbot Nicholas Litlington (d. 1386); and 342, Radulph Bathorpe
(d. 1455). For chronological formulas in Roman numerals, see
K. Menninger, *Number Words and Number Symbols: A Cultural
History of Numbers*, trans. from German by P. Broneer (Cam-
bridge, Mass., 1969), 284–86; J. Hilton, *Chronograms 5000 and More
in Number Excerpted out of Various Authors and Collected at Many
Places* (London, 1882), xiii–xiv, 1–37. Additional examples in J.
Hilton, *Chronograms Continued and Concluded: More than 5000 in
Number: A Supplement Volume to 'Chronograms,' Published in 1882*
(London, 1885); J. Hilton, *Chronograms Collected: More than 4,000
in Number*, vol. 3 (London, 1885), 493 (examples in Lincoln,
Peterborough, and Hereford cathedrals, 1380–1468).

[79] Munde vale. Titan vbi transierat Capricorni,
Farewell world. When the Sun enters Capricorn

[80] Octodecimque gradus, huic eo.¹³³ Munde vale.
And eighteen degrees more. Farewell world.

133. This astrological reference is to the Capricorn Ingress, when the Sun (Titan) enters into the cardinal sign of Capricorn (the Goat), marking the beginning of the Winter Solstice. Ingress begins at 0°, late in the day of 21 December. Each of the 12 Zodiacal signs or houses was divided into 30°, for a total of 360° in each calendar year. The precise date is given as 18° (out of 30) after the Capricorn Ingress, which is about 18 calendar days after the Winter Solstice (8 January 1461/2). In England under the Julian Calendar, a January 1462 date would be expressed as 1461 because the new year did not begin officially until 25 March, which was the date of the Feast of the Annunciation. C. R. Cheney, *Handbook of Dates for Students of English History* (Cambridge, 1995), 4–5. Bishop Neville's *Registrum commune* follows this practice; for example, the 1458 will of Master John Stevenys is dated 'Hac die tercia ffebruarii Anno domini Millesimo CCCC lviiᵒ' (fol. 124ʳ). Neville, *Registrum commune*, fols. 124ʳ–125ʳ (Exeter, Devon Record Office, chanter 12, pt. 1). Co-incidentally, Yorkist propaganda used the Sun in Splendor, often depicted emblematically within a white rose, as a symbol for Edward IV. The Sun signified rebirth and regeneration coming with Edward IV's political triumph and ascendancy. This view was found most clearly in the alchemical symbolism and prophecy of George Ripley (*c.* 1415–90), who was at one time a canon of the Augustinian Priory at Bridlington, Yorkshire, and was a member of the Neville Circle. Hughes, *Arthurian Myths and Alchemy* (as in note 93), 86–92. His verses and associated symbolism are included in approximately 23 Ripley alchemical rolls directly or indirectly based on a lost 15th-century exemplar, including Princeton Ms. 93, dating from the late 16th century. See J. M. Rampling, 'The Catalogue of the Ripley Corpus: Alchemical Writings Attributed to George Ripley (d. *c.* 1490),' *Ambix* 57/2 (2010), 125–201; Skemer, *Medieval & Renaissance Manuscripts* (as in note 10), 2: 309–11.

duna lanza e portata in cercho cum grande uituperio · e cridaueno · o
auaro Galba datte mo piacere e buon tempo · uno chiamato petrobil
liberto di nerone comproe pei cento pezze doro la testa di Galba e zi
tola in quello loco doue Galba auea perseguito nerone · finalmente
uno suo dispensatore chiamato arguio tolse la testa el corpo e si lo se
peli in uno suo orto su la stratta chiamata aurelia · Auea Galba ani
lxxiii · quando fu morto · fu imperatore sette mesi e sette giorni
fu di statura comune caluo li ogi neri podagroso e distorto le ma
ne e piedi naso camuso mangiaua assay · e lo inuerno mangiaua in
anzi di · e per la podagra non potea portare scarpe ne tegnire carte
in mano · fu anchora in luxuria uiciosissimo · el Senato li uolse far
leuare una statua ma poy vespasiano non lo sofferse · se maginaua
che siando in zudea auesse mandato fin de Spagnia alcun per farlo
occidere · a questo tempo fu Marcho fabio Quintiliano gran
de rhetorico · il quale fu primo che tenesse scola publica a roma e
che fusse salariato de publico ·

Qui finisse la uita di Galba · e cominza quella di Otto ·

i mazoi di Otto furon
duno castello chiamato
ferentino anticha et hon
orata famiglia · so auo fu
Senatore e pretore · il pa
tre simigliaua tutto qua
nto tiberio · come si fusse
generato da luy · ebbe
molte honoranze in roma
fu proconsulo in affrica
ebbe doy figli et una fig
lia sposata a druso figlio
di Germanico · naque qu
esto Otto a di xxvi · de
aprile · in adolescentia pro
digo e dissoluto in tanto chera batuto dal patre · andaua uolun
tieri di notte e facea molti recresimenti ad altruy · doppo la mor
te del patre simuloe di uolere bene ad una liberta quasi decrepita
e per questa tale femina fu molto domestico e familiare di Nerone
altri dicono questa domesticheza essere stata per uicio sodomitico

FIGURE 1. The emperor Otho gazing into a mirror. Paris, Bibliothèque nationale de
France, ital. 131, fol. 44.

PATRICIA STIRNEMANN

Inquiries Prompted by the Kane Suetonius (Kane Ms. 44)

BETWEEN 1431 and the mid-1440s, the Lombard illuminator conventionally known as the Master of the Vitae Imperatorum, along with his colleagues or emulators, painted eight copies of the *Lives of the Caesars* by Suetonius, listed below.[1]

1. Paris, Bibliothèque nationale de France, ital. 131, in Italian (Filippo Maria Visconti), 1431.

2. Princeton, Princeton University Library, Kane Ms. 44, in Latin, 1433.

3. Vatican, Biblioteca Apostolica Vaticana, Urb. lat. 437, in Italian (Bartolomeo Aicardi Visconti).

4. Madrid, Bibliotheca Nacional, Vit. 16.2, in Latin (Bartolomeo Aicardi Visconti).

5. Milan, Biblioteca Trivulziana, cod. 696, in Latin (Bartolomeo Aicardi Visconti), 1444.

6. Vatican, Biblioteca Apostolica Vaticana, Ottob. Lat. 1966, in Italian (Antonio da Pesaro), 1438.

7. Cambridge, Fitzwilliam Museum, McClean Ms. 162, in Latin (Giovanni Matteo Bottigella), 1443.

8. Madrid, Bibliotheca Nacional, Ms. 10025, in Latin.

Three manuscripts are in Italian and five are in Latin. The earliest, in Italian, was made for Filippo Maria Visconti in 1431. The Latin manuscript Kane 44 was made in 1433 for someone close to Filippo, because in two initials it bears the duke's device of the blue knotted veil. Three copies (two in Latin and one in Italian) were made for Bartolomeo Aicardi Visconti, bishop of Novara, whose family was allowed to take the name

Visconti because Bartolomeo's father denounced a conspiracy against Filippo Maria. The last two books were made respectively for the duke's counsellor Antonio da Pesaro (in Italian) in 1438 and Giovanni Matteo Bottigella (in Latin) in 1443, the year before he was named secretary to Filippo.

The painter's attitude when illustrating the Italian translation of the *Lives of the Caesars* for Filippo Maria Visconti in 1431 (Paris, BnF, ital. 131) is markedly different from that displayed in the Latin copy of the *Vitae Imperatorum*, Kane Ms. 44, written and illuminated two years later. The opening initials in the Italian copy are relatively banal—Caesar on horseback, Augustus enthroned, Claudius writing, Galba on horseback. Thereafter, however, the choice of events in Filippo Maria's manuscript is frequently unsettling (Fig. 1).[2] Otho holds a lance and a mirror, the latter referring to his effeminate affectations mentioned in the very last chapter of his life: removing all his body hair, wearing a refined wig to cover his baldness, pasting wet breadcrumbs on his face after shaving to keep his beard from growing. Vitellius is shown banqueting, referring again to later chapters in his life concerning his vices of outrageous gluttony and cruelty. In the first half of the manuscript, our artist ignores half of the emperors described by Suetonius. He then diligently evokes the later emperors whose biographies Antonio Rho crafted from a variety of sources, but mainly from the *Historiae Augustae*.[3]

The second series of portraits begins a bit acerbically with Marcus Aurelius, the admired philosopher-

1. For more information and bibliography on each of the manuscripts, see Anne Ritz-Guilbert, *Des drôleries gothiques au bestiaire de Pisanello. Le Bréviaire de Marie de Savoie* (Paris: CTHS-INHA, 2010). A. Ritz-Guilbert provides a 'Corpus du Maître des Vitae Imperatorum,' pp. 295–304: (a) Group I (the Master), n° 2, Paris, BnF, ital. 131; (b) Group II (followers), n° 12, Vatican, Biblioteca Apostolica Vaticana, Urb. lat. 437; n° 14, Biblioteca Apostolica Vaticana, Ottob. lat. 1966; n° 17, Cambridge, Fitzwilliam Museum, McCLean 162; n° 24 Milan, Bibl. Trivulziana,

cod. 696; (c) Others (manuscripts she had not been able to see): p. 302, Madrid, Mss. 10025 and Vit. 16. 2; p. 303, Princeton, Kane Ms. 44.

2. All the initials are published on the Mandragore website at the BnF.

3. Bartolomeo Aicardi Visconti also owned a copy of the *Historia Augusta* painted by the Master of the Vitae, Vatican, Biblioteca Apostolica Vaticana, lat. 1903.

emperor, on his deathbed. He is a victim of the plague that is ravaging Rome, and he chides his friends who are withdrawing precipitously from his bed-chamber: 'si jam me dimittis, vale vobis dico, vos precedens' ('if you are already leaving me, I bid you farewell, and pass on before you').

His debauched and profligate brother, Lucius Verus, on the other hand, admires the golden statue he had made of the horse named Volucer, which belonged to his favorite 'Green' chariot racing team in Rome. Lucius so adored the horse that when it died, the emperor had a tomb built for it on the Vatican Hill. Diadumenus was only nine years old when he became emperor and he reigned less than two unmemorable years. When his father proclaimed him emperor and gave him the name Antoninus, he promised five gold pieces to every soldier present when he made the announcement and delivered his harangue. Indeed Diadumenus is remembered only through his coinage. The cross-dressing Elagabalus was mad, perverse, and lived under the control of his mother and grandmother, with whom he is pictured, all three holding spindles (Fig. 2). And so the series continues either with debauchery, paganism, or assassinations, the only exceptions being the dream of Constantine and the restoration of Christianity by Jovianus.

The miniatures in the Princeton manuscript not only offer more heroic or dignified presentations of the emperors, even for the most loathsome, but they also go beyond the text of Suetonius (Fig. 3). The manuscript opens with a page displaying a conquering Julius Caesar surrounded by allusions to his five triumphs, his role as judge and ruler, his assassination, a pyramidal tomb, and the city of Rome. In his study of the iconography, J. Wilson Ferguson notes that the pyramid was considered to be the tomb of Romulus and that there are 'not altogether conclusive indications' that it was also thought to be the tomb of Julius Caesar.[4] The portrait of Augustus has been Christianized and evokes the legend of the Tiburtine Sibyl who foretells the coming of Christ, an event that is borrowed from the Golden Legend (Fig. 4). What is striking is the great tree that rises from the earth in the representation of the universe, which Augustus holds in his hand. Ferguson suggested that it was a symbol of the *Pax Romana*. It seems more likely that the tree is the second of the five demonstrations of the miraculous Nativity in the Golden Legend, the recognition of the Nativity as miraculous by all creations that had both being and life, such as plants and trees.[5] Emperor Tiberius, wearing armor and a red cloak, holds a rondel dagger with a cruciform blade in his right hand and a human heart in his left (Fig. 5). The only possible reference in Suetonius' text are the words of Augustus concerning his son in Chapter 68, 'his faults come from his nature, not from the heart.' The image may evoke the two natures of Tiberius and a latent Christianized interpretation as well. According to Eusebius and Tertullian, Tiberius enthusiastically received a letter from Pontius Pilate explaining the wonders surrounding the death of Jesus, recommending unsuccessfully that the doctrine of his deity be adopted by the Senate.[6] Caligula, for all his misdeeds, gets off lightly with a twisted cornucopia and basilisk, signifying his brutality, while the moon, whom he invited to share his bed, evokes his egotism.[7] Claudius holds the mushroom that poisoned him and in the upper corner of the miniature there is a phoenix, the solar bird that is reborn in the ashes of its predecessor, which may well refer to Seneca's *Apocolocyntosis* or *Ludus de morte Claudii*, a mordant satire on the failed apotheosis of Claudius (Fig. 6).[8] Nero is shown with a harp and in the upper register there is a scene of Tubal Cain and a lady tuning a lute while balancing a rebec on her lap (Figs. 7 & 8). The reference is a gentle nod to Nero's reputation as a musician, and the proto-Renaissance typology is found in a fourteenth-century manuscript made for Bruzio Visconti, the *Canzone delle virtu e delle*

4. J. Wilson Ferguson, 'The Iconography of the Kane Suetonius,' *Princeton University Library Chronicle*, 19.1 (1957), pp. 34–45, here pp. 36–37.

5. The four demonstrations of the Nativity concern (1) creations that do not have being (inert objects or substances); (2) those that have being and life (plants and trees); (3) those that have being, life, and sentiment (animals); (4) those that have being, life, sentiment, and discernment (man); (5) those that have being, life, sentiment, discernment, and intelligence (angels).

6. Eusebius, *Church History*, bk. 2, chap. 2. Tertullian, *The Apology*, v.

7. Ferguson, p. 40, Suetonius, 'Caligula,' bk. 22.

8. *The Satire of Seneca on the Apotheosis of Claudius*, by A. P. Ball (New York, 1902).

FIGURE 2. The emperor Elagabalus, his mother, and grandmother holding spindles. Paris, Bibliothèque nationale de France, ital. 131, fol. 63.

FIGURE 3. The emperor Julius Caesar. Princeton, Princeton University Library, Kane Ms. 44, fol. 3ᵛ.

FIGURE 4. The emperor Caesar Augustus and the Tibertine Sibyl. Princeton, Princeton University Library, Kane Ms. 44, fol. 27.

FIGURE 5. The emperor Tiberius. Princeton, Princeton University Library, Kane
Ms. 44, fol. 59ᵛ.

... in capitoliam connocarent.
Quidam nõ fine loco abolendam Cesarum memoriam, ac dir
ruenda templa censuerunt. obseruatum aut notatumeq; ē, in
pmis Cesares omnis, dz Gaii pnomen fierit, ferro pisse, ii in
de ab eo qui cumanit spribz sit occisus. ✝ Finis Caligule

FIGURE 6. The emperor Claudius. Princeton, Princeton University Library, Kane
Ms. 44, fol. 98.

FIGURES 7 & 8. The emperor Nero with a detail of Tubal Cain and a personification of
Music in the upper register. Princeton, Princeton University Library, Kane Ms. 44, fol. 113.

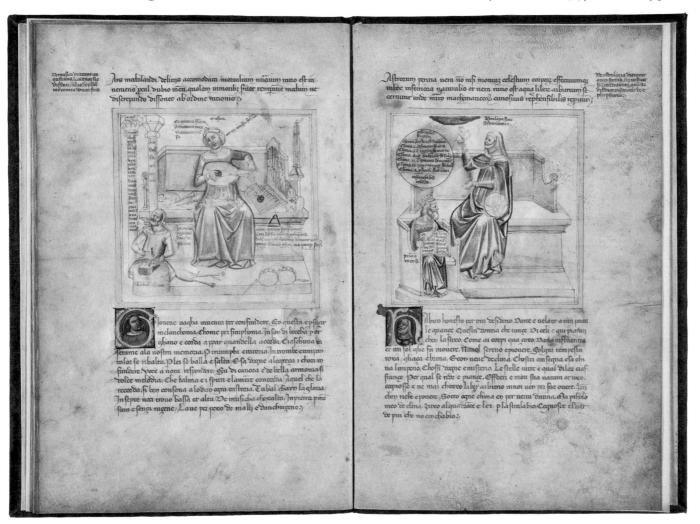

FIGURE 9. Music and Tubal Cain. Chantilly, Musée Condé, Ms. 599, fol. 9ᵛ.

scienze (Chantilly, Musée Condé, Ms. 599) (Fig. 9). Bruzio's manuscript depicts the virtues overcoming vices, who take the form of ancient tyrants and philosophers (e.g., Temperance overcomes Epicurus and Justice treads on Nero), and then passes to representations of the seven liberal arts and their ancient practitioners, namely Music and Tubal Cain or Astronomy and Ptolemy. Perhaps pressed for time, the inventiveness of the artist stops here and the remaining six emperors, including Otho and Vitellius, who were ridiculed in the earlier manuscript, are shown holding a sword, spear, baton, or, in the case of Vespasian, a model of the city of Jerusalem.

This very intelligent and sensitive artist has apparently groomed his iconography according to the recip-ient. The miniatures in the Kane manuscript converse with a humanist, beckoning recognition of literary and Christian allusions outside Suetonius's pungent accounts of the brutality and depraved behavior of the Caesars. The iconography in the duke's manuscript is censorious, dwelling on self-indulgence, perversion, and murder. The reason may well be that the artist disapproved of his patron and was sending a message. One of the six manuscripts painted by the Master of the Vitae Imperatorum for Filippo between 1428 and 1432 is a Breviary housed today in Chambéry, long thought to have been made for Filippo's second wife Marie de Savoie, whom he married in 1428. Yet the volume is replete with the emblems of Filippo, and it has recently been noted that the dedication to Marie

FIGURE 10. Scene of a murder. Chambéry, Bibliothèque municipale, Ms. 4, fol. 548.

on folio 319 (on the left) has been inscribed over an erasure.[9] It thus appears that the volume was originally ordered by Filippo for his own use, perhaps even before his marriage to Marie, and that only slightly later the dedication was changed and a sumptuous opening folio added depicting Marie being presented to the Virgin by the heavenly host.

Two consecutive folios in the Breviary, both painted by the Master of the Vitae, call attention to one of the duke's heinous crimes. In 1412 Filippo married Beatrice Lascaris di Tenda, widow of Facino Cane, and received a generous dowry of nearly 500,000 ducats. But in 1418 when Beatrice took too great an interest in affairs of state, Filippo falsely accused her of adultery with a minstrel, had her ladies in waiting

and the minstrel tortured and executed, and then had Beatrice beheaded. In the lower margin of folio 548 a bearded man is being stabbed with a rondel in the back,[10] and on folio 549 a bearded man is being lanced in the back by a knight holding a shield with Visconti arms (Figs. 10 and 11). The text on folios 548 and 548 verso is the office of saints Felix, Simplicius, Faustinus, and Beatrice. The martyrdom of these four saints by Diocletian is surely held in parallel to the murder of Beatrice and her attendants. Filippo Maria cannot help but have noticed the marginal scenes and understood the allusion.[11] This is probably why he gave the book to his wife while it was still in the making. He was also probably less than pleased with the iconography chosen for his copy of Suetonius and the lives of the

9. Ritz-Guilbert (as in note 1), p. 53. For color images, see the BVMM website.

10. Ritz-Guilbert (as in note 1), fig. 33 and detail, pp. 174–175; see also the BVMM website for an image in color.

11. I have followed the work of Anne Ritz-Guilbert on the Breviary of Marie de Savoie ever since she first undertook its description in the catalogue entitled *Manuscrits médiévaux de*

Chambery (Turnhout, 1998), pp. 30–43, pl. VI–X, figs. 28–55, 57–59, 61–65, 68–76, and extended her inquiry to a dissertation and then to the book, *Des drolleries* (as in note 1). We puzzled together more than once about the drolleries on fols. 548 and 548[v] and in many ways she deserves equal credit for the ultimate understanding of their meaning.

FIGURE 11. Scene of a murder, with the assassin holding a standard bearing the Visconti arms. Chambéry, Bibliothèque municipale, Ms. 4, fol. 549.

later emperors, which undoubtedly explains why he never asked this very gifted but circumspect artist to make another book for him.

Returning to Kane 44, possible solutions to a few other problems can be proposed. On folio 113ᵛ (Fig. 12), in the initial that introduces the life of Nero, one finds the Visconti blue knot or 'nodo' device and, on a scroll, the inscription TANGRI BEAU, which has been scratched out and rewritten TAIGRI EGAL(?). Elisabeth Pelligrin found a similar inscription, TANGRI VERA, on a copy of *Papias* that was made for Bartolomeo Aicardi Visconti; the manuscript is London, British Library, Add. Ms. 14806, fol. 76.[12] I have not yet been able to verify the reading. It is possible that the inscription on Kane 44 is a motto in French, *Tangre beau*, meaning 'desire for beauty.' It was quite common at

the time for northern Italian nobles to adopt French or German mottos, and it was Petrarch who devised the French motto 'A buon droyt' for the Visconti. Professor Massimo Zaggia has told me of another, *Suven avus*, which again has a somewhat bizarre phonetic spelling for *Souvent à vous*.[13]

The ownership of the manuscript has also posed problems. On folio 4, below the opening of the text of the life of Julius Caesar, one finds the arms of the Della Croce family (argent with an eight-pointed cross of gueules) surmounted by a white 'nodo' device. (Fig. 14) Originally, according to E. Pellegrin, the flanking initials were C.K. or C.R. The abrasions on the parchment are visible. Later in the fifteenth century, the letters I.O. were added. On folio 2ʳ⁻ᵛ are the verses of the fourth-century Greek poet born in France (at

12. Elisabeth Pellegrin, 'Bibliothèques d'humanistes lombards de la cour des Visconti Sforza,' *Bibliothèque d'Humanisme et Renaissance* 17 (1955), pp. 218–245, 2 pl., reprinted in *Bibliothèques retrouvées* (Paris, 1988), pp. 371–403, here pp. 394–395.

13. Massimo Zaggia, 'La versione latina di Pier Candido De-

cembrio dalla Repubblica di Platone: per la storia della tradizione,' in *Interpres*, vol. 13, 1993, pp. 7–55, esp. pp. 44–47: the motto is found in two manuscripts that belonged to Inigo de Avalos who was in Milan around 1435–1440.

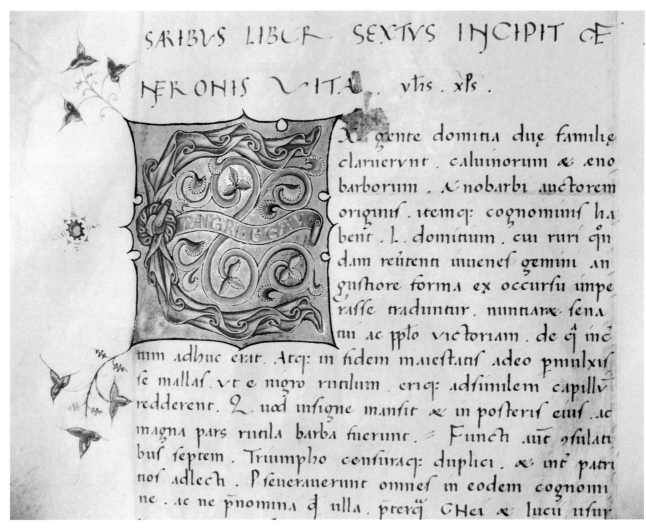

FIGURE 12. Initial with the *nodo* and devise TANGRI BEAU, overwritten. Princeton, Princeton University Library, Kane Ms. 44, fol. 113ᵛ.

Bazas, but established at Bordeaux), Julius Ausonius; in the manuscript the verses are, however, attributed to Suetonius. Following the verses on folio 2ᵛ is the inscription 'Suetonius Guineforti Delacroce' (Fig. 13). It is Guineforte who has had the verses of Ausonius added to the manuscript as well as the ex-libris, all of which are in the hand of this new scribe, as Don Skemer confirmed for me (Fig. 14). The arms on folio 4 must thus mark the original opening of the manuscript. It is possible that the arms are not over-painted, as has been thought, but have simply badly adhered, and that the original owner was a Della Croce, perhaps

Francesco della Croce, the *primicerio* of the Duomo in Milan to whom Pier Candido Decembrio dedicated his life of Saint Ambrose, and who had a library with many humanist works that he left to the churches of Milan.[14] The original initials on either side of the shield may have been F.R. for Francesco. As for the enigmatic initials I.O., which were added later in the century, might these belong to Giovanni Melzi? Under Francesco Sforza, this jurist served as ambassador to Venice, prefect of the ducal mint and the chamber of revenues, member of the extraordinary magistrature, and ducal counsellor. He was made a palatine count by

14. Evelyn S. Welch, *Art and Authority in Renaissance Milan* (New Haven, Conn., 1996), p. 130.

DE MORTIBVS EORVMDEM

Exegit poenas de Cefare curia mollis
Addidit Augustum diuuf matura fenectuf
Sera fenex campif exul nõ fata peregit
Terdecief periit repetito uulnere Gaiuf
Claudiuf ambiguo conclufit fata veneno
Xc atricida Nero proprio fe perculit enfe
Galba fenex periit fieuo proftratus Otone
Mox Oto famofuf clara fe morte peremit
Prodiga fuccedunt perimendi fceptra vitelli
Laudatum Imperium morf leuis vefpafiano
At Titus orbis amor rapitur florentibus annif
Seua grauem perimunt fed uifta pericula fratrem

VERSVS IN PRÆFATIO SVETONI

Caefareof proceres in quorum regna fecundis
Confulibuf dudum Romana potentia ceffit
Accipe biffenof fua quemqp monaftica fignat
Puofqp perplenam feriem Suetoniuf olim
Nomina ref geftaf vitamqp obitumqp pereul

FINIS

SVETONIVS GVINIFORTI DELACRVCE

FIGURE 13. Last lines of the verses of Ausonius and the ex libris of Guineforte Delacroce. Princeton, Princeton University Library, Kane Ms. 44, fol. 2ᵛ.

Frederick IV, and Gian Galeazzo Sforza named him to the Secret Council (*Consiglio segreto*). His villa in Vaprio was built on plans drawn by Leonardo da Vinci.[15] He also commissioned a retable for the church of Santa Maria Bianca della Misericordia in Milan from the artist Giovanni Ambrogio Bevilacqua. His arms, flanked by the initials I.O., have been identified in a copy of St. Augustine's *City of God*, sold at Sotheby's in 1991.[16]

Turning now to the well studied question of how the text of Suetonius returned to Italy and became available to Filippo Maria Visconti, we know that the Viscontis obtained Petrarch's library, which contained three copies of Suetonius. Petrarch not only had two copies of Suetonius made in Italy, one of each recension, but he also owned and annotated a manuscript (Paris, BnF, lat. 5802), which had been made at Chartres in the second quarter or middle of the twelfth century. The unusual contents of the Chartrain manuscript[17] match those of a manuscript in the library of Philippe de Harcourt, the bishop of Bayeux. Moreover, Harcourt's manuscript belongs to the small English textual tradition with the so-called 'Galba error'; it is thus likely that Philippe, who was chancellor of England under King Stephen, obtained the exemplar for his manuscript in England. Unable to shed any new light on how or where Petrarch obtained this manuscript, we turned our attention to the other twelfth-century books in Petrarch's library, and here we made three discoveries.

The first concerns a manuscript that, according to a note dated 1347 in Petrarch's hand on the second flyleaf, was bought for him by his father in Paris and given

15. Treccani online dictionary, 'Leonardo da Vinci.'

16. Sotheby's, 18 June 1991, lot 107. Apart from Kane 44 and the book sold at Sotheby's, the initials I. O. have been added to Paris, BnF, lat. 665 (Peter Lombard); lat. 5820 (Ammianus Marcellinus, *Rerum gestarum Romanorum Imperatorum*), lat. 6830-1 (Petrus de Crescentiis); Holkham Hall Ms. 345 (Livy); Oxford, Bodleian Library, Rawl. G. 68 (Leonardo Bruni, *De Bello Italico*).

17. Elisabeth Pellegrin, *La Bibliothèque des Visconti et des Sforza ducs de Milan, au XVᵉ siècle* (Paris, 1955), A. 178, p. 111: Suetonius de XII Cesaribus cum Florio, Tullio phisicorum, Frontino et Tulio tusculanarum questionum. This entry in the 1426 Visconti inventory at Pavia is in reality virtually identical to entry 76 in the library of Philippe de Bayeux (G. Becker, *Catalogi bibliothecarum antiqui*, library n° 86, Beccum): in alio Suetonius et Iulius Frontinus et Eutropius et Tullii Tusculanae et Philippica

eiusdem, because BnF, lat. 5802 actually contains Suetonius, the *Epitome* of Florus, the *Stratagemata* of Frontinus, the *Breviarium* of Eutropius, the *Orationes Philippicae* and *Tusculanae quaestiones* of Cicero. The arms of the Visconti are drawn on fol. 1ᵛ. For the evolution of the history of BnF, lat. 5802, see P. de Nolhac, *Pétrarque et l'humanisme*, I (Paris, 1907), pp. 246–248; G. Billanovich, 'Nella biblioteca del Petrarca. II. Un altro Suetonio des Petrarca (Oxford, Exeter College, 186),' *IMU*, vol. 3 (1960), pp. 28–58 (Galba error); Armando Petrucci, *La Scrittura di Francesco Petrarca* (Città del Vaticano, 1967), n° 39, pp. 125–126; L. D. Reynolds, ed., *Texts and Transmission: A Survey of the Latin Classics* (Oxford, 1983), p. 403 (Galba error); François Avril identified the Chartrain origin of lat. 5802 in B. Munk-Olsen, *L'étude des auteurs classiques latins aux XIᵉ et XIIᵉ siècles*, vol. II (Paris, 1985), p. 575, C.16.

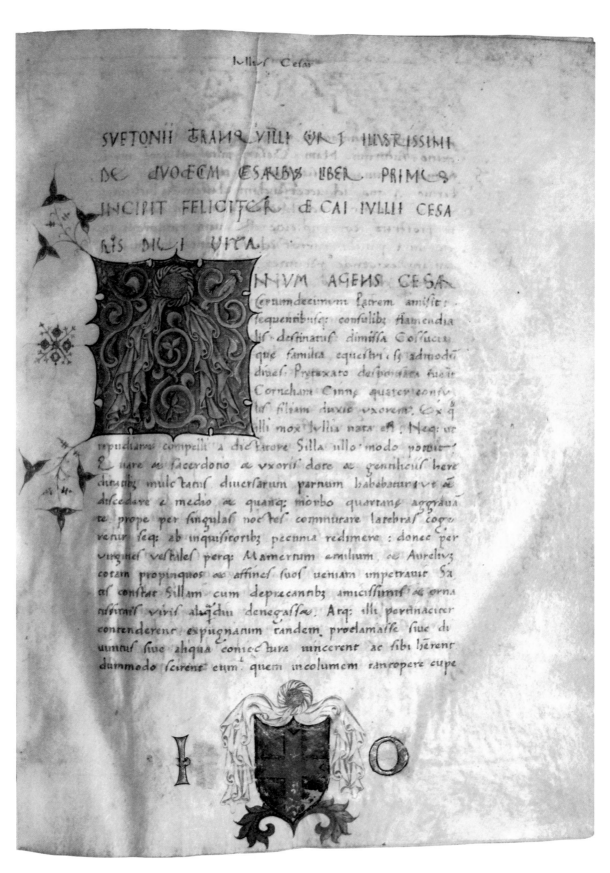

FIGURE 14. The first page of text written by the scribe of the manuscript, Milanus Burrus, and the Delacroce arms. Princeton, Princeton University Library, Kane Ms. 44, fol. 4.

to him during his youth (*tempore pueritie*). It contains Isidore's *Etymologiae* and *De fide catholica* (*De testimoniis legis et prophetarum*, Paris, BnF, lat. 7595).[18] The book was written in northern France, but not in Paris. Its script bears traits of manuscripts made in Amiens in the 1160s, notably the triangular barb on the capital T and the hooked head of the capital G. A scribe with many of the same habits worked for Hugh of Fouilloy, who was prior of Saint-Laurent-aux-Bois, a dependency of Corbie; the scribe wrote an early copy of Hugh's *De claustro animae*.[19] The decorated initials in Petrarch's book are a much finer version of those found in four books made at Corbie in the 1150s and 1160s (Amiens, Bibliothèque municipale, Mss. 22, 38, 41, 42).[20] Petrarch's Isidore appears to be a book that was 'made to order' for a private library by someone living on the fringes of the monastic world in Amiens in the third quarter of the twelfth century.

Another book that seems have had a similar type of origin is Petrarch's copy of the *Topography of Ireland* by Gerald of Wales (Paris, BnF, lat. 4846).[21] The book was made in England in the early thirteenth century. It ends with a very schematic map of England, Ireland, and the Orkney Islands. On the verso of the last folio, a fourteenth-century hand requests prayers for John of Drayton. In the catalogue of insular illuminated manuscripts at the Bibliothèque nationale de France, the entry on this manuscript notes that one John of Drayton gave a book to a priory of Winchester Cathedral.[22] More recently we discovered that a John of Drayton was abbot of Shrewsbury from 1279–1292. Also noted in the catalogue entry of 1987 is the word *primicerii* on the first folio, in the early thirteenth-century hand that wrote the line of poetry on the last

folio. Is the book that Petrarch acquired one that was part of an abbot's library, in a hazy zone between personal possession and community property? The book certainly looks to be one that was made to order, and not the product of a monastic scriptorium.

The last book is a twelfth-century copy of the *Carmina* of Claudian (Paris, BnF, lat. 8082), again made in England, probably in the 1170s.[23] Unfortunately, it was overlooked in the catalogue of insular manuscripts at the Bibliothèque nationale, as its content and possible provenance of origin would probably have excited much interest. The book is illuminated by the same artist who illuminated another copy of Claudian, Oxford, Bodleian Library, Auctarian 2 F. 16 (fols. 1–104), which I discovered by way of my photostats of Dorothy Callard's drawings of minor decoration in Bodleian manuscripts.[24] I think that both books were very probably made at or in the vicinity of Saint Albans, probably during the abbacy of Simon, between 1167 and 1183.[25] There are several books from Saint Albans that compare favorably with the Claudian, such as Harley 3847, a copy of Hugh of Saint Victor's *De Sacramentis*, which comes from Tynemouth, a dependency of Saint Albans.[26] Another is the much more handsome Ms. Royal 12. G.xiv, a copy of the *Etymologiae* of Rabanus Maurus.[27] The Claudian is also a fascinating manuscript for its abundant twelfth-century annotations, giving long résumés of the poems identifying places and people, and offering alternate readings. This appears to be the book of a very learned humanist magister.

How did Petrarch obtain two books made in England? It is not reported that he paid a visit to the country. One possibility is that the acquisitions were made

18. Pellegrin, *Bibliothèque* (as in note 17), A.100, p. 94; A. Petrucci (as in note 17) n°47, p. 127. The book is published in color on the Gallica website.

19. Paris, BnF, lat. 13417. The book is published in color on the Gallica website.

20. See BVMM site for examples of the decoration.

21. Pellegrin, *Bibliothèque* (as in note 17), A.376, p. 157; Petrucci, n° 34, p. 124. The book is published in color on the Gallica website.

22. F. Avril and P. Stirnemann, *Manuscrits enluminés d'origine insulaire VIIᵉ–XXᵉ siècle* (Paris, 1987), n° 73, p. 43, pl. XXI.

23. Pellegrin, *Bibliothèque* (as in note 17), A.42, p. 82. The book is published in color on the Gallica website.

24. A small photograph is published by O. Pächt and J. J. G. Alexander, *Illuminated Manuscripts in the Bodleian Library, Oxford: 3 British, Irish, and Icelandic Schools* (Oxford, 1973), n° 248, p. 26, pl. XXIV.

25. The script compares best with Cambridge, Trinity College, Ms. O.7.13 (Rodney Thomson, *Manuscripts from St Albans Abbey 1066–1235* [Woodbridge, 1982], volume II, figure 173).

26. Thomson, *St. Albans* (as in note 25), n° 68, p. 117, and British Library digitalized illuminated manuscripts.

27. Thomson, *St. Albans* (as in note 25), n° 31, p. 96, and British Library digitalized illuminated manuscripts.

through one of his acquaintances in Avignon. In the years 1330 and 1333 Edward II sent Richard of Bury to Avignon as ambassador, and Petrarch met him on the first visit. It is also known that in these same years, Richard of Wallingford, abbot of Saint Albans from 1326–1335, tried to bribe Richard of Bury by giving him four precious books and selling him thirty others for a very low price. It may be stressed that there is no internal evidence in the manuscript of Claudian to support the following conjecture, but it is worthwhile to entertain the idea that Richard of Bury gave the Claudian, and perhaps even the manuscript of Gerald of Wales, to the young Petrarch. Such a gift would have been a time-honored act of friendship and generosity on the part of a senior scholar toward a younger one.

I still remember vividly some thirty years ago when, shortly after meeting Richard Rouse for the first time in late 1982, I told him about finding the inventory of the library of Henry the Liberal, and he asked me if I knew Henry's copy of Gellius. 'How did you know that there's a Gellius on the list?' I asked. 'Because I know the book,' he answered, and sent me to an article he had written with Albinia de la Mare and P. K. Marshall identifying Henry's book in a copy of Gellius in the Vatican.[28] A few weeks later, a packet arrived in the post. Richard had sent me an inscribed copy of *Texts and Transmission*, an invaluable and much loved book that has remained close at hand ever since, and which I always open with renewed gratitude.

28. Albinia de la Mare, Peter K. Marshall, and Richard Rouse, 'Pietro da Montagnana and the Text of Aulus Gellius in Paris, BnF, lat. 13038,' *Scriptorium* 30 (1976), pp. 219–225.

LUCY FREEMAN SANDLER

Questions for Homeless Manuscripts: The Case of
Princeton Garrett Ms. 35

IN 1966, Isa Ragusa, for many years associated with the Index of Christian Art of Princeton University, completed a doctoral dissertation on the manuscript that is the focus of this essay, Garrett 35 of Princeton's large collection of medieval and Renaissance books.[1] Garrett 35 is a generously illustrated Psalter produced in England at the beginning of the fourteenth century. Before Dr. Ragusa studied the manuscript it was hardly known, and since the time of her dissertation, which was not published, it has been discussed at any length only twice, first in my entry in volume five of the Survey of Manuscripts Illuminated in the British Isles, which appeared in 1986,[2] and more recently in the entry in Don Skemer's monumental catalogue of Princeton manuscripts.[3]

We may wonder why this striking Psalter, which has thirteen full-page miniatures and large historiated initials at all the main text divisions, is not more widely known and discussed. It is not for lack of availability of images, because a complete set, at least in black and white, has been housed at the Index of Christian Art at least since the early seventies, when I first looked at them and the manuscript.[4] It seems likely to me that the reason for the neglect of the Garrett Psalter is that the book falls into the category of 'homeless' manuscripts, that is, manuscripts with no internal evidence of origin, destination, or date. In the case of Garrett 35, this means no ex libris, no original calendar, and no original litany, the components that usually convey the most textual information about the specifics of production, destination, and use over time.

How then could, or should, such a manuscript be studied? In what follows I am going to consider this question, although it has to be said from the outset that my answers are not going to reveal the who, for whom, where, and when of the manuscript with any precision. Rather I am going to suggest that manuscript homelessness can lead us to focus elsewhere, and in my view, rewardingly, on the book as a product of decision-making by designers, scribes, and artists. I am interested in the process of *making* that is revealed by close study of the tangible, physical book itself, above all the work of the artist. In this I am turning away from the current methodological concentration on patronage, reception, and context in the study of illuminated manuscripts. Such approaches have yielded valuable historical insights of course, but in this essay I aim to use this one homeless manuscript as the occasion for exploration of other ways medieval books and book art can be treated.

To focus on artistic decision-making is not to award to the medieval illuminator the same kind of individual self-awareness and desire for self-expression that we expect of post-medieval artists. Indeed, I make no plea for 'connoisseurship,' that is, the identification of the individual 'hand' as an end in itself. In connection with manuscript illumination this is often a failed enterprise, since medieval illuminators seem to have desired to immerse themselves in a group style, making it difficult to distinguish one individual from another. Rather, my aim is to understand the results of creative acts, to identify individual decisions in order to study their impact. In the end, this is a contextual approach to the study of Gothic manuscript illumination, but one that starts at the source rather than the end-product.

In book illumination, what decisions were made,

1. Ragusa, 'A Gothic Psalter in Princeton: Garrett Ms. 35,' Ph.D. diss. (New York University, 1966).

2. L. F. Sandler, *Gothic Manuscripts 1285–1385*, A Survey of Manuscripts Illuminated in the British Isles, 5, 2 vols., ed. J. J. G. Alexander (London, 1986), I: ills. 68, 80, II: 40–41, no. 35.

3. D. C. Skemer, *Medieval & Renaissance Manuscripts in the Princeton University Library* (Princeton, N.J., 2013), 2 vols., I: 35–38, pls. 11–15.

4. Now available in color on-line at the Index of Christian Art website: ica.princeton.edu.

or could be made, by artists? Given that medieval il-luminators were generally instructed to produce im-ages of specified subjects, a range of scenarios can be postulated: If for instance the artist was replicating a set model available at hand, he might vary formal ele-ments—scale, image proportions, placement in the text on one hand, and color, value, line, and surface detail on the other—subtly or more overtly affecting the way the resulting image communicated with its viewer. If the artist was drawing on a store of mental images, a body of pictorial traditions, his decision-making input would be greater, and might produce images that dif-fered to a greater degree from other contemporary representations of the same subjects, with the conse-quence of significant changes in meaning. While most of the illustrations of Garrett 35 adhere to norms of facture and iconography typical of early fourteenth-century English illumination, a number fall into the realm of the unexpected, and it is these departures from the norm that most clearly highlight the deci-sions made by the artist and their role in constructing the meaning of the picture and the picture-in-the-text for the reader/viewer/owner of the manuscript.

Garrett 35 is a small folio, in dimensions (about 10 × 7 inches) somewhat larger than the hand-size de-votional book carried by the Virgin in the Annuncia-tion on the first folio of the manuscript (Fig. 1); by implication then a book intended to rest on a lectern or *prie-dieu*. The Annunciation is the first of a series of full-page miniatures of the life of Christ. They are arranged in facing pairs, with blank versos and rectos between them. Perhaps the series was originally pre-ceded by a calendar, since folio 1 has the signature 'b.1,' suggesting that there was once a now-lost gathering of the manuscript, labeled 'a.' In Psalters, a gathering preceding a cycle of images before the main text usu-ally contained a calendar.

The New Testament subjects of the prefatory mini-atures form a normal sequence in the sense that none of them is unusual, even though the cycle is not dupli-cated in any other surviving English manuscript of the period:[5] Annunciation and Nativity (fols. 1ᵛ–2); Ado-ration of the Magi and Presentation of Christ in the Temple (fols. 3ᵛ–4); Entry into Jerusalem and Betrayal (fols. 5ᵛ–6) Flagellation and Christ bearing the Cross (fols. 7ᵛ–8); Crucifixion (now lost) and Resurrection (fol. 9); Ascension and Pentecost (fols. 10ᵛ–11); and the Trinity and Coronation of the Virgin (fols. 12ᵛ–13).

The Psalter text begins on a recto (fol. 14), facing a blank page, which is the verso of the Coronation. The ten main divisions have historiated initials with partial foliated borders or marginal extensions from the initial frames, only once including a figural motif: Psalm 1, David playing the harp (fol. 14); Psalm 26, the Anointing of David (fol. 31ᵛ); Psalm 38, David, kneeling before the Lord, pointing to his mouth (fol. 44); Psalm 51, a knight committing suicide (fol. 55); Psalm 52, a fool and David (fol. 55ᵛ); Psalm 68, Jonah in the water, the Lord above, blessing (fol. 67ᵛ); Psalm 80, David playing bells, in the border, a crouching hare (fol. 82); Psalm 97, Clerics chanting (fol. 95ᵛ); Psalm 101, Christ praying at an altar (fol. 97ᵛ); and Psalm 109, the Trinity (fol. 109ᵛ). The beginning of the litany, which follows the Canticles at the end of Psalm 150, is marked by a small decorated initial, but after its first page the original list of saints' names was replaced in the early fifteenth century by a standard Sarum litany, followed by ferial litanies, prayers, and, perhaps a little later in the century, the Office of the Dead of Sarum use, with a fine decorated initial (fol. 161).

All that can be said, from the slimmest of internal documentary evidence, is that in the fifteenth century the text of the manuscript was altered for Sarum, that is, the standard English use,[6] and from that, it might be concluded that previously the litany was not Sarum, or that the names of the saints invoked differed suffi-ciently from fifteenth-century Sarum use to warrant replacing most of the text. The provision of rubrics

5. No prefatory cycle in any 13th- or 14th-century English manuscript exactly duplicates any other in choice of subjects, with the exception of those of the Ramsey Psalter of *c.* 1300–10 (St. Paul in Lavantthal, cod. xxv/2, 19, and New York, Morgan Lib., Ms. M. 302) and the Barlow Psalter of the 1320s (Oxford, Bodleian Lib., Ms. 22); on these, see L. F. Sandler, *The Peter-* *borough Psalter in Brussels and other Fenland Manuscripts* (London, 1974).

6. For the developed Sarum litany, see F. Procter and C. Wordsworth, eds., *Breviarium ad usum insignis ecclesiae Sarum*, 3 vols. (London, 1882–86), II: 250–59; also R. W. Pfaff, *The Lit-urgy in Medieval England: A History* (Cambridge, 2009), 430–33.

FIGURE 1. Annunciation. Psalter, Princeton University Library, Garrett Ms. 35, fol. 1ᵛ (Princeton University Library).

relating to recitation of the litany in the fifteenth-century section suggests also that the manuscript might have come into the hands of an owner concerned with the formal liturgy, perhaps a cleric,[7] in turn suggesting that the original owner might have been a layperson. As for this original part of the manuscript, to state the obvious, the broad conclusion that this is an early fourteenth-century manuscript of English origin comes from the usual practice of comparison of script, layout, pictorial facture, and iconography with books of more certain documentation.

The extant manuscript images that offer the closest pictorial *comparanda* to those in Garret 35 appear in three books: the recently re-named Pabenham-Clifford Hours in the Fitzwilliam Museum;[8] the Vaux Psalter in Lambeth Palace Library;[9] and a Bible, also in the Fitzwilliam, in the McClean Collection.[10] The correspondences between these manuscripts and Garret 35 are incomplete and irregular, however. For example, the Annunciation from the Pabenham-Clifford Hours, possibly dated shortly after 1315 on the basis of its heraldic components, may be compared with the same subject in Garrett 35 (Fig. 2). The similarities between the two Annunciations are evident: large-scale figures clothed in voluminous curvilinear drapery, folds forcefully outlined in black and given slight substance by minimal shading, oval whitened faces with outlined features, and hair patterned in linear waves. The degree of similarity might be measured against an Annunciation from the contemporary Hours of Alice de Reydon, which belongs stylistically to a group of manuscripts centered around the Queen Mary Psalter (Fig. 3).[11] In the Alice de Reydon Annunciation the

figures fill less of the vertical space, although they are relatively taller, the garments cross the body horizontally, the stylized pattern of the fur lining of the Virgin's mantle is absent, and the facial contours are more defined, with facial features smaller and more delicate. Nevertheless, within the comparatively narrow range of components of early fourteenth-century images of the Annunciation—the basic pattern consists of just two figures on either side of a central axis, with the angel on the left, arm raised in some kind of address, and the Virgin on the right, head and hand indicating some kind of response—the different choices made by the artists stand out in any comparison. In Garrett 35, for instance, the joyously uplifted lips of both the angel and the Virgin in contrast to the impassive expressions of the figures in the Pabenham-Clifford Hours, the questioning instead of accepting gesture of the Virgin, and the sheer largeness of the figures, ballooning in the case of the angel and subtly twisting in three-dimensions in the case of the Virgin, are all particularly striking. In comparison, the Pabenham-Clifford figures seem thin and planar.

In the Pabenham-Clifford Hours the only other full-page miniature, the Trinity with evangelist symbols (Fig. 4), also shows many similarities with the image of the same subject in Garrett 35 (Fig. 5), not the least of which is the subject itself, a fairly rare combination of the *Gnadenstuhl* or Throne of Mercy form of Trinity with the evangelist symbols that are generally found in representations of Christ in Majesty. Most striking is the crucified Christ of both images. As Isa Ragusa noticed, the upper parts of the bodies are nearly identical, but the lower parts, as close as the

7. E.g., fol. 150, at the end of the list of apostles, the following rubric: *usque huc dicitur in qualibus ferie et a .propicius esto. usque ad finem tocius letanie* (on each weekday to be said up to this point and from 'propicius esto' to the end of the entire litany); cf. *Breviarium ad usum Sarum*, II: 249.

8. Cambridge, Fitzwilliam Mus., Ms. 242, formerly the Grey-Fitzpayn Hours; see D. D. Egbert, 'The Grey-Fitzpayn Hours: An English Gothic Manuscript of the Early Fourteenth Century now in the Fitzwilliam Museum, Cambridge, Ms. 242,' *Art Bulletin* 18 (1936), 527–39; Sandler, *Gothic Manuscripts* (as in note 2), I: ills. 73, 74, 77, II: 36–37, no. 31; J. A. Goodall, 'Heraldry in the Decoration of English Medieval Manuscripts,' *Antiquaries Journal* 77 (1997), 180–81.

9. London, Lambeth Palace Lib., Ms. 233; see Sandler, *Gothic*

Manuscripts (as in note 2), II: 35–36, no. 30, with earlier bibliography, and *Lambeth Palace Library: Treasures from the Collection of the Archbishops of Canterbury*, Exhib. cat., ed. R. Palmer and M. P. Brown (London, 2010), 53–55, no. 10 (entry by L. F. Sandler).

10. Cambridge, Fitzwilliam Mus., Ms. McClean 15; see Sandler, *Gothic Manuscripts*, I: ills. 65–7, II: 37–38, no. 32, with earlier bibliography.

11. On the Hours of Alice de Reydon (Cambridge University Lib., Ms. Dd.4.17), see Sandler, *Gothic Manuscripts* (as in note 2), I: ills. 168–69, 171–72, II: 75–75, no. 67, and *The Cambridge Illuminations: Ten Centuries of Book Illumination in the Medieval West*, Exhib. cat., ed. P. Binski and S. Panayotova (London, 2005), 190–91, no. 80 (entry by N. J. Morgan).

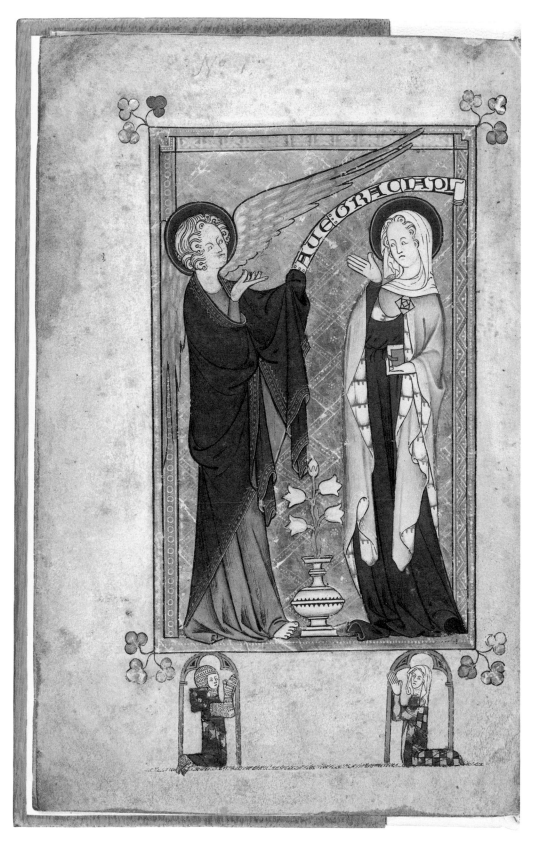

FIGURE 2. Annunciation. Pabenham–Clifford Hours, Cambridge, Fitzwilliam Museum, Ms. 242, fol. 2ᵛ (© Fitzwilliam Museum, Cambridge).

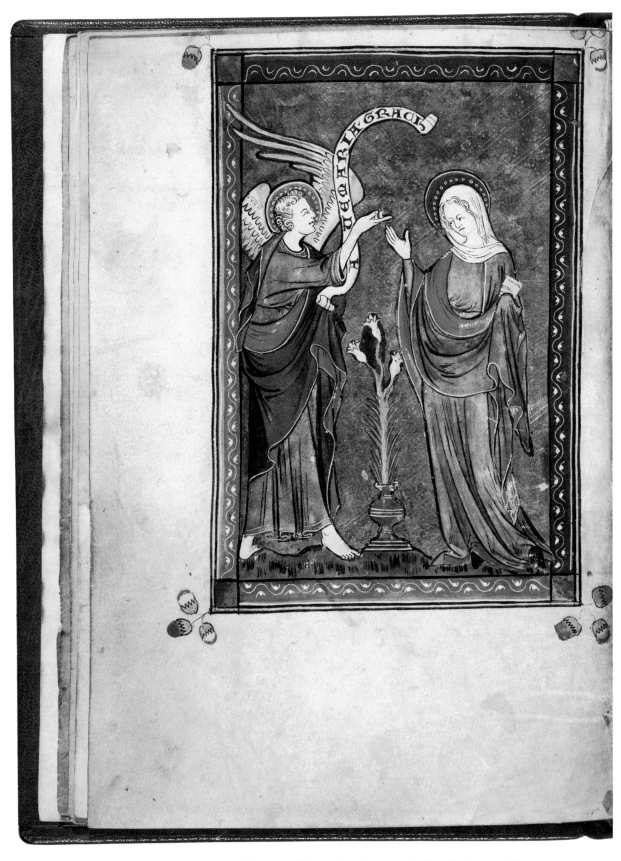

FIGURE 3. Annunciation. Hours of Alice de Reydon, Cambridge, University Library, Ms. Dd.4.17, fol. 5ᵛ (Cambridge University Library).

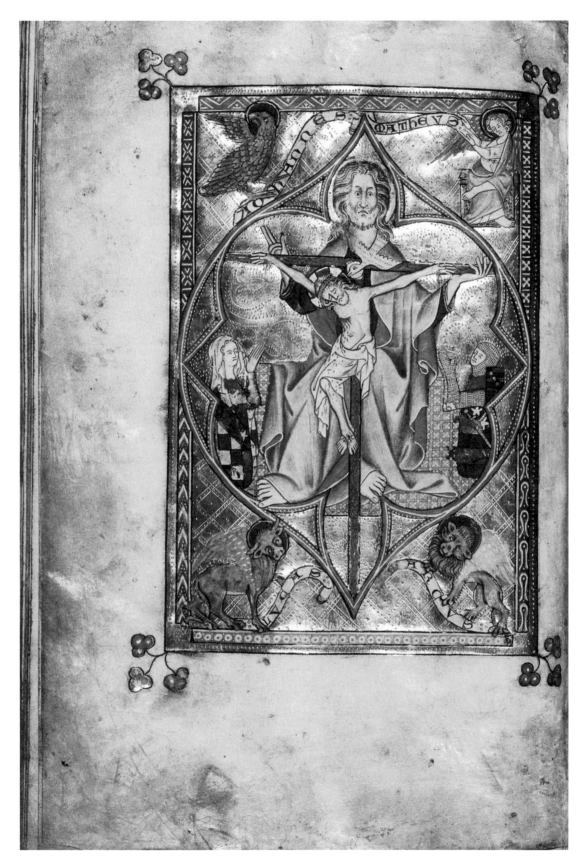

FIGURE 4. Trinity with Evangelist Symbols. Pabenham-Clifford Hours, Cambridge, Fitzwilliam Museum, Ms. 242, fol. 28ᵛ (© Fitzwilliam Museum, Cambridge).

drapery and leg positions are, are exactly reversed,[12] the direction of the limbs in Garret 35 being highly unusual, as if the artist had worked from a tracing of a detail, although not one taken from the Pabenham-Clifford Trinity, which has different dimensions. Here too, while the similarities are evident, the individual characteristics of each manuscript are underscored. In Garrett 35 again, as with the Annunciation, the monumental scale and immediacy of the image stand out, especially the figure of God-the-Father, whose body fills the entire height and width of the pictorial area, the graceful ogee arches of the inner frame of the Pabenham-Clifford image being omitted. Such elaborate inner frames are characteristic of images of Christ in Majesty, as for example in the Vaux Psalter (fol. 14ᵛ), another manuscript related stylistically to Garrett 35, where the Majesty is the sole full-page miniature. And from an early date, in other examples of the Trinity with surrounding evangelist symbols, the central group is also enclosed in a mandorla.[13] A few miniatures of the *Gnadenstuhl* Trinity of the late thirteenth and fourteenth centuries, however, such as the example in a picture-book of around 1290 to 1300 in the Fitzwilliam Museum (Fig. 6), another 'homeless' manuscript,[14] have compositional arrangements comparable to that of Garrett 35. The elimination of

the inner frame brings the large-scale Trinity group into direct rather than distant relationship with the viewer, an overt solicitation of devotion.

In most Throne of Mercy Trinities, as seen in the Pabenham-Clifford Hours, the Dove of the Holy Spirit flies downward between God-the-Father and Christ, visualizing the concept that the Holy Spirit proceeds from the Father *and* the Son. Again, the artist of Garrett 35 made an unusual choice in showing the Dove in upward flight, as if evoking pictorially the last words of Christ, as recounted in the Gospel of Luke (23:46), 'Father, into thy hands I commend my spirit. And saying this, he gave up the ghost.' In this way the illuminator gave pictorial form to a concept of the relation between Father, Son, and Holy Spirit not to my knowledge found in earlier or other contemporary representations of the Trinity.[15]

Since close stylistic analogues of the prefatory miniatures are few in number, we can reach only general conclusions about the date of the manuscript—and, in truth, no conclusions at all about where the book might have been produced, because the Pabenham-Clifford Hours and the Vaux Psalter themselves offer insufficient and conflicting evidence of place of origin and use.[16] It may be, however, that parallels between the historiated initials of Garrett 35 and those

12. Ragusa, 'Garrett 35' (as in note 1), 136–37.

13. See, for example, the early 12th-century Cambrai Missal, Cambrai, Bibl. municipale, Ms. 234, fol. 2; see W. Cahn, *Romanesque Manuscripts, The Twelfth Century*, A Survey of Manuscripts Illuminated in France, ed. F. Avril and J. J. G. Alexander, 2 vols. (London, 1996), 1: ill. 242, II: 121–22, no. 98, and for a color image, www.enluminures.culture.fr, *s.v.* Cambrai.

14. Cambridge, Fitzwilliam Mus., Ms. 370. See M. R. James, 'An English Picture-Book of the late Thirteenth Century,' *Walpole Society* 25 (1937), 23–32, pls. IX–XVII, Sandler, *Gothic Manuscripts* (as in note 2), 1: ills. 39–40, II: 27, no. 17, with further bibliography, and *Cambridge Illuminations* (as in note 11), 183–84, no. 75. The manuscript was owned by a monk named Richard, who is represented in adoration of the Virgin of the Coronation on fol. 5ᵛ, and named in an inscription on the page showing the Virgin interceding with Christ (fol. 2), but there are no further indications of provenance.

15. The rare motif of the dove of the Holy Spirit flying from the lips of the dying Christ to the face of the Father appears twice during the second half of the 14th century in manuscripts made for members of the Bohun family; see L. F. Sandler, 'The Anglo-Norman Office of the Cross in the Lichtenthal Psalter,'

in *Cultural Performances in Medieval France: Essays in Honor of Nancy Freeman Regalado*, ed. E. Doss-Quinby, R. L. Krueger, and E. J. Burns (Cambridge, 2007), 157–58, and fig. 5, citing Baden-Baden, Lichtenthal Abbey Archive, Ms. 2, fol. 162ᵛ, and the Hours of Mary de Bohun, Copenhagen, Kongelige Bibl., Ms. 547.4°, fol. 22ᵛ.

16. On the basis of identification of the coats-of-arms, the Pabenham-Clifford Hours was formerly called the Grey-Fitzpayn Hours and dated around the time of the marriage of Richard Grey of Codnor, Derbyshire, and Joan Fitzpayn, which took place by 1308; see Egbert, 'The Grey-Fitzpayn Hours' (as in note 8), 527–39. More recently, however, J. A. Goodall reinterpreted the armorials, identifying them as those of John de Pabenham of Bedfordshire and Joan Clifford of Frampton, Gloucestershire, who were married in 1314 or 1315, thus dating the manuscript to the second decade of the 14th century; see Goodall, 'Heraldry' (as in note 8), 180–81. The Hours of the Virgin in Fitzwilliam 242 are of Sarum use, the liturgical use of the province of Canterbury. The Vaux Psalter, or Vaux-Bardolf Psalter, was made for an as-yet-unidentified woman, a member of the Bardolf family of Norfolk and Nottinghamshire, who was married to a male member of the widely dispersed Vaux family of

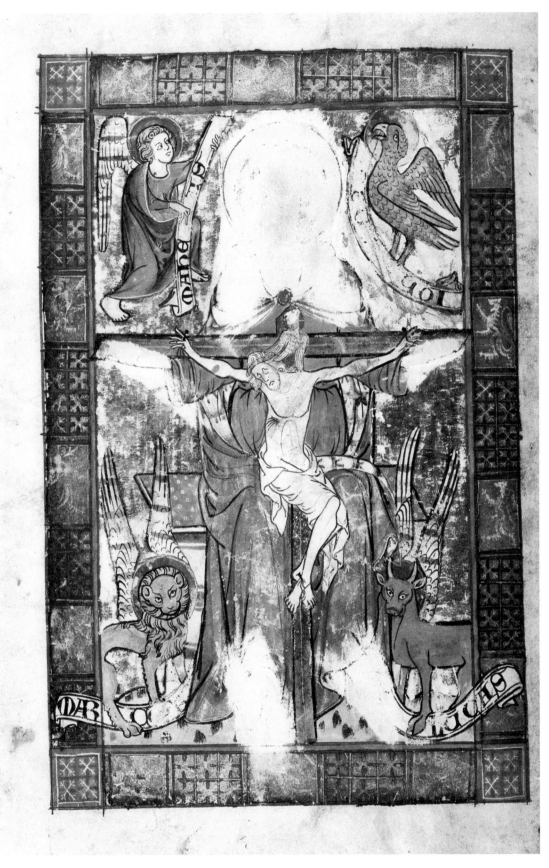

FIGURE 5. Trinity (damaged). Psalter, Princeton University Library, Garrett Ms. 35, fol. 12ᵛ (Princeton University Library).

FIGURE 6. Trinity. Picture Book, Cambridge, Fitzwilliam Museum, Ms. 370, fol. 3
(© Fitzwilliam Museum, Cambridge).

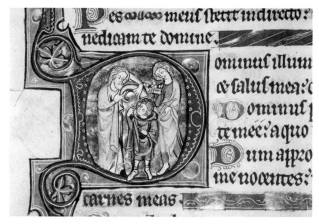

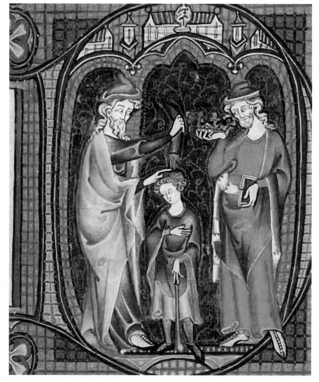

of other manuscripts offer some help in situating the manuscript. Such parallels appear in some of the psalm initials of the Vaux Psalter, where although the *mise en scene* is more elaborate, the overall compositions and iconographic details, for instance those of the initials for Psalm 26 (Figs. 7 & 8), are similar, in particular, the horn with which Samuel anoints David, and the crown held in the hand of Nathan. The similarities in technique—the shaded pinks, tans, and greys of garments with few additional strengthening black outlines—are also notable in both cases.

Further parallels to Garrett 35 are to be found in the psalm initials of a lectern Bible in the McClean collection at the Fitzwilliam Museum, another almost undocumented manuscript, but perhaps originally owned by a religious foundation, because it bears a fifteenth-century inscription allowing it to be removed from the custody of a prior, that is, a monastic officer, 'in case it is necessary in the future.'[17] Similarities in facture, composition, and iconography between Garrett 35 and the McClean Bible are evident, for example, in the initials for Psalms 38, 'I said, I will take heed to my ways: that I sin not with my tongue. I have set a guard to my mouth,' where the image is inspired by the words (Figs. 9 & 10), and also in the initials for Psalm 68, 'Save me, O God: for the waters are come in even unto my soul,' with the common subject of Jonah saved and the Lord above (Figs. 11 & 12), which is handled in the same way in the Vaux Psalter.[18] As before, the strength of these relationships

can be tested against contemporary manuscripts stylistically and iconographically unrelated to Garrett 35, for example, the Psalter of Richard of Canterbury,

Cambridgeshire, Staffordshire, and Northumbria. The calendar, in Anglo-Norman, shows similarities to those of the Austin Friars and includes saints venerated in the archdiocese of York, and the litany suggests the same broad geographical destination, limited only in being beyond the northern boundaries of the archdiocese of Canterbury; see D. D. Egbert, *The Tickhill Psalter and Related Manuscripts* (New York, 1940), 90–94, 175–81, identifying the provenance of the manuscript as Nottinghamshire, amended by Sandler, *Gothic Manuscripts* (as in note 2), II: 35–36, no. 30.

17. Bible, Cambridge, Fitzwilliam Mus., Ms. McClean 15, fol. 401ᵛ: *impignorentur extra Prioratum ob instanciam alienus persone seu necessitatis in futurum*, quoted from M. R. James, *A Descriptive Catalogue of the McClean Collection of Manuscripts in the Fitzwilliam Museum* (Cambridge, 1912), 15.

18. Vaux Psalter, London, Lambeth Palace Lib., Ms. 233, fol. 101: for a color image, see *Lambeth Palace Library, Treasures* (as in note 9), 55, no. 10.

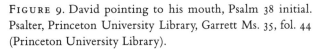

FIGURE 9. David pointing to his mouth, Psalm 38 initial.
Psalter, Princeton University Library, Garrett Ms. 35, fol. 44
(Princeton University Library).

FIGURE 10. David pointing to his mouth, Psalm 38 initial.
Bible, Cambridge, Fitzwilliam Museum, Ms. McClean 15, fol.
182 (© Fitzwilliam Museum).

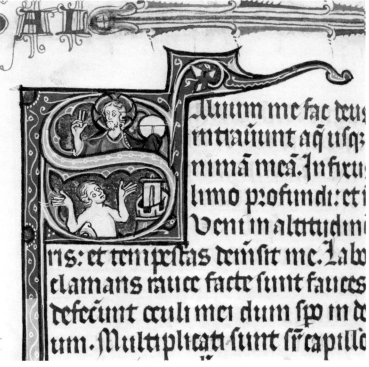

FIGURE 11. Jonah saved, Psalm 68 initial. Psalter, Princeton University Library, Garrett Ms.
35, fol. 67ᵛ (Princeton University Library).

FIGURE 12. Jonah saved, Psalm 68 initial. Bible, Cambridge, Fitzwilliam Museum, Ms. Mc-
Clean 15, fol. 186ᵛ (© Fitzwilliam Musem).

a monk of Christ Church, Canterbury, probably made between 1310 and 1320.[19] The contrast with the Psalm 26 initial is particularly interesting (Figs. 7 & 14). The Psalter of Richard of Canterbury has an alternative subject, David kneeling before the Lord and pointing to his eyes, virtually universal from the early thirteenth century in Parisian Psalters and breviaries, and becoming increasingly popular in England in the course of the fourteenth century.[20] The Anointing of David, the 'older' subject, was inflected in Garrett 35 by the artist's decision, exceptional to my knowledge, to show the young David pointing to his eye while he is being anointed, in this way adding an allusion to the opening words of the psalm, 'The Lord is my light and my salvation.'

From comparisons of miniatures and historiated initials, it appears that Garrett 35, the Pabenham-Clifford Hours, the Vaux Psalter, and the McClean Bible form a loose group, manuscripts illustrated by artists whose work was familiar to each other. Is there any way to be more precise about date and place of production? One further manuscript where parallels of facture suggest connections with the group to which Garrett 35 belongs may be introduced here. The manuscript is the famous volume at the New York Public Library, the Tickhill Psalter, written and gilded according to a later inscription by John Tickhill, the prior of Worksop, an establishment of Augustinian canons in the diocese of York, who held office between 1303 and 1314.[21] While Prior John served as scribe and gilder of the psalm *tituli*, all written in gold, the illustrations were executed, to the extent that they were completed,

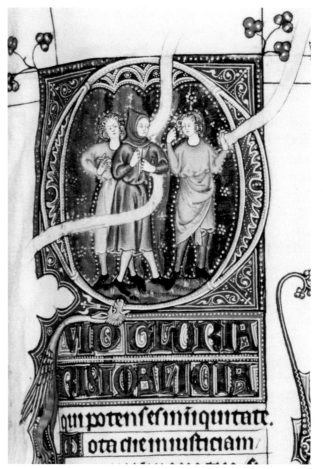

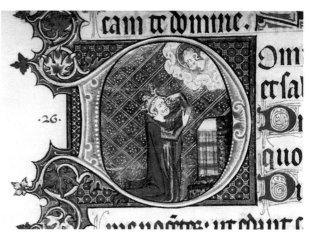

FIGURE 13 (*top*). David informed of death of Saul, Psalm 51 initial. Tickhill Psalter, New York Public Library, Spencer Ms. 26, fol. 50 (The New York Public Library).

FIGURE 14 (*bottom*). David pointing to his eye, Psalm 26 initial. Psalter of Richard of Canterbury, New York, Pierpont Morgan Library, Ms. G. 53, fol. 24ᵛ (Morgan Library and Museum).

19. Psalter of Richard of Canterbury, New York, Morgan Lib., Ms. G. 53; see Sandler, *Gothic Manuscripts* (as in note 2), II: 66–67, no. 57.

20. See G. Haseloff, *Die Psalterillustration im 13. Jahrhundert, Studien zur Geschichte der Buchmalerei in England, Frankreich und den Niederländen* (Kiel, 1938), 24 and Table 4; further, L. F. Sandler, 'The Bohun Women & Manuscript Patronage in Fourteenth-Century England,' in *Patronage: Power & Agency in Medieval Art*, ed. C. Hourihane (Princeton, N.J., 2013), 290.

21. Tickhill Psalter, New York, New York Public Library, Ms. Spencer 26; see Egbert, *Tickhill Psalter* (as in note 16), and, more recently, J. J. G. Alexander, J. H. Marrow, and L. F. Sandler, *The Splendor of the Word: Medieval and Renaissance Illuminated Manuscripts at The New York Public Library*, Exhib. Cat. (London, 2005), 201–07, no. 41.

by two different artists, the first of whom worked on a Psalter for Isabelle of France, possibly after her betrothal in 1303 in anticipation of her marriage to Edward II, which took place in 1308, a manuscript whose calendar and litany are patterned on the liturgical use of York archdiocese.[22] This first Tickhill artist was a master of the minuscule, whose work I have described as having the overall effect of a 'dazzling mosaic of tiny units of brilliant, variegated color and gold.'[23] It is the second Tickhill Psalter artist, however, whose work is related to that of the artist of Garrett 35 (Fig. 13). In my published description of the manuscript I cited the relatively large scale, the relative absence of detail, and the palette marked by what I called 'tonal homogeneity … by pink and grey toned with tan, and light blue shaded with deeper blue,' these colors applied to the garments of figures, often without additional outlines, as I said, 'contrasting abruptly with totally unmodelled black-outlined heads.'[24] All these features characterize the work of the artists of the group to which Garrett 35 belongs. Consequently, it seems safe to say that at least some of the manuscripts related to Garrett 35 were illuminated by artists working for patrons in the diocese of York early in the second decade of the fourteenth century, and from this to conclude tentatively that the place where they were based was the city of York itself, which was not only the seat of the northern archdiocese, but periodically the site of royal administration during the first fifteen years of the fourteenth century.[25]

To return to the main theme of this essay: fundamentally, the questions I want to raise are about medieval illuminators and the artistic decisions they made, either by habit, constraint, invention, or pride in their craft. I believe that all too often we overlook the myriad decisions that come together to form each painted image, and it is those made by the artist of Garrett 35 that I want to consider now. First of all, the general format of the full-page miniatures: as mentioned above, they are paired, as diptychs, with blank versos and rectos between each pair (Figs. 16 & 17). This rare and costly configuration is characteristic of the most luxurious productions, as for instance, the early thirteenth-century royal Moralized Bibles and the prefatory cycles of a few Continental and English manuscripts,[26] among English examples, for instance, the Passion miniatures of the Murthly Hours in Edinburgh,[27] and the early fourteenth-century series in the Hours of Alice de Reydon.[28] In Garrett 35, the compositions are carefully matched in formal and iconographic components. Their juxtaposition has the effect of focusing the eye and mind, and the blanks between the images slow down the otherwise straightforward narrative sequence. The large figure scale, the smooth surfaces, the discrete, flat gold grounds, the pure translucency of the colors and their studied alternation all lend to these images a distinctive and somewhat Apollonian *grandeur*. I am reminded of Paul Binski's recent characterization of the 'heroic' mode of Gothic architecture: large, ample, magnificent, and sublime in scale.[29] The corollary, integral with this, and not a separate category, is that, to quote Binski, 'as we gape at the huge, we peer in amazement at the little: the heroic and magnificent mode of great scale and the mode of miniature, of the "minificent," were and are not just antitheses but mutually dependent aspects of the same admirable thing.'[30] And the Garrett 35 artist was a master of integration of 'minificent' and 'magnificent,' that is, the incorporation of the startling, even 'low,' detail into the grand or 'high' picture.

22. Munich, Bayerische Staatsbibliothek, Cod. gall. 16; see Sandler, *Gothic Manuscripts* (as in note 2), I: ill. 59, II: 33–34, no. 27, with earlier bibliography, and A. Stanton, 'The Psalter of Isabelle of France, Queen of England: Isabelle as the Audience,' *Word & Image* 18 (2002), 1–27.

23. Sandler, *Gothic Manuscripts* (as in note 2), II: 32.

24. Sandler, *Gothic Manuscripts* (as in note 2), II: 33.

25. See W. M. Ormrod, 'Competing Capitals? York and London in the Fourteenth Century,' in *Courts and Regions in Medieval Europe*, ed. S. Rees Jones, R. Marks and A. J. Minnis (York, 2000), 75–98.

26. As noted by J. Lowden, *The Making of the 'Bibles moralisées,'* 2 vols. (University Park, Pa., 2000), I: 13, listing other French Psalters in which the practice is found.

27. Murthly Hours, Edinburgh, National Lib. of Scotland, Ms. 21000, late 13th century Passion miniatures by an English artist in a slightly earlier manuscript illustrated by Parisian artists; see J. Higgitt, *The Murthly Hours: Devotion, Literacy and Luxury in Paris, England and the Gaelic West* (London, 2000), 248–68.

28. Hours of Alice de Reydon, Cambridge University Lib., Ms. Dd.4.17, fols. 1ᵛ–12; see above, note 11.

29. P. Binski, 'The Heroic Age of Gothic and the Metaphors of Modernism,' *Gesta* 52 (2013), 3–19.

30. Binski, 'Heroic Age' (as in note 29), 10.

Two examples may be offered: First, the Entry into Jerusalem (Fig. 16). The miniature 'ass's colt' under the belly of Christ's mount is a motif mentioned in the biblical account,[31] and as such is not rare, but its prominent, central position is exceptional. The man spreading his garment beneath the feet of Christ and the disciples as they enter Jerusalem is also Scriptural, and such a figure is represented frequently in pictorial narratives of the Entry into Jerusalem. In Garrett 35, however, the eye is struck by the homely and active gesture of this villein, whose arms are still caught in the inside-out sleeves of his garment, as if he is struggling in his hurry to welcome and honor Christ. This detail, while unusual, is not unique, appearing for instance (along with the ass's foal) in an early fourteenth-century detached miniature inserted into the Gough Psalter at the Bodleian Library (Fig. 15), an image related in style to the illustrations of the well-known Peterborough Psalter in Brussels.[32] However, in the Gough miniature the double register of modes is not nearly so obvious; the action is more or less uniform in detail and tempo across the entire page, while in Garrett 35, together with, but equally in addition to the *maiestas* of the central figure of Christ, we see the humble ass and her foal and the equally humble gesture and open mouth of an ordinary individual. Such a rhetorical *amplificatio* might well have led the medieval viewer to recognize himself or herself too in the presence of the Divine.

A second example of a salient detail in the treatment of a standard subject is provided by the Pentecost miniature. The diptych of the Ascension and the Pentecost is beautifully paired, highly formal—in a word, 'magnificent' (Figs. 18 and 19). But a closer look at the Virgin and Apostles of the Pentecost reveals an exceptional departure from the standard composition. In the front rank are six seated, frontal figures, heads slightly raised; in the second rank, to the far left and far right, are the raised heads of two more. Between them, astoundingly, and uniquely as far as I know, are

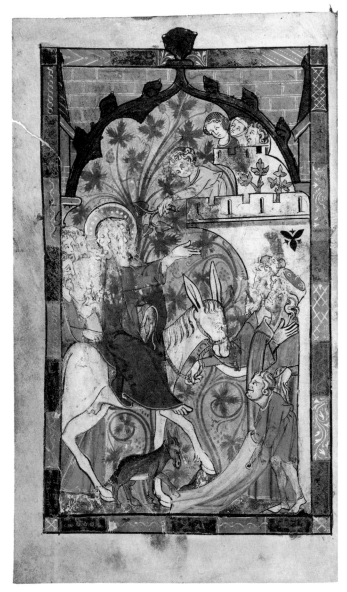

FIGURE 15. Entry into Jerusalem. Psalter leaf, Oxford, Bodleian Library, Ms. Gough liturg. 8, fol. 11ᵛ (Bodleian Library).

six further heads, seen directly from the rear, their wave-patterned hair tinted in rhythmically alternating red-brown and pale blue, fixing the attention of the viewer, and, incidentally, almost impelling a counting

31. For the ass's colt, see Matt. 21: 2–7; Mark (11: 2–7) and Luke (19: 30–35) say that Christ rode on the ass's colt, not the ass, and John (12: 14–15) mentions only the ass.

32. Gough Psalter, Oxford, Bodleian Lib., Ms. Gough liturg. 8, and Peterborough Psalter in Brussels, Brussels, Bibl. royale,

Ms. 9961-62, both first decade of the 14th century. In the Peterborough Psalter Entry into Jerusalem (fol. 33), Christ is also greeted by a man pulling his arms out of the sleeves of his garment. On these manuscripts, see L. F. Sandler, *The Peterborough Psalter in Brussels and Other Fenland Manuscripts* (London, 1974).

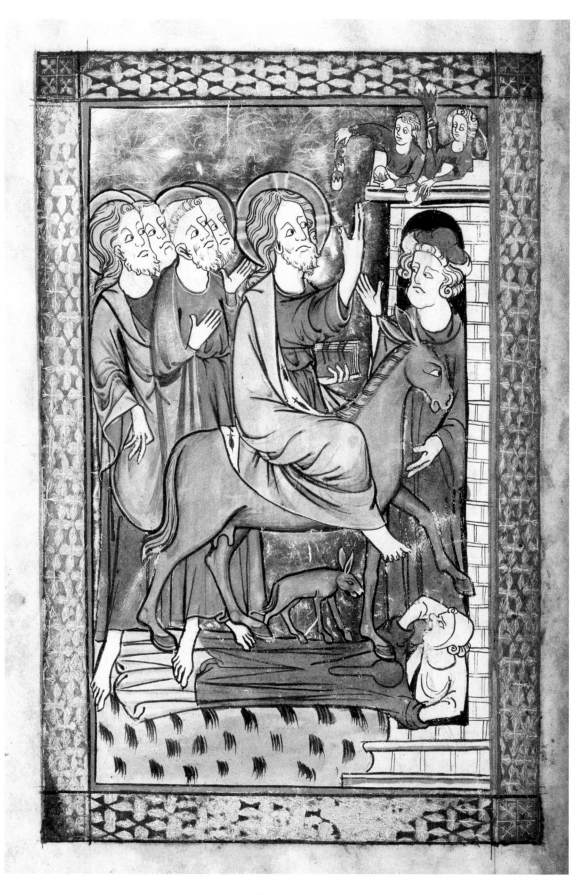

FIGURE 16. Entry into Jerusalem. Psalter, Princeton University Library, Garrett Ms. 35, fol. 5ᵛ (Princeton University Library).

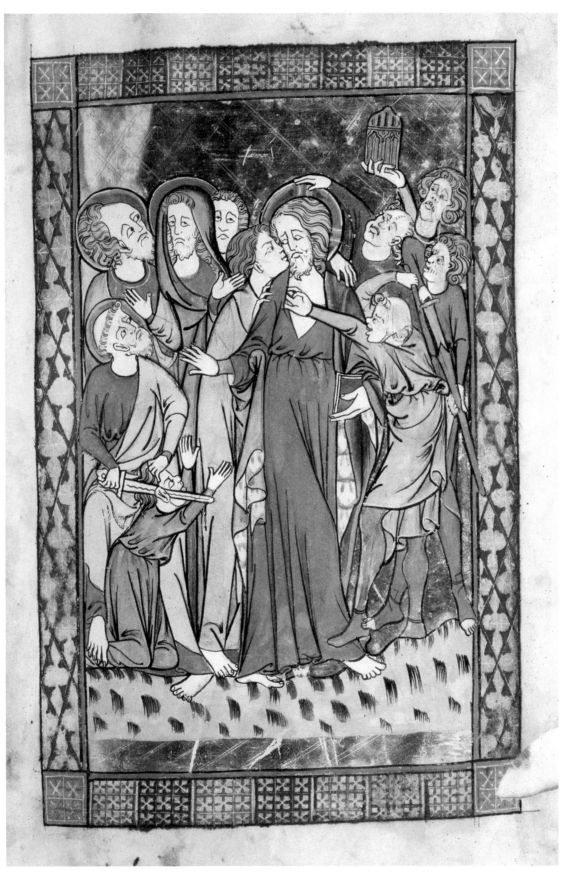

FIGURE 17. Betrayal. Psalter, Princeton University Library, Garrett Ms. 35, fol. 6
(Princeton University Library).

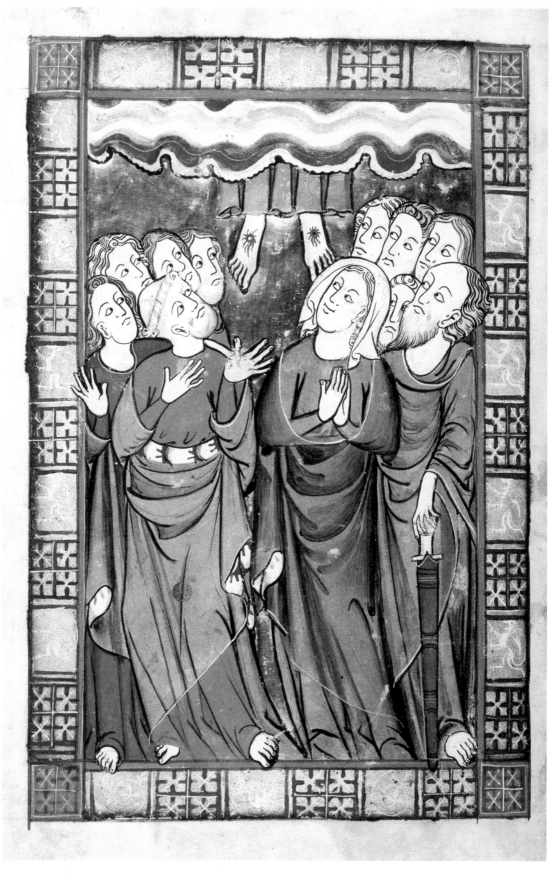

FIGURE 18. Ascension. Psalter, Princeton University Library, Garrett Ms. 35, fol. 10ᵛ
(Princeton University Library).

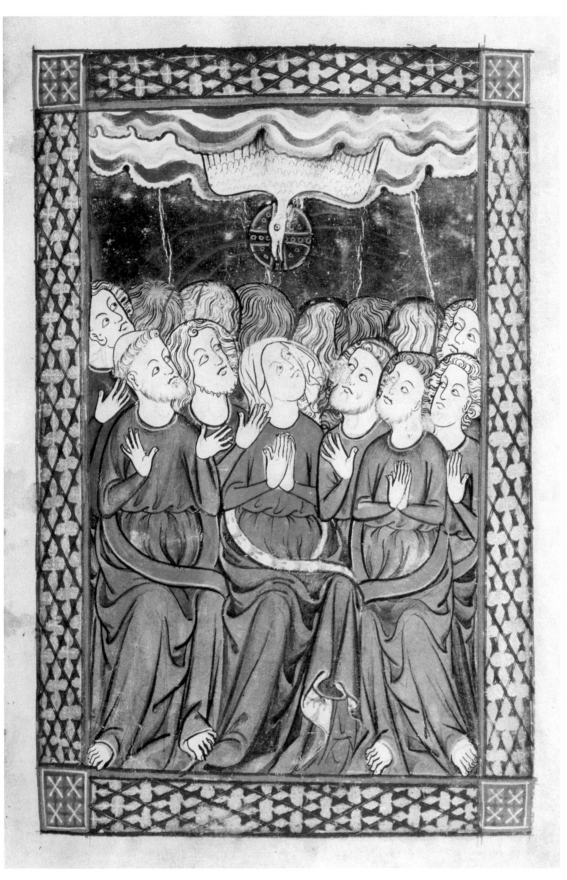

FIGURE 19. Pentecost. Psalter, Princeton University Library, Garrett Ms. 35, fol. 11
(Princeton University Library).

operation, the result of which is that we discover that in addition to the Virgin, whom we often find centered in the Pentecost, thirteen male figures are included. Except for Peter, on the left in the front, the others are unidentified, but the count presumably includes both Mathias, nominated to replace Judas, and Paul, and the red rays of the Holy Spirit are calibrated with each head. While heads in rear-view immediately make us think of the comments on Gothic illusionism in Otto Pächt's magisterial essay, 'A Giotteque Episode in English Medieval Art,'[33] I do not believe that the configuration here has much to do with the Classical tradition whose fortunes he discussed. Indeed, in those rare representations of the Pentecost where the Apostles are shown in a circle, it always seems to be the front figures who are seen from the rear, a configuration that focuses on the spatial and conceptual unity of the group.[34] What could the unique artistic decision of the Garrett 35 artist have meant to him, or to the viewer? Possibly an indication of the universal, catholic outward reach of the Apostles who, under the influence of the tongues of fire of the Holy Spirit, shown as curving red lines in the miniature, 'began to speak with divers tongues' so that 'every man heard them speak in his own tongue' (Acts 1:4–6).

The Garrett 35 artist made some startling and inventive formal and iconographic decisions in the historiated initials of the manuscript as well as in the large mini-

FIGURE 20. Suicide of a knight, Psalm 51 initial. Psalter, Princeton University Library, Garrett Ms. 35, fol. 55 (Princeton University Library).

atures. Among the examples is the illustration for Psalm 51 (Fig. 20). The initial shows a suicide, a fairly common subject.[35] More often than not, the suicide is identifiable by his crown as King Saul, who fell on his sword after his defeat by the Philistines (I Kings 31:4).[36] Saul's name is in the *titulus* of the psalm, not as a suicide, but in connection with his order to Doeg, the Edomite, to kill Achimilech and the priests of Nobe who were faithful to David, and this is one of the subjects occasionally employed as an illustration of the psalm.[37] Medieval commentators on Psalm 51, such as Honorius of Autun, sometimes interpreted

33. O. Pächt, 'A Giottesque Episode in English Medieval Art,' *Journal of the Warburg and Courtauld Institutes* 6 (1943), 51–70.

34. This convention of representing circular groups of figures with those in the foreground viewed from the rear and those further in the background from the front goes back to the Carolingian period, as for example in the Ascension in the Drogo Sacramentary (Paris, BnF, Ms. lat. 9428, fol. 71ᵛ). The same configuration also occurs in representations of the Last Supper; for a striking example of representations of all three subjects in this way, see the English M. R. James Memorial Psalter of the 3rd quarter of the 14th century (London, British Lib., Add. Ms. 44949), fols. 4ᵛ (Pentecost), 5ᵛ (Ascension), and 6 (Last Supper); see Sandler, *Gothic Manuscripts* (as in note 2), I: ill. 337, II: 141, no. 127, with bibliography.

35. Other 14th-century English examples include the Barlow Psalter (Oxford, Bodleian Lib., Ms. 22, fol. 67) and a Psalter in the Douce collection of the Bodleian Library (Ms. Douce 131, fol. 42ᵛ); see Sandler, *Gothic Manuscripts* (as in note 2), II: 99–100, no. 91 and 117–18, no. 106). Psalm 51 is illustrated in Psalters with a 10-part text division, common in England, but not uni-

versal, and sometimes with a smaller, or non-figural initial. In illustrated Psalters with an 8-part text division, following the pattern in the Breviary, Psalm 51 is not singled out.

36. E.g., the early 14th-century English Psalter, Oxford, Bodleian Lib., Ms. Douce 131, fol. 42ᵛ; for an illustration, see www.digital.bodleian.ox.ac.uk.

37. The standard *titulus* is: *In finem. Intellectus David, cum venit Doeg Idumaeus, et nuntiavit Sauli: Venit David in domum Achimelech* (Unto the end, understanding for David, when Doeg the Edomite came and told Saul: David went to the house of Ahimelech). Neither this, nor the other psalm *tituli*, was necessarily included in illustrated Psalters. Among early 14th-century examples of Doeg and the Priests as the illustration for Psalm 51 are four important East Anglian manuscripts, the Ormesby Psalter (Oxford, Bodleian Lib., Ms. Douce 366, fol. 71ᵛ), Gorleston Psalter (London, British Lib., Add. Ms. 49622, fol. 68ᵛ), Douai Psalter (Douai, Bibl. municipale, Ms. 171, fol. 64ᵛ), and Macclesfield Psalter (Cambridge, Fitzwilliam Mus., Ms. 1-2005, fol. 76); on the first three, see Sandler, *Gothic Manuscripts* (as in note 2), II: 49–50, no. 43, 56–8, no. 50, and 115–17, no. 105; on the Maccles-

the name 'Saul' as 'Death': *Per Saul significatur mors; per David vita Christi* (by Saul is signified death; by David, the life of Christ).[38] From the Carolingian period onward, Saul's suicide was taken as an example of royal downfall because of pride, especially in treatises on kingship;[39] and in general medieval discussions of suicide, writers as different as John of Salisbury[40] and Pope John XXII[41] identified one of its causes as *vana gloria*, the very vice against which the psalmist thunders in the opening line, *Quid gloriaris in malitia?* (Why does thou glory in malice?).

However, the figure in the illustration of Psalm 51 in Garrett 35 is not the crowned Saul but astoundingly a contemporary armored knight in helmet, chain mail, and orange surcoat, still holding his hunting bird in one hand and still accompanied by his hound as he thrusts an enormous silver sword through his body. Of course, the image is a cunning artifice, a symbolic conflation of one manifestation of nobility—the hunting bird and the hound—with another—the armor and sword.[42] The artist has made such a visual point of the heraldic red belt and sword scabbard, the only time in the manuscript this red was used, that we are bound to see the image as a purposeful departure from the familiar features of the subject. Were it read as a biblical subject, the image could represent the suicide of Saul's armor-bearer. After his defeat, Saul had begged his armor-bearer to stab him so that he would not be killed by an 'uncircumcised' enemy, but the armor-bearer would not, 'for he was struck with exceeding great fear' (I Kings 31:4), and so, after Saul killed himself, 'when his armourbearer saw this, to wit, that Saul was dead, he also fell upon his sword and died with him' (I Kings 31:5). In commenting on this event, Ra-

banus Maurus, among others, said that according to Hebrew commentators, Saul's armor-bearer was in fact Doeg himself,[43] the Doeg mentioned in the *titulus* of Psalm 51. It is only a distant possibility, however, that the Garrett 35 artist was familiar with this naming of Saul's suicidal armor-bearer.

What then would this image have meant at the beginning of the fourteenth century in England—to the artist, to whom I'd like to give credit for its invention, and to the reader/viewer of the book? Perhaps there is some socio-political reference. Perhaps this is the man about whom the Psalmist says in verses 7 and 8, 'Therefore will God destroy thee for ever: he will pluck thee out, and remove thee from thy dwelling place: and thy root out of the land of the living. The just shall see and hear, and shall laugh at him, and say: Behold the man that made not God his helper: But trusted in the abundance of his riches: and prevailed in his vanity.' And perhaps the artist intended the suicidal knight to evoke visually the fate of some player in contemporary events, someone who might have been perceived as an enemy of the beleaguered Edward I in the last decades of his reign, or one of the corrupt associates of Edward II. If so, we would be dealing with a sophisticated and politically knowledgeable illuminator, and an audience of high enough social status to appreciate the implications of the image in relation to the text it illustrates.

On the verso of the page with Psalm 51, the initial for Psalm 52 (Fig. 21) also is an unusual variant of the conventional subject, a fool before a king, a theme linked with the opening line, 'The fool said in his heart: there is no God.' In Garrett 35 the fool is identified by his double-pointed hood and his long robe split open

field Psalter, see S. Panayotova, *The Macclesfield Psalter* (London, 2008).

38. Honorius Augustodunensis, *Selectorum Psalmorum expositio* on the *titulus* of Psalm 51 (Migne, *PL*, 172: 290).

39. E.g., in the 9th century, Smaragdus, *Via regia* (Migne, *PL* 102: 957); cited by B. Zweig, 'Picturing the Fallen King,' in *Patronage: Power & Agency in Medieval Art*, ed. C. Hourihane (Princeton, N.J., 2013), 154, n. 27, and with further discussion and bibliography, *ibid.*, 151–74.

40. John of Salisbury, *Policraticus* 2:27 (Migne, *PL*, 199: 470); translated by A. Murray, *Suicide in the Middle Ages, Volume II: The Curse of Self-Murder* (Oxford, 2000), 207.

41. Pope John XXII, Sermon on the Assumption of the Virgin; see Murray, *Suicide in the Middle Ages*, 237, translated from Paris, BnF, Ms. lat. 3290, fol. 17.

42. As pointed out to me in oral communication by Dr. Patricia Stirnemann, knights did not hunt while wearing armor.

43. Rabanus Maurus, *Commentaria in libros IV Regum, In librum primum* (Migne, *PL* 109: 70): *Armigerum istum Hebraei Doeg Idumaeum dicunt fuisse, qui cernens Saul mortuum, seipsum ob metum David interemerit* (The Hebrews say that this armor-bearer was Doeg the Edomite, who, seeing Saul dead, committed suicide for fear of David).

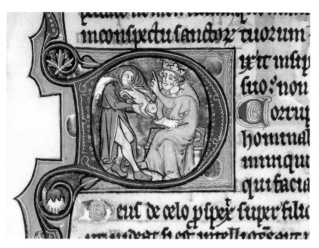

FIGURE 21. Fool before a king, Psalm 52 initial. Psalter, Princeton University Library, Garrett Ms. 35, fol. 55ᵛ (Princeton University Library).

to reveal his bare legs, but shod feet. These motifs offer no surprises, and belong to a long tradition of the representation of fools as totally naked, semi-clothed, and increasingly, in the late thirteenth and fourteenth centuries, dressed in the garb of professional jesters.[44] Often the fool is represented holding a round loaf of bread to his mouth, or actually eating it, this motif responding to the words of the textual simile, 'Shall not all the workers of iniquity know, who eat up my people as they eat bread?' (Psalm 51:5). These 'workers of iniquity' are the fools of the second line of the psalm, who are 'corrupted, and become abominable in iniquities.'[45]

Sometimes the Psalm 52 fool holds a scepter, or bauble, with a bulbous top, and sometimes the top of the 'scepter' is a limp balloon, a bladder made of organic animal material. In place of these motifs, in Garrett 35 the fool blows with puffed cheeks into the tail of an animal that most resembles a mouse whose body has swelled to giant size. In the Middle Ages the image of the mouse was weighted with numerous verbal and visual associations. Paired with 'cat,' 'mouse,' was male, as 'cat' was female, and even more, 'mouse' was the male sexual member that could be caught in the female 'mousetrap.'[46] In the medieval *mentalité*, blowing into the tail of an inflated 'mouse' would, I think, have fallen into the same category as playing inflated buttock-shaped bagpipes, and such bagpipes, sometimes incorporating animal heads, are staples of medieval marginalia.[47] Indeed, the action of the Garrett 35 fool suggests blowing into a bagpipe made of animal skin. By the early fifteenth century, when Psalm 52 was illustrated in the *Bible historiale*, a fool blowing into the tail of an animal *cum* bagpipe appeared more than once (Fig. 22).[48] The *mouse*-bagpipe remains unique however, to my knowledge.

It is possible that the Garrett 35 artist's choice of this particular animal was conditioned in some way by familiarity with the narratives and riddles of the legend of Marcolf, the gross but clever fool, and Solomon, the son of David, one of which features cats and mice.[49] Like the Marcolf and Solomon *bas-de-page* vignettes on the Psalm 52 pages of the Ormesby and Douai Psal-

44. See M. Laharie, *La folie au Moyen Age, XIᵉ–XIIIᵉ siècles* (Paris, 1991), esp. 18–19, 153–57, 276–77, tracing the concept of the fool from the mentally ill madman to the court jester.

45. Laharie (*La folie*, 157) discusses representations of the fool in Psalm 52 from the point of view of anthropology, sociology, and secular literature, but not in relation to the textual setting of the psalm. Thus she (mis)identifies the round shapes held by many fools as disks of cheese rather than the metaphorical loaves of bread eaten by the 'workers of iniquity' of verse 5.

46. See L. F. Sandler, 'A Bawdy Betrothal in the Ormesby Psalter,' in *Tribute to Lotte Brand Phillip, Art Historian and Detective*, ed. W. S. Heckscher *et al.* (New York, 1985), reprinted in *eadem, Studies in Manuscript Illumination 1200–1400* (London, 2008), 33–44, esp. 36, citing the 15th-century English lyric, 'Our Sir John': 'ser John ys taken In my mouse-trappe; | ffayne wold I have hem both nyght and day, | he gropith so nyslye a-bought

my lape, | I have no pore to say hym nay' (quoted from R. H. Robbins, ed., *Secular Lyrics of the XIVth and XVth Centuries* [Oxford, 1952], 20–21).

47. See L. M. C. Randall, *Images in the Margins of Gothic Manuscripts* (Berkeley, Calif., 1966), *s.v.*, Man [and variants] with bagpipe.

48. E.g., the *Bibles historiales* in London, British Lib., Ms. Royal 15 D. iii, fol. 262, Paris, early 15th century, style of the Boucicaut Master, and Ms. Royal 19 D. vi, fol. 267ᵛ, Paris, 1418–20, style of the Master of the Berry Apocalypse; see www.bl.uk, Catalogue of Illuminated Manuscripts for illustrations.

49. See *The Dialogue of Solomon and Marcolf: A Dual-Language Edition from Latin and Middle English Printed Editions*, TEAMS Middle English Texts, ed. N. M. & S. Bradbury (Kalamazoo, Mich., 2012), Sect. 13, online at d.lib.rochester.edu/teams/text/bradbury-solomon-and-marcolf.

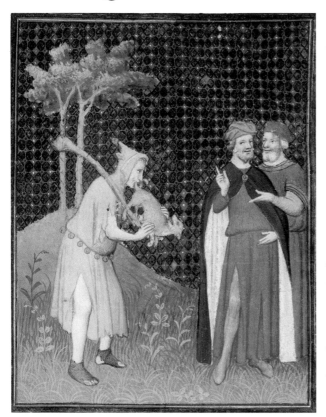

FIGURE 22. Fool before a king, Psalm 52 miniature. *Bible historiale*, London, British Library, Ms. Royal 15 D. iii, fol. 262 (© The British Library Board. All rights reserved).

FIGURE 23. Christ in prayer at altar, Psalm 101 initial. Psalter, Princeton University Library, Garrett Ms. 35, fol. 97ᵛ (Princeton University Library).

ters, which show Marcolf holding a captive hare as he rides on a goat toward the enthroned Solomon,[50] the pictorial image in Garrett 35 may represent a free, playful, and novel 'riff' on the literary theme, the creation of a very inventive artist.[51] In its immediate context, the image reinforces the psalm's condemnation of the fool who negates God and is thereby 'corrupted' and 'abominable in iniquities,' providing graphic material for meditation by the owner of the book on the meaning of the text.

A third of the historiated initials of Garrett 35 is also perplexing, again an unexpected variant of a pictorial theme much more standard. This is the illustration for Psalm 101 (Fig. 23), a psalm often showing David, or the owner of the manuscript, kneeling in prayer, a simple pictorial response to the opening line, 'Hear, O Lord, my prayer: and let my cry come to thee.'[52] When David is represented in prayer the altar is sometimes bare, that is, without Christian furnishings, although since David was equated with Christ, in some images a chalice or cross rests on the *mensa*.[53] Whether David or the book owner is shown, the Deity, the object of the prayer, also appears in some form to bless the supplicant.

In Garrett 35, however, the figure in prayer is neither David nor the owner of the book, but Christ himself, praying at a cloth-covered altar devoid of cross or chalice, and with no sign of the Deity above. This unparalleled choice can be considered in relation to a second pictorial tradition for the illustration of Psalm

50. Ormesby Psalter, *c.* 1310 (Oxford, Bodleian Lib., Ms. Douce 366, fol. 71ᵛ); for color illustration see www.digital.bodleian.ac.uk. Douai Psalter, after 1322 (Douai, Bibl. municipale, Ms. 171, fol. 65ᵛ); now nearly destroyed, for original state, see S. C. Cockerell, *The Gorleston Psalter* (London, 1907), 2–4; for present state, see www.enluminures.culture.fr, *s.v.* Douai.

51. For observations on the fluidity of Marcolf and Solomon imagery in relation to the textual tradition, see M. Curschmann,

'Marcolf or Aesop? The Question of Identity in Visio-Verbal Contexts,' *Studies in Iconography* 21 (2000), 1–45.

52. In the Vaux Psalter (see above, note 9), stylistically related to Garrett 35, Psalm 101 (fol. 148ᵛ) is illustrated with David praying at a draped altar furnished with a cloth-covered chalice.

53. For David at a bare altar, see the Bible of William of Devon (London, British Lib., Ms. Royal 1 D. i, fol. 249ᵛ) made in England *c.* 1260–70; for a color illustration, see www.bl.uk, Catalogue of Illuminated Manuscripts.

101, which evidently appeared first in the early twelfth-century St. Albans Psalter.[54] The St. Albans image was developed from St. Augustine's commentary on Psalm 101, in which the supplicant was interpreted as Christ himself, addressing the Father in his tribulations.[55] The St. Albans artist visualized this as Christ's prayer in the Garden of Gethsemane on the Mount of Olives while his disciples slept: 'Father, if thou wilt, remove this chalice from me; but yet not my will, but thine be done. And there appeared to him an angel from heaven, strengthening him.' The image shows Christ kneeling against a foliated backdrop (the garden), his gesture indicating a chalice resting on a series of horizontal bands perhaps suggesting an altar, and an angel responding to the prayer with a pointed finger. This innovative pictorial interpretation recurred occasionally thereafter as the subject of illustrations of Psalm 101, particularly on the Continent (Fig. 24). The later artists included the sleeping disciples, but not usually a chalice or an altar.

What the Garrett 35 artist seems to have done was to conflate elements of the normal image of the supplicant in prayer at an altar with the image of Christ in the Garden of Gethsemane. The kneeling figure *is* plainly Christ, although without a cruciform halo;[56] the artist included an altar, not characteristic of Gethsemane images, but the altar is empty, that is, without the chalice, and there is no comforting angel, no head or hand of God the Father, and no sleeping disciples—all often components of the Agony in the Garden. In this context, the empty altar is the most striking feature. The chalice that we might expect to be there has been removed, as if in response to Christ's plea for the end of his earthly suffering. Again, the Garrett 35 artist appears to have made an unprecedented decision. As a result, the words of the psalm are given a Christological inflection equal to that of his Trinity illustration of Psalm 109 (Fig. 25). As a pictorial response to the opening line, 'The Lord said to my Lord: Sit thou at my right hand,' the Trinity is a standard subject. On the

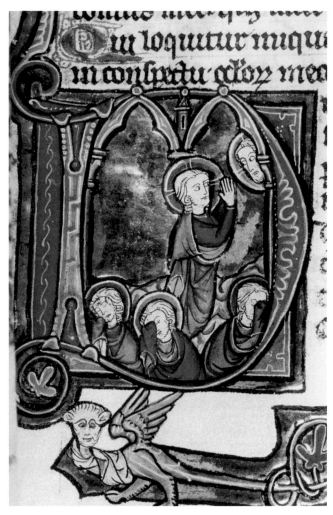

FIGURE 24. Christ in Prayer in Garden of Gethsemane, Psalm 101 initial. Psalter, New York, Morgan Library, Ms. M. 183, fol. 125 (Morgan Library and Museum).

other hand, the Christological subject of the Garrett 35 illustration for Psalm 101 is highly original, one of those cases in this manuscript that demonstrates the decision-making capacity of the artist who composed the image.

What is the sum total of decisions made by this artist? In formal terms his 'minificence' in 'magnificence' is the characteristic that distinguishes his work from

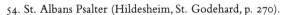

54. St. Albans Psalter (Hildesheim, St. Godehard, p. 270).

55. Otto Pächt in R. Dodwell, O. Pächt, and F. Wormald, *The St. Albans Psalter* (London, 1960), 242, citing Augustine, *Enarrationes in Psalmos* (Migne, *PL* 37: 1296, on Psalm 101).

56. The figure is identifiable as Christ by his physiognomy and

the treatment of his hair, paralleled not only elsewhere in Garrett 35, as for example in the Trinity miniature (fol. 12ᵛ) and the Trinity initial for Psalm 109 (fol. 109ᵛ), but virtually universal in the early 14th century.

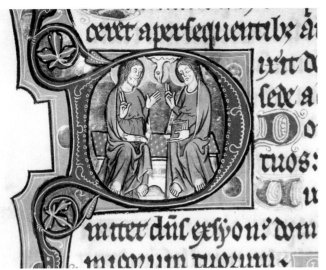

FIGURE 25. Trinity, Psalm 109 initial. Psalter, Princeton University Library, Garrett Ms. 35, fol. 109ᵛ (Princeton University Library).

that of the artists closest in style. This is not simply a feature of so-called line, form, and color, but facture in the service of the construction of pictorial meaning. In thematic terms, the artist's manipulation of the components of standard subjects suggests a level of theological awareness that went beyond the simple Christian catechism, and a high degree of sociopolitical sophistication that could communicate with an equally sophisticated audience.

A final point: accepting that Garrett 35 is a 'homeless' manuscript has led to a focus on the practice of an individual illuminator, and in turn to highlight his departures from norms of facture and iconography. What emerges is an expanded view of the potential for meaning built into images by their creators, even when, as in this case, we do not know who the artist was, where he was, or for whom he illuminated this book. The case study of Garrett 35 should encourage us to look at manuscripts that do not fall into the homeless category equally closely as products of decisions made by artists. Whether responding to instructions, texts at hand, visual memory, working conditions, or even their own self-images, medieval artists should be held responsible—for better, or worse—for every stroke laid on the parchment. And it is our responsibility to grant recognition to their art practice in our own practice as art historians.

WALTER CAHN

A Late Medieval Compendium of Ancient Wisdom: Guillaume de Tignonville's 'Dits moraux des philosophes'

THE CAREER of Guillaume de Tignonville, to the extent that it can be somewhat fitfully glimpsed on the basis of the fragmentary documentary evidence available to us, reveals an unusual combination of activities: diplomat and political operative, purveyor of a single translation of a Latin text for which he is chiefly remembered, and more occasionally, of courtly poetry. Tignonville is a hamlet located about forty miles south of Paris, on the road to Orléans, with Pithiviers to the south being the closest town of any size. The *Grande encyclopédie* of 1902 counted 319 inhabitants, and Google more recently found 340 souls there. The Tignonvilles have left only faint traces on the historical record reaching back to the second quarter of the thirteenth century, when one of Guillaume's ancestors was *bailli* (bailiff) of Etampes not far to the northwest, while his widow patronized the Chapter of Notre-Dame in that city. The male members of this modest local aristocracy seem thus to have been employed in the service of the royal administration, and Guillaume's own father, Louis, had himself been appointed bailiff and provost of Troyes in Champagne from 1399 to 1401. Tignonville's location also makes it understandable that the clan, and our Guillaume in particular, gravitated in the circle of Duke Louis of

Orléans, a son of Charles V, and brother of the reigning monarch after 1380, Charles VI.[1]

We know next to nothing about Guillaume's early years and the nature of the education he received. He is thought to have been born around the middle of the fourteenth century, or perhaps a decade or so later. As a diplomat, whose missions took him to Italy, the papal court at Avignon, and to Germany, he likely had some legal training, as is also suggested by the fact that among his last recorded acts, he gave to Duke Jean de Berry two volumes of the Justinianic codes, the *Infortiatum* and *Digestum vetus* in their French version, which he owned.[2] Like his better known colleagues who worked as translators for the bibliophile king Charles V, among them Jean Corbechon, who translated Bartholomeus Anglicus' *De proprietatibus rerum*, Laurent de Premierfait, who translated the Latin and Italian works of Boccaccio into French, or Nicole Oresme, who did the same for the major writings of Aristotle, he may have come by his linguistic skills on the basis of clerical training or attendance at the university, but this remains no more than conjecture.[3]

In June 1401, Tignonville was elevated to the important post of *prévôt* (provost) of Paris, and thus made

1. Biographical information on Guillaume de Tignonville, his family, and career has been collected by R. Eder in his still fundamental study 'Tignonvillana inedita,' *Romanische Forschungen* 33 (1915), 851–73. See further, L. Level, *Guillaume de Tignonville, 'prévôt de Paris,'* in Positions de thèses de l'École nationale des Chartes (1935), 137–44; L. Pastoureau-Level, Positions de thèses (1936), 145–49; A. Demurger, 'Guerre civile et changements du personnel administratif dans le royaume de France de 1400 à 1418: l'exemple des baillis et des sénéchaux,' *Francia* 6 (1978), 194–95; G. Tyl-Labory, 'Guillaume de Tignonville,' *Dictionnaire des lettres françaises: le Moyen Âge*, eds. G. Hasenohr and M. Zink (Paris, 1992), 647. C. Gauvard, 'Les humanistes et la justice sous le règne de Charles VI,' in *Pratiques de la culture écrite*

en France au XVe siècle: Actes du colloque international du CNRS, Paris, 16–18 mai 1992, eds. M. Ornato and N. Pons, (Louvain-la-Neuve,1995), 231–38.

2. J. Guiffrey, *Inventaires de Jean, duc de Berry (1401–1416)*, 2 vols. (Paris, 1894–1896), 1: 266, nos. 995 and 996.

3. J. Monfrin, 'Humanisme et traductions au Moyen Âge,' in A. Fourrier, *L'Humanisme médiéval dans les littératures romanes du XIIe au XIVe siècle* (Paris, 1964), 217–46; A. Vernet, 'Les traductions latines d'œuvres en langue vernaculaire au Moyen Âge,' in *Traductions et traducteurs au Moyen Âge: Actes du colloque international du CNRS, 26–8 May 1986* (Paris, 1989), 225–41; C. Bozzolo, ed., *Un traducteur et un humaniste de l'époque de Charles VI. Laurent de Premierfait* (Paris, 2004).

responsible for the administration and police of this restless and not infrequently violent city, which he oversaw from headquarters in the Châtelet. A number of ordinances that he issued are preserved in the archives. One of them (January, 1404) forbids the inhabitants of the city 'to throw garbage, building waste and other filth' into the Seine and orders that the river bed be cleaned at the expense of those who have been guilty of soiling it. In March of the same year, he forbad lepers to have any contact with the inhabitants and ordered the expulsion of foreigners afflicted with the disease. Several months later, he prohibited people from stealing pigeons, evidently already a prized delicacy on Parisian tables.[4] Two events of more than ordinary importance, however, took place on his watch, both of them recorded in some detail by contemporary chroniclers, though with some differences in perspective or points of view. On 16 October 1407, Tignonville carried out the arrest of two malefactors accused of having committed homicide and theft, and a month later, after a summary judgment, he had them hanged. Since it was claimed that they were students, and hence in clerical orders, their fate was to be determined by ecclesiastical authority, which protested energetically against this affront to its prerogatives. Courses of the university were suspended and the bishop and rector lodged a vigorous protest to the king, forcing Tignonville after much bitter wrangling, to make amends.[5]

A more sensational and politically fraught event took place on 23 November, less than a week later, the murder on a street, near the royal hotel Saint-Paul, of Duke Louis of Orléans. Tignonville, who in his provostial capacity was charged with the investigation of the crime, came rapidly to the conclusion that it had been carried out at the behest of John the Fearless, duke of Burgundy. Already battered in the factional strife that surrounded him and under pressure from the Burgundian camp, Charles VI thought it best to dismiss Tignonville from his position, but attached to him, or eager to retain his services, he appointed him

to preside over the Chambre des Comptes, a kind of chairman of the Federal Reserve of the regime, so to say, whose task was to oversee the collection of revenues from the crown estates and control the fragile finances of the kingdom.[6] In this later phase of his career, he tended to disappear from public view or at least from its contentions, though he undertook a number of diplomatic missions on behalf of the king as a mediator between the factions around the royal princes, and as a negotiator with England in the Hundred Years War. He is last heard of in 1414 when he is thought to have died, though whether from natural causes or otherwise is not known.

This brief recitation of the main events in the public life of an aristocrat of middling standing fails to accord with the ideal of the age, with its emphasis on the punctilious performance of ritual, self-conscious display, and conspicuous consumption, described by Johan Huizinga in a chapter of his classic but surely one-sided *The Autumn of the Middle Ages* as 'The Craving for a More Beautiful Life.' It is not the case, however, that these elements were altogether lacking in the life of our man. Chivalric Orders were then all the rage, and Charles VI, having to compete on this front with the Order of the Golden Fleece founded by Philip the Good of Burgundy and Edward III's Order of the Garter in England, to mention only two conventicles of this kind among many others, established his own chivalric society in 1400, the Court of Love (*Cour amoureuse*, or *Cour d'amour*), whose purpose was 'to honor the female sex and cultivate poetry,' as it is stated, in the course of regular, presumably annual, assemblies. According to the elaborate by-laws, membership was organized along hierarchical lines, with three great *conservateurs* at the top, and below them, a *Prince d'amour* surrounded by twenty-four *ministres*, and it is among the latter that Tignonville's name is found. This document is all that survives of the enterprise, and it is uncertain whether such meetings ever took place, the future of the gathering having been fatally compromised by the king's grave mental condition

4. Eder, *Tignonvillana inedita* (as in note 1), 856–58.
5. Eder, *Tignonvillana inedita*, 861–66, and Gauvard, *Les humanistes et la justice*, 239–44 (both as in note 1).

6. For a reconstruction of the event and its implications, see B. Guénée, *Un meurtre, une société: L'assassinat du Duc d'Orléans, 23 novembre 1407* (Paris, 1992).

and the increasing civil unrest that marked the last years of his reign.[7]

In 1402, Tignonville was drawn into the quarrel over the *Romance of the Rose*, and particularly by Jean de Meun's completion of this allegorical poem, judged by Christine de Pizan and her supporters to be injurious to women. The dossier composed of arguments from partisans and detractors of the *Romance*, to which a number of prominent controversialists, like Jean de Montreuil and Jean Gerson contributed, was turned over by her to Tignonville, addressed as 'tres chier seigneur, noble et saige chevalier,' with a plea to adjudicate the rights and wrongs on each side of the case and help to resolve their differences. Of our man's competence to function as an adequate judge in literary matters, we have only Christine's far from disinterested opinion, who seems to have been on friendly terms with him.[8] A short poem in praise of loyalty in love that he contributed to the collection contained in the *Livre des Cents Ballades* is all that now remains of whatever efforts he may have made in this domain, and it is evidently an inadequate basis on which to assess their merit.[9]

Anyone interested in Guillaume de Tignonville's life and work must take as a starting point the documentation assembled by the German scholar Robert Eder under the title 'Tignonvillana inedita' and published in the journal *Romanische Forschungen* based in Erlangen in 1915.[10] Though not entirely free of error or minor infelicities, as should be expected of a study now nearly a century old, it remains an impressive and inescapable starting point for any further reflection on the subject.[11] For his reconstruction of Guillaume's activities, Eder quotes liberally from archival documents and contemporaneous historical accounts, most notably those of Nicholas de Baye, Jean Juvenal des Ursins, and the chronicle of the monk (Religieux) of Saint-Denis.

But the larger part of Eder's study is devoted to the edition of Tignonville's only extended literary work, his translation from the Latin of a collection of wise sayings by ancient authors, which circulated under the title *Dits moraulx des philosophes*.[12] The source of the work was a compilation in Arabic made by Abu al-Wafa Mubashir ibn Fatik, active in Damascus around the middle of the eleventh century. Its transmission to the West has occasioned much painstaking philological spadework, which I am not competent to assess, and remains somewhat tentative. There was a Castilian translation of it made in the first half of the thirteenth century, known as *Bocados de oro*,[13] which was the source of a Latin version, entitled *Liber philosophorum moralium antiquorum*,[14] which has been attributed to the physician and diplomat Giovanni da Procida and originated in southern Italy according to some, and in Venice according to others, to be dated in the second half of the same century.

We do not know when Tignonville's translation was carried out, nor his motives for doing so, nor the circumstances that surrounded the project. It was definitely completed before 1402, the date of a manuscript in the Bibliothèque nationale de France (Ms. fr. 572), written at Aix-en-Provence by a scribe named Andrivet de Brese, and completed, according to the

7. A. Piaget, 'La Cour amoureuse dite de Charles VI,' *Romania* 20 (1891), 417-454, esp. 427; C. Bozzolo and H. Loyau, *La Cour amoureuse dite de Charles VI* (Paris, 1982), I: 61, no. 33.

8. E. Hicks, *Le débat sur le Roman de la Rose* (Paris, 1977), 7–8, no. 11.

9. G. Raynaud, ed., *Les cent ballades. Poème du XIVᵉ siècle composé par Jean le Seneschal...* (Paris, 1905), 211–12, no. VI. Eustache Deschamps also mentions a poem of Guillaume de Tignonville whose argument he endeavors to refute, but Tignonville's own composition is lost. E. Deschamps, *Œuvres complètes d'Eustache Deschamps, publiés d'après le manuscrit de la Bibliothèque nationale par le Marquis de Queux de Saint-Hilaire*, Paris, 1882, III: 214, no. 413 (Plus a de mal en armes qu'en amours / Et plus de griefz, ce soustient Tymonville). For the literary activity of this milieu, see D. Poirion, *Le poète et le prince. L'évolution du lyrisme*

courtois de Guillaume de Machaut à Charles d'Orléans, Université de Grenoble, Publications de la Faculté des Lettres et Sciences humaines, 35 (Paris, 1965).

10. Eder, *Tignonvillana inedita* (as in note 1).

11. I have discovered no other biographical information about this author, nor any other publication, and I would grateful to anyone who might be able to help me flesh out this inadequate picture, to the extent possible.

12. Eder, *Tignonvillana inedita* (as in note 1), 908–1019

13. M. Crombach, *Bocados de Oro: Kritische Ausgabe des altspanischen Textes* (Bonn, 1971).

14. E. Franceschini, 'Il "Liber philosophorum moralium antiquorum." Testo critico,' *Atti del Reale Istituto Veneto di scienze, lettere, ed arti* 91, part 2 (1931–1932), 393–597 (not available to me).

colophon, on the tenth of July of that year, which is the earliest dated copy of the text thus far identified.[15] Commissioned by (or on behalf of) a man named Jean le Voyer, described as a 'knight, chamberlain of the king, and Lord of La Clarté,' the volume has spaces left blank for a frontispiece miniature and for illustrations throughout the text, though this decoration was left unexecuted. In spite of its qualitatively modest or routine aspect, it offers proof that the work was designed to accommodate some form of decoration from the beginning, or at an early date. This is confirmed by the fact that less than a year later, according to an entry in the inventory of the library of Jean de Berry made in 1416, the duke in January 1403 acquired from Regnault du Montet, a dealer in Paris who regularly supplied him with precious manuscripts, a copy of Tignonville's *Dits moraux*, said to be 'historiated at the beginning with a painted illumination and elsewhere in black and white' (i.e., in grisaille).[16] It has unfortunately not been located, and must be presumed lost.

Dits moraux was widely read or at least widely diffused in its time. Eder, who attempted the first comprehensive census of surviving manuscripts, listed thirty-seven copies, most of them dated in the fifteenth century, and consulted twenty of these in order to establish his critical edition of the text, which remains the only one thus far attempted.[17] Since then, other manuscripts have come to light, and several recent estimates that have been made are in the rough range of fifty copies. My own list still in progress comes to sixty-eight items, plus a few others mentioned in sales catalogues whose present whereabouts have yet to be determined.[18] It might be noted that neither Eder's list nor mine includes the copies of several Middle English translations of Tignonville's French version, *Dicts and Sayings of the Philosophers*, of which thirteen copies are extant.[19] This places the *Dits moraux* well below the absolute best sellers among the literary works that circulated in late medieval France, like the *Roman de la Rose*, of which about two hundred manuscripts have been identified,[20] or the *Grandes chroniques de France*, of which Ann Hedeman counted at least one hundred and thirty surviving copies,[21] but it takes us within reasonable range of the *Miroir historial* of Vincent de Beauvais, of which the latest tally available to me lists eighty-seven items, and of Laurent de Premierfait's French translation of Boccaccio's *De casibus virorum et mulierum illustrium*, of which sixty-nine copies have been identified.[22]

But circumscribing with any degree of accuracy or gauge the resonance of *Dits moraux* in its time is a complicated task, because the genre of proverbs, aphorisms, and wise sayings ascribed to ancient authors, real or mythical, had a very large currency. Beyond Tignonville's collection, there was in wide circulation the text known variously as *Moralités des philosophes*, *Roman de moralitez*, *Enseignements des philosophes*, and so forth, identified as a translation of the *Moralium dogma philosophorum* attributed to the Chartres master William of Conches, and the versified *Livre de philosophie et de moralité* composed in the first half of the thirteenth century by a little-known author named Alard

15. A. Coville, *La vie intellectuelle dans les domaines d'Anjou-Provence de 1380 à 1435* (Paris, 1941), 137–39.

16. Guiffrey, *Inventaires* (as in note 2), I: 238, no. 917: 'Item, un livre des Diz moraulx des philosophes ... historié au commancement d'enluminure et ailleurs de blanc et de noir.' On the activities of Regnault du Montet, see F. Avril, 'Trois manuscrits napolitains des collections de Charles V et de Jean de Berry,' *Bibliothèque de l'École des Chartes*, CXXVII, 1969, 303–04. The Duke also owned what may have been another copy of the text, presumably without an elaborate decoration: 'Item, un autre livre des Diz des philosophes...' (228, no. 868)

17. See Eder, *Tignonvillana inedita* (as in note 1), 876–77.

18. See the Appendix.

19. *The Dicts and Sayings of the Philosophers. The Translations Made by Stephen Scrope, William Worcester, and an Anonymous Translator*, ed. C. F. Bühler, Early English Text Society,

211 (Oxford, 1941); *The Dicts and Sayings of the Philosophers*, ed. J. W. Sutton (Kalamazoo, Mich., 2006). Fragments of a Provençal translation have also been discovered: C. Brunel, 'Une traduction provençale des 'Dits des philosophes' de Guillaume de Tignonville,' *Bibliothèque de l'École des Chartes*, C, 1939, 309–328.

20. These statistics are drawn from J. Monfrin, 'Les traducteurs et leur public en France au Moyen Âge,' in Fourrier, *L'Humanisme médiéval* (as in note 3), 247–62.

21. A. Hedeman, *The Royal Image: Illustrations of the Grandes Chroniques de France, 1274–1422* (Berkeley and Los Angeles, Calif., 1991), 272, n. 18

22. R. C. Famiglietti, 'Laurent de Premierfait: The Career of a Humanist in Early Fifteenth-Century Paris,' *Journal of Medieval History* 9, 1983, 25, in Bozzolo, *Laurent de Premierfait* (as in note 3), 31.

de Cambrai.[23] The Princeton University Library, as I learned from Mr. Skemer's impressive new catalogue, has in its Princeton Ms. 153 what seems to be another text of this kind, a set of quatrains entitled *Proverbes des philosophes* or *Proverbes des sages*.[24] Moreover, passages from Tignonville were interpolated into the compilation known as *Trésor des histoires*, and some of the sayings transmitted through his translation made their way into other collections.[25] It might be argued that the genre itself never really went out of fashion, informing the later classic works of La Fontaine, La Rochefoucauld, and Nicolas Chamfort, among others.

Dits moraux des philosophes is a fairly compact work, usually covering no more fifty to seventy manuscript folios, and in a substantial number of cases, combined with other writings of a similar or related kind, like the so-called *Disticha Catonis* or the pseudo-Aristotelian *Secretum secretorum* to form a more appropriately-scaled volume. Initially consigned to parchment surfaces, it is increasingly encountered after the middle of the fifteenth century in more modest copies on paper. As of 1477, a Middle English translation was printed by Caxton in what is said to have been the first printed book to appear in England, and in 1486, the first of a series of French editions was published by Vérard in Paris. The French text is set out without a preamble or *accessus* of any kind, and introduced only by a rubric, which at its most expansive, as in a copy of the work made for Jean de Lannoy, an advisor of the Duke of Burgundy and knight of the Golden Fleece,[26] identifies its author as 'noble home messire Guillaume de Tignonville, chevalier, conseiller et chambellan du Roy, notre Sire' (noble man and knight, counselor and chamberlain of the king, our lord), though it is often much more laconic and may omit Tignonville's name altogether.

The text consists of the sayings attributed to twenty-two separate authors, and a concluding twenty-third section containing the single sayings of an additional, rather large group of presumably lesser known sages. Among the twenty-two principal contributors of ancient wisdom are Hermes, Homer, Solon, Hippocrates, Pythagoras, Diogenes, Socrates, Plato, Aristotle, Alexander the Great, Ptolemy, and Galen, but also a handful of philosophers with strange names like Zalqualquin, Loginon, or Macdarge, transmitted in a variety of spellings, whom despite much effort, it has been impossible to identify further, and may indeed be wholly imaginary.

Spaces of variable length are allotted to the wise sayings of each of these personages, ranging for a mere ten to fifteen lines to a substantial number of pages in some cases. Comparison with the Latin text, which still remains to be systematically done, shows that Tignonville's translation does not follow his source line per line, but involved a process of abridgment or condensation.[27] The first of the philosophers has a biblical-sounding name, Sedechias, and is said to have been 'the first who through God's will the law was received and wisdom understood' (*le premier qui par la volonte de Dieu loy fu receue et sapience entendue*). His Moses-like foundational role in the collection, is expressed through sixteen precepts or *vertuz*, some of them reiterations of the Ten Commandments, others more in tune with medieval concerns. The first precept is to know God and his angels. The second is to cultivate discretion in order to be able to distinguish good from evil, and act accordingly. With the third, which specifies that obeisance is due to the king and his princes, 'whom God has put on earth in order to lead and have power over the [common] people,' we are in the more mundane world which Tignonville inhabited. The seventh pleads for the protection and defense of strangers and pilgrims, and the ninth is a demand to abstain from fornication.

Each of the philosophers is introduced by a brief

23. J.-C. Payen, 'Le livre de philosophie et de moralité d'Alard de Cambrai,' *Romania* 87, 1966, 145–47, and the critical edition by the same author, *Le livre de philosophie et de moralité d'Alard de Cambrai*, ed. J.-C. Payen (Paris, 1970).

24. Princeton University Library, Princeton Ms. 153, fols 180–186ᵛ. See D. C. Skemer, *Medieval & Renaissance Manuscripts in the Princeton University Library* (Princeton, N.J., 2013), II: 417–18.

25. P. Meyer, 'Les premières compilations françaises d'histoire ancienne,' *Romania* 14 (1885), 1–81; G. Doutrepont, *La littérature française à la cour des ducs de Bourgogne: Philippe le Hardi, Jean sans Peur, Philippe le Bon, Charles le Téméraire* (Paris, 1909), 407.

26. Lille, Médiathèque municipale Jean Lévy, Ms. 316 (635), fol. 3.

27. See Eder, *Tignonvillana inedita* (as in note 1), 895–908, for some examples of this process.

biographical or anecdotal sketch, which is followed by a recital of the sayings attributed to them, introduced in very economical and repetitious fashion by the words 'Et dit' and 'Et dit que' (And he said, or said that), echoing the Latin *Dixit*. Thus, quoting more or less at random, we find Sedechias again with more than a touch of cynicism opining 'And he said [*Et dit*] If you have a true friend who loves you dearly, you should consider him better than your father, mother, brother or other relatives who desire your death in order to inherit your fortune.' It will already have been apparent that Tignonville's conception of *moralite* has a strong political component, and indeed his work sometimes sounds like a manual of advice to princes, tinged here and there with a certain Machiavellian flavor. We learn from one of the ancient sages that there are 'Three things that a prince must avoid, that is to say, drinking too much, frequenting minstrels and other musicians, and madly carousing with women.' And another advises that 'A wise prince must not enter into a dispute with one who is more powerful than himself' and 'when a king has conquered and vanquished his opponents, he must deal with them fairly, judiciously, generously and with patient forgiveness, for in this way, he will make friends of his former enemies.' Are these not recommendations that one might be tempted to pass on to one of our current statesmen?

Manuscripts of the *Dits moraux* were produced exclusively—or nearly exclusively—in northern France, that is to say, where the *langue d'oïl*, which is the language of Tignonville's translation, was spoken, and in the French-speaking cities of Burgundy and Flanders. The clientele for the most luxurious of these productions was the upper reach of the nobility, along with some people of a lesser rank who gravitated around them. Among the documented owners of the work in the first group were the Dukes of Burgundy Philip the Good, and John the Fearless, Anthony, the brother of Charles the Bold, known as the Grand Bâtard of Burgundy, and somewhat later, Margaret of Austria who owned two copies; among men of the second

rank, we find the already mentioned Jean de Lannoy, along with Philip de Hauteville, who like Tignonville, was an official in the *Cour d'amour*, and Duke Louis of Bruges, whose copy eventually made its way with his other manuscripts into the royal library. At a lower level of the social scale, we occasionally find men like Johannin de Sailly, described as a merchant of Chalon-sur-Saône, who on the 19th of August in the year 1454, completed a copy of the work on paper, we are told, in his own hand.

In the remarks to follow, I focus on a group of *Dits moraux* manuscripts that, as it happens, are found in several collections along the eastern seaboard of the United States, and thus, within convenient reach, at least for this retired inhabitant of Connecticut. In fact, they are the only illustrated copies of the work in America known to me. Beyond convenience, however, it is also the case that these manuscripts, in their different ways, exhibit the variety of pictorial solutions in play among the illuminators of this text. My first example is the fine copy of the Boston Public Library, a work that has thus far received surprisingly little attention. Purchased from a New York dealer in 1941, it has no known earlier ownership history.[28] Its cycle of illustrations, executed in a grisaille technique, enlivened here and there by light washes of color, begins with a presentation miniature on a patterned reddish background, showing a kneeling donor offering a volume to a seated, unidentified patron (Fig. 1). This, at any rate, is one possible reading of the scene. The seated figure, who wears a tall hat with flanging sides and angular indentations at the top, seen as well in several other illustrations of the manuscript, appears to depict a noble personage in a commanding role, though not (or not necessarily) a king. I would propose to see the youthful figure with short curly hair kneeling before him as an intended portrait of Tignonville, the only one, I should say, that we now possess.[29] Such scenes of presentation are rare in copies of the *Dits moraux*, in good part, we may suspect, because our author does not mention a patron or sponsor of his translation at

28. Boston Public Library, Ms. f. Med. 91. Vellum, 101 fols., 307 × 238 mm. The purchase is reported by M. Munsterberg, 'The Sayings of the Philosophers,' *More Books: The Bulletin of the Boston Public Library*, XVI, no. 7 (September 1941), 315–18.

29. According to Raynaud, *Cent ballades* (as in note 9), a man-

uscript of this collection of poetry (Chantilly, Musée Condé, Ms. 1680) once contained portraits of 13 authors, but 4 of these (fols. 64–67), including that of Guillaume de Tignonville, are said to be missing.

FIGURE I. Presentation miniature. Guillaume de Tignonville, *Dits moraux des philosophes*,
Boston, Public Library, Ms. f.Med. 91, fol. 1 (*c.* 1400–1410) (courtesy of the Trustees
of the Boston Public Library/Rare Books).

all, making it appear as a kind of free-lance job. In other respects, however, the illustration of the Boston manuscript conforms to a pattern that is more or less standard for the production of copies of the work of an artistically more ambitious kind. Each of the ancient authors is allowed an author portrait in the form of a smaller framed vignette. In most instances, these authors are shown addressing a group of two or three men, but there are also attempts to characterize them in more particular ways, as in the figure of Ptolemy striking a bell and an anvil with hammers (Fig. 2), and Galen shown with the more or less standard attribute for a physician of a flask (Fig. 3). Although the text contains, so far as I could see, few explicit statements allied to Christian doctrine, it is somewhat surprising that Tignonville's list of ancient sages should include someone named St. Gregory (Saint Grégoire), intended as a reference to the sixth-century pope, and hence depicted wearing the triple-tiered papal tiara. A check through the manuscripts of the Latin text available to the translator, and its Arabic and Spanish sources, would be required to determine whether this identification goes back to these earlier writers, or, as I suspect, that it was one of Tignonville's purposeful or unguarded emendations. The manuscript must have been executed around 1400 or even a few years earlier, and perhaps by the same artist who illustrated the presentation copy of the moral/allegorical poem of

FIGURE 2 (*above*). Ptolemy. Guillaume de Tignonville, *Dits moraux des philosophes*, Boston, Public Library, Ms. f. Med. 91, fol. 52ᵛ (courtesy of the Trustees of the Boston Public Library/Rare Books).

FIGURE 3 (*below*). Pope Gregory and Galen. Guillaume de Tignonville, *Dits moraux des philosophes*, Boston, Public Library, Ms. f. Med. 91, fol. 60 (courtesy of the Trustees of the Boston Public Library/Rare Books).

FIGURE 4. The philosopher Tac. Guillaume de Tignonville, *Dits moraux des philosophes*, Cambridge, Harvard University, Houghton Library, Ms. Typ. 207, fol. 4, *c.* 1420 (Harvard University, Houghton Library).

FIGURE 5. Battle of Alexander at Serapion. Guillaume de Tignonville, *Dits moraux des philosophes*, Cambridge, Harvard University, Houghton Library, Ms. Typ. 207, fol. 18ᵛ (Harvard University, Houghton Library).

Honoré Bouvet, dedicated to Valentina Visconti, the Milanese spouse of Louis of Orléans, which is datable between 1398 and 1408.[30]

The Tignonville manuscript in the Houghton Library of Harvard University was acquired in 1954.[31] Earlier, during the nineteenth century, it was in several English collections, but nothing is known of its prior history. It is unfortunately a much damaged object, now consisting of twenty-eight parchment folios, with about a third or more of the original miniatures missing, along with an undetermined number of text pages. The manuscript is written in a single and rather wide column, and the spaces allotted to the illumination tend to be narrow and oblong, sometimes exceedingly so, which promotes compositions with multiple incidents laid out in a horizontal sequence rather than focused on a single, dominant condensation of the action. An example is the miniature which precedes the sayings attributed to one Tac (or Zac), the third of the authors anthologized in Tignonville's collection: the author, seated on the left, surrounded by a pair of attendants, addressing a group of figures at the right, dressed like himself in curiously exotic striped garments (Fig. 4). Another, similarly panoramic composition is the battle scene outside the walls of the city of Serapion, one of several illustrations inspired by the legendary history of Alexander the Great, which is featured at length in the work (Fig. 5).[32] But the encounter between Diogenes in his barrel and Alexander has a more solemn, static and less distracting air, being staged closer to the foreground and enlarged as if through the intervention of a zoom lens (Fig. 6).

30. Paris, Bibliothèque nationale de France, Ms. fr. 811, on which see the entry in the exhibition catalogue U. Baurmeister and M. Lafitte, *Des livres et des rois: La bibliothèque royale de Blois* (Paris, Bibliothèque nationale de France, 1993), 42–3 (no. 3).

31. Cambridge, Mass., Harvard University, Houghton Library, Ms. Typ 207. Vellum, 29 leaves, 305 × 225 mm. R. S. Wieck, *Late Medieval and Renaissance Illuminated Manuscripts, 1350–1525,*

in the Houghton Library (Cambridge, Mass., Harvard College Library, 1983), 14 (no. 6).

32. On Alexander illustrations in *Dits moraux* manuscripts, see D. J. A. Ross, *Alexander Historiatus: A Guide to Medieval Illustrated Alexander Literature* (London, Warburg Institute Surveys, 1, 1963), 6–7.

FIGURE 6. Diogenes and Alexander. Guillaume de Tignonville, *Dits moraux des philosophes*, Cambridge, Harvard University, Ms. Typ. 207, fol. 60 (Harvard University, Houghton Library).

FIGURE 7. Ezekiel, Socrates, and Cicero. Guillaume de Tignonville, *Dits moraux des philosophes*, New Haven, Yale University, Beinecke Library, Ms. 285, fol. 1, *c.* 1400–1410 (Beinecke Rare Book and Manuscript Library, Yale University).

The manuscript is currently attributed to the Master of the Harvard Hannibal (after his participation in the illustration of a copy of Livy's *Decades* at Harvard University), a *Notname* for a painter active in the capital around 1420, whose considerable oeuvre, showing connections with both the Limbourg and Boucicaut workshops, has been assembled by Millard Meiss.[33]

We may deal more rapidly with the *Dits moraux* copy in the Beinecke Library at Yale University, since it is a much less ambitious work, whose decoration is limited to the first page, with its prefatory miniature, foliate border, and ornate initial letter (Fig. 7).[34] But, in fact, such is the case of a fairly large number of copies, which invite the reader's attention to the matter at hand through a single image that is intended to speak not for itself, but as much as possible, for the contents of the work as a whole. The address of a speaker to an audience was the favored, if stereotyped, subject for this role, but it had many variations, like the ceremonious gathering composed of learned men and persons of lesser rank which lends a certain solemnity to the scene in the Houghton Library manuscript (Fig. 8). The Yale manuscript, which likely dates from the early years of the fifteenth century, features three standing figures, respectively identified by inscriptions on their scrolls as Ezekiel, Socrates, and Cicero (Fig. 7). Neither the first, nor the last of these men are mentioned among the sages whose writings are anthologized in the *Dits moraux*, and their congregation in a single image seems on first glance difficult to explain. But it seems to me likely that these representatives of Hebrew, Greek, and Roman learning were chosen collectively to embody ancient wisdom.

The Tignonville manuscripts in New York and Philadelphia, to which I turn next, belong to a substantially later period than the copies in Boston, Cambridge, and New Haven that have already been mentioned, and both have yet to be localized with any degree of

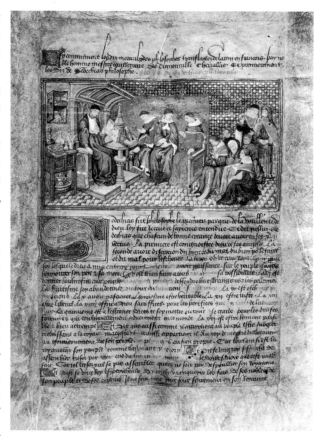

FIGURE 8. Sedechias addressing an audience (miniature retouched). Guillaume de Tignonville, *Dits moraux des philosophes*, Cambridge, Harvard University, Ms. Typ 207, fol. 1 (Harvard University, Houghton Library).

precision. The manuscript of the Philadelphia Free Library betrays an ambitious conception, but its execution is prosaic and rather lifeless.[35] Following the now familiar formula, each of the separate twenty-three sections is preceded by an author portrait—here, Socrates—a figure in a formulaic interior or standing in a landscape studded with bush-like clumps of trees and rocky formations, distant echoes of those found in Italian Trecento painting (Fig. 9). Although this seem rather unpromising territory in which to look for real

33. M. Meiss, *French Painting in the Time of Jean de Berry*, Part 3: *The Limbourgs and Their Contemporaries*, I, II (New York, 1974), 391. Meiss dates the manuscript *c.* 1418–1420.

34. New Haven, Yale University, Beinecke Rare Book and Manuscript Library, Ms. 285. Vellum, 80 fols., 294 × 210 mm. W. Cahn and J. Marrow, 'Medieval and Renaissance Manuscripts at Yale, A Selection,' *Yale University Library Gazette* 52, No. 4 (April 1978), 219–21 (no. 45). B. A. Shailor, *Catalogue of Medieval and*

Renaissance Manuscripts in the Beinecke Rare Book and Manuscript Library, Yale University (Binghamton, N.Y., 1987), II: 56–7.

35. Philadelphia, Free Library, Rare Book Department, Ms. Lewis E 209. Vellum, 128 fols., 278 × 200 mm, dated 1473 (fol. 58ᵛ). An inscription in a later hand probably datable in the 16th century and only partially legible refers to one 'Pierre de la Vacherye, sécretaire du Roy' (fol. 15), thus far not further identified.

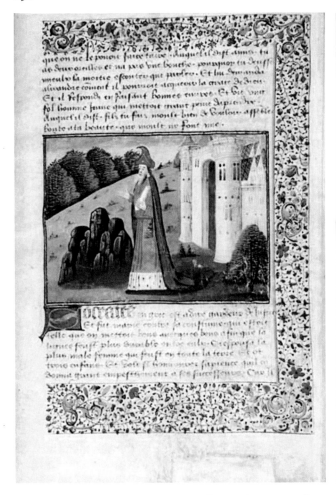

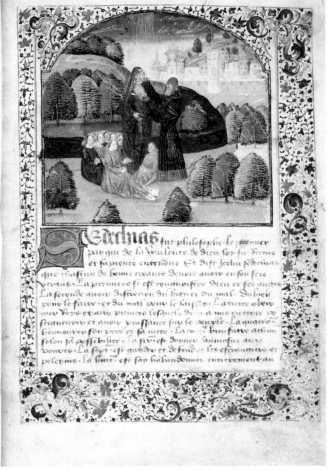

FIGURE 9. Socrates in a landscape. Guillaume de Tignonville, *Dits moraux des philosophes*, Philadelphia Free Library, Ms. Lewis E. 209, fol. 24, 1473 (Free Library of Philadelphia, Rare Books).

FIGURE 10. The philosopher Sedechias. Guillaume de Tignonville, *Dits moraux des philosophes*, Philadelphia Free Library, Ms. Lewis E. 209, fol. 11 (Free Library of Philadelphia, Rare Books).

originality, the painter gives the portraits of two of the sages an unusual allegorical inflection, for which there seems to be no warrant in the text. Sedechias is shown in the process, apparently, of unveiling a blue-robed woman, whom I take to be a personification of philosophy (Fig. 10), while Homer, clad in white, embraces a woman holding scales in one hand and the globe of the world in the other (Fig. 11). In the manuscript catalogue of the Free Library, the work's origin is given as Bourges, though without supporting evidence. It was completed, according to an inscription (fol. 58ᵛ), on the first of April 1473.

My fourth and last example, Ms. 771 of the Pierpont Morgan Library, differs in its decorative scheme from the manuscripts that have already been mentioned,

and indeed, is unparalleled within the entire corpus. Instead of single, isolated portraits, the sages are depicted in groups and interacting with each other. A large miniature at the head of the text shows them in a conclave presided over by a crowned personification, seated on an ornate dais within a palatial interior, and wielding a scroll inscribed 'Dame Philosophie en son Grand Conseil' (Fig. 12). The authors, some of them engaged in dialogue with their neighbors, are seated before her, six on the left and seven on the right. Three additional miniatures precede the wise sayings respectively of Socrates, Plato, and Aristotle, who, it would seem, have displaced Sedechias as the dominant spokesmen of ancient philosophy, which they have remained to this day. Socrates, who receives inspiration from an

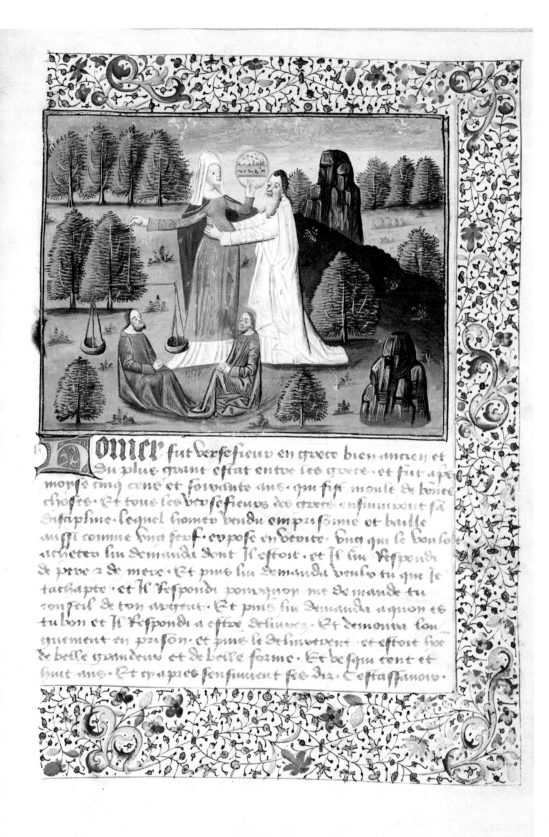

FIGURE 11. Homer. Guillaume de Tignonville, *Dits moraux des philosophes*, Philadelphia
Free Library, Ms. Lewis E. 209, fol. 1 (Free Library of Philadelphia, Rare Books).

angel, lectures to a group of men (Fig. 13), and Plato is similarly occupied (Fig. 14), while Aristotle addresses the seated Alexander, his star pupil, and three standing sages with their attributes, among which can be found Pope Gregory wearing the triple tiara and displaying his keys (Fig. 15). These scenes are staged in elaborate spaces framed by architectural props, through which can be glanced elements of landscape, and a varied staffage including bystanders, a one-legged beggar, and an attentive monkey. The manuscript is thought to have been written and illuminated around 1460. John Plummer in the exhibition catalogue *The Last Flowering* tentatively localized it in Central or southeastern France, though without great conviction, and its origin remains very much an open question.[36]

The conception of ancient wisdom exemplified by the *Dits moraux* incorporates, as we have seen, a marked orientalizing current, traceable in the first instance, of course, to its source in a compilation of Arabic origin. This strong identification of wisdom with the East—an amorphous East, admittedly, that stretched from the Mediterranean to India—has left other traces in the literature of the later Middle Ages, among which, notably, is the already-mentioned *Secret of Secrets*, translated from Arabic by Philip of Tripoli in 1272; the widely-diffused romance of Barlaam and Josaphat; the Indian fable collection Kalila and Dimna, whose French translation was presented to Philip le Bel in 1313; and the *Livre de Sidrac le philosophe*, an encyclopaedic dialogue thought to have been composed in Frankish territory of the eastern Mediterranean.[37] Tignonville's *Dits* had thus a good deal of company. Yet the popularity achieved by his parade of ancient worthies also owes much, I think, to the vogue of *uomini famosi* that developed in humanistic circles in the wake of Petrarch's *De viris illustribus* and the translations of Boccaccio's *De casibus virorum illustrium* and *De mulieribus claris*, much prized in northern Europe. Tignonville must have been familiar with this tradition, and it is from it, I would surmise, that he drew inspiration.

36. New York, Pierpont Morgan Library, Ms. M. 771. Vellum, 157 fols., 290 × 207 mm, (fols. 45ᵛ–154ᵛ). J. Plummer, *The Last Flowering: French Painting in Manuscripts, 1420–1530, from American Collections* (New York, Pierpont Morgan Library, 1982), 58–59 (no. 77).

37. C. H. Haskins, *The Renaissance of the Twelfth Century* (Cambridge, Mass., 1927), esp. ch. IX, 278–302. See A. Vernet in *Traductions et traducteurs au Moyen Âge* (as in note 3). A general treatment of this topic with special emphasis on English developments is found in D. Metlitzki, *The Matter of Araby in Medieval England* (New Haven, Conn., and London, 1977), esp. part II, 95ff., 'The Literary Heritage.'

Appendix

Manuscripts of Guillaume de Tignonville's
Dits moraux des philosophes

This inventory expands on and, in places, corrects, the lists given in R. Eder, 'Tignonvillana inedita,' *Romanische Forschungen* 33 (1915), 876–877; the online *Archives de littérature du Moyen Âge* (ARLIMA), at www.arlima.net, most recently updated on 28-01-2013; and *Répertoire des textes et des manuscrits médiévaux en langue d'oc et d'oïl* (IHRT/CNRS Jonas) at http://jonas.irht.cnrs.fr/, last updated on 24-08-2013. Omitted are several entries, whose present whereabouts I have not been able to trace, apparently referring to *Dits moraux* manuscripts found in sales catalogues, kindly brought to my attention by Prof. Lisa Fagin Davis.

1. Berlin, Staatsbibliothek Preussischer Kulturbesitz, Ms. Hamilton 46, fols. 34–112ᵛ.

2. Bern, Burgerbibliothek, Ms. 667.

3. Blois, Bibliothèque municipale, Ms. 33.

4. Boston, Boston Public Library, Ms. f.Med. 91 (ex Ms. 1518).

FIGURE 12. Frontispiece with Lady Philosophy. Guillaume de Tignonville, *Dits moraux des philosophes*, New York, Morgan Library, Ms. M. 771, fol. 45ᵛ, *c.* 1460 (New York, The Morgan Library and Museum).

FIGURE 13. Socrates addresses an audience of philosophers. Guillaume de Tignonville, *Dits moraux des philosophes*, New York, Morgan Library, Ms. M. 771, fol. 71 (New York, The Morgan Library and Museum).

FIGURE 14. Plato addresses an audience of philosophers. Guillaume de Tignonville, *Dits moraux des philosophes*, New York, Morgan Library, Ms. M. 771, fol. 87 (New York, The Morgan Library and Museum).

FIGURE 15. Aristotle addresses an audience of philosophers. Guillaume de Tignonville, *Dits moraux des philosophes*, New York, Morgan Library, Ms. M. 771, fol. 103 (New York, The Morgan Library and Museum).

5. Brussels, Bibliothèque royale de Belgique, Ms. 9545-46.

6. Brussels, Bibliothèque royale de Belgique, Ms. 10812-16, fols. 1–145ᵛ.

7. Brussels, Bibliothèque royale de Belgique, Ms. 10409.

8. Brussels, Bibliothèque royale de Belgique, Ms. 11071.

9. Brussels, Bibliothèque royale de Belgique, Ms. 11108.

10. Brussels, Bibliothèque royale de Belgique, Ms. 11109.

11. Brussels, Bibliothèque royale de Belgique, Ms. 11111-12, fols. 101ᵛ–156.

12. Brussels, Bibliothèque royale de Belgique, Ms. 11114.

13. Brussels, Bibliothèque royale de Belgique, Ms. 10394-414, fols. 307–391.

14. Cambridge, Mass., Harvard University, Houghton Library, Ms. Typ 207.

15. Chalon-sur-Saône, Bibliothèque municipale, Ms. 34.

16. Chantilly, Bibliothèque du Château, Ms. 287 (ex Ms. 839).

17. Foix, Bibliothèque municipale, Ms. 23.

18. Ghent, Universiteitsbibliotheek, Ms. 335 (ex Ms. 359).

19. Lille, Médiathèque municipale Jean Lévy, Ms. 315 [614].

20. Lille, Médiathèque municipale Jean Lévy, Ms. 316 (635), fols. 1–75.

21. Lille, Médiathèque municipale Jean Lévy, Ms. 322, fols. 43–227.

22. London, British Library, Royal Ms. 16.F.X.

23. London, British Library, Royal Ms. 19 A.VIII.

24. London, British Library, Royal Ms. 19 B.IV, fols. 1–74.

25. London, Lambeth Palace Library, Ms. 456, fols. 143–189.

26. Lyon, Bibliothèque municipale, Palais de arts, Ms. 949 [ex. Ms. 852], fols. 26–88.

27. Manchester, John Rylands Library, French Ms. 65, fols. 1–89ᵛ.

28. Modena, Biblioteca Estense universitaria, Ms. Est 24 (*olim* XI.B.15) fols. 45–155.

29. Munich, Bayerische Staatsbibliothek, Ms. 395 (Cod. gallici 59).

30. New Haven, Yale University, Beinecke Rare Book and Manuscript Library, Ms. 285.

31. New York, Morgan Library, Ms. M.10.

32. New York, Morgan Library, Ms. M.771, fols. 45ᵛ–154ᵛ.

33. Nogent-sur-Marne, Fondation Smith-Lesouëf, Ms. 73, fols. 71–182.

34. Oxford, Bodleian Library, Rawlinson Ms. D.537, fols. 1–66.

35. Paris, Bibliothèque de l'Institut de France, Ms. 312 Réserve, fols. 352–365.

36. Paris, Bibliothèque nationale de France, Arsenal Ms. 2311, fols. 1–86.

37. Paris, Bibliothèque nationale de France, Arsenal Ms. 2312, fols. 1–126.

38. Paris, Bibliothèque nationale de France, fr. 572, fols. 1–76ᵛ.

39. Paris, Bibliothèque nationale de France, fr. 812, fols. 226ᵛ–320ᵛ.

40. Paris, Bibliothèque nationale de France, fr. 1105, fols. 1–77.

41. Paris, Bibliothèque nationale de France, fr. 1106.

42. Paris, Bibliothèque nationale de France. fr. 1107, fols. 1–106ᵛ.

43. Paris, Bibliothèque nationale de France, fr. 1164, fols. 1–22.

44. Paris, Bibliothèque nationale de France, fr. 1694.

45. Paris, Bibliothèque nationale de France, fr. 5328, fols. 190–231ᵛ.

46. Paris, Bibliothèque nationale de France, fr. 12440, fols. 1–95.

47. Paris, Bibliothèque nationale de France, fr. 19039, fols. 1–199.

48. Paris, Bibliothèque nationale de France, fr. 19123, fols. 1–88.

49. Paris, Bibliothèque nationale de France, fr. 19124, fols. 1–78.

50. Paris, Bibliothèque nationale de France, fr. 24296.

51. Paris, Bibliothèque nationale de France, fr. 24297.

52. Paris, Bibliothèque nationale de France, nouv. acq. fr. 1119, fols. 1–8 (incomplete).

53. Paris, Bibliothèque nationale de France, nouv. acq. fr. 1157, fols. 132–220ᵛ.

54. Paris, Bibliothèque nationale de France, nouv. acq. fr. 6458, fols. 95–106 (incomplete).

55. Paris, Bibliothèque nationale de France, nouv. acq. fr. 10404.

56. Paris, Bibliothèque nationale de France, nouv. acq. fr. 10641, fols 1–60ᵛ.

57. Paris, Bibliothèque nationale de France, nouv. acq. fr. 10059, fols. 16–63ᵛ.

58. Philadelphia, University of Pennsylvania, Annenberg Rare Book and Manuscript Library, Cod. 941.

59. Philadelphia, Free Library, Rare Book Department, Ms. Lewis E 209.

60. Poitiers, Bibliothèque municipale, Ms. 250 (179), fols. 100ᵛ–113 (extracts).

61. Reims, Bibliothèque municipale, Ms. 887 (incomplete).

62. Saint Petersburg, National Library of Russia, Ms. FR.Q.V.III.4.

63. Toulouse, Bibliothèque municipale, Ms. 874.

64. Tours, Bibliothèque municipale, Ms. 757, fols. 2–140ᵛ.

65. Tours, Bibliothèque municipale, Ms. 758 (destroyed by fire in 1940).

66. Turin, Biblioteca nazionale universitaria, Ms. L.III.6.

67. Turin, Biblioteca nazionale universitaria, Ms. L.IV.21.

68. Valencia, Biblioteca universitaria, Ms. 748.

Present location unknown

69. Amsterdam, Bibliotheca Philosophica Hermetica, Ms. 203. Recently sold, present owner unknown.

70. E. König and H. Tenschert, eds., *Leuchtendes Mittelalter I. Libri manu scripti illuminati vom 10 bis zum 16 Jahrhundert*, Katalog XXI (Rotthalmünster, 1989), 104–105, fols. 32–44 (No. 19).

71. A. Labitte, *Catalogue des manuscrits précieux des XIIIᵉ, XVᵉ et XVIᵉ siècle sur vélin et ornés de miniatures…*, Paris, Hotel Drouot, Tuesday, 18 March 1879, No. 18. Stems from the library of Anne de Polignac (*c.* 1495–1554) at Verteuil in Angoumois. Purchased by Bachelin; Dr. Bourevoy (1895); Horace de Landau (1824–1903) and Mme. Finaly, his niece.

RICHARD & MARY ROUSE

Will Power: Manuscripts in Medieval Testaments

SCHOLARS prefer to study medieval manuscripts through a detailed examination of the surviving books themselves, and for good reason.[1] We are all keenly aware, however, that what survives is just a fraction of what once existed. For that reason, medievalists study in addition the documentary records, such as medieval library catalogues, post-mortem inventories of book-owners, sales of their effects, and accounts of payments to book-makers, to help fill the great gaps in our knowledge left by the manuscripts that have perished. We want here to consider one such category of documents, the last wills and testaments of the wealthy—nobles, members of the royal family, rich prelates. We shall examine three examples, each of which tells us something different and distinctive about books in the time when these wills were written. In each case the will's implications are broader than merely the mention of a named book or two.

I.

The first testament we consider, in many ways the most interesting, is also the earliest. This is the will of Guala Bicchieri. To historians of medieval England and to students of Old English literature his name may well be familiar. To the rest of us, probably not. Guala was born in the second half of the twelfth century, perhaps around 1170, to a prominent North Italian family in Vercelli, near the Piedmont/Savoy border not far from Turin. Of his schooling as a young man we have no contemporary documentation, but there are clear indicators from his later life. His successful employment by the papacy as a judge, his command of canon law, even his later demonstrable friendship with Buoncampagno (*c.* 1170–after 1240), all point to

legal training in Bologna. Other signs point to subsequent studies in the Parisian schools, presumably in the later 1180s. As an example, Pope Innocent III was known even among his contemporaries for the unusually heavy concentration of Romans in his college of cardinals, causing one to suppose that his exceptional reliance on the North Italian Guala denotes an early and close connection; the most likely explanation is that they were fellow students in the schools of Paris, along with a number of other young Italian expatriates of the same social class.

Guala as a young cleric was a canon of the cathedral church of Sant' Eusebio in his home city of Vercelli, around the turn of the century. In January 1205 Innocent III named him cardinal deacon of Santa Maria in Portico; within five years he was elevated (1210 or '11) to become cardinal priest of San Martino ai Monti (S. Martinus in Montibus).

As a cardinal, Guala fit perfectly into Innocent III's program of increasing the political power of the Church, serving the papacy repeatedly and almost continually as diplomat, negotiator, judge, and legate, one of the most important papal trouble-shooters across Western Europe, from Jerusalem in the East and Sicily in the South to Scotland in the Northwest. Many of his legations dealt with specific problems, settling particular issues between contending or even warring opponents. In France in 1208–1209, however, he was a legate *a latere*, meaning that, in theory, he exercised broadly the full authority of the pope. The results of this French legation were mixed. Guala intervened widely, and mostly for the good it seems, in ecclesiastical affairs in France; among other reforms he attempted via synodal statutes and other legislation to reduce concubinage among the priesthood, to insist

1. A shorter version of this article was presented on 26 October 2013 at the conference *Manuscripta Illuminata* held at Princeton University under the auspices of the Index of Christian Art. We are grateful to the participants for questions and suggestions that have improved the work. Remaining errors and infelicities are our own special contribution. We thank Brett Landenberger for his generous and capable technical assistance in the production of the genealogical diagrams.

that canons be in residence, even on one occasion conferring the pallium on a newly elected archbishop. But Guala's preaching of a Fifth Crusade among the French, one of Innocent III's strongest hopes, produced no practical results. And inevitably Guala was dragged into the quagmire of quarrels and litigation and threats and counterthreats between the papacy and the French crown over Philip Augustus's insistence, beginning in 1193, that he be allowed to repudiate his wife Ingeborg of Denmark or to have this union annulled by the pope, versus the insistence of the pope (Celestine III and then, from 1198, Innocent III) that Philip restore her to her rights as queen. Guala could satisfy neither party. (The matter was later settled with a pro-forma reconciliation in 1213.) During his time in France, however, Guala renewed important old ties from his student days and made new ones, reinforcing especially his relations with the Augustinian house of Saint-Victor and one of its most famous masters of the time, Thomas Gallus (Thomas of Saint-Victor).

Guala's most significant legation, on behalf of Innocent and then of Innocent's successor, took him to England, 1216–1218. His arrival at the end of April 1216 found King John at odds and eventually at war with his barons, in the months after the signing of the Magna Carta, and he faced invasion by Prince Louis of France as claimant to the English throne with baronial support. As part of the resolution of John's earlier long dispute with the papacy, John in 1213 had given England to the pope, to receive it back as a fief—one of Innocent III's major forays into civil governance (though its practical import was minor). Guala, once again a legate *a latere*, therefore used his unlimited papal authority in support of the pope's vassal, John. Innocent died in July, only three months after Guala took up his legation. However, as putative overlord of Britain, the next pope, Honorius III, had no option but to continue his predecessor's policy. Guala's power as legate was magnified by John's weakened political and military situation with the invasion in June by Prince Louis of France; and then Guala's influence was further increased in October 1216, when King John unexpectedly died, leaving his nine-year-old heir Henry III to be a ward of the papacy—which is to say, a ward of the legate. Guala did not himself act as regent for the boy-king; but he was instrumen-

tal in the naming of William Marshal as regent, and in engineering Henry's hasty coronation only some ten days after his father's death. When Prince Louis of France signed the Treaty of Lambeth ten months later, in September 1217, resigning his claim to the English throne as the candidate of the rebel barons, Guala was by no means the only factor in Louis's decision, but his influence was not negligible; he had used all the tools of diplomacy on both sides of the Channel to bring about this conclusion.

Guala's principal legatine actions, however, were directed aggressively at the English clergy, changing the composition of the English church for years to come. Those prelates who had conducted services and administered the sacraments while the island was under papal interdict were dismissed and punished, despoiled of their benefices; those suspected or known to have backed the rebels against legatine orders, or to have supported the invasion of England by the excommunicated Prince Louis of France, Guala summarily removed from their offices or pulpits, replacing them with his own nominees. A great many of these nominees were Italian, and no small number were members of his own *familia*, his entourage. It is assumed, and in some cases documented, that prelates under suspicion of treason were eager to gain the legate's favor with lavish gifts and hospitality, matters that we would consider bribes but which at the time were fairly routine. Outraged English chroniclers, however, insisted that Guala carried the practice to extremes seldom seen; and it is clear that when the legate left England he was a much wealthier man than he had been upon arrival.

On his return to Rome in 1219 the cardinal continued to serve the papacy, particularly as diplomat and settler of disputes. His last recorded appearance at the Roman curia was as witness to a papal document dated 9 May 1226, late in the reign of Honorius III. We know that Guala lived on into the beginning of the papacy of Gregory IX (19 March 1227), for it was from Gregory that he received papal permission to make a will, the *licentia testandi*, on 29 May 1227. His will, dictated from his sickbed in San Martino ai Monti at Rome, bears that same date, with a brief codicil added 31 May 1227, the day of his death.

Even before his legation to England, Guala had begun by 1213 to amass property in and around Ver-

celli for a projected religious foundation.[2] Before Guala left Italy for England, the bishop of Vercelli had ceded to the cardinal the local parish church of Sant' Andrea with permission to introduce regular canons there, a first step toward Guala's planned foundation of a house of Augustinians. In November 1217 (the timing suggests that it was in recognition of Guala's role in the peace settlement with Prince Louis), King Henry III of England granted the income from the church of Saint Andrew in Chesterton (Cambridgeshire) as support for the legate's Italian foundation with the same dedication.[3] (Historians usually refer to this as a gift from 'the young king of England': Henry was not merely 'young,' he was a ten-year-old child, and the gift came through the regents whom Guala had been instrumental in appointing.) On Guala's return to Italy in 1219 he brought with him four Augustinians from Paris to form the nucleus of the community of the new Sant' Andrea that he was building at Vercelli (ground was broken that same year, 1219); among the four Victorines was Thomas Gallus, named as first abbot of Guala's foundation. Guala had been deeply impressed with the Augustinian house of Saint-Victor in Paris; and he had known Thomas Gallus doubtless since his time as a student at Paris in the 1180s, an association renewed with his legation to France in 1208–1209. Thomas, ex officio as abbot of Sant' Andrea, was named one of the three executors of Guala's will, along with Giacomo de Carnario, papal subdeacon and provost of Guala's home church the cathedral of Vercelli, and Stefano da Fossanova, cardinal priest of the basilica of the Twelve Apostles.

Guala's will in 1227 made provision for prayers in more than four dozen churches and religious houses and hospitals and leproseries for the good of his soul (and the souls of his kinsmen, and the souls of all the faithful departed), and suitable gifts were left to the poor and the ill. But aside from these specific bequests, he named his foundation of Sant' Andrea of Vercelli as the sole heir of all his goods, real and personal: *In primis, Dominum et Redemptorem meum Iesum Christum et ecclesiam Beati Andree Vercellensis omnium bonorum meorum mobilium et immobilium ubicumque fuerint heredes instituo* (First, I designate my Lord and Redeemer Jesus Christ and the church of Sant' Andrea of Vercelli the heirs of all my goods, real and personal, wherever they may be).[4] During his lifetime, Guala had already given to his foundation in 1224 a gift of some thirty books—fifteen books of scripture or biblical commentaries and ten liturgical books (Missals, Graduals, Antiphonals, Ordinals, collections of collects), along with a smattering of patristics—to serve as the cornerstone of a collection.[5] It was his will in 1227, however, that truly established the library of Sant' Andrea, with its simple but sweeping bequest.

The itemized list of Guala's ninety-eight books does not appear in his will, but it was created in the execution of this opening provision.[6] The booklist is in effect a detailed quittance from an heir to an executor, with which the Augustinians of Sant' Andrea of Vercelli formally acknowledged to one of the executors, Giacomo de Carnario, receipt of the books that constituted a sizable part of Guala's personal possessions. Thomas Gallus, acting here not as Guala's executor but as abbot and representative of Sant' Andrea, gave this quittance on the abbey's behalf: 'Let all men who

2. For the stages in the growth of the foundation and the constant stream of donations conferred upon it by Guala and his friends, see the useful 'Cronologia' of M. Cassetti in his *L'Abbazia e l'ospedale di S. Andrea di Vercelli nel secolo XIII: Mostro documentaria* (Vercelli, 1982), 91–8.

3. We do not know any reason for Guala to manifest a special devotion to St. Andrew. Perhaps it was nothing more than the accident of the pre-existing dedication of the Vercellese parish church that formed the seed of his new abbey.

4. For the will, see A. Paravicini Bagliani, 'I testamenti dei cardinali del duecento,' *Miscellanea della Società romana di storia patria* 25 (Rome, 1980), 4–7 (documentation) and 110–20 (text of the will and codicil); for the quoted passage, 110.

5. The list is printed by C. Segre Montel, *I manoscritti miniati*

della Biblioteca nazionale di Torino I: *I manoscritti latini dal VII all metà del XIII secolo* (Turin, 1980), 168–69, and see 166; and cf. G. Tibaldeschi, 'La biblioteca di S. Andrea di Vercelli nel 1467,' *Bollettino storico vercellese: Società storica vercellese* 17 (1988), 61–106 at 65 and n. 43.

6. The booklist is printed and discussed by A. Hessel and W. Bulst, 'Kardinal Guala Bichieri und seine Bibliothek,' *Historische Vierteljahrschrift* 27 (1932), 772–94 at 781–84. They reproduce, with editorial numbering and with modernized capitalization and punctuation, the 18th-century transcription of a no-longer-extant original printed (under a pseudonym) by G. A. Frova, *Gualae Bicherii presbyteri cardinalis S. Martini in montibus Vita et Gesta collecta a Philadelfo Libico* (Milan, 1767), 174–78 note (p).

may see this document know that Master Giacomo de Carnario, subdeacon of the lord pope and provost of Sant' Eusebio of Vercelli, transferred to me, Thomas, abbot of Sant' Andrea of Vercelli, and to its chapter, the items recorded below given by the testament of the blessed lord Guala, sometime cardinal priest of San Martino and founder of our church, after the cardinal's death,' and the booklist follows.[7]

Although this preamble was written by Thomas, one does not know whether the list was drafted by Thomas Gallus or by Guala himself. We strongly suspect it was Guala, mostly on the basis of the seeming one-by-one additions stuck on the end of an otherwise sensibly organized list; but that is speculation. Whoever its compiler, the list records one of the larger private libraries known from the early thirteenth century.

Before we consider the list as a whole, we should like to clear the decks by taking up and, regretfully, dispensing with its most controversial item, no. 43 in the edition, *Omeliarium de capella domini cardinalis de bona littera Anglicana* (a Homiliary from the lord cardinal's chapel, in good English script). Scholars in the past have tried, understandably and with some wishful thinking, to connect this entry with the famous English manuscript known simply as the Vercelli Book, which is one of only four surviving collections of Anglo-Saxon verse. A tenth-century codex, now Ms. CXVII in the Chapter Library of Vercelli, this manuscript contains twenty-three homilies and six pieces of verse, all in Anglo-Saxon. The Vercelli Book is the type of impressive volume that an English prelate with an uneasy conscience might well have given to Cardinal Guala, the powerful papal legate who was bent on reforming the English Church early in the reign of Henry III. To be sure, Guala would not have read Anglo-Saxon; but the object itself, though not lovely to look at, was an imposing gift that could have been portrayed to Guala as a monument of the early Chris-

tianization of England. The fact that the first piece of alliterative verse is *Andreas* would have been characterized as a graceful allusion to the cardinal's new foundation in his home city of Vercelli. And after all, if the Vercelli Book did not come from England via Guala Bicchieri, what possible reason explains the presence of this Anglo-Saxon compendium in North Italy?

That question has never been adequately answered; but as others have noted, there are serious obstacles to the identification. For one thing, a minor matter but worth consideration, all known surviving manuscripts from Sant'Andrea are now in Turin, in the Biblioteca nazionale universitaria. Moreover, there survives in the Biblioteca nazionale a manuscript of Latin homilies, D.I.22, dating from the late twelfth or early thirteenth century, bearing the Sant' Andrea anathema, clearly written and decorated in England. Costanza Segre Montel, the Italian scholar who has most thoroughly studied the Turin manuscripts and the other surviving collections from libraries of the suppressed monasteries of the Piedmont/Savoy, states that this manuscript 'without a doubt' is to be identified with no. 43 on the list of Guala's books. One might quibble with that pronouncement, because among the books that Guala gave to Sant' Andrea in 1224 yet another presumably English Homiliary is recorded,[8] also a candidate for identification with Turin D.I.22.

A more serious obstacle to identifying the Vercelli Book with no. 43 in Guala's booklist is the fact that a hand, of the late eleventh century or early twelfth, has written on folio 24[v] a Latin verse from the Breviary; the hand has been judged as probably Italian, while the verse itself is 'distinctively North Italian,'[9] for it displays a telltale textual omission reported nowhere else. This note would seem to place the Vercelli Book already in Vercelli, by the early twelfth century at latest. For the sake of argument one might suppose that it is just as likely for a North Italian to travel to

7. 'Notum sit omnibus presentes litteras inspecturis quod magister Iacobus de Carnario d. pape subdiaconus et prepositus s. Eusebii Vercellensis hec que subscripta sunt consignavit mihi Thome abbati s. Andree Vercellensis et eiusdem loci capitulo de testamento b.m.d. Guale tituli s. Martini quondam presbiteri cardinalis et ecclesie nostre fundatoris, post decessum eiusdem cardinalis'; *ibid.* 781.

8. The origin of none of the books is stated, but several of

the books in that gift were certainly English: Peter of Riga's *Aurora* and a rare work, Richardus Pratellensis on Ecclesiasticus, survive and are visibly English in origin; and although Guala's manuscript of Bede's *Historia Anglicana* no longer survives, that one also must have come from England.

9. C. Sisam, ed., *The Vercelli Book*, Early English Manuscripts in Facsimile 19 (Copenhagen, 1976), 44.

England for unknown reasons, as for an English book to be brought for unknown reasons to North Italy. A North Italian who was copying a verse from his home-diocese Breviary? Conceivable, but the evidence is already stretched to a dangerous point.

Was Guala Bicchieri responsible, then, for bringing the Vercelli Book to Vercelli, and did he bequeath it to his Augustinian house? The remaining obstacle to this interpretation, added to those already adduced, we find insuperable. It lies in the circumstantial language of the will's booklist: 'a homiliary from the lord cardinal's chapel.' The only other books explicitly recorded as being in his chapel are a Bible (specifically said to be the one he used in his chapel), a collection of the sermons of Saint Leo the Great, and an Epistolary; these are all books for liturgical use.[10] Guala could have used a Latin Homiliary for liturgical purposes in his chapel as well. But he would not, could not, make use of an Anglo-Saxon Homiliary in this respect. No. 43 in the booklist was not the Vercelli Book.

Guala's books on the booklist are organized by category—to such an extent, indeed, that the twentieth-century editors inserted roman numerals dividing the list into five supposed sections. But though the numbers are modern and editorial, the arrangement itself dates from 1227, the product of an orderly and ordering mind. The first twenty-six items named are biblical, beginning with five whole Bibles and continuing with volumes containing parts of the scripture, arranged in the sequence that, by the time of Guala's death, was fast becoming standard.[11] Seven of these manuscripts contain glossed scriptures: Genesis and Exodus together, Kings, the Psalter, Isaiah, and three sections of the New Testament.[12] The next category,[13] fourteen titles, are books of law and statutes, divided evenly seven and seven between canon and civil law.

There are two minuscule groupings consisting of two twelfth-century theological compendia from the Paris schools—Peter Comestor's *Historia scolastica* and the *Sentences* of Peter Lombard—and three books that the cardinal kept, and used, in his chapel.[14] They are followed in the list by a group of four liturgical texts: an Antiphonal, a Missal, a Breviary, and a Martyrology;[15] in addition to their similar contents, these four are related by the fact that each, at the time of Guala's death, was not in his library but in the hands of one of his friends or acquaintances. The Breviary, it is said, had been left in the possession of Bartholomeus of Santa Cecilia and Johannes Barunes of Rome expressly for the purpose of selling it,[16] with the proceeds doubtless to go to Sant' Andrea; one wonders if the other three were meant for the same purpose. Presumably, the liturgical use of the Augustinian house did not correspond with that of the Roman cardinal.

The next group, the largest category, consists of twenty-seven volumes of patristic texts.[17] The first eleven of these, unsurprisingly, are works or collections of works by Augustine, as befit a house of Augustinians. The other patristic codices contain works of Gregory the Great, Gregory of Nazianzus, Ambrose, Jerome, Origen, and Bede's commentary on the Book of Acts. The twenty-two miscellaneous titles at the end of the list clearly represent afterthoughts or late discoveries: collections of letters (patristic, episcopal, papal), sermon collections (scholastic or anonymous), homilies, canon law, exegesis, and some glossed scripture (Acts and Pauline epistles, together). The final entry emphasizes this hodge-podge quality: 'And various other books of the doctors and philosophers,' works obviously not worth an itemized record.[18]

As we have said, the booklist records an impressive personal library. More impressive still is the manner

10. Nos. 44 and 45, and the Bible, no. 4, listed among the Bibles at the head of the list.

11. S. Castronovo, 'Il tesoro di Guala Bicchieri cardinale di Vercelli,' in *Gotico in Piemonte*, ed. G. Romano (Turin, 1992), 165–239 and pls., has color plates (tavole 50–54) of one of Guala's Bibles.

12. Nos. 12, 14, 16, 22, 24, 25.

13. Nos. 27–40.

14. Nos. 41–42 and 43–45, respectively.

15. Nos. 46–49.

16. No. 48: 'Breviarium noctivum totius anni remansit penes d. Bartholomeum de s. Cecilia et d. Johannem Barunem Rome ut venderent.'

17. Nos. 50–76.

18. No. 99: 'Et alii libri varii doctorum et philosophorum.' This in turn is followed by a brief summary of the coins and real property left to the house. Castronovo 'Tesoro' (as in note 10) describes Guala's gifts, including architectural details of Sant'Andrea, as well as post-Guala treasures from the abbey.

in which the books are described. For nearly a third of the titles, thirty-one of the ninety-eight, the list remarks on the script in which the text is written, in a fashion probably unique for this date. Here is the sort of thing we mean: 'A Bible in Bolognese script, covered in red leather. A Bible in English script, which the cardinal used in his chapel. A small, very precious Bible in Parisian script, with letters of gold and with purple ornamentation. A glossed Genesis and Exodus in one volume, written in good Parisian script. Exodus, Leviticus, Numbers, and Deuteronomy, each in a separate volume written in ancient script' (i.e., pre-Gothic script).[19] And so on. Every one of the twenty-six biblical codices, and another five volumes from other parts of the list, have their script described in some fashion. Usually the description betokens the book's place of origin, though some of the scripts are described in terms of quality (*bona littera* or *optima littera*), and in two cases the list remarks on the script's age—*de littera antiqua*.[20]

These unexpected descriptions of script have two implications. To begin with, they reveal that the compiler who made the list, either Guala or Thomas, was capable of distinguishing one script from another: not simply to judge its quality, that one script was good, another the very best, another 'ancient' (meaning earlier than the style current in 1227); but, more impressive, the compiler was able to classify a script by its origin, as Bolognese (there are two of those), as English (two again), as coming from Lombardy or from the Arezzo (one each), or especially as Parisian—no fewer than sixteen[21] are characterized as being written 'in Parisian script' or 'good Parisian script' or even 'the very best Parisian script.'[22] But obviously, the other implication of such descriptions is the assumption that these classifications of script would have meaning for those who read the list—would enable them to identify which volume was intended.

Recognition by those who read the descriptions was, of course, the point—the only point—of character-

izing the script. Lists like this, an inventory of books received from Guala's estate, take care to describe items in a manner that makes them recognizable; it is for that reason that the codices of patristic works, for example, are described as fully as possible with author and contents: 'Augustine, *Contra Donatistas*, with nine other works of his, in one volume'; 'Augustine, *De conflictu viciorum* and *De duodecim abusionibus*, in one volume to which is prefixed Isidore's *De summo bono*,' and so on.[23] This method of identification, however, is not applicable to biblical manuscripts, where author and contents are not distinctive. Therefore, for all the complete Bibles, the list's compiler added a description of its binding and any conspicuous decoration, and for these and all the other scriptural manuscripts (historical books, or gospels, or Pauline epistles, or the like) he added a description of the script, to confirm the book's identity.[24]

Because of the careful descriptions, a few of the manuscripts in Guala's bequest have been identified among books that survive today. The Vercelli abbey, like all of Italy's houses, was suppressed in the revolutionary wars at the end of the eighteenth century and beginning of the nineteenth, a period of depredation as well as consolidation. But well before then, the collection left by Guala had been seriously altered over the years. There were additional gifts to Sant'Andrea, especially in the course of the thirteenth century—a good thing for the abbey, to be sure, but they add an element of uncertainty to the identification of the original gift. And there were losses from numerous causes: In the late fifteenth century, the Victorine canons were ousted and replaced by the order of Lateran canons in 1467, not an amicable transition; and then and later, manuscripts were discarded as they were replaced by printed books. In the sixteenth century especially, warring armies swept back and forth through northern Italy as the French contested the control of the Duchy of Milan and its hinterland.

19. Nos. 3–10.

20. Nos. 7–10 (a single description) and 61.

21. There are other books almost certainly from Paris that we have not counted; see nos. 41–42, Peter Comestor's *Historia scholastica* and the Lombard's *Sentences*.

22. No. 24, 'de littera optima Parisiensi.'

23. Nos. 51 and 54, respectively.

24. Presumably, recognition of the book's origin took into account (perhaps not consciously) the totality of the appearance of the page and of the codex, not the script in isolation. We thank Elizabeth Sears for this suggestion.

All of Guala's manuscripts that are known to survive are found, as we have said, in Turin's Biblioteca nazionale universitaria. In the later Middle Ages Vercelli had been annexed by the Duchy of Savoy, and it remained (with brief interruptions) under Savoyard rule up to the suppression of the monasteries at the end of the eighteenth century and beyond. The University of Turin was a foundation of the House of Savoy in their principal city, Turin. It is no surprise that, when the duchy's monasteries were suppressed in the Napoleonic period, their books gravitated to the university library. Among the university's books today there are perhaps twenty-two[25] that previously belonged to Sant' Andrea of Vercelli; they include two of the books (mentioned above) that Guala gave to the abbey in his lifetime, in 1224: a biblical commentary of Richardus Pratellensis (no. 12) and the 'versified Bible' (the *Aurora*) of Peter of Riga.[26] Of the other twenty, six can be identified in the list from Guala's bequest of 1227, with perhaps a seventh. We give them the numerals assigned by the list's editors:[27]

> No. 5, the small, very precious Paris Bible decorated with gold and purple, would be a marvelous find. It is possibly Turin, Bibl. naz., E.VI.1, which has a Vercelli ex libris; but the ex libris note is late, and one has to explain away an obliterated fourteenth-century ex libris from a Cistercian house near Spire, visible with ultraviolet light.[28]
>
> No. 53, a collection of Augustine's works, is probably Turin I.V.5.
>
> No. 67, a collection of Ambrose's works with the *De virginitate*, is probably Turin I.V.7, a manuscript of English origin.
>
> No. 68, Ambrose *Super Lucam*, was probably Turin I.V.30, burnt in 1904.
>
> No. 80, Epistles of Arnulf of Lisieux, is Turin D.IV.32, of English origin.
>
> Nos. 86 and 88, anonymous sermons and sermons of Peter Comestor, are now composite as Turin E.V.26.

The wording of the booklist that belongs to Guala's will obliges us to surrender the possibility that the cardinal was responsible for the presence of the Vercelli Book in Italy. This same careful and circumstantial wording, however, permits the identification in the twenty-first century of six or seven other books that Guala da Bicchieri gave to his abbey, some eight hundred years ago.

II.

The second testament we consider is that of Gérard de Montaigu, a century later than Guala's. Gérard was an ecclesiastic and a highly successful lawyer.[29] He came to Paris from the diocese of Laon early in the fourteenth century, under the patronage of Guy de Laon, head of the chapter of the Sainte-Chapelle in Paris, and he obviously prospered. In the course of the 1320s and '30s, payments and receipts and gifts reveal that Gérard served a stellar collection of patrons with his legal talents, to many of whom he was on retainer: Cardinal Pierre Roger who became Pope Clement VI, Countess Mahaut of Artois (peer of France and mother of Philip V's queen), Clémence of Hungary the widow of King Louis X, Queen Jeanne de Navarre and her husband Philippe d'Évreux, the count of Blois, the duke of Burgundy, the duke of Brittany, and the reigning queen of France Jeanne de Bourgogne. And in 1332, he was named *avocat du roi en parlement* (one of only two such) by King Philip VI. His ecclesiastical benefices had increased in step with his standing as a lawyer, and he held canonries (in absentia) at Chartres, Reims, Châlons, and ultimately Notre-Dame of Paris, the most lucrative prebend in France. Gérard died a very wealthy man, sometime in the week from 30 November to 6 December, 1339.

Gérard's will bequeaths twenty-one volumes individually[30]—to his chaplain, to a friend who was also an executor, to the Collège de Laon, to his three nephews: Simon de Montaigu, a Celestine monk; Jean de

25. See Tibaldeschi (as in note 5), 92–93 n. 55; this tally includes 3 burned in the 1904 fire of the Turin library but sufficiently described to make identification probable or definite.

26. Segre Montel (as in note 5), 169 and nn. 574–75.

27. The identifications are those of Segre Montel, 168–71 and notes.

28. Its ex libris is in a 15th-century humanist script, and a 14th-century ex libris of the Cistercians of Maulbronn is visible under ultraviolet light.

29. Concerning Gérard, see R. and M. Rouse, *Manuscripts and Their Makers: Commercial Book Producers in Medieval Paris, 1200–1500*, 2 vols. (London, 2000), 1: 217–25, 232–33, and notes.

30. Archives nationales de France (hereafter AN), M 141 no. 2; booklist edited, Rouse and Rouse (as in note 29), 2: 192–93.

Montaigu alias Jean le Rouge, an established lawyer; and Gerardino, his youngest nephew, a budding lawyer; and also to a great-nephew Jean, son of his niece—a boy so young that the gift was made contingent upon his remaining alive for a year from the date of Gérard's death. A look at the list of these books, however, is rather disappointing. Gérard left liturgical books to his chaplain, left his own Bible to his friend and executor, and gave a complete four-volume set of Vincent of Beauvais's *Speculum historiale* to the Collège de Laon. An excellent accumulation of law books Roman and canon were divided evenly between his lawyer-nephews Jean le Rouge and Gerardino; a Psalter, book of meditations, and mediocre copies of canon law went to his monk-nephew Simon; and optimistically he left a collection of five law-books to his great-nephew, the baby Jean.

All told, pretty much what one would expect, as bequests from a working lawyer primarily to his lawyer-descendants. The particular aspect of Gérard's will that makes it worth our notice is the fact that, less than a week from the date of the will's last codicil, there was a post-mortem inventory of Gérard's estate that enumerated even more books.[31] Two documents, created almost simultaneously, encourage comparison. A few of the inventory's books are duplicates from the will, books that the executors have not yet taken possession of for distribution to the legatees. But when one discounts those, there remain twenty-one manuscripts in the inventory that Gérard did not bequeath. These, like all remaining items of his personal property, were to be sold, and the proceeds divided among four different charities: the poor of his hometown of Montaigu, poor householders of Paris, poor scholars at Paris, and the Parisian Hôtel-Dieu.[32] In effect, the books were to be left to the vagaries of the marketplace. So what can we say about them, in comparison to the books in the will?

From the time Gérard began to dictate his will, on August second of 1339, nearly four full months passed until he dictated the last codicil on November thirti-

eth. Thus, one cannot assume that these 'orphan' manuscripts were omitted from his will because he died before he had time to remember them. The impression is that Gérard did not find these books worth singling out. Why did he relegate them to the second tier? In many cases the answer is self-evident: they are physically of little value, incomplete, without covers. 'Part of a book of saints' legends, without boards, containing the Life of Saint Louis'; 'some students' notes on canon law, without boards'; or what the assessors who made the inventory called simply 'other small quires.' The inventory in many cases, as we have seen, uses words like *parvus* (small), and *libellus* (booklet), indicating that works are undersized, which must be another reason that Gérard misprized them: 'a small old book [i.e., twelfth century?] called Hugh's De archa Noe'; 'a small letter collection of Petrus de Vineis'; 'a small Breviary, use of Rome'; 'the Office of the Dead in a booklet.'

The reasons why others were disregarded are not self-evident: Gérard's book collection shows a real fondness for history, but he gave none as a bequest: 'the Chronicles of Martin of Troppau, in boards'; 'a small green book of British chronicles' (Geoffrey of Monmouth?); 'eight quires of other chronicles, without boards'; and 'a small book of the history of Jerusalem, without boards,' none bequeathed. The inventory lists three items of medicine or natural history: 'a small booklet of medicine in large old letter' (it was Galen's *Ars parva*); 'a small book of pseudo-Aristotle's *De natura rerum*'; and 'a green medical book called Rasis *Ad Almansorem*.' None figured among his bequests, not even to his friend and personal physician Jean de Coucy, the eminent dean of the university's medical school. The commonest category of books left in Gérard's library were hagiographic collections, five of the total of twenty-one. There was the incomplete and unbound saints' legends with the Life of Saint Louis, which we have already noted; and, in addition, 'legends of the histories of many saints,' 'a small, old collection of saints' legends,' 'a book of saints' legends, written in

31. AN, S6458 no. 8; booklist edited, Rouse and Rouse (as in note 29), 1: 190–92.

32. In Italian cities from as early as the 13th century legacies of this sort, estates that were to be sold so that the proceeds might be distributed, were dealt with by public auction; D. C. Skemer,

'Inside a Book Auction in Quattrocento Padua,' in *The Books of Venice / Il libro Veneziano*, ed. L. Pon and C. Kallendorf, Miscellanea Marciana 20 (Venice, 2008), 101–25. We have not seen any suggestion of this procedure in medieval Paris.

old script' (pre-Gothic, doubtless), and a *Legenda aurea* 'in boards covered with red leather.'[33] But bound or not, complete or partial, small or large, no manuscript of hagiography figured among Gérard's bequests, not even for the monk Simon.

The most important volume among the unbequeathed gives grounds for sober reflection. Among the large group of Gérard's books that the household inventory located 'in his study adjoining his bedchamber' was a volume containing 'the French-language book of Fauvel, along with a number of shorter works in French,' a description whose terms surely identify it as manuscript 146 of the fonds français in the Bibliothèque nationale de France. This versified political satire, filled with novel illuminations and innovative music, is regarded today as a fourteenth-century landmark in the history of art, the history of music, the history of literature, and the political and social history of Paris under the last Capetians.[34] It has been the subject of repeated study, it has benefited from a scholarly facsimile publication, and it continues to be the focus of articles and conferences and exhibits. Possibly Gérard as a young man had been part of the group who created this manuscript, sometime around 1316–1318. Certainly Gérard in his mature years knew who the book's anonymous creators had been. This book, which modern scholarship would readily designate as the single most interesting and most significant object in Gérard's possession, he left with the rest of his excess personal property to be sold off and the proceeds given to the poor.

For historians it is sobering to recognize that what we in the twenty-first century find enormously im-portant seemed of no particular consequence to its fourteenth-century owner at the time of his death. Perhaps Gérard felt that, although the creation of this book had been fun and greatly daring in its day, nevertheless situations had evolved with the passing of twenty years. The original targets of the satire were all dead, as indeed were many of the work's creators; and the *Roman de Fauvel* may have seemed to Gérard de Montaigu to be simply an outdated collection of vernacular verse that, because of its many illustrations and its many songs with music, might nevertheless produce a reasonable sum of money for his favorite charities when it was sold.

Gérard's will was a matter of choices; *Fauvel* was not one of the chosen. This is a salutary lesson for historians.

III.

The last testament we consider is that of Blanche de Navarre.[35] There were at least three historically significant women of that name in the late French Middle Ages, so we should specify that we mean the Blanche de Navarre who was briefly the queen of France in the middle of the fourteenth century.[36] Still in her teens, she married King Philip VI as his second wife (see Genealogies) in January 1350;[37] Philip, between thirty-seven and forty years her senior,[38] died in August of that year. To be a widow, in fourteenth-century French society, was legally the most advantageous position a woman could occupy. To be a royal widow meant, in addition, that a woman was reasonably safe from her family's badgering her into remarriage:

33. Unlike the others, this book is probably identifiable as Munich, Bayerische Staatsbibliothek, Clm 10177.

34. Concerning BnF, Ms. fr. 146, see Rouse and Rouse (as in note 29), 1: 225–32, and notes for bibliography to 2000.

35. Concerning the carefully organized structure of Blanche's will, see B. Buettner, 'Le système des objets dans le testament de Blanche de Navarre,' *Clio: Histoire, Femmes et Sociétés* 19: *Femmes et Images* (2004), 37–62.

36. The others were Blanche de Navarre (1177–1229), daughter of Sancho VI de Navarre and countess of Champagne by her marriage to Count Thibaut III; and Blanche de Navarre (1226–83), daughter of Count Thibaut IV of Champagne and duchess of Brittany by her marriage to Duke Jean I.

37. Philip VI's first wife Jeanne de Bourgogne died in De-cember 1349 and the marriage with Blanche de Navarre took place in January 1350; *Les Valois*, in the series Nouvelle histoire généalogique de l'auguste Maison de France 3, ed. P. van Kerrebrouck *et al.* (Villeneuve d'Ascq, 1990), 83–5. We have used this as our authority for Valois names and dates, and for Capetians the previous volume in the series (though published later), *Les Capétiens 987–1328*, ed. P. van Kerrebrouck, vol. 2 (Villeneuve d'Ascq, 2000). Unfortunately this latter (p. 184) states that Blanche was widowed in 1349 after one year of reign ('Veuve en 1349 après un an de règne'), which is not only wrong but disconcerting to find in one's 'authority.'

38. Van Kerrebrouck *et al. Valois* 83 gives Blanche's birth date as 1330, Philip's as 1293; older sources cite her birth date as 1333.

GENEALOGIES
FOR THE TESTAMENT OF
BLANCHE DE NAVARRE

These diagrams of the royal families of France and Navarre are ruthlessly
stripped of everyone whose presence is not required for an understanding
of Blanche's will. We give below separate family trees for the two royal
houses of France, the direct Capetians and the Valois, and for the royal
house of Navarre. The Capetians in the fourteenth century repeatedly
intermarried their first and second cousins in order to keep the reins of
power concentrated in family hands. Those men and women whose names
reappear on a second (or even third) "tree" are marked with an asterisk (★)
at their first appearance(s).

DIRECT CAPETIANS

HOUSE OF NAVARRE

Jeanne queen of Navarre m. Philippe d'Évreux (kg of Navarre by marriage)

Charles II (le Mauvais) kg of Navarre Blanche de Navarre★ m. Philip VI kg of France

Charles III kg of Navarre

HOUSE OF VALOIS

Philip VI kg of France

+ (m. 1) Jeanne de Bourgogne

Jean II (le Bon) kg of France

Charles V kg of France Jean de Berry Philippe (le Hardi) de Bourgogne

Charles VI kg of France Louis d'Orléans
m. Isabeau de Bavière m. Valentina Visconti

+ (m. 2) Blanche de Navarre

Jeanne de France

for what new husband could compete with the memory of a king of France? Blanche de Navarre died in 1398, having lived as dowager queen for nearly half a century. In her later years she was occasionally called upon by King Charles V, along with her aunt, that other long-lived royal widow Jeanne d'Évreux (widow of Charles IV),[39] to help negotiate the tangled problems between the crown of France and Blanche's wildly ambitious older brother Charles le Mauvais, king of Navarre. But primarily Blanche spent her widowhood withdrawn from the public eye, in her Paris residence and in her château of Neaufles, near Gisors. Her only child, her daughter Jeanne, had died without issue long before (1371), leaving Blanche with no obvious principal heir. She therefore gave much thought, evidently over quite a long period of time, to the appropriate disposition of her worldly goods.

Blanche dictated her will, in her Paris hôtel on 18 March 1396.[40] It is a long and interesting document, containing 190 provisions drafted in careful legal language. Its emphasis is entirely on the logistics of dying: meticulously detailed provision for her lavish obsequies, her sepulture, the naming of her executors, and a near-endless series of steps for the good of her soul in the form of more than 150 bequests of money and relics to religious houses and orders and hospices whose prayers she sought. Among it all only a single book is mentioned, a vernacular Life of Saint Louis that was given to the nuns of the Hôtel-Dieu of Vernon (founded by Saint Louis), along with a reliquary containing the saint's 'joint' (knuckle? wristbone?).[41]

Her books make their appearance, instead, in Blanche's lengthy codicil signed two days later, on March twentieth.[42] The codicil, as she had planned in advance, was the repository of all personal bequests,

'confirming, not retracting, the will, but wishing to amplify it,' as she says. Many of the legacies at the end of the codicil are simple gifts of a small amount of money to administrators, her ladies-in-waiting, members of the household, down to the lowest servants, in all her residences and on all her estates, a hundred or more such provisions. But at the beginning come the more personal bequests, making this codicil a touching and frankly astonishing document. For each such bequest, the elderly queen explains why the item is appropriate for its recipient, and often she relates as well the item's history and how it came into her hands. There is of course a wide variety of objects bequeathed in this way, rings and other jewels, cloaks, paintings, reliquaries; fortunately for our purposes, some forty of the items are books.

Blanche arranged the personal bequests in the order of the recipients' rank, beginning with the king of France and descending to her non-noble retainers. Routinely, she bequeathed to each person at least one object (such as a jewel, a relic, a robe) and one appropriate book. An example is her bequest to Isabeau de Bavière, wife of King Charles VI: 'We leave to our very dear daughter the queen of France[43] a golden cross designed for hanging in a niche: it is decorated with five rubies, four sapphires, and nine pearls, and it opens to show a piece of the True Cross inside. And along with that, one of our books which begins *Audi fili Israel*, which contains much good instruction; it belonged to milady the queen Jeanne de Bourgogne [first wife of Philip VI], and we beg her to keep it all her life for love of us.'[44] This book can be identified as the so-called *Legiloque*, a devotional collection created by Marie, countess of Saint-Pol, who gave a copy to her daughter Mahaut, countess of Valois, stepmother

39. Jeanne d'Évreux, with two younger sisters and probably a younger brother as well, is said without documentation, by van Kerrebrouck, *Capétiens,* 179–80 (and by virtually every other source), to have been born in 1310, while her mother Marguerite d'Artois (*ibid.* 229) is known to have died in April 1311. Jeanne's supposed birthdate is clearly too late, by around five years; see R. and M. Rouse, 'Publishing Watriquet's *Dits*,' in their *Bound Fast with Letters: Medieval Writers, Readers, and Texts* (Notre Dame, Ind., 2013), 164–214 at 167 and n. 28.

40. L. Delisle, ed., 'Testament de Blanche de Navarre, reine de France,' *Mémoires de la Société de l'histoire de Paris et de l'Île-de-France* 12 (1885), 1–64. Atypically, the will was written almost

two years before her death, and she is said at that time to be sound not only in mind but in body ('saine de corps, d'entendement, et de pensée'): 'Testament' 4, no. 1.

41. *Ibid.,* 11, no. 35.

42. *Ibid.,* 28–55.

43. Isabelle is her 'daughter' by courtesy, as is the case with all the other impossible relationships recorded in the will. Exceptionally the relationships reflect blood kinship, such as her brother (the late king of Navarre Charles II le Mauvais), her nephew (Charles III), her aunt (Jeanne d'Évreux), or her great-grandmother (Marie, second wife of King Philip III).

44. *Ibid.,* 29, nos. 194–95.

of King Philip VI. Although Blanche does not say so, it must have been Mahaut de Valois who in turn gave this book to her daughter-in-law, Jeanne de Bourgogne.[45] The important connection for Blanche was that a book that had belonged to a former queen of France, Jeanne de Bourgogne, should be given by a dowager queen of France, herself, to the current queen of France, Isabeau de Bavière.

Transmission from like to like, such as this one from queen to queen to queen, seems to have been Blanche's special delight. Thus, she gives 'to our very dear daughter the duchess of Orléans an emerald set in a ring, which was given to us by our son Jean de Berry. And a book of prayers and devotions that belonged to our very dear ladies the queen Marie (de Luxembourg, second wife of King Charles IV) and to madame the queen Jeanne d'Évreux (Charles's third wife); and the book was given to us by the duchess of Orléans her (Jeanne's) daughter, who recently died (in 1393); the book begins after the calendar, *Gloria in excelsis Deo*.'[46] So: a book that belonged to the dowager duchess of Orléans—Blanche, daughter of King Charles IV born to Queen Jeanne d'Évreux in April 1328 two months after Charles's death and married to Duke Philippe d'Orléans—is given to the current duchess of Orléans, Valentina Visconti, wife of Duke Louis, the reigning king's younger brother, a transmission duchess to duchess that Blanche de Navarre thought was quite fitting.

For many of her books, Blanche demonstrated a fondness and even a passionate attachment. Here she is in her will's codicil, spinning out a long and affectionate description of the fortunes of the miraculous Breviary 'brought by an angel' to Saint Louis in 1250, when he was a captive of the Saracens:

> We leave to our very dear and much-loved nephew the king of Navarre [Charles III] the breviary that belonged to my lord king Saint Louis of France, the one that the angel brought to him when he was imprisoned by the enemies of the faith; and then it belonged to my lord king Philip [III], his eldest son, who

died in Aragon, husband of milady queen Marie [de Brabant], our great-grandmother; he gave it to her during his lifetime. And since then it has come from heir to heir, in the lineage of milord Saint Louis. And our brother the king of Navarre [Charles II le Mauvais], his [Charles III's] father, gave it to me. And out of reverence for the holiness of milord Saint Louis, and because by grace it has come through our line, and because after it came to us we promised our brother that it would return to our line, therefore we will and order that it remain in the hands of our said nephew, and henceforth to his successors, without ever being alienated. We command that they keep it always, as a precious and noble jewel come down from our ancestors, and that it never leave our family.[47]

One of the most elaborate of these manuscript provenances traces another book with connections to the family's saint/king:[48]

> We leave to our very dear son the duke of Burgundy [Philippe le Hardi] the psalter from which my lord Saint Louis learned to read; and next it belonged to milady the grand-duchess Agnès, duchess of Burgundy, his daughter; and from the duchess Agnès it came to her daughter, our lady the queen Jeanne de Bourgogne [the first wife of King Philip VI]; and after her death it came to our lord and spouse [Philip], who gave it to us. And he bore witness, as did also that queen's waiting women whom he had assigned to us, that this was truly the very book in question. We very much wish that it remain in the lineage [of Burgundy]. And for that reason we beseech our said son [Duke Philippe] that he keep it and see that it is held by his successors in his line, for love of those from whom it has come.

With this weight of history behind it, the book not surprisingly long remained in the estate of successive dukes of Burgundy in the Low Countries. It is last recorded in their library in the inventory of 1467. By the eighteenth century it had come into the hands of the burgomaster of Leiden, who gave it to the university library in 1741, where it remains.[49]

The types of books in Blanche de Navarre's will do

45. Concerning the *Legiloque*, see R. and M. Rouse, 'French Literature and the Counts of Saint-Pol, ca. 1178–1377,' in their *Bound Fast with Letters: Medieval Writers, Readers, and Texts* (as in note 39), 308–56 at 327–33 and notes.

46. Delisle 'Testament' (as in note 39), 31, nos. 212–13.

47. *Ibid.*, 29, no. 196.

48. *Ibid.*, 29–30, no. 200.

49. P. M. de Winter, *La bibliothèque de Philippe le Hardi, duc de Bourgogne (1364–1404)* (Paris, 1985), 260–61 catalogue no. 39, now Leiden University Library Ms. BPL 76A.

not surprise us: among the forty are six breviaries and four Psalters, a fourth of the total in themselves. There are two books of chronicles, an unexpected treatise on the training of dogs and falcons for the hunt; she leaves two copies (two versions?) of Giles of Rome's *De regimine principum*, two examples of what are called 'our books of *cirurgie*,' which sound rather like domestic first-aid manuals, and a manuscript of the disorganized but very popular encyclopedia of science called the *Book of Sidrac*. All the rest are devotional books of one sort or another—miracles of the Virgin, saints' lives, on living and dying well, a Missal in French and one in Latin, and so on. It is rather surprising to find only two Books of Hours in the bequests of this royal lady, but the wording gives a clue to the explanation. One is a gift to Jean duke of Berry, called 'our most beautiful Hours,' and the second, which is bequeathed to her sister Jeanne viscountess of Rohan, she describes as 'the best Hours that we have, second only to those that we leave to our son of Berry.' Clearly, she owns other Books of Hours, perhaps many others, and this tells us that we must not regard her bequests as comprising the whole of her library. Nevertheless, it is worth noting that there is a total absence of theology, no philosophy, no classical poets whether in Latin or in translation, no church Fathers save one book with Gregory's *Dialogues* and *Liber pastoralis* that she bequeathed to her confessor.

From the standpoint of books, Blanche de Navarre's will is memorable not for any rarities that it describes. Instead, it is important, it is surely unique, for the numerous and credible statements of provenance that it preserves.

★ ★ ★

These three wills certainly provide the names of several books left by their testators. But as we have pointed out, when the documents are considered as a whole they may very well afford other and unexpected insights into the literate culture in which they have were drafted.

VIRGINIA REINBURG

An Archive of Prayer: The Book of Hours in Manuscript and Print

MANUSCRIPTS and early printed books abound in oddities and exceptions. A Book of Hours in the Princeton University Library provides a perfect example (Figs. 1–2).[1] Issued by the renowned Paris publisher Antoine Vérard in 1501, the book was printed on vellum and profusely illustrated with engraved borders, initials, and full-page miniatures—signatures of Vérard's style.[2] Then owners took the book in hand, transforming an already quite beautiful example of early printing into an object designed to belong to specific individuals and families. Someone—and likely more than one person—painted the miniatures (Fig. 1), added records of the Tonnellier and Harlet families (Fig. 2), and transformed the colophon page to proclaim the book to be 'Hours for the use of Sanz' rather than Rome (Fig. 2). This book can be considered 'manuscripta' and 'illuminata' only if both terms are construed broadly. The Tonnellier-Harlet Hours is a printed book. Yet it is also handwritten, if partially, and illuminated, if clumsily.

This kind of personally crafted book is far from rare among manuscript and printed Books of Hours, and can offer valuable clues to the meanings that these books held for their early owners. For the Book of Hours was the best selling book in France from the fifteenth century into the early decades of the sixteenth century. It was such an object of desire and exchange that, as Albert Labarre determined in his study of inventories after death in sixteenth-century Amiens, fully half of all inventories that included books recorded Books of Hours.[3] He also found that the Book of Hours was often the *only* book possessed by those who owned books. But *why* was this book a bestseller? Why was *a Latin prayerbook* a bestseller in an era of generally low literacy and uneven knowledge of Latin? It is true that for royal, noble, bourgeois, and artisan families, it was a prized possession signifying their wealth and social position. But this is a question that is not adequately answered by seeing the Book of Hours mainly as a status symbol for owners, an item of conspicuous consumption or display, or desired only for its beautiful images. Why a book, why this book, why not another religious book?

We get closer to an answer by recognizing that the Book of Hours was a book of many uses. It was a prayerbook, the prayerbook of the laity (although it was also owned by priests, monks, and nuns). It often served as a primer for literacy, as suggested by a print of a book peddler (Fig. 3) proclaiming sales of 'beautiful ABCs and Hours' together, and as seen in a short alphabet book, published in Paris in 1581 or 1591, designed as an appendix to a printed Book of Hours (Fig. 4). Family records or *livres de raison* were sometimes added to Books of Hours, as in the Tonnellier-Harlet Hours just discussed (Figs. 1–2). So for many owners, the Book of Hours combined prayer book with art object, reference work, and family album.

I will argue that the Book of Hours could be this all-purpose book, and thus a bestseller, because it was an archive of prayer, and moreover an archive whose meaning and authority rested on both *writing* and *the liturgy*. I propose the term 'archive' cautiously. The

1. *Ces presentes heures a lusaige de Sanz* [colophon, modified] (Paris: Antoine Vérard, 9 February 1500 [=1501]), Princeton University Library (ExI5942.247.11). The meaning of 'Sanz' is unclear. Hanns Bohatta records an edition that may be the same as this one, a Book of Hours for the use of Rome published by Vérard on the same day, with the same signatures: Bohatta, *Bibliographie der Livres d'Heures (Horae B.M.V.), Officia, Hortuli Animae, Coronae B.M.V., Rosaria und Cursus B.M.V. des XV. und XVI. Jahrhunderts,* 2nd ed. (Vienna, 1924), 27, no. 684. Vérard

followed the customary practice of recording dates in his day, changing the year on the feast day of the Annunciation (March 25), not January 1.

2. See M. B. Winn, *Anthoine Vérard, Parisian Publisher, 1485–1512: Prologues, Poems and Presentations* (Geneva, 1997).

3. A. Labarre, *Le livre dans la vie amiénoise du seizième siècle: L'enseignement des inventaires après décès, 1503–1576* (Paris, 1971), 164–77.

FIGURE 1. Opening leaf. *Ces presentes heures a lusaige de Sanz* [colophon, modified] (Paris: Antoine Vérard, 9 February 1500 [=1501]). Princeton University Library, ExI5942.247.11 (courtesy of the Princeton University Library).

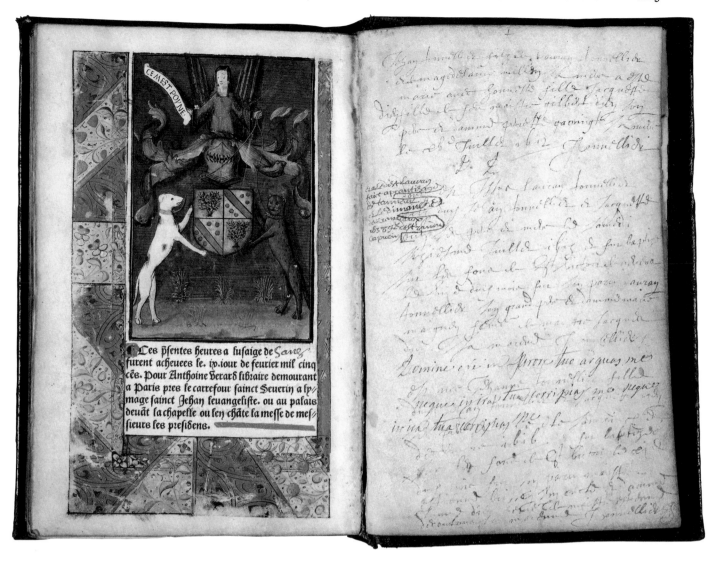

FIGURE 2. Colophon page and facing leaf. *Ces presentes heures a lusaige de Sanz* [colophon, modified] (Paris: Antoine Vérard, 9 February 1500 [=1501]), Princeton University Library, ExI5942.247.11 (courtesy of the Princeton University Library).

word can suggest factual certainty and documentary fixity, although Arlette Farge, Ann Laura Stoler, and others remind us that using archives demands careful attention to how and why they were created, and how they became authoritative.[4] In the most obvious sense, the Book of Hours is an archive of the religious and cultural past for today's scholars and book lovers. But it was also an archive for early owners of Books of Hours themselves, for it was a collection of prayers and other materials they collected, memorized, and transcribed. The owners were the archivists, working within certain loose conventions. They crafted their own books, or deliberately chose them or lived with and preserved their ancestors' choices that had been thrust upon them. Thus for its owners and readers, the Book of Hours was an archive because it preserved materials—both written and visual—and ordered them for further use.

4. See A. Farge, *The Allure of the Archives,* trans. T. Scott-Railton (New Haven, Conn., 2013); and A. L. Stoler, *Along the Archival Grain: Epistemic Anxieties and Colonial Common Sense* (Princeton, N.J., 2009), chaps. 1–2.

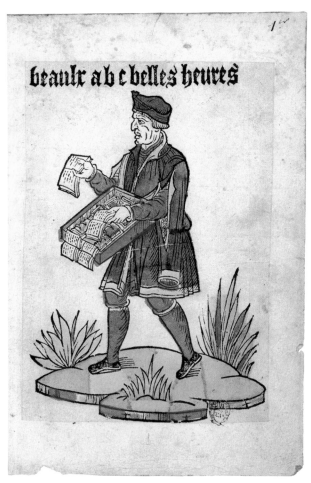

FIGURE 3. Book peddler, from *Les cris de Paris,* hand-colored woodcut (Paris, *c.* 1500), Bibliothèque de l'Arsenal, Rés. Est. 264, p. 1 (© Bibliothèque nationale de France).

FIGURE 4. [*ABC, L'oraison dominicale*] (Le Mans: Mathurin Le Roux, 1581 or 1591), Bibliothèque nationale de France, Rés. X. 2822 (© Bibliothèque nationale de France).

The Book of Hours could serve as an archive of prayer because it was intimately attached to the liturgy, with all the authority that the liturgy held for late medieval and early modern people. The book was a tool and an emblem of intercessory prayer, which in this era was saturated with the liturgy. The Book of Hours has not always been considered a liturgical book, because according to now antiquated assumptions, it was intended for private rather than public use. It has sometimes been called 'quasi-liturgical.'[5] But drawing rigid boundaries between public and private, or liturgical and quasi-liturgical, makes little sense of the religious

lives of medieval and early modern Christians.[6] The liturgy could lodge in many places—not all of them 'public'—like the birthing chamber and the deathbed, both key sites of ritual experience. Furthermore, the words of 'private' prayer were collectively generated and often expressed in plural form. But whatever terminology we use for the Book of Hours, it provided a bridge between the liturgy and the home. It lent authority to practices of prayer—however the practices arrived there—when those practices were represented inside the same book that included liturgical texts like the Office of the Dead. The Book of Hours lent

5. L. M. J. Delaissé, 'The Importance of Books of Hours for the History of the Medieval Book,' in *Gatherings in Honor of Dorothy E. Miner,* ed. U. McCracken *et al.* (Baltimore, Md., 1974), 203.

6. For discussion of these issues in early medieval manuscripts, see Henry Mayr-Harting's chapter in the present volume.

authority to practices of prayer when those practices were inscribed inside the same book that owners took with them to Mass, funerals, matins, and vespers.

In the following pages I consider two topics: (1) the owners of Books of Hours as the books' *makers* or archivists; and (2) the practices of prayer that the book recorded and facilitated, practices that were fundamentally *speech*—or talking to and about God, the Virgin Mary, and the saints—preserved in writing, and fundamentally liturgical.

Owners as Makers of the Book of Hours

Recent art-historical scholarship on patronage emphasizes the participation of a variety of historical actors in creating a work of art.[7] This new work acknowledges the complexities of 'patronage' as a concept in artistic and cultural production, and sheds light on the ways that works of art were collectively made, whether artists or patrons are identifiable or—as is often the case in the pre-modern world—anonymous or nearly so.

This approach is particularly well suited to Books of Hours, both manuscript and print. For the Book of Hours was the product of many hands. Although it included liturgical texts, no ecclesiastical institution or official controlled it until the late sixteenth century. Many people fashioned it: scribes, artists, printers, booksellers, devotional writers, and the books' patrons, later owners, and readers. The books' contents were conventional—calendars, Latin offices and litanies, Latin and vernacular prayers, and images. Royal and aristocratic patrons and their spiritual advisors could exercise a good deal of control over the texts and images in bespoke manuscripts.[8] And as Kathryn A. Smith

and Adelaide Bennett have shown, less well-off patrons might do the same.[9] So-called 'mass produced' Books of Hours present a different profile of the owners' intervention. For shop copy manuscripts and printed books, the scribes, printers, artists, and booksellers produced the standard texts and images in Books of Hours, working from exemplars available in their workshops. Mary and Richard Rouse have highlighted the role of the Paris booksellers (often also scribes and miniaturists) as book contractors, entrepreneurs, and financiers with fingers on the pulse of their markets.[10] This continued into the print era, when the great printers of the early decades of the sixteenth century organized most editions.[11] Booksellers both responded to and created a market for Books of Hours.

Because so many hands crafted the Book of Hours, it changed in concert with larger cultural, religious, and social transformations. Of special importance were the era's shifts in linguistic practice. As French gradually began to displace Latin and the regional vernaculars, the Book of Hours evolved from a collection of primarily Latin texts into a Latin-French hybrid. By the early sixteenth century, publishers, authors, and the reading public had transformed the Book of Hours into a work legible to francophone readers with a bit of facility in Latin.

It was above all the owners who made their books. We know quite a lot about who owned Books of Hours. For the first century or so of its existence, the Book of Hours belonged almost exclusively to royalty and high-ranking aristocrats. Many bespoke manuscripts were made for women, and for that reason modern scholars sometimes identify the Book of Hours as a woman's genre.[12] There is truth to this for the thirteenth and fourteenth centuries, especially in

7. For examples, see *Patronage: Power and Agency in Medieval Art,* ed. C. Hourihane, Index of Christian Art Occasional Papers, 15 (Princeton, N.J., 2013), esp. the chapters by A. Bennett (233–55) and A. Kumler (297–319).

8. For an example, see F. Avril, L. Dunlop, and B. Yapp, *Les Petites Heures de Jean, duc de Berry (ms. lat. 18014 de la Bibliothèque Nationale, Paris)* (Lucerne, 1988–89).

9. See K. A. Smith, *Identity and Devotion in Fourteenth-Century England: Three Women and Their Books of Hours* (London, 2003); and A. Bennett, 'A Thirteenth-Century French Book of Hours for Marie,' *Journal of the Walters Art Gallery* 54 (1996), 21–50.

10. R. H. Rouse and M. A. Rouse, *Manuscripts and Their*

Makers: Commercial Book Production in Medieval Paris, 1200–1500 (Turnhout, 2000), 14 and *passim*.

11. See V. Reinburg, *French Books of Hours: Making an Archive of Prayer, c. 1400–1600* (Cambridge, 2012), chap. 1.

12. On women and Books of Hours, see Bennett, 'A Thirteenth-Century French Book of Hours for Marie' (as in note 9); Smith, *Identity and Devotion* (as in note 9); D. Alexandre-Bidon, 'Prier au féminin? Les livres d'heures des femmes,' in *Homo Religiosus: Autour de Jean Delumeau,* ed. A. Cabantous (Paris, 1997), 527–34; and Reinburg, *French Books of Hours* (as in note 11), 71–76.

France, as Bennett has shown.[13] But after 1400, and especially in the era of print, the French Book of Hours was often more distinctively a family possession. In the later period, women continued to own Books of Hours and give them as gifts. But the many extant Books of Hours owned by families show that multiple generations of kin had a hand in making a family's book, adding to them, modifying them, leaving them to children and grandchildren in their wills.

The emergence of the family-owned Book of Hours is in part an effect of expanding literacy and book ownership. After 1400, men and women of less wealth and lower social rank began to acquire books. During the sixteenth and seventeenth centuries, members of merchant, artisan, and legal/office-holding families left their marks in surviving Books of Hours. Yet despite these changes in the social composition of its owners, the Book of Hours remained largely what had long been: a book of conventional contents, fashioned by its owners into a personal or family possession, and a book with multiple uses.

Each owned book was a deliberately created object. And each was unique: fabricated not only by book artisans and publishers, but also by the owners themselves, who chose and remade their books, leaving their traces scattered throughout. They chose the books—both new and used—from booksellers' wares, and altered inherited and second-hand books. Sometimes all we know about owners comes from the names inscribed in surviving books, as in a printed Book of Hours from Boston College's John J. Burns Library (Figs. 5–6), or monogrammed bindings, like the early seventeenth-century gold-tooled leather binding with the initials 'M L' created for Princeton's Garrett Ms. 56, a fifteenth-century manuscript Book of Hours for the use of Rouen (Fig. 7). Blanche Rat, a merchant's wife, left a more detailed note of ownership in a Book of Hours printed by Antoine Vérard in 1501: 'These Hours belong to Dame Blanche Rat, wife of sire Jehan Pichonat, the merchant, living in the rue Saint-Denis, at the sign

FIGURE 5. *Les heures nostre dame a lusaige de Poitiers* (Paris: Gillet Hardouyn, n.d. [calendar for 1509–21]), fol. c4ᵛ, John J. Burns Library, Boston College, BX2080.A2 1509Z.

FIGURE 6. *Les heures nostre dame a lusaige de Poitiers* (Paris: Gillet Hardouyn, n.d. [calendar for 1509–21]), fol. &1ᵛ, John J. Burns Library, Boston College, BX2080.A2 1509Z.

13. Bennett, 'A Thirteenth-Century French Book of Hours for Marie' (as in note 9); 'A Woman's Power of Prayer versus the Devil in a Book of Hours of ca. 1300,' in *Image and Belief: Studies in Celebration of the Eightieth Anniversary of the Index of Christian Art,* ed. C. Hourihane, Index of Christian Art Occasional Papers, 3 (Princeton, N.J., 1999), 89–108; 'Issues of Female Patronage: French Books of Hours, 1220–1320,' in *Patronage* (as in note 7), 233–55; 'Some Perspectives on Two French *Horae* in the Thirteenth Century,' in *Books of Hours Reconsidered,* ed. S. Hindman and J. Marrow (London, 2013), 19–40; and her chapter in the present volume.

FIGURE 7. Front cover. Princeton University Library, Garrett Ms. 56 (Book of Hours, use of Rouen, 1490s) (courtesy of the Princeton University Library).

FIGURE 8. Reverse of the last leaf of the book. [Book of Hours, use of Rome] (Paris: Antoine Vérard, 20 January 1500 [=1501]), Boston Public Library, ★★Q.405.107 (courtesy of the Trustees of the Boston Public Library/Rare Books).

of Saint Nicolas, near Saint-Innocent in Paris' (Fig. 8). Some books bear signs of more elaborate refashioning. Owners stitched together manuscript quires with print, added prayers to patron saints, and devotions to be remembered and perpetuated. They adorned their books with images, medals, and pilgrim badges.[14] A good example of the latter is a Book of Hours for the use of Paris, with a badge from the shrine of Saint Martha of Tarascon (Provence) sewn to the book's flyleaf (Fig. 9).[15] Also fixed to the page are a small representation of the instruments of Christ's Passion (the *Arma Christi*) in cross-stitch, and a small painted image of Veronica's veil (the Vera Icon).

Family records (*livres de raison*) inscribed inside Books of Hours provide the best evidence about the books' owners.[16] These are records of a family's life, not personal diaries, although they might include bio-

FIGURE 9. Bibliothèque de l'Arsenal, Ms. 1176A rés., fol. Aᵛ (Book of Hours, use of Paris, 15th century (© Bibliothèque nationale de France).

graphical notes.[17] The *livres de raison* inscribed in Books of Hours are what I would call a modified version of the genre, absent household accounts and lists of property in land and goods often included in the freestand-

14. On these kinds of added materials, see D. Bruna, 'Témoins de dévotions dans les livres d'heures à la fin du moyen âge,' *Revue Mabillon*, n.s., 9 (1998), 127–61; and the many articles by K. Köster, among which see especially 'Kollektionen metallener Wallfahrts-Devotionalien und kleiner Andachtsbilder, eingenäht in spätmittelalterliche Gebetbuch-Handschriften,' in *Erlesenes aus der Welt des Buches: Gedanken, Betrachtungen, Forschungen,* ed. B. Haller (Wiesbaden, 1970), 77–130.

15. Bibliothèque de l'Arsenal, Ms. 1176A rés., fol. Aᵛ (Book of Hours, use of Paris, 15th century). On these objects see D. Bruna, *Enseignes de pèlerinage et enseignes profanes* (Paris, 1996), 17–18; and M. H. Foster, 'Pilgrimage Through the Pages: Pilgrim's Badges in Late Medieval Devotional Manuscripts,' Ph.D. diss. (University of Illinois, Urbana-Champaign, 2011), 36–37.

16. For further discussion of personal materials added to

Books of Hours, see Reinburg, *French Books of Hours* (as in note 11), esp. chap. 2; and E. Duffy, *Marking the Hours: English People and Their Prayers, 1240–1570* (New Haven, Conn., 2006).

17. On *livres de raison* in general, see N. Lemaître, *Le scribe et le mage: Notaires et société rurale en Bas-Limousin aux XVIᵉ et XVIIᵉ siècles* (Ussel, 2000); N. Z. Davis, 'Ghosts, Kin, and Progeny: Some Features of Family Life in Early Modern France,' *Daedalus* 106 (1977), 87–114; J. Tricard, 'Vie religieuse et attentes familiales particulières dans les livres de raison limousins de la fin du moyen âge,' in *Religion et mentalités au moyen âge: Mélanges en l'honneur d'Hervé Martin,* ed. S. Cassagnes-Brouquet (Rennes, 2003), 395–407; and S. Mouysset, 'De père en fils: Livre de raison et transmission de la mémoire familiale (France du Sud, xvᵉ–xviiiᵉ siècle),' in *Religion et politique dans les sociétés du Midi,* ed. N. Lemaître (Paris, 2002), 139–51.

ing *livres de raison*. Keepers of family records in Books of Hours—almost always the family's patriarch—usually confined themselves to listing marriages, births, baptisms, and deaths, along with occasional notes of offices acquired and transferred to sons. Notices of baptisms often include the names of a child's godparents, a rich source of information about the family's extended kin and social networks. Books of Hours with family records were usually family possessions, tended by the male head of household, and passed along to sons and grandsons, although sometimes to daughters. Most of the family records in Books of Hours were written later than the books themselves, and often by the books' later owners. They date from no earlier than the mid-fifteenth century, and usually between the late fifteenth and the mid-seventeenth centuries. Many open with the betrothal or marriage of the owners, possibly meant as a clear claim to new marital property (the Book of Hours) along with a renewed lineage.

A few examples show some of the ways that Books of Hours archived and preserved family history. A Breton Book of Hours now in the Boston Public Library (Ms. q. med. 81) appears to have remained in one family for at least two centuries (Figs. 10–11).[18] Thomas de Québriac probably commissioned the book for his wife, Marguerite de Fontenay, in the 1420s. The book includes three portraits of Marguerite, including one of the patron present at the Mass of Saint Gregory (Fig. 10).[19] On the opening leaves of the manuscript appear notices from the late sixteenth and early seventeenth centuries of the births of children in the Guémadeuc family (Thomas' grandchildren, if not Marguerite's as well), plus later notes (Fig. 11). Middle nobility from the region of Rennes, the Québriac and Fontenay families benefitted from the patronage of

the dukes of Brittany, making it possible for them to commission a profusely illustrated manuscript from artists with Paris and Flemish connections. That family members from later generations kept the book and moreover endowed it with family records suggests that this Book of Hours was an important emblem of the family's patrimony, and a repository of family memory.

But Books of Hours could also change owners, and this may have been more common than a book remaining in a single family, especially among non-noble families. A fifteenth-century manuscript Book of Hours for the use of Toul (Princeton Ms. 116) includes one notice about the Loches from the duchy of Bar (1454), one recording the birth of 'Glaude,' surname unknown (1502), and a longer list of the births of the children (including triplets) of Charles du Plessier and Isabeau de Hamel of Biache in Picardy (1618–1624) (Fig. 12).[20] This is a shop copy manuscript, but a nice book by early modern standards. It is unclear how the book passed from one family to the next, although movement of peoples and goods along the corridor linking Lorraine and the Burgundies to Picardy and the southern Low Countries was common.

Another example shows a similar chronology and geographical move: an exceptionally fine early fifteenth-century manuscript (Houghton Library, Richardson Ms. 42) from Paris, somehow acquired and modified by a family from Champagne with social aspirations and clear religious and political convictions (Figs. 13–14).[21] The original patron of this manuscript from the Rohan Master's workshop is unknown. By the 1540s, Antoine de Buz and his family owned it. De Buz, seigneur de Villemareuil and *bailli* of Meaux (Champagne) from 1542 to 1560, recorded in the book the dates of his betrothal (a long one), marriage, and children's births and baptisms (Fig. 14). This was the

18. Boston Public Library, Ms. q. med. 81 (Book of Hours, use of Rennes, *c.* 1427, with later additions). On the manuscript, see D. Booton, 'A Breton Book of Hours for M. de Fontenay, Lady of Chasné,' *Scriptorium* 58 (2004): 174–201; and J.-L. Deuffic, 'Notes de bibliologie: Livres d'heures et manuscrits du moyen âge identifiés (xivᵉ–xviᵉ siècles),' *Pecia* 7 (2009), 83–90.

19. I discuss this image in *French Books of Hours* (as in note 11), 119–23.

20. Princeton University Library, Princeton Ms. 116 (Book of Hours, use of Toul, second quarter of the 15th century, with later additions). On the manuscript see D. Skemer, *Medieval &*

Renaissance Manuscripts in the Princeton University Library, 2 vols. (Princeton, N.J., 2013), 11:344–46.

21. Houghton Library (Harvard University), Richardson Ms. 42 (Book of Hours, use of Paris, *c.* 1420–25, with later additions; the De Buz Hours). On the manuscript see E. Panofsky, 'The de Buz Book of Hours: A New Manuscript from the Workshop of the Grandes Heures de Rohan,' *Harvard Library Chronicle* 3 (1949), 163–82; and R. Wieck, *Late Medieval and Renaissance Illuminated Manuscripts, 1350–1525, in the Houghton Library* (Cambridge, Mass., 1983), 8–9.

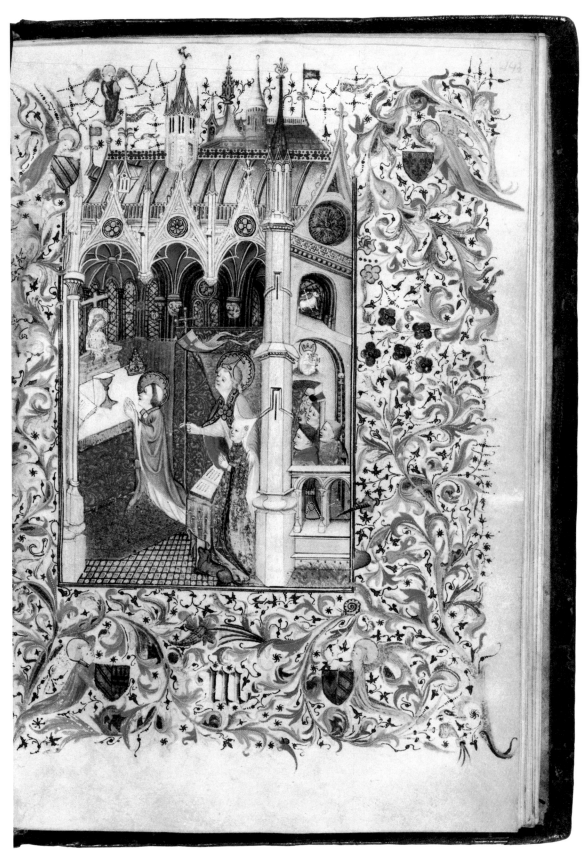

FIGURE 10. Mass of Saint Gregory, with patroness. Boston Public Library, Ms. q. med. 81, fol. 143ᵛ (Book of Hours, use of Rennes, *c*. 1427, with later additions) (courtesy of the Trustees of the Boston Public Library/Rare Books).

FIGURE 11. Front pastedown. Boston Public Library, Ms. q. med. 81 (Book of Hours, use of Rennes, *c.* 1427, with later additions) (courtesy of the Trustees of the Boston Public Library/Rare Books).

FIGURE 12. Princeton University Library, Princeton Ms. 116, fols. 1ᵛ–2ʳ (Book of
Hours, use of Toul, second quarter of the 15th century, with later additions) (cour-
tesy of the Princeton University Library).

aspiring family par excellence. Antoine married Barbe
de Louan, whose family apparently outranked the De
Buz. As *bailli*, Antoine was the chief royal adminis-
trative officer of a medium-sized city in an impor-
tant province. His brother Jean de Buz was bishop of
Meaux from 1535 until 1552, when he apparently met
a violent end in a romantic dispute. In his *livre de rai-
son*, Antoine de Buz recorded the names of his chil-
dren's godparents, among them not only his brother
the bishop, but members of illustrious noble families
from Champagne, including King François I's niece
François de Longwy, a countess and widow of the
admiral of France. The family's Book of Hours repre-

sented a material expression of Antoine's (and probably
his brother Jean's) strategy of raising the De Buz fam-
ily's fortunes. Antoine managed to acquire a luxurious
illuminated manuscript Book of Hours more than a
century old. By the 1540s, the Book of Hours was not
only a possession showing pride in a family's station,
but also emblematic of fierce Catholic commitment
in an era of growing Calvinist–Catholic disputes. An-
toine de Buz's son Antoine demonstrated that religious
and political commitment by joining the Catholic
League in the 1590s.

Owners of Books of Hours who penned fam-
ily records were not all from the office-holding and

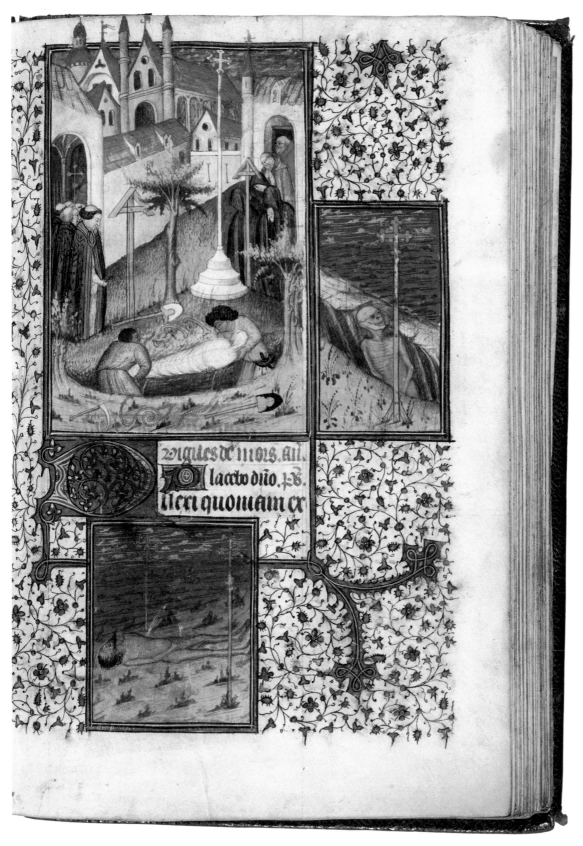

Figure 13. Burial service. Houghton Library (Harvard University), Richardson Ms. 42, fol. 118ᵛ (Book of Hours, use of Paris, c. 1420–25, with later additions).

FIGURE 14. Notes from the De Buz family. Houghton Library (Harvard University), Richardson Ms. 42, fol. 195ʳ (Book of Hours, use of Paris, *c.* 1420–25, with later additions).

intensively literate classes. They could also hail from more modest circles, as did François Harlet. Harlet, one of the later owners of the Tonnellier-Harlet Hours (Figs. 1–2), was a merchant tanner from Nevers.²² But he also had aspirations. Tanners did not rank among the aristocrats of the artisanry, as mercers, wholesale grocers, goldsmiths, and printers did. But Harlet was a merchant tanner, meaning he was a master of his trade who owned his own shop—however modest—and could employ apprentices and assistants. Harlet, the son of a master carpenter, married Jehanne Tonnellier, the daughter of Jehan Tonnellier, 'a merchant,' as Harlet wrote—probably a merchant tanner, because Jehanne's brother was a tanner. Before François Harlet wrote in the book, his father-in-law owned it. Daughter Jehanne then acquired the family's book, and her husband added their children's births and baptisms to it. Did the book go to Jehanne because her older brother Laurens, who had trained as a tanner, joined the Capuchins in 1638 (as their father dutifully recorded)? François Harlet and Jehanne Tonnellier came from proud artisan families, and in their kin and social networks were apothecaries, carpenters, tanners, and eventually priests and lawyers. Like the De Buz family, the Tonnellier-Harlet families must have thrown in their lot with the Catholic reformers of the early seventeenth century. Not only did Jehanne's brother become a Capuchin, but some of the children were baptized in Nevers' Jesuit church of Saint-Pierre.

These Books of Hours with family records are diverse in materials, and express a similar diversity in geography and social station. Yet the families who owned them probably all acquired the books because they wanted a book that signified not only literacy, financial means, and an elevated social status, but also allowed them to proclaim and preserve family lineage framed by a liturgical book.

These books demonstrate the ways that Books of Hours were a collective creation that could express lineage and family pride through names, monograms and coats-of-arms, and family records. But the devo-

tional texts and images in Books of Hours—especially additions by later owners—also show the ways it expressed and represented a family's devotional choices.

Two examples suggest the flavor of these assembled books. The first is a book (possibly from Rouen) owned by Marie Douette in 1570, and then by the Penart family in 1618.²³ Here printed and manuscript quires are sewn together in a single binding. To a fifteenth-century manuscript Book of Hours someone—and likely more than one someone—added hand-written prayers to the family's patron saints (Geneviève, Roch, Anne, and Barbe), a preacher's *exemplum*, and prayers for the protection of maritime merchants. Printed matter was also added: a short instruction about devout reception of the sacraments of confession and communion; an art of dying; and a printed account of the legend and pilgrimage of the Mont du Calvaire in Dauphiné (all published in Paris in the 1580s).

Another example also shows that owners exercised choice in modifying a book and making it more useful for their specific purposes. This is a printed Book of Hours for the use of Lyon, published by Agnès Sucevin (the widow of Jehan de Brie) in Paris in 1527 or 1528.²⁴ Three priests from the Flamant family of Burgundy and Franche-Comté owned the book over a century and a half, beginning in 1530. The Flamant fathers were itinerant priests, travelling around villages on the borders of the Burgundies, France, and Savoy to say Mass and perform baptisms, marriages, and funerals. They copiously annotated their book with medical recipes, additional prayers in Latin and French, and liturgical formulas useful to priests who owned no other books. Among the added texts is a French prayer or charm for healing wounds, lesions, or plague sores. This collection of materials was probably added in a variety of ways—copied from other books, transcribed from memory, or in the case of the charm perhaps dictated by a knowledgeable villager for a priest's future use. The Flamant Book of Hours shows the ways owners could use and remake books, texts, and prayers, drawing on both oral and written sources.

22. *Ces presentes heures a lusaige de Sanz*, Princeton University Library (as in note 1).

23. Bibliothèque Sainte-Geneviève, Ms. 2694 (Book of Hours and devotional miscellany, 15th to early 17th centuries, possibly from Rouen).

24. G. Pérouse, 'Des Heures à secrets,' *Bibliothèque d'Humanisme et Renaissance* 48 (1986): 757–70. For further discussion of the book, see V. Reinburg, 'Oral Rites: Prayer and Talk in Early Modern France,' in *Spoken Word and Social Practice: Orality (1400–1700)*, ed. L. Twomey and T. V. Cohen (Leiden, in press).

Archiving and Scripting Prayer

I now turn to the ways that Books of Hours archived and 'scripted' prayer, defined here simply as talking to God, the Virgin Mary, and the saints.

The Book of Hours was a tool and an emblem of intercessory prayer, which in this world was inflected by the liturgy. Many of the featured texts in Books of Hours were liturgical offices. For Christians of this era, rites of collective or public worship were the principal means through which God granted grace and assistance. The liturgy was the template for the bond between God and humanity. I call attention here to the liturgy *of the Hours,* not just the Mass and sacraments. Laypeople were drawn to the liturgy of the Hours. Ancient and effective, hourly prayer was identified with the world of the monasteries, filtering down from there to cities and towns by the late Middle Ages. Offices were part of the tenor and texture of daily life in cities. Matins and vespers were recited in cathedrals, capitular and collegial churches, mendicant churches, and even large parishes. They were even common in town and village parishes.[25] Laypeople and clerics alike donated funds to support having offices said for their own intentions and the souls in purgatory. They donated candles, candlesticks, lamps, wax, tallow, and oil to illuminate those rites.[26] The fifteenth-century records of Saint-Jacques-de-la-Boucherie, a parish in the merchant quarter of Paris, burst with donations large and small: for the curé or chaplain to sing matins 'loudly and well'; for a cleric 'to say and sing vespers every day, at about three hours after noon'; for an expensive beeswax candle to burn 'on the high altar during the hours.'[27] The liturgy of the Hours touched the lives of the faithful every day, in ways that have not been fully enough appreciated.

There are many kinds of prayers in Books of Hours besides offices or hourly prayer. There are prayers linked to the Mass and sacraments; prayers to God, the Virgin Mary, and saints; meditations on Christ's and Mary's passions; prayers associated with pilgrimage and confraternities; penitential practices; the arts of dying; and prayer with images. But like the offices, most prayers in Books of Hours were intercessory in some fashion. The Book of Hours includes some prayers addressed to God. But most are addressed to the Virgin Mary and the saints, asking for their intervention before God, and in exchange offering them praise, tribute, or donations.

Indeed, to pray was to participate in a grand network of spiritual patronage and kinship, where all exchanges and relationships were reciprocal. This was a world in which nearly everyone assumed that eternal salvation as well as most earthly business was best conducted through intercession, and facilitated by the grand and small courtesies of patronage. The Book of Hours was perfectly attuned to the culture of intercession in the late medieval and early modern world.

And prayer was the quintessential practice of intercession and patronage. It was both a *rite* and *speech*, the goal of which was to sustain a relationship with God, the Virgin Mary, or a saint. Such relationships were reciprocal. Devotees asked for assistance, and in exchange offered praise, tribute, and donations. In return, they hoped to be rewarded with help 'in this life' and salvation in the life to come. All gestures and words of prayer were collectively created, albeit often—not always—individually expressed. Woven into the language and rites of prayer were contemporary understandings about social relations, power and authority, the natural and supernatural worlds, and the bonds linking human beings to God.

The Book of Hours is full of talk. Many texts in Books of Hours are psalms, because they are the material of which offices were composed. And in the psalms, prayer is verbal communication between a human being and God. The psalmist sometimes speaks directly to God. Often he recounts that he spoke to

25. For example, the parish church of Saint-Michel-sur-Orge, a small wine-producing village south of Paris (*c.* 1550–1710), as discussed in N. Lemaître, *L'obituaire de Saint-Michel-sur-Orge* (Paris, 2002).

26. See C. Vincent, *Fiat Lux: Lumière et luminaires dans la vie religieuse en Occident du XIIIᵉ siècle au début du XVIᵉ siècle* (Paris, 2004).

27. L. Fritsch-Pinaud, 'La vie paroissiale à Saint-Jacques-de-la-Boucherie au xvᵉ siècle,' *Paris et l'Île-de-France: Mémoires publiés par la Fédération des Sociétés Historiques et Archéologiques de Paris et de l'Île-de-France* 33 (1982), 7–97, quotations on 80–83.

God and God replied. An example is the opening psalm of the office of the dead (*Dilexi quoniam*), found in every Book of Hours: *Dilexi quoniam exaudiet Dominus vocem orationis meae* (I have loved because the Lord will hear the voice of my prayer).[28] Readers of Books of Hours could easily find assurance that God listened and responded to those who addressed him. For example this prayer, stitched together from biblical verses, was designed for 'anyone in some trouble or adversity': 'Amen, amen, I say to you, whatever you ask in prayer, believe that you have received it, and it will be yours. When the righteous cry for help, the Lord hears them, and delivers them out of all their troubles.'[29] Like many of the prayers in Books of Hours, this is a textual mash up. The first sentence is a paraphrase from Mark's Gospel (11:24), and the second is Psalm 34:17. The prayer's message is clear: God will answer those who speak to him, and grant their requests.

There are additional signs in Books of Hours that to pray was to speak to God, the Virgin Mary, angels, and saints. Rubrics instructed readers when and how 'to say' particular prayers. Two common examples: 'Prayer to say ... to the sweet Virgin Mary.'[30] 'The following are some devout prayers to say every morning.'[31] Paul Saenger pointed out that such rubrics refer to the custom of reading aloud, in an era when silent reading was increasingly common.[32] But it is important to add that in these rubrics 'say [this prayer]' is synonymous with 'pray.'

Prayer was a dialogue. More specifically: in the activity of prayer, the devotee's speech forms part of a dialogue or verbal exchange with God or a saint. I do not wish to raise a theological argument here, although many late medieval and early modern writers—Gerson and Erasmus for example—termed prayer a dialogue between human beings and God. Nor do I ask the reader to suspend judgment about whether a god or saint 'really' participates in a dialogue with one who prays (although ideally readers will do so). Rather, my point is a different one, about language: remaining strictly within the semantic and formal terms of the prayers themselves, we can see that devotees participated in a dialogue with the person or persons they addressed.[33]

Dialogue is embedded in the texts of prayers. Psalms provide many examples. But other prayers also include scraps of dialogue, usually paraphrased words spoken by God or a saint, or allusions to a previous exchange. Often the devotee mentions that the addressee spoke to the faithful. Here is an example: 'and you spoke kindly to the Samaritan woman, asking her for a drink.'[34] A prayer to Saint Catherine: 'make an argument against me, according to the clergy's custom.'[35] A prayer to Mary, the last line of the *Obsecro te*: 'And at the end of my life show me your face, and announce to me the day and hour of my dying and death.'[36]

Prayers took the form of many different kinds of speech: confessions, laments, orations, lessons, arguments, debates, oaths, stories, poems, songs and hymns, greetings, proverbs, riddles, and street or market cries. A few examples show the wide range of modes of speech among prayer texts. There are debates resembling

28. Ps. 114:1 (Vulgate/Douai-Reims English translation).

29. Library of Congress, Ms. 51, fol. 131ʳ (Book of Hours, use of Rome, late 15th or early 16th century; Flanders). 'Amen amen dico vobis quitquid orantes pecieritis [*sic*] credite qui accipietis et fiet vobis. Clamaverunt iusti et dominus exaudivit eos et ex omnibus tribulationibus eorum liberavit eos.'

30. BnF, Ms. lat. 14828, fol. 2ʳ (Book of Hours, use of Rome, 15th century with later additions; Paris region and the Loire valley): 'Oraison a dire ... a la doulce vierge marie.'

31. *Heures en Françoys & Latin à l'usaige de Romme* (Lyon: printed by Macé Bonhomme for Guillaume Rouille, 1549), fol. T1ʳ: 'Cy apres ensuyuent aucunes deuotes oraisons à dire tous les matins.'

32. P. Saenger, 'Books of Hours and the Reading Habits of the Later Middle Ages,' in *The Culture of Print,* ed. R. Chartier (Princeton, N.J., 1989), 141–73.

33. For further discussion, see Reinburg, *French Books of Hours* (as in note 11), chap. 4.

34. British Library, Add. Ms. 31838, fol. 17ʳ (devotional miscellany, 15th century; France): 'et benignement parlas a la samaritaine en luy demandant a boyre.'

35. P. Rézeau, *Les prières aux saints en français à la fin du moyen âge: Prières à un saint particulier et aux anges* (Geneva, 1983), 139: 'faiz contre moy .I. argument, selons l'usaige de clargie.'

36. Latin text from the *Obsecro te*: 'Et in novissimis diebus meis ostende michi faciem tuam et annuncies michi diem et horam obitus et mortis mee.' See *Ces presentes heures a lusaige de Rome* (Paris: printed by Philippe Pigouchet for Simon Vostre, n.d. [calendar 1502-20]), fol. K3ᵛ. For an English translation of the entire prayer, see R. Wieck, *Time Sanctified: The Book of Hours in Medieval Art and Life* (New York, 1988), 163–64.

the long exchanges between characters in mystery plays. There are rhyming jingles: 'If you want to get salvation quickly and without delay | if you have no excuse | hear Mass once a day.'[37] The rubrics and titles of some prayers could be described as cries—either market calls, the early modern version of advertising jingles, or public street announcements. Some prayers seem designed to be sung. An example is a rhyming Latin prayer to Saint Sebastian commonly included in Books of Hours: *O sancte sebastiane | semper vespere et mane....*[38] It is easy to see how close prayer could come to everyday speech.

The three most common types of prayer in Books of Hours are what I have called the colloquy-style prayer, the contract-style prayer, and the charm.[39] The three categories are not sharply discrete. But many prayers conform roughly to these patterns, each of which can be linked to specific speech genres in the late medieval and early modern world. For colloquy-style prayers, it was audiences and other forms of conversation. Contract-style prayers resemble oaths, vows, and other legal agreements. Charms can be linked to songs, medical or culinary recipes, storytelling, and the Latin liturgy.

Colloquy-style prayers are relatively formal exchanges with God, Mary, or a saint. They are like conversations one would have with a lord, magistrate, or master. They resemble audiences, a similarity reinforced by the request expressed in one prayer: 'Lord, give me a hearing.'[40] Colloquy-style prayers begin with an invocation, and sometimes a request to be heard, followed by a request for assistance. Often the prayer also includes an argument in which the devotee presents a case for why God or the saint should grant a request. In the invocation, the devotee calls upon the person to whom the prayer is addressed: 'Lord God,'

'madame Saint Martha,' and so on. The devotee then makes a request, usually followed by a promise to devote one's self or life to God or the saint: 'Sweet Saint Lawrence ... I present my soul to you, in your hands.'[41] Sometimes the devotee reminds the addressee of his or her past generosity: 'Lord Jesus Christ, I pray you by the tears which you wept over Jerusalem and by all the drops of your blood.'[42] Devotees appealed to the Virgin Mary in similar terms: 'Most worthy mother of God, today I give you my entire life, I beseech you please to guide me and direct my affairs, and keep me from mortal sin and sudden death.'[43]

Colloquy-style prayers portray God and the saints as persons with a history of behaving intelligibly and benevolently toward human beings. More precisely, in these prayers God, Mary, saints, and devotees play roles familiar in the world of early modern lordship and patronage. Patron-client relations were hierarchical and reciprocal. They were negotiated through words and deeds. A high value was placed on personal presence, verbal tributes, and gifts. Clients assured patrons of their loyalty, deference, and obedience. They humbly pledged their fidelity and service, in exchange for the patron's favor. Colloquy-style prayers capture perfectly the logic of patron-client relations: an idiom of humility and service, and relationships inflected by honor, fidelity, and obedience.

The contract-style prayer is a variation of the colloquy. Here the mutual obligation between the devotee and God or a saint is more concretely stated. The contract style draws on words spoken in vows, oaths, and contracts. These prayers resemble acts of 'faith and homage' (*foi et hommage*), an artifact of seigneurialism still very much alive in the fifteenth and sixteenth centuries.[44] They can also resemble a less common prac-

37. Bibliothèque Sainte-Geneviève, Ms. 2721, fol. 80ʳ (prayer book, use of Guillemites, 16th century; Paris): 'Se veulz donc salvacion | Acquerir brief & sans sejour | Se navez excusacion | Oyez messe une foiz le jour.'

38. Bibliothèque Mazarine, Ms. 511, fol. 258ʳ (Book of Hours, use of Troyes, 15th century).

39. See Reinburg, *French Books of Hours* (as in note 11), chap. 4.

40. J. Paul Getty Museum, Ms. Ludwig IX.11, fol. 140ʳ (Book of Hours, use of Poitiers, c. 1466–70): 'Sire donne moy audience.'

41. Rézeau, *Les prières aux saints* (as in note 35), 303: 'Doulx saint Laurens ... je te presente mon amë en tes mains.'

42. BnF, Ms. nouv. acq. lat. 703, fol. 145ᵛ (prayer book, 15th century; France): 'Domine Iesu Criste precor te per lacrimas quas super Iherusalem emisisti et per omnes guttas sanguinis tui....'

43. BnF, Ms. lat. 14828 (as in note 30), fol. 2ʳ: 'Tresdigne mere de dieu je me donne a vous au jourdhuy tout ma vie vous supplie quil vous plaise me conduire & adresser mes affaires Et me garder de peche mortel & de mort subite.'

44. J. R. Major, '"Bastard Feudalism" and the Kiss: Changing Social Mores in Late Medieval and Early Modern France,' *Journal of Interdisciplinary History* 17 (1987), 509–35.

tice: the vows or contracts made between sworn brothers.[45] Acts of faith and homage and sworn brotherhood affirm a legally binding relationship between two or more people who shared 'one house, one hearth, and one purse.'[46] Contract-style prayers share with these legal acts the statement of concrete, mutual obligation between the parties. A good example is the *O intemerata*. The prayer is addressed to Mary and Saint John, imagined as they stood at the foot of Jesus' cross at Calvary. The devotee declares unequivocal faith in the power and intercession of Mary and John: 'I indeed believe firmly and accept without any doubt that he who wants to be yours will belong to God, and he who does not want to be yours will not belong to God, for you can obtain whatever you ask from God without delay.'[47] The words have the air of a vow. A prayer addressed to Christ employs a slightly different lexicon, closer to that used in oaths and contracts: 'Jesus, you who are the true witness and true sovereign of all, I make you this assurance, that I will, as a loyal Christian, in youth and old age, live and die in your faith.'[48] Contracts, vows, and contract-style prayers share a juridical language—that used to create enforceable legal agreements between two or more parties.

By way of a conclusion, I offer you one final example of how the Book of Hours archived and scripted the speech that was prayer. This is 'the prayer that Notre-Dame du Puy held in her hand,' a short French prayer of about four lines found in two Paris prayer books.[49] In the prayer, the devotee dedicates herself to the Virgin 'in soul and body,' and asks that the Virgin protect her from sin, comfort her, and pray to Jesus on her behalf. The Virgin addressed here is Our Lady of Le Puy in Auvergne, the object of an important pilgrimage from the early Middle Ages until the French Revolution. The prayer is inscribed in two women's Books of Hours from Paris, one from the fourteenth century and the other from the fifteenth century. This suggests that the prayer was associated with a Paris confraternity, shrine, or altar dedicated to Notre-Dame du Puy. Infertility and childbirth were among Our Lady of Le Puy's specialties, so it makes sense that the prayer was found in two women's books. The text preserved the memory of a relationship between the person or persons reciting the prayer and Notre-Dame du Puy. The prayer was copied, or transcribed from memory, so it could be repeated later at home, in church, or at a confraternity's gathering. The devotion was recorded so it could be perpetuated. These Books of Hours framed the practice by preserving it in a book— a book that was precious because it was a valued possession, and likely to be the owner's only book. But the framework was liturgical, because the Book of Hours both symbolized and scripted intercessory prayer rooted in the liturgy, and moreover, *authorized* by the liturgy.

Personally crafted Books of Hours like this one expose key features of Books of Hours, providing important clues about how owners made and used their books. The Book of Hours was both an emblem and a tool of intercessory prayer, and often fashioned into an archive of family memory and pride.

45. A. Tulchin, 'Same-Sex Couples Creating Households in Old Regime France: The Uses of Affrèrement,' *Journal of Modern History* 79 (2007), 613–47.

46. Tulchin, 'Same-Sex Couples' (as in note 45), 614.

47. A passage from the *O intemerata*: 'Credo enim firmiter, fateor indubitanter, quia uelle uestrum uelle Dei est et nolle uestrum nolle Dei est; unde et quicquid ab illo petitis sine mora obtinetis.' See A. Wilmart, *Auteurs spirituels et textes dévots du moyen âge latin: Études d'histoire littéraire* (Paris, 1932), 489. English translation: Wieck, *Time Sanctified* (as in note 36), 164.

48. Library of Congress, Ms. 59, fol. 98ʳ (Book of Hours, undetermined use, *c.* 1430; Amiens): 'Ihesus qui es tiesmoing certain | Et de tous iustes souverain | Ie te fais protestacion | Que ie vueil comme lealle christienne | En ta foy ione & anchienne | Vivre et morir sans fiction.'

49. BnF, Ms. nouv. acq. lat. 592, fol. 120ᵛ (Book of Hours, use of Paris, 14th century); and Bibliothèque Mazarine, Ms. 509, fols. 107ᵛ–108ʳ (Book of Hours, use of Paris, first half of the 15th century). See Reinburg, *French Books of Hours* (as in note 11), 225–29; and V. Reinburg, 'Prayers,' in *Medieval Christianity in Practice,* ed. M. Rubin (Princeton, N.J., 2009), 159–63.

fol. 5ʳ fol. 7ʳ fol. 7ᵛ fol. 8ʳ

fol. 10ʳ fol. 10ᵛ fol. 73ᵛ fol. 96ᵛ

fol. 146ᵛ fol. 154ᵛ fol. 161ᵛ fol. 173ᵛ

A selection of leaves from the Chambly Hours (Princeton University Art Museum, Ms. 2010-115) shown at actual size. The figures that follow are shown enlarged.

ADELAIDE BENNETT

The Chambly Hours: A Diminutive French Book of Hours of the Fourteenth Century (Ms. 2010-115) in the Princeton University Art Museum *

IN 2010 Richard Turner, an alumnus of Princeton University, donated a diminutive fourteenth-century French Book of Hours to the Princeton University Art Museum.[1] This manuscript is truly remarkable for its size, layout of decoration, and imagery. In this paper, I explore these aspects and concentrate in particular on the significance of its unusual heraldry and possible ownership.

In height and width, this Book of Hours measures 58 × 40 mm (see opposite and Figs. 1, 2). Its original size was slightly larger, based on evidence of occasional, slight trimming, particularly of heads of creatures and figures, and tips of leaves at the top and outer lateral margins.[2] Sometime before the twentieth

century, the book was rebound in Italian parchment covered with the Vulgate Bible text of Isaias 38:10–14 (the first part of the Canticle of Ezechias) written in *textura rotunda* script and embellished with one-line blue and red majuscule versals. It is encased in brown leather with 'Missal' inscribed in gold capitals on the front. The justification size of 20 × 18 mm for both miniatures and text-blocks of only eight lines points to this manuscript as being one of the smallest decorated Books of Hours to survive from the thirteenth to the middle of the fourteenth centuries. The tiniest known French example, a manuscript of *c.* 1340 for Paris use and measuring 30 × 20 mm, is in Saint-Petersburg.[3]

The petit Princeton book of 187 folios includes just

* I owe much gratitude to Emeritus Professor James Marrow of Princeton University and to François Avril, Emeritus Conservator of Manuscripts in the Bibliothèque nationale de France, for informing me of this little and precious illuminated manuscript and its heraldry, which led me to conclude definitively on the historical value and genealogical importance of this French Book of Hours. I wish to thank Calvin Brown, Associate Curator of Prints and Drawings, Norman Muller, Art Conservator, and Betsy Rosasco, Research Curator of Later Western Art, all of the Princeton University Art Museum, for their kind assistance and information regarding Ms. 2010-115, and Colum Hourihane, the Director of the Index of Christian Art, for his advice.

1. Cited in *Record of the Art Museum, Princeton University* 70 (2011), 90. The manuscript was previously in Cape May, New Jersey, where Richard Turner resided in retirement. He was the grandson of Frank Jewett Mather, who was the Director of the Princeton University Art Museum to 1946. Turner had a distinguished teaching career in art history (especially Renaissance) at Princeton and New York Universities (his obituary appeared in the *New York Times*, September 23, 2011: http://www.nytimes.com/2011/09/23/arts/design/a-richard-turner-dies-at-79-wrote-inventing-leonardo.html?_r=0). In addition, Richard Turner had lent this Book of Hours to the Princeton University Art Museum for five years from 1963 to 1968. The loan number of '25.63' appears on the reverse of the front bind-

ing; the last two digits of 63 refer to the year 1963. The return of this book, labelled 'Franco-Flemish,' as well as four other items to the owner in 1968 was confirmed by the Museum receipt dated 28 May 1968 with the signature of 'A. Richard Turner.' Ms. 2010-115 is catalogued with 109 records and images on the website of the Index of Christian Art.

2. E.g., fols. 6ʳ, 10ʳ, 12ᵛ, 18ᵛ, 19ʳ, 25ʳ, 29ᵛ, 33ᵛ, 35ʳ, 36ᵛ, etc.

3. Saint-Petersburg, Public Library, Ms. Erm. lat. 17 of 201 folios with the justification of 14 × 6 mm: A. de Laborde, *Les Principaux Manuscrits à peintures conservés dans l'ancienne Bibliothèque Impérial publique de Saint-Pétersbourg*, 2 vols. (Paris, 1936–38), I: 37, with earlier bibliography; T. Voronova and A. Sterligov, *Western European Illuminated Manuscripts of the 8th to the 16th Centuries* (Bournemouth and St. Petersburg, 1996), 80–1, figs. 72–81; T. Voronova and A. Sterligov, *Western European Illuminated Manuscripts 8th to 16th Centuries* (London, 2006), 60–1, figs. 70–9. The Hermitage collection of Western European manuscripts, including this Book of Hours, entered the Public Library in 1861. On the miniaturization of devotional books from the late 13th century on, see, e.g., comments in *Enluminures: A Pageant of Manuscript Books from the 13th to the 19th Centuries* (Paris, 1993), 26–9 (no. 6, 'Miniature Psalter' from France, Lorraine, Metz, *c.* 1280–90, 48 × 30 mm with a justification of 31 × 18 mm) and in E. König, *The Book of Hours of Claude de France* (Ramsen, 2012), 9, 35–7, 44–8, 118 nn. 60, 62, 119 n. 77, 119–20 n. 84. Slightly smaller in

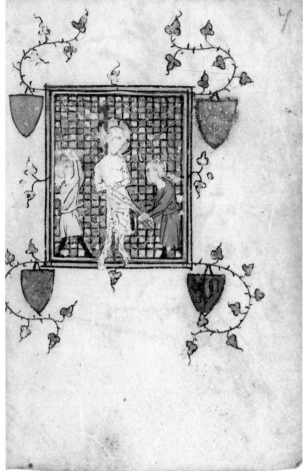

FIGURE 1. Short Hours of the Cross, Sext, Collect. Princeton University Art Museum, Ms. 2010-115, Book of Hours, fol. 10ʳ.

FIGURE 2. Flagellation of Christ, Hours of the Cross, Terce. Princeton University Art Museum, Ms. 2010-115, Book of Hours, fol. 7ʳ.

four basic texts. This begins with the Short Hours of the Cross, the Hours of the Virgin, the Seven Penitential Psalms, and the Litany with petitions and one collect, and concludes with two short prayers. The book shows flaking paint due to wear and tear. It lacks two

miniatures at Matins and Vespers of the Short Hours of the Cross, and probably a calendar, a standard liturgical text at the beginning of a Book of Hours.[4] Although this book has no historiated initials, it is richly illuminated with twenty extant miniatures for

size but little larger in justification than Ms. 2010-115 is a Metz Book of Hours of *c.* 1300 (52 × 37 mm with justification of 24 × 18 mm) in Geneva, Bibliothèque publique et universitaire, Ms. lat. 36; slightly larger than the Princeton codex are two other Metz Books of Hours of similar dating, one in Paris, BnF, Ms. lat. 1361, in size of 60 × 43 (34/35 × 29/30) mm, and the other in Nuremberg, Stadtbibliothek, Ms. Solger 4.12, in size of 70 × 50 (40–45 × 30–35) mm.

4. The quire structure of 187 folios begins with the Short Hours of the Cross and ends with two short prayers, as follows:

I^8 $(1-8^v)$, II^{8-2} $(9-11, x, x, 12-14)$, $III^8-XXIII^8$ $(15-182)$, $XXIV^{6-1}$ $(x, 183-187)$. Catchwords in regular script of brown ink appear at center of bottom margins on the last folios of quires III–XV, and XXIII (the last catchword, *sancta*, intended for the first leaf of quire XXIV, now missing, which once contained the list of virgin saints in the Litany). In the first quire, folio one now consists of a torn sliver of parchment at the inner margin, revealing on the recto a border of foliate stems, and on the verso remnants of two heraldic escutcheons (identified below).

the first three texts and decorated with marginalia of foliate borders inhabited by creatures, primarily birds, and a few hybrids on many of the text pages.

The texts provide information on the chronology and liturgical use of the Princeton manuscript. The Hours of the Cross (fols. 1–14) is shortened to seven canonical hours of Matins to Compline, excluding Lauds.[5] This Office (Figs. 2–5, 11–12) began to appear shortly before or around 1320 in French Books of Hours, establishing at least a *terminus post quem* for the Princeton Hours.[6] Afterwards, it eventually replaced the much longer Hours of the Passion with eight canonical hours (Lauds included).[7] Because of the small size of the Princeton codex, the Office of the Cross is briefer than usual. The canonical hours of Matins to Compline omit the introductory versicles of *Domine labia mea aperies* and *Deus in adiutorium* with their responses, and include only two texts of the hymn and collect. Each hour starts with a hymn stanza of four verses followed by the standard versicle of *Adoramus te domine* with its response of *Quia per sanctam crucem*, and the collect. For example, Matins commences with the hymn of *Patria sapientia*, and each of the succeeding hours begins with a different stanza of this same hymn. Terce, for example, begins the third stanza, *Crucifige*

clamitant hora tertiarum (Fig. 3). In Matins, the collect of *Domine ihesu christe filii dei uiui* is fully written out, but in other hours, such as Terce, only the incipit of the first few words provides a cue to the collect text (Fig. 4). French rubrics occasionally appear in this Office.

In the following section, the text of the Hours of the Virgin is the longest in the book (fols. 14ᵛ–137ʳ).[8] It adopts the use of Paris, which by the second quarter of the fourteenth century often extends beyond the borders of the Île de France. Yet, this Office of the Virgin is short. Because of this book's small dimensions, Matins includes just one nocturn of three lessons instead of the usual three nocturns of nine lessons. Moreover, there is only one collect instead of two in each canonical hour from Lauds to Compline. The Prime to Compline collects dwell on the Holy Spirit, undoubtedly from the Hours of the Holy Spirit.[9] Otherwise, psalms and collects are fully transcribed. Rubrics are chiefly in Latin.

The text of Seven Penitential Psalms (fols. 137ᵛ–178ᵛ) is next. In the ensuing Litany of saints (fols. 179ʳ–183ʳ), five French saints are included among twenty-seven saints (after apostles). Interestingly, these five are local to the northeast region of France: two Picard martyrs, Quintin, the apostle and deacon of Amiens,

5. V. Leroquais, *Les Livres d'heures manuscrits de la Bibliothèque Nationale*, 3 vols. (Paris, 1927), 1: XXV–XXVI; R. Wieck, *Time Sanctified: The Book of Hours in Medieval Art and Life*, with Essays by Lawrence R. Poos, Virginia Reinburg, John Plummer (New York, 1988), 162, on the organization and selection of texts in the Hours of the Cross; E. Sandgren, *The Book of Hours of Johannete Ravenelle and the Parisian Book Illumination around 1400*, Figura Nova Series 28 (Uppsala, 2002), 42; and E. Drigsdahl for comments on the Short Hours of the Cross in www.chd.dk/tutor/HSCruce.html (accessed 12/01/2013).

6. Other examples from the latter part of the second decade of the 14th century to the 1320s are in five Books of Hours: (1) Baltimore, Walters Art Museum, Ms. W. 93, Book of Hours for use of Chalons-sur-Marne, fols. 130ᵛ–142 [not added] (L. Randall *et al.*, *Medieval & Renaissance Manuscripts in the Walters Art Gallery*, France, 875–1420 [Baltimore, Md., 1989], 1: 149–152, no. 57); (2) New York, Public Library, Ms. Spencer 56, Psalter-Hours, fols. 419ᵛ–423ᵛ, added at the end of the book after 1316 during the papacy of John XXII (1316–34), with the French rubric: *Pape iehan le xxii composa cez heures et donna a chascun dicent icelles tant de fois comme il lez diront i an d'indulgence laquele chose nous ottroit celui qui est benoit ou siecle des siecles. Amen;* (3) Los Angeles, The J. Paul Getty Museum, Ms. Ludwig IX.3/83

ML 99, Book of Hours, for use of Amiens, *c.* 1300, fols. 1ʳ–2ʳ [Prime to Compline], added after 1316–*c.* 1320 (A. Euw and J. Plotzek, *Die Handschriften der Sammlung Ludwig*, 4 vols. [Cologne, 1982], 2: 74–83, at 74, 82, figs. 23, 24, for Hours of the Cross); (4) Troyes, Bibliothèque municipale, Ms. 1905, Book of Hours, East France, *c.* 1300, fols. 1–2 (added later); (5) Paris, BnF, Ms. lat. 1394, Book of Hours for use of Amiens, 1320s, fols. 37ᵛ–40ᵛ, Matins to Compline (Leroquais, *Livres d'heures* [as in note 4] 1: 224–6, no. 107).

7. The Hours of the Passion is also termed as the Long Hours of the Cross; I prefer the former to avoid confusion with the Hours of the Cross.

8. This sequence of the Hours of the Cross and the Hours of the Virgin apparently is said to be typical of Flemish Books of Hours, whereas the reverse, the Hours of the Virgin before the Hours of the Cross, is usually the norm for French *Horae*, as mentioned in S. Nash, *Between France and Flanders: Manuscript Illumination in Amiens* (London and Toronto, 1999), 130, 146, n. 7.

9. R. Baltzer, 'The Little Office of the Virgin and Mary's Role at Paris,' in *The Divine Office in the Latin Middle Ages: Methodology and Source Studies, Regional Developments, Hagiography*, ed. M. Fassler and R. Baltzer (Oxford, 2000), 463–84, at 474–81.

FIGURE 3. Hours of the Cross, Terce, *Crucifige clamitant hora tertiarum*, the 3rd stanza of the Hymn, *Partris sapientia*. Princeton University Art Museum, Ms. 2010-115, Book of Hours, fol. 7ᵛ.

FIGURE 4. Hours of the Cross, Terce, Collect. Princeton University Art Museum, Ms. 2010-115, Book of Hours, fol. 8ʳ.

and Firmin, the first bishop of Amiens; and three bishop confessors, Eligius of Noyon, Vedast of Arras, and Amand, venerated in St. Omer and Flanders. One mendicant saint, Francis of Assisi, is listed as the last in the Litany. The folio with the names of the virgin saints is missing between folio 182, which has the catchword of 'sancta,' and folio 183, which begins on its first line with 'Omnes sancte uirgines.' The list of petitions (fols. 183ʳ–184ʳ) is short. The five *Ab* petitions focus on the avoidance of evil, evil thoughts, error, perpetual punishment, and enemies, but the notable one is *A pena*

perpetua, which seems unusual prior to its use in the Princeton Book of Hours.[10] The *Per* petitions are absent. Only two *Ut* petitions for peace and for request for remission of sins are enlisted. On folios 184ʳ–185ʳ appear the *preces*, followed by just one standard collect on folios 185ʳ–186ᵛ, *Fidelium deus omnium conditor et redemptor animabus famulorum famularumque*. The *Horae* concludes on folios 186ᵛ–187ᵛ with two prayers, one for the souls of all deceased faithful, *Anime omnium fidelium deffunctorum*, and the other for thanksgiving, *Agimus tibi gracias omnipotens deus pro uniuersis beneficiis*.[11]

10. An earlier example known to me is a Book of Hours of *c.* 1300 for use of Metz, in Paris, Bibliothèque de l'Arsenal, Ms. 288.

11. The last but short prayer appears on folio 187ʳ, but the

badly rubbed and blackened verso masks most of the lines of text, including the conclusion of this prayer; nevertheless I was able to see the final words, *requiescant in pace*, on the last eighth line.

The second is usually the blessing after the meal, but since there is no blessing before the meal in this manuscript, this should perhaps be regarded as a thanksgiving prayer.[12] The Office of the Dead is absent.

Twenty panel miniatures are visual markers for the canonical hours of the two Offices of the Cross and the Virgin, and the Seven Penitential Psalms. For the Hours of the Cross, the extant illustrations begin at Prime with Christ before Pilate washing his hands (fol. 5r); Terce with the Flagellation (fol. 7r, Fig. 2); Sext with Christ bearing the Cross (fol. 9r); None with the Crucifixion (fol. 10v, Fig. 5); and Compline with the Entombment (fol. 12r). This Princeton codex appears to be one of the relatively few examples to exhibit a full Passion cycle for this Short Office, for the majority of later *Horae* illustrate just the Matins, usually with the subject of the Crucifixion.[13] The Hours of the Virgin exhibit a full cycle of eight episodes of Christ's Childhood, from Matins with Annunciation (fol. 14v); Lauds with Visitation (fol. 44v); Prime with Nativity (fol. 73v, Fig. 6); Terce with Annunciation to Shepherds (fol. 87v); Sext with Adoration of the Magi

(fol. 96v, Fig. 7); None with Presentation (fol. 104v); Vespers with Flight to Egypt with the Fall of Idols (fol. 113v); to Compline with Massacre of the Innocents (fol. 122v).

For the third text, Seven Penitential Psalms are illustrated with figures. Psalms 6 and 31 portray Christ blessing and holding a globe (fol. 137v), and King David playing a harp (fol. 141v), respectively. Five other psalms are unusual for depicting saints. Two cephalophore martyrs, possibly Denis of Paris (d. *c.* 250 or 258) and Nicaise of Reims (d. 407), are shown, one holding the crown of his skull at Psalm 37 (fol. 146v, Fig. 8) and the other holding his severed mitered head at Psalm 50 (fol. 154v, Fig. 9). Of these two, there are more extant examples of Denis holding the top part of his head than those of Nicaise; so the figures could be Denis for Psalm 37 and Nicaise for Psalm 50.[14] Nevertheless, there is, besides Nicaise, another candidate for a mitered cephalophore for Psalm 50. He is Firmin the Martyr and first Bishop of Amiens, who is listed in the Litany on folio 182r. There are other examples of Firmin holding his head. For instance, at one end of

12. This prayer is uncommon in Psalter-Hours or Books of Hours before the Princeton Hours; in a Brabant Psalter-Hours of the late 13th century (Paris, BnF, Ms. nouv. acq. lat. 1017, p. 276 [recto]), this prayer of *Agimus tibi gratias* is used as a thanksgiving prayer, following two prayers of blessing, one (*Benedictio ad comestionem, Oculi omnium in te sperante domine*) before the meal and the other (*Post comestionem, Confiteantur tibi domine omnia opera tua*) after the meal. In fact, the text of *Agimus tibi gratias* does not appear in the indices in vol. 2 of Leroquais, *Livres d'heures* (as in note 5), and V. Leroquais, *Les Psautiers manuscrits latins des Bibliothèques de France*, 2 vols. (Mâcon, 1940–41); only one example without the rubric is found in V. Leroquais, *Les Bréviaires manuscrits des bibliothèques publiques de France*, 5 vols. (Paris, 1934), 2: 13–7, no. 212 (Compiegne, Bibliothèque municipale, Ms. 1–2, Breviary of Saint-Cyran, 15th century, Ms. 1, paginated 134).

13. Earlier than the picture cycle of the Princeton Book of Hours are Baltimore, Walters Art Museum, Ms. w. 93, fols. 130v–142 (7 historiated initials from Matins to Compline), and Los Angeles, The J. Paul Getty Museum, Ms. Ludwig IX.3 / 83 ML 99, fols. 1–2 (6 historiated initials from Prime to Compline). For example, among later 31 examples of 15th-century Books of Hours attributed to Amiens illuminators by Nash, just one manuscript, the Collins Hours, now in Philadelphia, Museum of Art, Ms. 45-65-4, has a full cycle of tipped-in miniatures at beginning of each of the 7 hours in the Hours of the Cross (Nash, *Manuscript Illumination in Amiens* [as in note 8], 355, no. 25, table showing subjects for the Office of the Cross). Also

only the Hours of Thiébaut de Luxembourg (Brussels, Bibliothèque royale, Ms. 9785, fols. 92r–133v) includes the Hours of the Passion, here illustrated with the full pictorial cycle for all 8 canonical hours (*ibid.*, 277).

14. Numerous examples in the Index of Christian Art, Princeton University, show both Denis of Paris and Nicaise of Reims holding their severed heads. Occasionally, however, these two saints hold tops or crowns of their heads. For Denis with the top or crown of his head, French examples appear as follows: Bourges, Cathedral, Chapel of the Virgin, stained glass window 1 of *c.* 1210–15; Tours, Cathedral of St. Gatien, Choir, stained glass, 13th century; Cambridge, Fitzwilliam Museum, Ms. 300, Psalter-Hours of Marie de Brabant of *c.* 1274, fol. 202v, illustration for the Lauds Suffrage to Denis of Paris; Chantilly, Musée Condé, Ms. 1887/51, Breviary of Jeanne d'Evreux of *c.* 1330, fol. 392r, illustration for Matins first lesson of the saint's feast day of October 9th; The Hague, Koninklijke Bibliotheek, Ms. 76.F.5, Saint-Bertin Picture Bible-Vitae Sanctorum of early 13th century, fol. 28v (mitered crown); Chartres Cathedral of Notre Dame, South Portal sculpture, south side of pier 1, datable to *c.* 1230–40, here identified either Denis or Nicaise holding top of his head. Examples of Nicaise with the top or crown of his head are as follows: Glasgow, Museum, Burrell Collection, stained glass panel of early 14th century, 45.373/359 (with no name); and New York, Morgan Library, Ms. M. 27, Book of Hours of *c.* 1420–30 for Rouen use, fol. 161v, illustration for the Collect in the Suffrage to Nicaise.

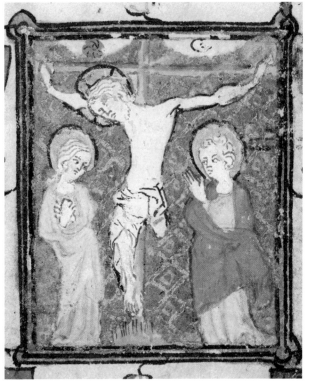

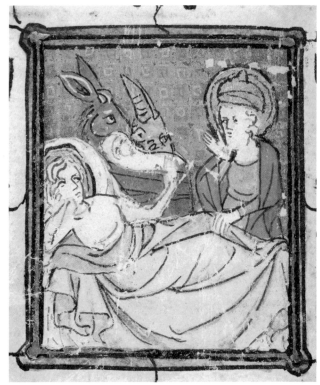

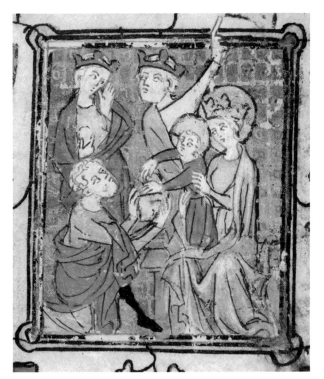

FIGURE 5. Crucifixion, Hours of the Cross, None. Princeton University Art Museum, Ms. 2010-115, Book of Hours, fol. 10ᵛ.

FIGURE 6. Nativity, Hours of the Virgin, Prime. Princeton University Art Museum, Ms. 2010-115, Book of Hours, fol. 73ᵛ.

FIGURE 7. Adoration of the Magi, Hours of the Virign, Sext. Princeton University Art Museum, Ms. 2010-115, Book of Hours, fol. 96ᵛ.

FIGURE 8. Cephalophore Martyr, Third Penitential Psalm 37. Princeton University Art Museum, Ms. 2010-115, Book of Hours, fol. 146ᵛ.

FIGURE 9. Cephalophore Martyr, Fourth Penitential Psalm 50. Princeton University Art Museum, Ms. 2010-115, Book of Hours, fol. 154ᵛ.

the destroyed late twelfth-century metal casket shrine of Firmin the Martyr from Amiens Cathedral, the saint is recorded as holding his head.[15] A thirteenth-century limestone cultic statue of Firmin with his mitered head, likely of Amiens provenance, is also to

be found in New York (Metropolitan Museum of Art, 1936.81).[16] Moreover, at Amiens Cathedral, a statue of Firmin holding his head, made later around 1375, appears on the north exterior of the chapels dedicated to both John the Baptist and John the Evangelist.[17]

15. The Shrine of Firmin the Martyr was made during the episcopate of Theobald III of Amiens, 1169–1204, according to inscriptions on the front base of the casket. J. Corblet, *Hagiographie du diocèse d'Amiens*, 5 vols. (1869–75), 2: 166, 183–94; G. Durand, *Monographie de l'église Notre Dame: Cathédrale d'Amiens*, 2 vols. (Paris, 1901–03), 2: 42–6; K. Gould, *The Psalter and Hours of Yolande of Soissons* (Cambridge, Mass., 1978), 110 n. 113; and M. C. Gaposchkin. 'Portals, Processions, Pilgrimage, and Piety: Saints Firmin and Honoré at Amiens,' in *Art and Architecture of Late Medieval Pilgrimage in Northern Europe and the British Isles*, ed. S. Blick and R. Tekippe, 2 vols., Studies in Medieval and

Reformation Traditions: History, Culture, Religion, Ideas, CIV (Leiden and Boston, Mass., 2005), 1: 238–39.

16. C. Little, 'Monumental Gothic Sculpture from Amiens in American Collections,' in *Pierre, lumière, couleur: Études d'histoire de l'art du Moyen Âge en l'honneur d'Anne Prache*, ed. F. Joubert and D. Sandron (Paris, 1999), 251–53, figs. 8–9; *Set in Stone: The Face in Medieval Sculpture*, ed. C. L. Little, Exhib. cat., The Metropolitan Museum of Art, New York (New Haven, Conn., and London, 2006), 196–97 (no. 81), color pl. p. 197.

17. Durand, *Cathédrale d'Amiens* (as in note 15), 1: fig. 143; C. Sherman, *The Portraits of Charles V of France (1338–1380)*,

FIGURE 10. John Baptist, Fifth Penitential Psalm 101. Prince-ton University Art Museum, Ms. 2010-115, Book of Hours, fol. 161ᵛ.

FIGURE 11. Fiacrius of Meaux, Seventh Penitential Psalm 142. Princeton University Art Museum, Ms. 2010-115, Book of Hours, fol. 173ᵛ.

The Cathedral was the cult center for the relic of the Baptist's head on the charger (received in 1206). If, in the Princeton codex, the second cephalophore is Firmin, he and Denis would surely be venerated as patron saints of Amiens and France, respectively. Fir-min's presence may well explain the sequential choice of the two saints—John the Baptist with the Lamb of God for Psalm 101 (fol. 161ᵛ, Fig. 10), and John the Evangelist with the chalice for Psalm 129 (fol.

170ᵛ, Fig. 16). At the last Psalm 142 (fol. 173ᵛ, Fig. 11) Fiacrius of Meaux, the gardener with the spade, is depicted.[18] Normally, hagiographical figures such as these five would have illustrated Suffrages in Books of Hours.

All twenty miniatures adhere to the same format and size. Although these twenty pages have no text, the miniatures are actually not full-page. For instance, on folio 5 recto (Fig. 12), the Prime miniature of Christ

Monographs on Archaeology and the Fine Arts sponsored by the Archaeological Institute of America and the College Art As-sociation of America, xx (New York, 1969), 58, 60–2, 80, text fig. 2 p. 61, fig. 52.

 18. In the Parisian Book of Hours of Yolande de Flanders of

the 1340s in London (British Library, Ms. Yates Thompson 27, fol. 70ᵛ), Fiacrius of Meaux, wearing a hood and scapula over white tunic, holds a spade; he figures with four other saints in the margins of Hours of the Virgin at Terce (K. Morand, *Jean Pucelle* [Oxford, 1962], pl. xxa).

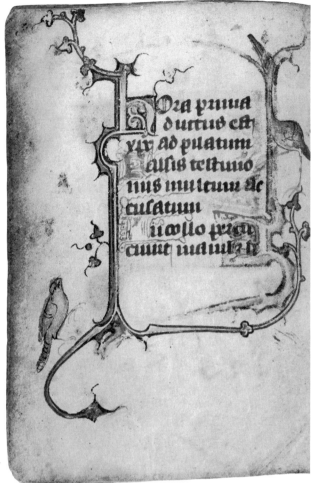

FIGURE 12. Christ before Pilate, Hours of the Cross, Prime. Princeton University Art Museum, Ms. 2010-115, Book of Hours, fol. 5ʳ.

FIGURE 13. Hours of the Cross, Prime, Hymn. Princeton University Art Museum, Ms. 2010-115, Book of Hours, fol. 5ᵛ.

before Pilate in the Hours of the Cross, measuring 20 × 18 mm, is set within the nearly square frame with pendant armorials in the surrounding space. Four escutcheons hang from wire-like, curvilinear, foliate tendrils issuing from the frame corners. The blank bottom margin between the lower frame of the miniature to the edge of the page measures approximately 20 mm. The spacious lower margins are typical of this codex. So too are the wide lateral outer margins with dimensions of 14–15 mm, a practical solution to avoid touching the miniature or text when turning a page of this miniscule book. On the verso of folio 5 (Fig. 13), the parchment is thin enough to see the text of eight lines approximating the size of the recto miniature. The script is legible. Here the text-block of 20

× 18 mm exhibits ample margins which are inhabited by two birds, one a stork—recognizable for the red color of its bill and legs—amid the foliate stems sprouting from the initial H of the hymn, *Hora prima*. Pages with generous outer lateral and bottom margins of miniatures and text-blocks in equivalent sizes seem to enhance the paradoxical illusion of capaciousness in this little prayer book.

These miniatures show a uniform style of conservative draftsmanship. Figures are drawn in brown ink with no modelling of flesh and drapery. Their apparels are painted in pastel colors of blue, pink, gray, or lavender-gray, and rarely yellow, in sharp contrast to bright orange. Figures are set against strong colorful patterns of yellow lozenges against blue backgrounds,

and diapered squares, either in predominantly red, pink, and pale lavender, or multicolored.

Marginalia focus on birds, which are depicted on eighty-one pages. Some are storks, and a few are owls. An owl perches on a trefoil leaf in the right margin of folio 131[v], appropriately in Compline, the nocturnal Office of the Virgin (Fig. 14). Most birds seem naturalistically rendered with their plump breasts and often with one leg raised, but regrettably, they cannot be identified.[19] There are twenty-five butterflies and eight dogs, such as a crouching dog eyeing a butterfly on a Matins page of the Virgin (fol. 34[r]). In another case, a dog runs with a bone in its jaws (fol. 97[r]) in the lower margin of the Sext text of the Virgin. There are seven rabbits—for example, one pursues a dog on the text page of Psalm 12 in Compline of the Virgin (fol. 123[v])—and two lions. Butterflies flutter about in the margins of the sacred text; most of them have red wings with scales in white and sometimes in black (e.g., Fig. 3). Occasionally there are hybrid men issuing from vertical foliate stems in the left margins, engaged in different activities: one blowing a trumpet on folio 25[v], another with the same instrument beside the Vespers hymn of *Ave maris stella* on folio 116[r], one ringing two bells on folio 36[v], one throwing a ball on folio 125[v], and another wielding sword and buckler on folio 72[r].

One of the most interesting aspects of this book is the heraldry, and it is this that identifies the recipient, user, and owner of this devotional book. The same set of four pendant armorials is found on twenty miniatures, for example, the Annunciation to the Shepherds (fol. 87[v], Fig. 15) in the Terce Hours of the Virgin or Evangelist John (fol. 170[v], Fig. 16) for the sixth Penitential Psalm 129. On the upper dexter side of the picture frame is the armorial of Chambly, *gules, three scallops or*, and on the lower dexter is that of Ronquerolles, *gules, papelonné argent*. On the upper sinister side is the escutcheon of Bazentin, *azure, semy of fleurs-*

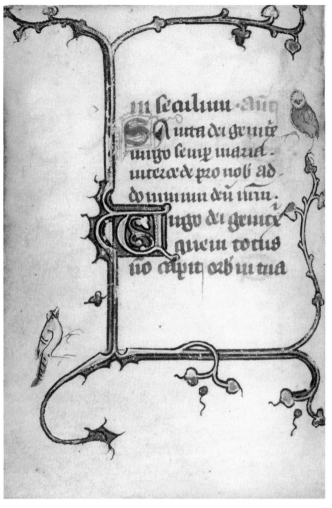

FIGURE 14. Hours of the Virgin, Compline, Hymn. Princeton University Art Museum, Ms. 2010-115, Book of Hours, fol. 131[v].

de-lis argent, and on the lower sinister is the shield of Fiennes, *argent, a lion rampant sable*.[20] These heraldic arms represent four families. The first three are allied by common pedigree through marriage; the fourth is linked to the third above. Of the four, the literature on the Chambly family is the best known.[21] Of relevance to this manuscript is the particular Chambly family

19. I found no comparable bird species in B. Yapp, *Birds in Medieval Manuscripts* (London, 1981). This was also confirmed by two medievalists with specialty in ornithology, Richard Wright and Alison Beringer, whom I wish to thank for their advice.

20. I owe thanks to François Avril for identifying the coats of arms in his correspondence with James Marrow (11 June 2011).

21. M. J. Depoin, 'La Maison de Chambly sous les capétiens

directs,' *Bulletin philologique et historique (jusqu'a 1715) du Comité des travaux historiques et scientifiques* (1914), 117–62, at 152–53 (for the family and descendants of Jean Hideux de Chambly, seigneur of Ronquerolles, 1293–99). For the genealogy table 3 of Jean Hideux de Chambly and Marguerite de Ronquerolles on page 8, see http://racineshistoire.free.fr/LGN/PDF/Chambly .pdf.

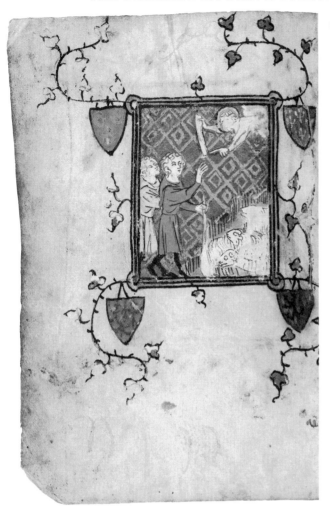

FIGURE 15. Annunciation to Shepherds, Hours of the Virgin, Terce. Princeton University Art Museum, Ms. 2010-115, Book of Hours, fol. 87ᵛ.

FIGURE 16. Evangelist John, Sixth Penitential Psalm 129. Princeton University Art Museum, Ms. 2010-115, Book of Hours, fol. 170ᵛ.

of Jean Hideux, seigneur of Ronquerolles, whose descendant may well have owned and used this Book of Hours. Since the late eleventh century, the Chamblys had been castellans of the castle named after them, situated close to the south Oise border and west of Senlis in the Île de France.[22] The name Chambly derives from the French *chambellan*, denoting the office of the chamberlain. In the thirteenth century, members of the extensive Chambly clan were associated with

the royal household, for instance, Pierre V de Chambly, *dit* Hideux, served as a chamberlain to King Louis IX.[23] In fact, his father, Pierre IV de Chambly de Laon, who died in 1282, was involved with the process of promoting the canonization of King Louis, which finalized in 1297.[24] The Chambly arms appear on seals, for example, on a 1294 seal of Isabelle de Rosny, second wife of Pierre V de Chambly and stepmother of Jean Hideux, with her husband's Chambly three

22. W. Jordan, *Louis IX and the Challenge of the Crusade: A Study in Rulership* (Princeton, N.J., 1979), 106, for the map of Chambly, which was the site of Louis IX's *tournée* in 1248.

23. Depoin, 'Maison de Chambly' (as in note 21), 130, and M. Prinet, 'Armorial de France composé à la fin du XIIIᵉ siècle ou

au commencement du XIVᵉ,' *Le Moyen Âge* 31 (1920), 1–49, at 12 n. 2. Pierre V de Chambly *dit* Hideux was the father of Jean Hideux, seigneur of Ronquerolles.

24. Depoin, 'Maison de Chambly' (as in note 21), 127.

scallops on the dexter side and her Rosny family arms of two bars on the sinister side.[25]

The Chambly descendants continued to be prominent members of the fourteenth-century noblesse, as is attested by their symbolic presence in this Book of Hours. It is the conjunction of these three arms of Chambly, Ronquerolles, and Bazentin that confirms which generation of the Chambly family is represented. It is Marguerite de Chambly, daughter of Jean Hideux de Chambly, chevalier and seigneur of Ronquerolles, and Marguerite, heiress and dame of Ronquerolles (adjacent to and west of Chambly in Île de France).[26] This daughter, who used the title of *dame de Ronquerolles*, married Renaud de Montauban, seigneur of Bazentin, located in Picardy (in the Somme region between Amiens to the south and Arras to the north). Their eldest daughter was Marie, dame of Bazentin, Montauban, Averdoingt, and Ronquerolles, who married Pierre, seigneur of Flavy in Picardy.[27] Marguerite de Chambly's marriage to Renaud de Bazentin lasted from 1319 to 1343, the year of her husband's death by decapitation for giving intelligence to the English enemy.[28] This twenty-four year span would date this Book of Hours to the decades of the 1320s and the 1330s. These three family arms are verified in late thirteenth-century rolls of arms.[29] They are also confirmed in the *Armorial le Breton* (Paris, Archives de France, AE I 25, MM 684), an original painted compilation of two different periods, *c.* 1300 and mid-fifteenth century. The painted armorials of Chambly, Ronquerolles (Fig. 17), and Bazentin (Fig. 18) appear in the *c.* 1300 section (pp. 18–46), representing a generation or two before the Princeton codex.[30]

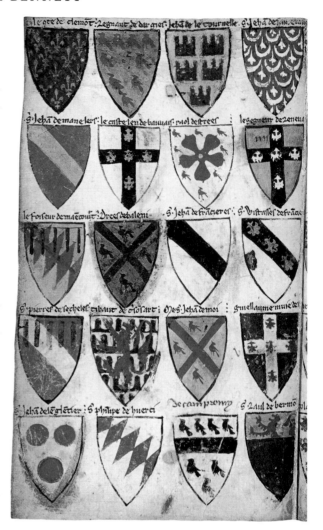

FIGURE 17. Ronquerolles, Coat of Arms, in *Armorial le Breton*, Paris, Archives de France, AE I 25, MM 684, p. 24, no. 259, first row, no. 4, illustrated in E. de Boos *et al.*, *L'Armorial Le Breton* (Paris, 2004), 80.

25. B. Bedos Rezak, 'Women, Seals, and Power in Medieval France, 1150–1350,' in *Women and Power in the Middle Ages*, ed. M. Erler and M. Kowaleski (Athens, Ga., and London, 1988), 61–82, at 68, 71–3, fig. 8 (Seal of Isabelle de Rosny, dated 1294).

26. Depoin, 'Maison de Chambly' (as in note 21), 153; see the genealogy table in E. de Boos *et al.*, *L'Armorial Le Breton* (Paris, 2004), 246.

27. For biographical accounts of these family members pertaining to the genealogy table (p. 246) in Boos, *Armorial Le Breton* (as in note 26): Chambly (nos. 245, 888), Ronquerolles (nos. 259, 884), Bazentin-Montauban (nos. 372 with Boulonnaise connections, 539, 883, 885), Averdoingt (ancestor for the house of Bazentin, no. 886), and Flavy (descendant of all the above, no. 883). I have yet to find the birth date of Marie de Bazentin, the wife of Pierre de Flavy.

28. Page 8 in http://racineshistoire.free.fr/LGN/PDF/Chambly .pdf.

29. M. Popoff, *Artois et Picardie: Beauvaisis, Boulonnais, Corbiois, Ponthieu, Vermandois,* Marches d'armes, 1 (Paris, 1981), for the Vermandois Roll of Arms, pertaining to Artois and Picardy and datable to 1280–1300: no. 268 p. 258: *Le sire de Basentin porte d'asur à fleurs de lis d'argent. Baneres*, and no. 269 p. 258: *Le sire de Ronqueroles porte de gueulles pappellonné d'argent. Baneres*; for the Chifflet-Prinet Roll, now considered datable to *c.* 1297, printed in Prinet, 'Armorial de France' (as in note 23), no. 27 p. 12: *Mesire Piere de Chambeli porte les armes de gheules a trois coquilles d'or* (in ref. to Pierre V de Chambly *dit* Hideux, d. 1297).

30. Reproduced in Boos, *Armorial Le Breton* (as in note 26): pl. p. 23, no. 245 (*Chambely*, Pierre V de Chambly); pl. p. 24, no. 259 (*Sire Jehan de Saneville & Ranqueroles*, Jean, seigneur of

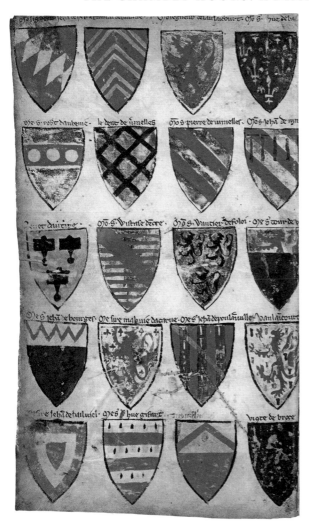

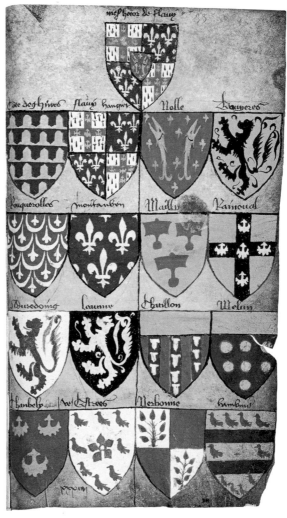

FIGURE 18. Bazentin, Coat of Arms, in *Armorial le Breton*, Paris, Archives de France, AE I 25, MM 684, p. 38, no. 539, first row, no. 4, illustrated in E. de Boos *et al.*, *L'Armorial Le Breton* (Paris, 2004), 94.

FIGURE 19. Painted Coats of Arms of Chambly-Ronquerolles-Bazentin in the mid-fifteenth-century genealogy of Hector de Flavy, in *Armorial le Breton*, Paris, Archives de France, AE I 25, MM 684, p. 65, illustrated in E. de Boos *et al.*, *L'Armorial Le Breton* (Paris, 2004), 121.

The mid-fifteenth-century section shows a full-page family genealogy consisting of painted armorials from Chambly to Ronquerolles to Bazentin (labelled Montauban) to Hector Flavy of a prominent Picard family (Fig. 19).[31] This Princeton book therefore provides and confirms another earlier documentation of these same families.

The fourth coat of arms, *argent a lion rampant sable,*

Ronquerolles, living *c.* 1299); pl. p. 38, no. 539 (*Mon seigneur Hue de Basantin,* Hue, seigneur of Bazentin, d. 1298); and pl. p. 29 no. 372 (with a label of five gules: *Basantain,* Jean III, seigneur of Bazentin, Montauban and Averdoingt, and son of Hue, seigneur of Bazentin).

31. Boos, *Armorial Le Breton* (as in note 26), pl. p. 65 (nos. 888, 884, 885, 883, 881); for biographical accounts, see pp. 225–27: nos. 888 (*Chanbely*), 884 (*Ronquerolles*), 885 (*Montauben / Bazentin*), 883 (*Flavy Hangiet*), and 881 (*Mesire Hetor de Flavy*). Hector de Flavy

(*c.* 1410–66), seigneur of Montauban-de-Picardie, was the 5th of 6 sons of Raoul de Flavy, seigneur of Bazentin. Raoul was the son of Pierre de Flavy and Marie, dame of Bazentin, Montauban, Averdoingt and Ronquerolles (see the genealogy table, *ibid.*, 246). Charles de Flavy (1430–d. before 1464), a brother of Hector and 3rd son of Raoul, was seigneur of Ronquerolles; his armorial is identical to that of Hector, except for the center overall shield, *gules papelonné argent* of Ronquerolles, cited in M. Popoff, *Armorial de Gelre (Bibliothèque royale de Belgique, Ms 15652-15656)* (Paris,

needs further explanation (Figs. 15, 16). At first, one might think that this represents the armorial of Averdoingt, except that its tincture of lion rampant is sinople (green).[32] Yet, this same armorial on all twenty miniatures shows the rampant lion firmly outlined and painted in black, showing no alteration of green pigment to black.[33] This heraldry was borne by the noble family of Fiennes. A thirteenth-century relative, Guillaume II de Fiennes (d. 1302) was the Constable of Boulonnais (Artois).[34] His armorial is included in three rolls of arms: the Chifflet-Prinet of 1297, the Vermandois of 1280–1300, and the *Le Breton* of *c.* 1300.[35] In the *deluxe* Flemish Psalter of the Count of Flanders, Guy de Dampierre, *c.* 1278 (Brussels, Bibliothèque royale, Ms. 10607), a similar coat of arms appears in the lower right medallion of the frame.[36] In addition, the armorial of *argent a lion rampant sable* occurs in at least two later Books of Hours with stylistic connections to Saint-Omer in the Franco-Flemish region. In Baltimore (Walters Art Museum, Ms. w. 90), the Book of Hours of *c.* 1300 shows a male dancer blowing a trumpet with a banner of the same arms in the right

margin of the opening page of Matins in the Hours of the Virgin for use of Saint-Omer (fol. 22r), and a soldier with the same heraldic shield in the bottom margin of the Terce chapter of the Virgin (fol. 70v).[37] More pertinent, the other Book of Hours for Amiens use, probably after *c.* 1320, in Paris (Bibliothèque nationale de France, Ms. lat. 1394) displays the arms of *argent, a lion rampant sable* of Fiennes (fol. 84r) and three escutcheons of *azure, semy of fleurs-de-lis argent* of Bazentin (fols. 31r, 41r, 67r). Moreover, this codex includes a variant armorial with the black lion of the Heuchin branch of Fiennes on three folios, as follows: *argent, semy of billettes sable and lion rampant of the same* (fol. 21r).[38] On another shield (fol. 77r), this same heraldry is impaled with that of Bazentin, as follows: *argent, semy of billettes sable and lion rampant of the same dimidiated with azure, semy of fleurs-de-lis argent, on a bend argent of the same.*[39] Thus, these escutcheons surely confirm the family connections between Fiennes and Bazentin.[40] Pertaining to the Princeton Hours, it may be worth noting that the *Le Breton* armorial book of *c.* 1300 includes the arms of Jean de Fiennes, the son of

2012), 478 (no. 1695). For the period between 13th century and 15th century on family members of Flavy whose name derives from the village of Flavy-le-Martel in Aisne, arrondissement of Saint-Quentin, in Picardy, see P. Champion, *Guillaume de Flavy, Capitaine de Compiègne; contribution à l'histoire de Jeanne d'Arc et à l'étude de la vie militaire et privée au XVe siècle* (Paris, 1906), 1–4.

32. If the lion rampant were in green or *sinople*, then the coat of arms might have pointed to the seigneury of Averdoingt, held by Jean Bazentin, who was the grandfather of Renaud de Montauban, the latter as the husband of Marguerite de Chambly, dame of Ronquerolles. The Averdoingt armorial appears in the mid-15th century section of the *Le Breton* book (Boos, *Armorial Le Breton* [as in note 26], color pl. p. 65, no. 886).

33. For this observation, I wish to thank Norman Muller, the Conservator of the Princeton University Art Museum, who examined this particular armorial in the Ms. 2010-115 under the microscope on 21 November 2013.

34. G. Brault, *Rolls of Arms: Edward I (1272–1307)*, 2 vols. (Woodbridge, Suffolk, 1997), 2: 164 (Fiennes, Guillaume de) for the date of his death in 1302.

35. For the Fiennes armorial in the Chifflet-Prinet Roll, see Prinet, 'Armorial de France' (as in note 23), no. 56 p. 20: *Li conestables de Boulonnois porte les armes d'argent a un lion noir couronné d'or*; in the Vermandois Roll, see Popoff, *Artois et Picardie* (as in note 29), no. 225 p. 254: *Le sire des Frennes porte d'argent à lion de sable. Baneres* (listed under Artois); and in Boos, *Armorial Le*

Breton (as in note 26), pl. p. 39 (no. 569), p. 194 (no. 569): *Guiliaumes de Fienes, d'argent au lion de sable.*

36. K. Carlvant, *Manuscript Painting in Thirteenth-Century Flanders: Bruges, Ghent and the Circle of the Counts* (London and Turnhout, 2013), color pl. 17 (fol. 9v). A number of shields in corner medallions of miniatures should be considered with caution, as some may have been restored or redone. See C. Gaspar and F. Lyna, *Les Principaux Manuscrits à peintures de la Bibliothèque royale de Belgique*, 2 vols. (Brussels, 1937, repr., 1984), 1: 222, for the identity of Fiennes, but also other names of Nortwyck, Bouchorst, and Créquy have been suggested.

37. Randall, *Manuscripts in the Walters Art Gallery* (as in note 3), 138–42 (no. 54), at 140 (under section 6, 'Drolleries').

38. C. Loizeau de Grandmaison, *Dictionnaire heraldique* (Paris, 1852), col. 85: Heuchin, Artois.

39. Leroquais, *Livres d'heures* (as in note 5), 1: 224–27 (no. 107); E. S. Greenhill, 'A Fourteenth-Century Workshop of Manuscript Illuminators and its Localization,' *Zeitschrift für Kunstgeschichte* 40 (1977), 1–25, at 8–10, 12 and n. 39, 14, 18 and n. 54, figs. 8–11 (fols. 13r, 15r, 20r, and 84r, the latter with the Fiennes arms).

40. Boos, *Armorial Le Breton* (as in note 26), nos. 372 and 887, mentions that Jean III, seigneur of Bazentin, Montauban, and Averdoingt, and son of Hue, seigneur of Bazentin, married Dame de Leaune who inherited lands in the Boulonnais region. It is useful to note that Guillaume II de Fiennes was the Constable of Boulonnais (Artois).

Guillaume II (*argent, a lion rampant sable with label of 5 points gules*).[41] After his father's death, Jean de Fiennes would have inherited the arms of *argent, a lion rampant sable*. Born *c.* 1270–1277 and died *c.* 1333, he was appointed the keeper of the Castle of Cassel in Flanders in 1307 by the French King Philip IV. Jean married Isabelle, daughter of Guy de Dampierre, Count of Flanders.[42] The Jean de Fiennes armorial with a label appears on the same page with three Dampierre arms in the *Le Breton* part of *c.* 1300.[43] Jean de Fiennes' life span thus may be suitable for the armorial in the Princeton Hours, and his relationship to the Chambly-Ronquerolles-Bazentin clan may also be commemorated on the basis of friendship, as comrade in arms,[44] or as a witness to the marriage ceremony of Marguerite de Chambly, dame of Ronquerolles, and Renaud de Montauban, seigneur of Bazentin, or as godparent to the newborn. In the Princeton book, the Fiennes coat of arms relates directly to the Bazentin arms

above on the sinister side of all twenty miniatures. The Bazentin armorial also underscores its lineage to Chambly, Ronquerolles, as well as Fiennes.

In light of the heraldic evidence and its impact on the chronology of the Princeton Hours, the stylistic background also points to the 1320s and 1330s. Its rather mediocre figure style cannot be compared in quality with books of devotions for royal or high nobility, such as the Hours of Jeanne de Savoie of *c.* 1325 in Paris (Musée Jacquemart-André, Ms. 1), or the later Hours of Jeanne de Navarre, after 1336, now in Paris (Bibliothèque nationale de France, Ms. nouv. acq. lat. 3145); both are in the style of Jean Pucelle, the most prominent Parisian artist during this period.[45] A more apt comparison would be a small Parisian Book of Hours of the same use from the 1320s in Cambridge (Fitzwilliam Museum, Ms. 89-1972).[46] For the suffrage of Eustace of Rome (fol. 22ʳ), his vision is pictured in the nearly square miniature with foliate shoots of

41. Boos, *Armorial Le Breton* (as in note 26), color pl. p. 39 (no. 570), p. 194 (no. 570): *d'argent au lion de sable, au lambel de gueules*.

42. On Jean de Fiennes, Baron of Fiennes and Tingry (Pas-de-Calais), Artois, see P. Anselme, *Histoire genealogique et chronologique de la maison royale de France...*, 9 vols. (Paris, 1726–33), 6 (1730): 169; F.-A., Aubert de La Chesnaye-Desbois, *Dictionnaire de la noblesse*, 3rd ed., 19 vols. (1863–77), 8 (1866): col. 41; Boos, *Armorial Le Breton* (as in note 26), 194 (no. 570). See table 3 of the Fiennes branch of Guillaume II de Fiennes and Blanche de Brienne in http://racineshistoire.free.fr/LGN/PDF/Fiennes .pdf. Another candidate for possessing the arms of Fiennes in the Princeton Hours is Jean's son, Robert *dit* Moreau, but his activities, including being the Constable of France appointed in 1357, appear to have been recorded in documents from 1337 to 1380 (Anselme, *Histoire genealogique*, 6: 166–67, 170). I think that Robert *dit* Moreau is a generation too late to be associated with the Princeton Hours. For his painted arms in the late 14th century, see M. Pastoureau and M. Popoff, *L'Armorial Bellenville*, 2 vols. (Lathuile, 2004), 1: 62 (no. 67): *fienes, d'argent au lion de sable lampassé de gueules*, 2: color pl. fol. 2ʳ; also for the later Netherlandish Gelre Roll of Arms, see Popoff, *Armorial de Gelre* (as in note 31), 221 (no. 414): *die he(r) va(n) vielgen, d'argent au lion de sable armé et lampassé de gueules*. The term of *lampassé de gueules* (equivalent to the English term, langued in gules, that is, a tongue visible in tincture of gules) appears to be a later addition to the Fiennes arms recorded in these two rolls. Robert *dit* Moreau died childless in *c.* 1380.

43. Boos, *Armorial Le Breton* (as in note 26), color pl. p. 39 (no. 570 for Jean de Fiennes, and nos. 556–58 for members of the Dampierre family).

44. The Vermandois Roll of 1280–1300 mentions the arms

of Fiennes (no. 225), along with Bazentin (no. 268), and Ronquerolles (no. 269) in the section of Artois, in Popoff, *Artois et Picardie* (as in note 29), 254 and 258.

45. A good survey of this period in the first half of the 14th century may be found in Morand, *Jean Pucelle* (as in note 18), F. Avril, 'Trois Manuscrits de l'entourage de Jean Pucelle,' *Revue de l'art* 9 (1970), 37–48; F. Avril, *Manuscript Painting at the Court of France: The Fourteenth Century (1310–1380)* (New York, 1978); *Les Fastes du Gothique: Le Siècle de Charles V*, Galeries nationales du Grand Palais, 9 octobre 1981–1ᵉʳ février 1982 (Paris, 1981), 289–97 (nos. 235–43, 246–48, 265 by F. Avril) on Jean Pucelle and followers; C. Sterling, *La Peinture médiévale à Paris: 1300–1500*, Bibliothèque des Arts, 2 vols. (Paris, 1987), 1: 69–136; R. S. Wieck, 'The Savoy Hours and its Impact on Jean Duc de Berry,' in *Beinecke Studies in Early Manuscripts, The Yale University Library Gazette*, Supplement, 66 (1991), 159–80 (the Hours of Blanche of Burgundy, wife of Count Edward of Savoy, in the 1330s, New Haven, Yale University Library, Ms. 390); for the book of 10 essays and full bibliography on Jean Pucelle and his influence, most recently published in November of 2013, see *Jean Pucelle: Innovation and Collaboration in Manuscript Painting*, ed. K. Pyun and A. Russakoff (London and Turnhout, 2013).

46. F. Wormald and P. Giles, *A Descriptive Catalogue of the Additional Illuminated Manuscripts in the Fitzwilliam Museum Acquired Between 1895 and 1979 (Excluding the McClean Collection)*, 2 vols. (Cambridge, 1982), 2: 570–72. The manuscript measures 70 × 50 (45 × 35) mm, which in size is very close to the Metz Book of Hours in Nuremberg (cited in note 3). As in the Princeton Hours, the Matins text in the Hours of the Virgin is curtailed to one nocturn of three lessons.

trefoil leaves and knobbed stems from its frame, and the still linear figure style.[47] In the Princeton book, the draftsmanship in brown ink is occasionally sloppy, suggesting that this was a provincial product, perhaps in Picardy. Yet its decorative repertory of curvilinear and rectilinear stems with pointed trefoil leaves inhabited by creatures in the margins follows the fashion of the courtly devotional books that illustrate birds. There are often recognizable species populating the margins, for instance, of the Franciscan Breviary of Blanche de France of *c.* 1320 in the style of Jean Pucelle, now in Vatican City (Biblioteca Apostolica Vaticana, Ms. Urb. lat. 603).[48] In the Princeton Hours, most of the birds are generic. If there is a salient feature of the Princeton Hours, it is the butterfly, the only insect rendered in this book. In twenty-five instances, it is colored principally in red with white and occasionally black scales (fol. 130[r], Fig. 20). The *papillon* surely evokes the heraldic *gules, papillonné argent* of the Ronquerolles armorial. Thus, the presence of the *papillon* or butterfly infers Marguerite de Chambly, dame of Ronquerolles and wife of Renaud de Montauban, seigneur of Bazentin, as the user and owner of this book. Another creature is the stork, a favorite in prayer books for aristocratic women, and in the Princeton Hours it may signify the couple's hope for a family.

The layout of the four armorials that frame each miniature of a holy scene or figure throughout the Princeton Hours is unusual. There is a precedent of a different sort in the aforementioned Flemish Psalter of Guy de Dampierre, *c.* 1278, in Brussels (Bibliothèque royale, Ms. 10607), or the Picard Psalter-Hours of the 1290s in New York (Morgan Library and Museum, Ms. M. 729), where armorials frame each narrative scene. In the Dampierre Psalter, escutcheons in four corner medallions alter in heraldry from miniature to miniature.[49] In the Morgan Psalter-Hours, shields vary in number from four to six, and family arms are not always consistently placed in the same position in miniatures.[50] Another variation is the use of the same armorials for the first framed miniature in a dated Miscellany of 1323 (Cambridge, Fitzwilliam Museum, Ms. 20). On the first folio beginning with the history of Anna, all four escutcheons point to the Vianden family in Brabant, possibly to Louis, Count of Vianden, born *c.* 1290.[51] This page also features naturalistic birds in the margins (with stems and foliage somewhat like those in the Princeton Hours). This book is illuminated in a Parisian style of Jean Pucelle whose artistic influence extended from the late second to the fourth decade of the fourteenth century, and beyond Paris to northeast France and Flanders. By contrast to the aforementioned examples, the selection and position of the four armorials remain fixed for each miniature throughout the Princeton Hours.

47. The image of St. Eustace on fol. 22[r] is reproduced in A. Bennett, 'Commemoration of Saints in Suffrages: From Public Liturgy to Private Devotion,' in *Objects, Images, and the Word: Art in the Service of the Liturgy*, ed. C. Hourihane, Index of Christian Art, Occasional Papers 6 (Princeton, N.J., 2003), fig. 11, p. 71.

48. C. Vaurie, 'Birds in the Prayer Book of Bonne of Luxembourg,' *The Metropolitan Museum of Art Bulletin* 29 (1971), 279–81; G. Hutchinson, 'Attitudes toward Nature in Medieval England: The Alphonso and Bird Psalters,' *Isis* 65, no. 226 (1974), 5–37, at 28, for French and Flemish manuscripts from the 2nd quarter of the 14th century on. The Breviary of Blanche de France (daughter of King Philip V of France) of *c.* 1320 is perhaps one of the earliest French *deluxe* royal books for depictions of numerous naturalistic birds in the margins (on this manuscript, see the full set of photographs in the Index of Christian Art, and for bibliography, see N. Morgan, 'A French Franciscan Breviary in Lisbon and the Breviaries by Jean Pucelle and his Followers,' in *Quand la peinture était dans les livres: Mélanges en l'honneur de François Avril*, ed. M. Hofmann and C. Zöhl, Ars Nova, Studies in Late Medieval and Renaissance Northern Painting and Illumination [Turnhout, 2007], 203–21, at 208, 211, 220 n. 11 with earlier bibliography).

49. For the Dampierre Psalter, see Gaspar and Lyna, *Les Principaux Manuscrits* (as in note 36), 1, 222–23; 2, 43–5 (no. 95), at 45, under the section, of *Héraldique* (list of names for escutcheons by folio number); Carlvant, *Manuscript Painting in Flanders* (as in note 36), color pls. 17 (fol. 9[v]), 18 (fol. 104[r]), figs. 60(f)–60(j), 60(m)–60(o).

50. Gould, *Psalter and Hours of Yolande of Soissons* (as in note 15), pls. 1b, 2–4; 10, 12, 14–16, 21, 25, 26, 28–30, 33, 35–38; A. Stones, *Gothic Manuscripts 1260–1320*, A Survey of Manuscripts Illuminated in France, Pt. 1, 1–2 (London and Turnhout, 2013), 1: ills. 434 (fol. 85[v]), 437 (fol. 296[v]); 2: 230–39 (cat. III-33).

51. *Illuminated Manuscripts in Cambridge: A Catalogue of Western Book Illumination in the Fitzwilliam Museum and the Cambridge Colleges*, ed. N. Morgan, S. Panayotova, *et al.*, part 1, vol. 2: The Meuse Region, Southern Netherlands (London, 2009), 53–6 (no. 161) with earlier bibliography, color fig. p. 55 (fol. 1[r]).

FIGURE 20. Hours of the Virgin, Compline, Psalm 130. Princeton University Art Museum, Ms. 2010-115, Book of Hours, fol. 130ʳ.

I conclude on the significance of the same four heraldic arms linked with twenty miniatures, and on the commission by a noble family whose roots extended from the Île de France to Artois and Picardy. The shields not only highlight the family identity, the history of lineage, and social connections, but also are signifiers of the religious culture by virtue of their proximity to pictures of sacred content and holy figures.[52] Like mementos of emblems, symbols, or images, these escutcheons commemorate and personalize the connections of family members with the Lord, the Virgin, and saints in their daily lives. This is not only a book of devotions but also a book of social distinction of families joined by marriage. Instead of the usual

52. Cf. M. Michael, 'The Privilege of 'Proximity': Towards a Re-definition of the Function of Armorials,' *Journal of Medieval History* 23 (1997), 55–74.

devotees' portraits seen in numerous Books of Hours, the displayed armorials testify to the family alliances of two generations through the matrilineal line (of the two Marguerites, the mother and her daughter) from Chambly and Ronquerolles to Bazentin. They affirm the legality of the conjugal relationship between wife and husband and cement the ties between families. This pocket-sized Book of Hours was intended for Marguerite de Chambly, dame of Ronquerolles, with her husband, Renaud de Montauban, seigneur of Bazentin, in a kinship-based, noble household. The Chambly Hours is of simple contents, including just two brief prayers for the soul and for thanksgiving, and was a portable family book used for home, church, and travel. Moreover, in this manuscript the owners surely conveyed their personal reverence for local saints with pictures memorializing Denis of Paris and Fiacrius of Meaux from the Île de France, and Firmin the Martyr along with John the Baptist and John the Evangelist at Amiens in Picardy. Relatives of the Chambly, Ronquerolles, and Bazentin families continued to maintain their social prominence, important enough for the fifteenth-century herald to enlist their armorials for the Picard genealogy of Hector de Flavy, who obviously had high regard for his ancestors.

MARILYN ARONBERG LAVIN

A New Allegory of Divine Love: The Netherlandish Blockbook 'Canticum Canticorum'

MY AIM IS TO RE-INTRODUCE you to a late fifteenth-century blockbook called the *Canticum Canticorum* that follows the traditional identification of Bride and Bridegroom of the biblical *Song of Songs* as the Virgin Mary and Christ.[1] This book is a great work of Northern Renaissance Art that I call the 'Sistine Ceiling of woodcuts.' The thirty-two framed compositions on eight sheets, four to an opening, unlike most contemporary woodcuts, do not reflect the stiffness of the hard wood on which they were carved. On the contrary, these prints exude ethereal elegance and an atmosphere that is transparent and luminous. Figures composed of flowing contours are completely enveloped by ample draperies, augmented with short, parallel hatchings that suggest volume but do not add weight. This effect gives the figures physical presence while detracting nothing from their supple buoyancy. They seem to hover above the ground, since contact between vertical and horizontal is always hidden beneath the drapery's breaking folds. In fact, throughout the suite, not one foot is visible. By the same token, seated figures are supported by nothing; their positions are correct, but the human forms float like candle flames above the ground.[2] The easily read gestures of prayer, acclamation, and response are made with otherworldly modesty and meekness. As a result, all characters manifest a pervasive air of mystical spirituality, fully expressive of the content they represent.

In spite of all their delicacy, the human beings hold sway over their backdrops. In the architectural set-tings of many scenes, they miniaturize the buildings and subject them to the human drama. Landscapes too are abstracted, with simplified rocks, plants, and stratified hills. These elements articulate the pictorial space, which often rises to a high horizon, giving something of a 'bird's eye-view' in the Gothic manner. In other cases, particularly scenes with tile floors, the view recedes into space on the basis of linear perspective, the 'modern' technique only recently imported from Italy. Yet there are further elements that subvert what at first glance looks like burgeoning naturalism. In most scenes, the main characters are rendered slightly larger in scale than other figures, recalling the hierarchical progression familiar in medieval art. This disjunction is furthered by super-sized banderoles furling dramatically around the figures. In the new context, the combination represents a modern way of seeing the spiritual realm as part of the practical world, or more specifically, a new visualization of the intersection of the two.

The designer has never been identified; Hans Memling is most frequently mentioned, although he is not documented as a draftsman, as well as Dieric Bouts, and Petrus Christus. Nor is the date firm, although watermarks place the paper between 1465 and 70. As for locale, Ghent, Bruges, and Tournais are all possible, since they, like other Netherlandish towns, were active in the book trade.[3] The *Canticle* shares many motifs with the great works of contemporary painting (more so than with manuscript illumination), but none offers

1. This essay is a summation of material fully developed in my forthcoming book: *An Allegory of Divine Love: The Netherlandish Blockbook 'Canticum Canticorum'* (Philadelphia, Pa., 2014).

2. Only Christ/sponsus has seating support in three of the compositions.

3. There has been a major reorientation in the study of woodcuts and blockbooks during the last decade, bringing about a reassessment of both their chronology and precedents. See P. Parshall and R. Schoch, eds., *Origins of European Printmaking:* *Fifteenth-century Woodcuts and their Public* (New Haven, Conn., 2005); and P. Parshall, ed., *The Woodcut in Fifteenth-Century Europe*, Studies in the History of Art, 75 (New Haven, Conn., 2009). In the latter publication, two articles, P. S. Needham, 'Prints in the Printing Shops,' 38–91, and N. F. Palmer, 'Woodcuts for Reading: The Codicology of Fifteenth-Century Blockbooks and Woodcut Cycles,' 93–117, are fundamental contributions to the field, with pertinent bibliography, including each authors' own earlier work.

a level of positive twinning with the prints. I there-
fore suggest that, in the light of the unique character
of this artist's nuanced style, we baptize the designer
as 'The Master of the *Canticum Canticorum.*'

As a blockbook, perhaps its most salient aspect is the
fact that it has no printed identification. The sheets
bear no page-signatures or rubrics. The framed scenes
contain no titles. There is no commentary of any kind.
The title page contains the words *Canticum Cantico-
rum,* but nothing more. Verbal matter consists solely of
Latin inscriptions that appear in elaborately scrolling
banderoles often as big as the figures themselves. The
verses quoted without identification seemingly have
been chosen at random, since, in the sequence, they do
not follow the order found in the biblical poem. The
title of the book guarantees the texts as sacred, and the
figures with halos indicate the same for the pictures.
The texts clearly go with the pictures, or possibly it
is the other way around, since the two media can be
described as almost physically intertwined.

Almost everything I have said so far distinguishes
the *Canticum* from other contemporary blockbooks
with which it was frequently bound. Pages of the
Biblia Pauperum, for example, are arranged in all-over
patterns with commentary and instruction included
in the compositions (Fig. 1). Scenes in *Speculum Hu-
manae Salvationis* most often appear at the top of the
pages with columns of prose commentary covering
the other two-thirds of the sheets. Biblical narratives,
such as Apocalypse illustrations, frequently use super-
imposed scenes similar to the *Canticum,* two to a folio,
but the scenes are not individually framed and they
always are identified with titles and page numbers.[4]

The order the *Canticle* sheets are bound—which
varies from copy to copy—has always been contro-
versial. Some say there is no particular order and that
the variations are meaningless. Rather than concern
with the book as a work of art, therefore, most of the
effort has gone toward its attribution, date, and prov-
enance.[5] Everyone agrees, however tacitly, on which

FIGURE 1. Christ and the Magdalene. *Biblia Pauperum,* block-
book, c. 1460–70, ·|·, Sächsische Landesbibliothek, Staats- und
Universitätsbibliothek, Dresden, Inv.-Nr.: g 152 (photo: SLUB
Dresden / Deutsche Fotothek / Martin Würker).

sheet is the first: inscribed in the composition in the
upper left is the first verse of the first chapter of the
biblical poem, *Osculetur me osculo oris sui* (Let him kiss
me with the kisses of his mouth). It is assumed that
with this opening salvo the rest of the poem should
follow in good order. We are disabused of this notion
immediately, however, because the second banderole in
the same composition does not follow on the first but
is taken from much further on in the poem, Chapter
5, verse 1. In the second composition, the first inscrip-

4. A. Henry, *'Biblia Pauperum:' A Facsimile and Edition* (Al-
dershot, 1987); A. Wilson and J. L. Wilson, *A Medieval Mirror:
'Speculum humanae salvationis,' 1324–1500* (Berkeley, Calif., 1984);
for the *Apocalypse,* see Palmer, 'Woodcuts for Reading' (as in
note 3), 17–20.

5. Please see the Appendix for a listing of the eight extant

complete sets of the *Canticum Canticorum,* plus one illuminated
manuscript, which shows the various orders in which the sheets
are gathered. The first four exemplars are all in the same order,
the one I accept as correct. The other five entries vary from the
first four and from each other.

tion (that is, first on the left) is Chapter 7, verse 5, and the second is Chapter 1, verse 4. If we take this new sequence seriously, that is, if we recognize that it was chosen for a purpose, we will find that while using hallowed biblical material arranged in unexpected ways, the authors were proceeding to create a new poem.

This technique of 'order in disarray,' in fact, has a long life as a rhetorical tactic. It was commonly employed in the visual arts, being one of the driving forces in the organization of monumental mural decoration throughout the Middle Ages. In my book *The Place of Narrative*, I show that more than fifty percent of fourth- to sixteenth-century fresco and mosaic cycles applied the out-of-order disposition. I even found a number of set patterns of narrative disarray.[6]

In the literary realm, what became known as the cento (from Greek κέντος, meaning 'to stitch together,' as in a patchwork) was used, again, from the fourth century on, primarily in Latin epithalamic poetry. Perhaps the most famous executor of the *Cento nuptialis* was Ausonius (*c.* 310–*c.* 395), whose often quite ribald poem is composed entirely of lines culled from various works by Virgil. In the Christian realm, the poetess Faltonia Proba wrote her 694-line cento, also made up of Virgilian lines, to tell the story 'from creation to the coming of the Holy Spirit.' Although sometimes called 'unimaginative,' Faltonia's work was praised not only by Isidore of Seville but also by Boccaccio and Christine de Pizan, bringing awareness of the form into the fourteenth and fifteenth centuries. In medieval liturgy, which habitually drew on the *Song of Songs* for material, the 'collage' technique was ubiquitous; I give but part of one example—an eleventh-century antiphon sung at Cluny on the feast of the Assumption, where the order of the verses begin: [4,7], [4,11], [2,11], [2, 12], and so on. Centonization is thus more than just rearranging the order of lines. It is a creative process of mining of poetic ideas, in our case from the biblical poem, to create new meaning.[7]

At this point, I must say a few words about the biblical *Song* itself and where it was in the public domain around 1465. In form, it is an epithalamium or nuptial song, which, by the time it was added to the Bible in the fourth or third century B.C.E., was considered so powerful and so noble it was presumed to be of royal origin and attributed to King Solomon himself, hence the frequent title The Song of Solomon. However, the carnal desire the poem depicted and its erotic imagery were so graphic that, almost from the beginning, rabbinical scholars cast the passionate relationship as a divinely inspired allegory of Yahweh's love for his chosen people. The allegory, called the 'Royal Wedding,' was incorporated in the Christian Bible with the bridegroom identified as Christ and the Word of God, and the bride as his beloved Ecclesia, the aggregate of Souls. The other characters are the Daughters of Jerusalem/Sion, souls of believers who are attendants of the Bride; and Angels who are 'Friends of the Bridegroom,' the guardians of souls before the coming of Christ. The poem was proclaimed as a major link in the chain of the Old Testament premonitions that are typologically fulfilled in the New, expressing through its portrayal of erotic passion the godhead's ardor and satisfaction with the decision to forgive man's sin through the sacrifice of redemption. During the twelfth century, a veritable flood of commentaries issued forth from the monasteries of Europe, mainly under the impetus of St. Bernard of Clairvaux (1090–1153), who joined the abstract notion of Ecclesia with the human *sponsa* and identified her with the Virgin Mary. In effect, a new character called Maria-Ecclesia was established, and once and for all, the Old Testament love poem was seen as the primary vehicle for Marian ideology and devotion. Fascination with the Canticle can be measured by the fact that there are more commentaries on it than any other biblical book (including commentaries by Luther and Calvin).[8] But nevertheless the poem remains a problem.

6. Marilyn Aronberg Lavin, *The Place of Narrative: Mural Decoration in Italian Churches, 431–1600 A.D.* (Chicago, Ill. and London, 1990; 2nd ed., 1994).

7. I thank Dr. Anastasia Drandaki for information on the word 'cento.' T. Klauser, ed., *Reallexikon für Antike und Christentum*, 22 vols. (Stuttgart, 1950–2004), 2 (1954): 972–74; S. McGill, *Virgil Recomposed: The Mythological and Secular Centos in Antiq-*

uity (Oxford/New York, 2005); J. Ziolkowski and M. C. J. Putnam, eds., *The Virgilian Tradition: The First Fifteen Hundred Years* (New Haven, Conn., 2008), 471–75; M. Quilligan, *The Allegory of Female Authority: Christine de Pizan's 'Cité des Dames'* (Ithaca, N.Y., 1991), 96–9.

8. Please see the discussion of this subject in M. A. Lavin and I. Lavin, *Liturgia d'Amore: Immagini dal 'Cantico dei Cantici'*

Because of its direct allusions to sex and physical consummation, over the centuries there have been many warnings that the poem should be approached only by readers who were properly prepared to accept it on the allegorical level.[9] Unlike the Psalms, the *Song of Songs* never appears in the Catholic liturgy in its entirety, or even in large portions. Only short, disparate phrases are extracted and quoted in hymns, antiphons, and responses, on feasts of the Virgin and those of other female saints.

In terms of visual expression, images began in late medieval commentary manuscripts, starting with a single type: an allegorical couple in the form of Christ and a mature, stalwart female Ecclesia (Fig. 2). At first they merely take hold of one another. Later the two fall into a passionate embrace, bodies close, arms entwined, faces merged in a kiss, the bride having evolved into a figure of great femininity representing the Church, the Soul, and then Mary herself (Fig. 3). Finally, the infant Christ replaces the man in the arms of his loving mother, appearing within the circumference of the letter 'O,' the first letter of the first word of the first verse of the Song: *Osculetur.*[10]

A new turn was taken around 1240 when it came to illuminating the aristocratic *Bible Moralisée.* Dozens of images were invented for selected verses of the book of the *Song*, arranged to follow the order of scriptures (Fig. 4). On each folio, the passages are inscribed in the margin, next to medallions containing pertinent images, miracles of short-hand illustration. While the characters often touch each other affectionately, there is less than a modicum of lovemaking and no attempt to connect the scenes one to the other. Although viewing these manuscripts was apparently restricted to a

FIGURE 2. Christ and Ecclesia. Frowin Bible, 1143–1178, manuscript illumination, Engelberg Stifsbibliothek, Cod. 4, Bd. 2, fol.69ᵛ (photo: Author's archive).

closed circle of royalty for the first few decades, by the third quarter of the thirteenth century the new motifs somehow spread abroad, becoming models for other illustrations. Among the earliest reflections are

nell'*Arte di Cimabue, Michelangelo, e Rembrandt* (Siena/Modena, 1999), 13–15, 247–48, and *The Liturgy of Love: Images from the 'Song of Songs' in the Art of Cimabue, Michelangelo, and Rembrandt* (Lawrence, Ks., 2001), 1–2, 105–06.

9. Denys's warning, e.g., comes at the beginning of his Commentary on the *Song of Songs: Doctoris Ecstatici, D. dionysii cartusiani, opera omnia.* 42 vols. (Monstrolii, 1896–1913) 7 (1898), 'Enarratio in Canticum Canticorum Salomonis,' 293–447. In translation it reads: 'How this book should be read. See how many wise and expert witnesses: [Origen, Gregory the Great, Gerson], show us what sort of men the readers and listeners to this book ought to be, a book that on the surface of it gives the impression of being carnal indeed, but turns out to

be deeply spiritual when understood rightly. Its readers have to be, I say, men of piety and purified from sensuality. Otherwise when meeting the words for things of the flesh they will be led to think of sexuality, rather than rising to things intellectual and spiritual, and will suffer harm to their souls.... [Readers] must lift up their hearts to remember God, to think of Our Lord Jesus Christ, His Church and the Blessed Mother and their very pure mutual love. Let them concentrate on such things at least in a general way, and stay away from any indecent representations.'

10. For identification of these images and color reproductions, see again Lavin and Lavin, *Liturgia d'Amore* (as in note 8), figs. 33–37, 57, and 59.

FIGURE 3. Sponsus and Sponsa. 1123, attributed to the Alex Master, manuscript illumination, Bede. Commentary on the *Song of Songs*, Cambridge, King's College, Ms. 19, fol. 21ᵛ (photo: Author's archive).

FIGURE 4. *Bible Moralisée*, 1235–1245, Paris, Bibliothèque nationale de France, Ms. lat. 11560, fol. 73ᵛ.

found in the *Rothschild Canticles*. With its enormous and complex array of prophets, saints, and mystical visions, the manuscript also quotes and pictures many verses of the *Song of Songs*, often drawing on the *Bible Moralisée* as a source.[11]

Although very little evidence has survived, *Song of Songs* illustrations undoubtedly continued in an unbroken chain into the fourteenth century. I assume this line of reasoning because the religious literature of the time is dense with allegorical love stories, enriched with *Canticum* quotations, allusions, and imagery. Two works stand out: one by an aristocratic Franciscan friar, Lamprecht von Regensburg, whose four-thousand-line Latin poem in rhymed couplets has Love, or Caritas, shoot through the heart both Christ and the soul, the latter in the form of a woman. Travelling the world in search of the shooter, the woman

finds Christ is the source of the love, and a heavenly wedding is arranged, modeled on the *Song of Songs*. The second work is a song in twenty strophes set to music by a travelling minstrel known as Frauenlob. He takes up the theme of the bride/sponsa and presents a theological, philosophic, and mystical lyric that brings the woman into complete loving union, spiritual and physical, with her spouse. While Mary and Christ are not mentioned in this text, the title *Marienleich* makes the subject clear. Both works were translated into German and then Dutch and were widely known by the fourteenth century. Another literary genre, recently published for the first time, is Dutch lectures, a group of which are known as the 'Limburg Sermons.' They are all composed on the basis of direct allusions to the *Song of Songs*, and documented from about 1310 forward. The genre continued throughout the

11. Le Comte A. de Laborde, ed., *Bible Moralisée, Conservée à Oxford, Paris et Londres*, 5 vols. (Paris, 1911–27) 2, Paris, BnF, lat. 11560, fols. 66ᵛ–93ᵛ, pls. 290–317; J. F. Hamburger, *The Rothschild*

Canticles: Art and Mysticism in Flanders and the Rhineland circa 1300 (New Haven, Conn., 1990), 21–24, 61, 81.

FIGURE 5. Mural No. 4, Cistercian Convent, Chełmno, Poland (photo: Courtesy
Ewa Herniczek).

century and into the next, providing another devo-
tional precedent for our *Canticum* blockbook, this time
in the language of the Netherlands.[12]

Thus we may assume that there once also existed an
unbroken chain in paintings and illuminated manu-
scripts with Canticle illustrations of which the fol-
lowing instance is only one example (Fig. 5). On the
walls of the out-of-the way cloistered church of the
Cistercian female convent at Chełmno, Poland (no-
torious Kulmhof, in German), is the first mural cycle
based on the *Song of Songs*. Circling the walls of the
nuns' sanctuary from south to north, the murals pres-
ent an astonishingly large number of Canticle scenes
(thirty or so), over-laid with flat banners inscribed,
presumably, with *Song* verses, all of which have dis-
appeared. The cycle continues without a break with
eleven Passion scenes. The graphic style is charming
but rather unsophisticated, and was clumsily restored
in the 1950s. The compositions convey a coherence

of expression that is, in fact, far beyond the ability of
the painter(s), a disjunction that implies reliance on a
series of set model(s). Here, the scenes are arranged in
a sequence that emphasizes the rapturous relation be-
tween Christ and his glorified Church, since the cycle
starts with several bedroom scenes. In the Cistercian
context the choice of the *Song of Songs* was obviously
inspired by St. Bernard, the great Cistercian reformer
and promulgator of the erotic poem's spiritual power.
His eighty-six sermons on the Song (which go only
through the first three chapters) are written in un-
abashedly sexual language, and were routinely read
by all who entered the order, male or female. These
little-known murals were studied by a young Polish
woman, Ewa Herniczek, who rightly identified the
'imitatio sponsi et imitatio Christi' as basic tools for
the nuns' internal improvement leading to full unity
with God.[13]

While no evidence remains, the tradition of *Song*

12. This literature is discussed at length by H. E. Keller, *My
Secret is Mine: Studies on Religion and Eros in the German Middle
Ages,* Studies in Spirituality, Supplement 4 (Leuven, 2000); B.
Newman, *Frauenlob's Song of Songs: A Medieval German Poet and*

his Masterpiece (University Park, Pa., 2006); W. Scheepsma, *The
Limburg Sermons: Preaching in the Medieval Low Countries at the
Turn of the Fourteenth Century*, trans. D. F. Johnson (Leiden, 2008).
13. E. Herniczek, *Unio Mystica: Średniowieczne malowidła nad*

illustrations surely must have continued unabated in the century that followed, since, although separated by more than a hundred years in time and more than a thousand kilometers in distance, nineteen scenes in the Chełmno frieze forecast similar subjects in our *Canticum Canticorum* cycle, implying dependence on similar models. In both cases, more lines of the *Song of Songs* are presented outside of the biblical context than had ever been put forth without the traditional *caveat*. However, the audience for the cycles changed from cloistered nuns to a broad public of educated book-buyers. Of course, the styles are radically different. And even more so is the sequence of scenes, to which we now return.

Because the order of the verses in our blockbook, not to say the order of its sheets, has been designated as an incomprehensible jumble, no previous attempt has been made to find an overall theme or plot. It should be obvious that I believe the unknown creators chose the verses with rigorous care, organized them into thirty-two episodes, and used the divine love affair to create a long, ample narrative with a statement of theme, recapitulation, climax, and resounding dénouement. I would go so far as to say that recognition that the verses are not in biblical order is the first step in understanding that there is an alternative theological message embedded in the book. I admit that without titles or commentary, finding that meaning is something of a problem, which I see under three headings: First, studying the pictures individually to decipher their subjects; then seeing the relationship between the centonized poetic lines to get the gist of their sequence; and third, considering the thirty-two framed compositions as a sequential series in an attempt to find a unified structure.

Regarding the first problem: We have already seen that some of the motifs find precedence in earlier visual images related to the *Song of Songs*. But how many Dutch readers knew these particular sources? The answer comes from the fact that in almost every instance the configurations rely on poses and groupings deeply ingrained in the Christian iconographic tradition. We may assumed that the artist recalled these configurations objectively to form what have been called *recursive* images from which the observer could search his own experience and take a cue (Fig. 6).[14] A path is thereby opened for grasping the meaning of the same elements in new settings. In no way do I suggest direct dependence on other works of art; rather I refer to motifs, themes, poses, and types of compositions that would have been part of the common visual vocabulary. My examples are drawn from Netherlandish art (Fig. 7), and German repertories, dating both before and shortly after the presumed date(s) of the *Canticum*, and from Italian panel paintings and frescoes, recognizing the interchange between north and south, which was not unusual by this period.

Reading through the centonized verses in the inscriptions, the reader would find the new poem and be delighted by its personal, passionate tone. As a devout bibliophile he also might seek help from one of the many commentaries on the Canticles, in particular that of Denis the Carthusian whose elaborate analysis was published at almost the same time as the blockbook.[15]

Then, having begun to understand the pictures and the words, the reader/spectator has to sustain this approach throughout the thirty-two units before the overall content starts to emerge. Observation, study, contemplation, and devotion are, in fact, the creative elements expected from the onlooker. They are the *tertium quid* that complete the book as a work of art. This process is essentially what I followed in the recuperation of the theological drama that, according to me, goes something like this:

emporą dawnego kościoła cysterek w Chełmnie [The Medieval Paintings above the Nuns' Gallery in the Former Church of the Cistercian Convent at Chełmno] (Kracow, 2009). See also R. Bartal, '"Where has your beloved gone?": The Staging of the *Quaerere deum* on the Murals of the Cistercian Convent at Chełmno,' *Word & Image* 16, 3 (2000), 270–89. I thank both of these scholars for their generosity in supplying me with photographs of this cycle.

14. A series of comparative illustrations for each of the 32 composition will be found in my forthcoming publication, Lavin, *Allegory of Divine Love* (as in note 1). I borrow the term *recursive* from A. Nagel and C. S. Wood, *Anachronic Renaissance* (New York, 2010).

15. Denys, *Commentary* (as in note 9 above).

FIGURE 6. Simon Marmion, Scenes from the Life of St. Bertin, 1459, detail, *St. Bertin's Miracle of the Wine*, left end, Gemäldegalerie, Staatliche Museen zu Berlin (photo: © bpk / Gemäldegalerie, SMB / Jörg P. Anders. Andersorderon). See Fig. 12 (Sheet V, 9b).

FIGURE 7. Rogier van der Weyden. *Visitation,* 1445, Museum der bildenden Künste, inv. no. 1550, Leipzig (photo: bpk Berlin / Museum der bildenden Künste / Art Resource, N.Y.). See Fig. 10, Sheet III, 5a.

(Fig. 8) Sheet I: Christ-Logos chooses his bride and shows her the ideal life. She is elevated with foreknowledge of both joys and sorrows. The couple plights their troth. The bride described her lover to her maidens.

(Fig. 9) Sheet II: She declares her faith. Christ returns her commitment. He informs her of the mystery of the Eucharist. He assures her eternal virginity.

(Fig. 10) Sheet III: He declares her purity. They embrace spiritually. She opens her garden. They are mutually wounded, sick with love.

(Fig. 11) Sheet IV: They are bound together in the garden. Seeking love, they become impatient. They plan a tryst. The maidens glorify their mistress.

(Fig. 12) Sheet V: The couple plans their marriage. Christ ordains his future bride as *sacerdos*. At the half-way mark, she achieves his goal, becoming Mary, venerable Ecclesia. She gives and receives charity. The one liturgical image in the sequence forecasts the Virgin's bodily assumption; she will be accepted in heaven.

(Fig. 13) Sheet VI: Mary steps out to reassure her companions, as she is called back by Christ. Now assisted by an angel, she explains the passion to them. She demonstrates the Sacrament. She supports the sacrifice.

(Fig. 14) Sheet VII: Mary defends herself from public scorn. In private, she enacts Holy Mass. She brings Christ to her mystic bed. They enter the bed chamber.

(Fig. 15) Sheet VIII: Mary assumes her terrestrial throne. The lovers consummate their marriage before witnesses. They seal their eternal bond. Remembering her naïve self, Mary receives the crown of heaven.

If the book was for a monastic audience we should remember that at least from the late twelfth century on, entry into a monastic community was recognized as a marriage with Christ, with much effort expended on instructing the suppliants how to carry out mar-

FIGURES 8–15, SHEETS I–VIII (*opposite and on the pages following*). Canticum Canticorum, 1st edition, New York, Morgan Library, PML 21990. Purchase: 1923 (photos: Morgan Library and Museum).

ital duties.[16] One of the original functions of our blockbook, then, might have been as a wedding gift, a meditational *exemplum*, a veritable manual of mutual love between the professed monastic and the Savior. This class of readers, for whom meditation was part of daily life, had enough training in reading the Bible and observing religious works of art to study the *Canticum Canticorum* and unpack its meaning. Those who constructed the new *Canticum* poem, well trained in theology, and the professional designers and cutters whom they commissioned, grasped the new concepts, respected and adapted what traditions there were for *Song of Songs* illustration, and invented new images where they were called for. Only this procedure could have produced a work of art of such thoughtful artistic and religious value.

The success and admiration for the first edition of the book was soon followed by a second. And at this point a caption was added in Dutch, recut within the frame of the first composition, which reads: 'This (suite of prints) is the prefiguration of Mary the Mother of God, and is called in Latin *Canticum Canticorum*.' The announcement unequivocally confirms the identification of the *sponsa* as the Virgin Mary. At the same time, the vernacular language redirects the publication to a second audience, one that knew some Latin but that had to be prompted in a familiar tongue to take up its challenge. This new public, primarily urban elite, could have been members of third (or lay) orders, or, more generally, a literate level of pious devotees.

We can see from the extensive re-cuttings and multiple 'pulls,' that the book had many printings and a wide circulation.[17] We may surmise that in all these cases, it would have served a parallel function in showing the path to fulfillment in a good marriage, this time on earth as well as in the spiritual world. Beautiful

16. W. M. Johnston, ed., *Encyclopedia of Monasticism*, 2 vols. (Chicago, Ill. and London: 2000), 1: 646–48.

17. M. Meertens, *Het Blokboek 'Canticum Canticorum' als Godsdienstig Kunstwerk*, vol. II of *Canticum Canticorum* (Antwerp, 1949); *Blockbücher des Mittelalters: Bilderfolgen als Lektüre*, eds. S. Mertens, E. Purpus, and C. Schneider (Mainz: P. von Zabern, 1991), 405–06, list of extant copies.

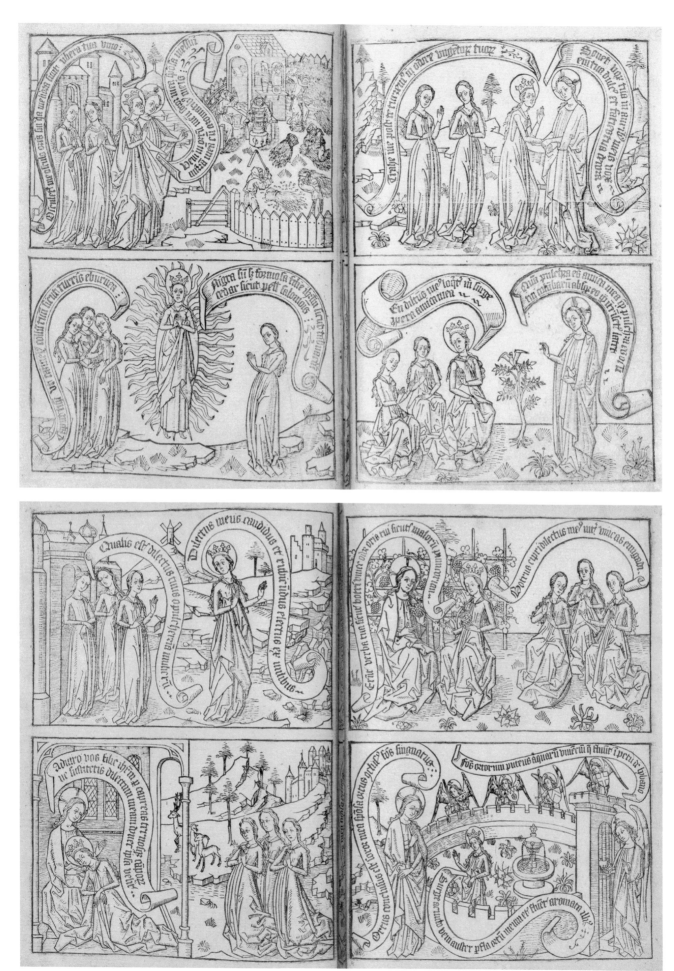

FIG.
8,
Sheet
I

FIG.
9,
Sheet
II

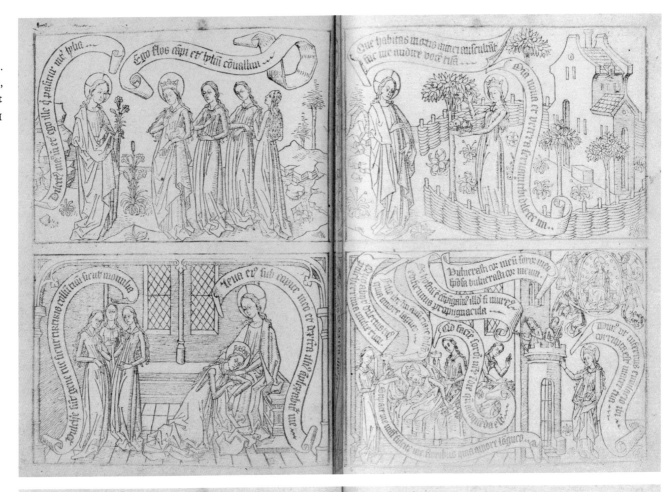

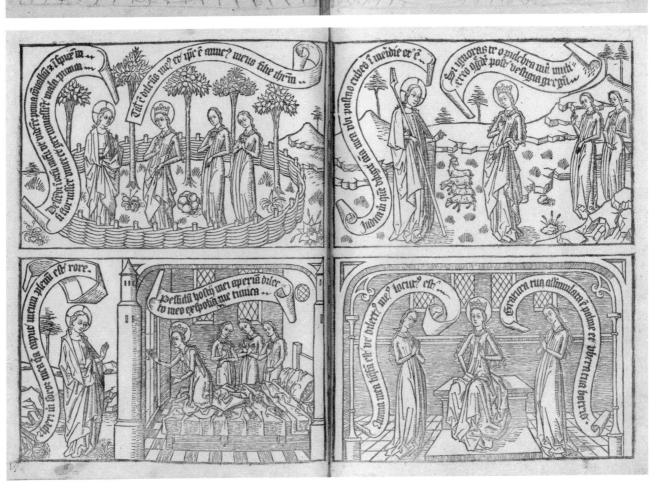

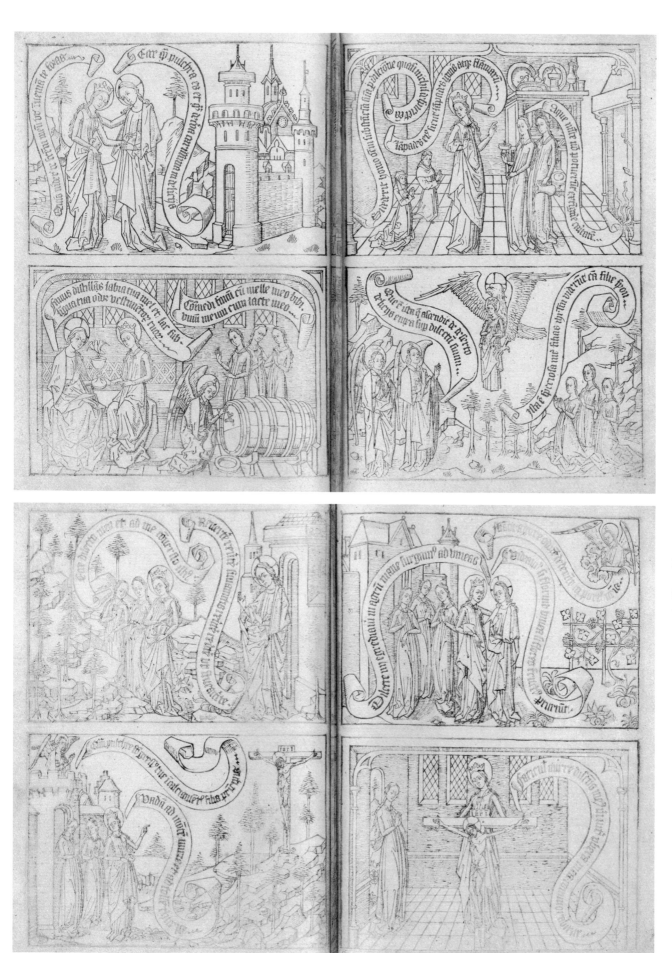

FIG.
14,
Sheet
VII

FIG.
15,
Sheet
VIII

copies, such as a painted version in Munich, or the gold-edged copy in the Morgan Library, would have been suitable as gifts, to be cherished and maintained. In this manner, the Suite would have entered into the literature of marriage manuals, the tradition for which had a rich and wide-spread development outside the convents throughout the fourteenth and fifteenth centuries.[18]

One last observation: in this exegetical work, the *sponsa* becomes the Virgin Mary, but not a loving mother. The story does not follow Mary's life events. Rather, it recounts a metaphysical romance that might be called 'the marital education of the Virgin,' delineating how Christ-Logos chose his bride; how she left her secular life and was prepared for her role as co-redemptress. At the same time, the story has an ulterior and contemplative level, dramatizing the founding of the early Church, its trials and triumphs in becoming the savior's beloved Ecclesia. In this journey, Mary recognizes her calling, understands her mission, accepts her responsibilities, and arrives at glorification. Her final perfection gives reassurance to every loving soul, through identification with the Queen of Heaven, that s/he too will obtain salvation from the young and handsome Savior. This precious book must have proved irresistible to a pious, educated, aesthetically oriented society, as a guide, a song, and a promise.

18. See L. Staley, *Languages of Power in the Age of Richard II* (University of Park, Pa., 2005), 267–95.

Appendix

ORDER HERE ACCEPTED AS ORIGINAL

Munich, Bayerischen Staatsbibliothek, Blockbüch, Xylogr. 32: facsimile: *Canticum canticorum Societatis in honorem Marées pictoris conditae opus, tricesimum quartum editio archetypum anni circiter 1465 imitans* (Munich: Berolini, 'Ganymedes,' 1921–22); copy in Lilly Library, Bloomington, Ind., scanned in full color.
Order: 1 2 3 4 5 6 7 8.

New York, Morgan Library, PML 21990: no facsimile; page borders brushed with gold.
Order: 1 2 3 4 5 6 7 8.

Paris, Bibliothèque nationale de France, Rés. xylo. 27, petit in-folio: Francis Bouvet, ed. *Le cantique des can-tiques. Canticum canticorum. Historia seu providentia Beatae Mariae Virginis ex Cantico canticorum.* Facsimile (Paris: Bibliothèque nationale, Éditions de minuit, 1961).
Order: 1 2 3 4 5 6 7 8.

London: British Museum: Department of Printed Books, Scriverius ed. (owned by Pieter Schrijver) Ms. 1C.47, 2nd ed.: J. Ph. Berjeau. *Canticum Canticorum, Reproduced in Fac-simile from the Scriverius copy in the British Museum* (London: Trubner & Co., 1860).
Order: 1 2 3 4 5 6 7 8.

ALTERNATE ORDERS

Munich, Bayerischen Staatsbibliothek, Blockbüch, Xylogr. 33: Paul Clemen. *Canticum Canticorum. Holztafeldruck von etwas 1465.* (Zwickauer Faksimiliedrucke 4, Zwikau, 1910).
Order: 1 3 2 4 5 6 7 8.

Oxford, Bodleian Library, Auch. M 3.12: Nigel Palmer, *A Catalogue of Books Printed in the 15th Century now in the Bodleian Library, Oxford,* eds. Alan Coates *et al.* (Oxford: University of Oxford Press, 2005), 6 vols., vol. 1, BB-7, pp. 18–20. Order varies from that reported in 1771: Karl van Heinecken. *Idée Générale d'une Collection Complette d'Estampes* (Leipzig/Vienna: Jean Paul Kraus, 1771), 374–77, titled 'Historia seu Providentia Virgins Mariae ex Cantico Canticorum.'
Order: 1 2 4 6 3 5 7 8.

London, British Museum, Department of Printed Books,
 Cracherode.1B.46; 2nd ed.: same order as Bodelian
 Blockbook.
 Order: 1 2 4 6 3 5 7 8.

Vatican, Biblioteca Apostolica Vaticana, Pal. lat. 143 (cut,
 recut, rearranged 2 ×; now rearranged to match Mor-
 gan/Munich/Paris, pasted): *Biblia pauperum: riprodu-
 zione del codice Palatino latino 143*. Intro. Lamberto Do-
 nati and Luigi Michelini Tocci (Città del Vaticano:
 Biblioteca Apostolica Vaticana, 1979), Series: Codices
 e Vaticanis selecti. Series Minor; vol. 4; bound with
 Biblia pauperum and *Speculum Humanae Salvationis*.

Order: 1/2 3/10 11/12 13/14 15/6 7/8 9/4 5/16; re-
bound in 1979: 1 2 3 4 5 6 7 8.

Augsburg, Universitätsbibliothek, Cod. I. 3. 2° IV, Furt-
 meyr-Bibel MS (painted Ms. of whole Bible): *Die
 Furtmeyr-Bibel in der Universitätsbibliothek Augsburg*:
 Kommentar / herausgegeben von Johannes Janota; mit
 Beiträgen von Helmut Graser ... [et al.] (Augsburg:
 Müller und Schindler, 1990). The *Song of Songs* in
 full color, 'folio' by 'folio': two scenes to a page; Figs.
 69–84, manuscript fols., 76r–83v.
 Order: 1 3 2 5 4 6 7 8.

INDEXES

GENERAL INDEX

(Italic numbers indicate text figures)

INDEX OF MANUSCRIPTS

(Italic numbers indicate text figures)

PRINTED BY PURITAN | CAPITAL
HOLLIS, NEW HAMPSHIRE

BOUND BY
ACME BOOKBINDING
CHARLESTOWN, MASSACHUSETTS

DESIGNED AND COMPOSED BY
MARK ARGETSINGER
HOLYOKE
MASSACHUSETTS